Learning to Look at Sculpture

Learning to Look at Sculpture is an accessible guide to the study and understanding of three-dimensional art. Sculpture is all around us: in public parks, squares, gardens and railway stations, as part of the architecture of buildings or when used in commemoration and memorials, and can even be considered in relation to furniture and industrial design. This book encourages you to consider the multiple forms and everyday guises sculpture can take.

Exploring Western sculpture with examples from antiquity through to the present day, Mary Acton shows you how to analyse and fully experience sculpture, asking you to consider questions such as: what do we mean by the sculptural vision? What qualities do we look for when viewing sculpture? How important is the influence of the classical tradition and what changed in the modern period? What difference does the scale and context make to our visual understanding?

With chapters on different types of sculpture, such as free-standing figures, group sculpture and reliefs, and addressing how the experience of sculpture is fundamentally different due to the nature of its relationship to the space of its setting, the book also explores related themes, such as sculpture's connection with architecture, drawing and design, and what difference changing techniques can make to the tactile and physical experience of sculpture.

The book is richly illustrated with over 200 images, including multiple points of view of three-dimensional works. Examples include the Riace Bronzes, Michelangelo's *David*, Canova's *The Three Graces*, medieval relief sculptures, war memorials and works from modern and contemporary artists such as Henry Moore, Cornelia Parker and Richard Serra, and three-dimensional designers like Thomas Heatherwick.

A glossary of critical and technical terms, further reading and questions for students make this the ideal companion for all those studying, or simply interested in, sculpture.

Mary Acton was Course Director of the Undergraduate Diploma and Advanced Diploma in the History of Art at Continuing Education, University of Oxford. She continues to teach at the University of Oxford and works as a freelance lecturer. She is the author of the bestselling *Learning to Look at Paintings* (1997, 2009) and *Learning to Look at Modern Art* (2004).

Learning to Look at Sculpture

Mary Acton

Routledge
Taylor & Francis Group

LONDON AND NEW YORK

First published 2014
by Routledge
2 Park Square, Milton Park, Abingdon, Oxon OX14 4RN

and by Routledge
711 Third Avenue, New York, NY 10017

Routledge is an imprint of the Taylor & Francis Group, an informa business

British Library Cataloguing in Publication Data
A catalogue record for this book is available from the British Library

Library of Congress Cataloging in Publication Data
Acton, Mary.
 Learning to look at sculpture / Mary Acton.
 pages cm
 1. Sculpture—Appreciation. 2. Sculpture—Themes, motives.
 3. Visual perception. I. Title.
 NB1142.5A29 2014
 730.1′1—dc23 2013037604

ISBN: 978-0-415-57737-3 (hbk)
ISBN: 978-0-415-57738-0 (pbk)

Typeset in Galliard
by Keystroke, Station Road, Codsall, Wolverhampton
Printed in Great Britain by Ashford Colour Press Ltd

To my husband John and all my students past and present.

Contents

Plates

DISCLAIMER

Although every effort has been made to trace copyright holders, this has not been possible in all cases. Any omissions brought to our attention will be remedied in future editions.

king a set in three dimensions. I have tried to use an
appeared in no figure which involves both the ... a ... world-sheet.

Preface

This book is intended as a companion volume to *Learning to Look at Paintings* and *Learning to Look at Modern Art*. This means that, like the others, it is not a sequel. Inevitably there is some overlapping with the other two books, particularly in relation to artists who practised both painting and sculpture and, in the more modern sections, when it comes to collage and installation.

I have been interested in sculpture for a long time, particularly its three-dimensional and tactile qualities and the way they can relate to the spectator and to their setting. This story includes the sense in which sculpture is always in the spectator's space, and part of our world, in a way that painting cannot be. I practised sculpture when I was at school and more recently when I went to a life modelling class. I also learned a great deal about sculptural qualities when I was teaching in an art school. But, as so often, it is my students who have encouraged me to write this book because they say they are less familiar with sculpture, even though it is around us and more accessible than painting, in the sense of being present in both the interior and exterior environment.

There are many fine books about techniques, tools and materials in sculpture, but there does not seem to be so much information about looking at art in three dimensions. I have tried to take an approach to sculpture which involves looking for its essential plastic characteristics, like the contour, the tactile qualities, Henry Moore's idea of the hole and the bump, its scale and setting. This can include the relationship between form and space, solid and void, movement and stillness, the reflective and non-reflective surfaces, smooth finish and unfinished effects. Then there is the whole area connected with what it is possible to do with carving and not with modelling, and vice versa, and how the installation has allowed other techniques to

be used, particularly in the exploration of interior and exterior space. There is too the subject of replication, of copying with a pointing machine, and how it was used to copy a carving from a bronze, or how plaster could be carved in the process of making models for bronze casts. Then, in the case of installations, there is the whole issue of several versions of the same work. A glossary is included to take care of some of the special vocabulary and definitions, like different types of tool and technical terms used in sculpture.

Overall, the subject of looking at sculpture is wide ranging and complex, so this is designed to be a book for dipping into as much as for reading all the way through. I have received a great deal of enthusiastic interest and help from all sorts of colleagues and friends too numerous to name individually. In particular, I would like to thank my husband, John, who has read every word of the manuscript and, once again, brought his point of view as a designer and maker of furniture to bear on my writing; he also has been very helpful in taking photographs for the illustrations, as has my editor's friend, Finbar Good. Also, there have been friends and relatives who have taken an interest, whether through their suggestions, or their companionship on expeditions to look at sculpture; my friend Lyn Evans, who was such a help with the other two books, also encouraged me with the writing in the early stages of this one. Another very helpful aspect was when I went to look at medieval sculpture in Burgundy with my husband, my brother Freddie Grimwood and my niece and nephew, Katherine and Nicholas; my friend, Carole Machin, who is an art historian and teacher of undergraduates, has also encouraged me in all sorts of ways, particularly when we went to Broadgate in London to see the sculptures there, and to the David Nash exhibition at Kew Gardens.

I have also received a lot of encouragement from colleagues at the Oxford University Department for Continuing Education, like my Director of Studies Dr Catherine Oakes, an expert and distinguished scholar in Medieval Studies, who read some of the sections on medieval sculpture and made helpful suggestions; she also encouraged me to run a number of short courses at Continuing Education on various aspects of looking at both traditional and modern sculpture. In these, I have been able to try out my ideas and have received lively, discursive and helpfully controversial responses. The groups were all eager, inquisitive and informed about many aspects of the subject. Also, the sculptor Pam Foley, who teaches a clay modelling life class at Sunningwell School of Art, which I attended for several years,

helped me a lot and opened up many different approaches to this complex subject. There, I absorbed a great deal about looking and working in three dimensions which is integral and fundamental to sculpture. I learned in particular about the way the life model is turned and you turn your work with it, and how the different points of view completely change your visual experience and interpretation. This was especially true when drawing and modelling the figure in movement, which was very interesting in this context. I also received a great deal of help particularly when writing Chapter 8, on Sculpture and Drawing, from the staff in the Print Room at the Ashmolean Museum in Oxford. The Acting Supervisor, Dr Caroline Palmer, and her assistant, Katherine Wodehouse, were very encouraging with suggestions, particularly about the Salviati Vase.

The other person who has been of paramount importance is Gabrielle Evans, from Cytec Computer Systems, who has taught me patiently and imaginatively about the new technology, and has helped me so much with sourcing pictures and presenting the manuscript. At Routledge I have been treated with patience and encouragement by my editor, Natalie Foster, and her assistant Sheni Kruger; the readers who looked at the original synopsis and made helpful suggestions, and Nik Imrie who has worked with perseverance at the image permissions which have been complicated and long-winded at times. I should also thank the production team at Routledge for the same kinds of reasons and particularly Anna Callander.

Mary Acton

Introduction

There is a sense in which sculpture is all around us if we think of it simply as the experience of three-dimensional qualities. Sometimes for instance you will hear people talk of sculptural form in gardens and in planting arrangements. Even if we ignore these aspects, sculpture exists in all sorts of public places, particularly in the urban environment, and you are just as likely to see it in a busy street as in a museum; it can also exist as part of buildings and its architectural connection is as important as any part of its setting. However, it is important to say straight away that this book is not trying to cover every aspect of this potentially ubiquitous subject.

Like *Learning to Look at Paintings* and *Learning to Look at Modern Art*, *Learning to Look at Sculpture* will be about looking, and particularly about the differences in the experience of looking at three-dimensional art. Examples have been chosen from all periods, from the ancient Greeks and Romans to the present day, but the concentration will be on Western sculpture. Ethnographic, Eastern and Far Eastern sculpture has not been included except where it may have influenced sculpture in the West. An obvious example of this would be the influence of alternative cultures on the art of the early twentieth century which was partly covered in *Learning to Look at Modern Art*. The issue of repetition between the books has been important in the writing of this one which is intended as a companion to the other two. Some aspects, like that of the installation, will be covered again, but with different examples, and from many points of view in relation to the three-dimensional visual experience. The changes which have taken place since the 1960s and 1970s have been profound, especially in the development of land art, and in the use of different materials for sculpture, marking a real break with the classical tradition. However, just as in painting, there are still artists, like

Antony Gormley or Ron Mueck, who work with traditional subject matter and retain an interest in the human form.

There will be a strong thematic element throughout this book, but the structure of each chapter will be broadly chronological as it is in the other two books, and an attempt to relate the modern to the past will also be made. There is inevitably some repetition in relation to recurring aspects like the interaction between architecture and sculpture. Also, some artists like Rodin, Michelangelo or Antony Gormley appear in more than one chapter. This has happened in the other two books and here it applies because sculptors have been interested in more than one type of sculpture which can interact with other areas of their work, like the use of plaster models or drawings for example. Some chapters are longer than others depending on the nature of the subject, and on how many different examples and areas are being covered in connection with each topic; this applies particularly to Chapter 2 on the free-standing figure and its legacy. There, the importance of surface and texture is also considered and, in particular, the tactile qualities of sculpture, which so often cannot be experienced in museums because of value and security, although touch can and should ideally be a major part of it. Of course it might be achieved in private collections with objects like porcelain figures or Fabergé eggs. Some people say that objects like this do not count as sculpture but another aspect of this book is the interesting subject of the visual and historical boundaries between sculpture and painting, sculpture and drawing or sculpture connected to architecture and design.

Everywhere in this book the three-dimensional visual experience is most important and that is why, wherever possible, I have tried to include more than one viewpoint in the illustrations. Here, we should listen to one of the great sculptors of the recent past. On the subject of viewing in the round, Auguste Rodin is recorded by his friend Dujardin Beaumetz as quoting what the celebrated sixteenth-century sculptor Benvenuto Cellini had to say in his *Treatise on Sculpture*:

> When a sculptor wants to model a figure nude or draped, he takes the clay or wax and begins with the front of the figure which he does not leave without having many times raised up, cast down, advanced, shoved back, turned and returned each limb. When finally he is satisfied with this first point of view, he works on one of the sides of his maquette; but then, quite often it happens, that his figure seems less graceful to him. Thus he finds himself forced,

in order to make his new point of view agree with the former one, to modify that which he had already finished. And each time that he changes his point of view he will encounter the same difficulties, there are not only eight of these points of view, but yet more than forty, for however slightly one turns the figure, a muscle shows too much or too little and the aspects vary infinitely.

(Quoted in Elsen, *Rodin, Readings on His Life and Work*: 163)

The emphasis here is on the way different angles of view are essential to sculpture. In more modern times, with the advent of the turntable, the model in the studio can be turned and the artist can move his/her turntable to match the changed viewpoint. But, however it is done, viewing in the round is fundamental to the making and experience of sculpture. This applies as much to the spectator as to the artist. In recent years, the relationship of the spectator's vision to the physical three-dimensional experience of walking through, and inside, as well as outside an installation, has been emphasised. The idea of so-called site specific work has been particularly significant, where the setting has been as important as the work itself. Richard Serra's sculpture at Broadgate in London is an example of this, as we shall see in Chapter 7.

The other point about the use of a quotation like this is its authenticity because it is a primary source and comes from the artist's own experience. I have always been a great believer in backing up one's viewpoint with appropriate use of artists' writings; I have also used the expert opinions of others, not only current writers, but also people of the past. The study of historiography plays a large part in the academic study of the history of art and it is important for sculpture if you consider the influence of a writer like Johann Joachim Wincklemann. His famous dictum, expressed as 'noble simplicity and calm grandeur', with its renewed emphasis on heroic idealisation of the human form, helped to reinvigorate the dominance of the classical tradition in sculpture from the middle of the eighteenth century. This aspect will be considered particularly in the first chapter, where we will look at how the classical period established the main types, materials and techniques of sculpture, which have been used for generations.

Chapter 1 will be about Greek and Roman sculpture and the development of sculptural types. Also included here will be the way the classical tradition gradually became superseded in the twentieth century by the interest in ethnographic art, particularly through the

work of artists like Picasso and Matisse. The invention of collage by
Picasso and Braque brought a new concept of what sculpture could
be. Then, at about the same time, there was the development by the
Russians of a new kind of sculpture altogether, through the use of
new materials and new ideas about space. The influence of both
collage and Russian Constructivism on the arrival of installation art
and land art in particular will also be covered in this chapter. However,
fascination with the study of the human figure has not died out and,
just as with painting, traditional techniques continue, if you think of
the recent memorial to Bomber Command in Green Park in London
for instance which will be discussed in Chapter 6. After Chapter 1 the
following five chapters will take their cue from the established types
and techniques of the classical tradition but always including linked
modern examples from the twentieth century to the present day.

Chapter 2 is concerned with changing approaches to the free-
standing figure from early Christian times through to the period of
Iconoclasm and the continuing fear of idolatry in medieval times, to
the revival of the classical nude in the Italian Renaissance, and its
ongoing development, up to the work of Antony Gormley. Themes
which will be important in these early chapters will be connected with
the idea of mimesis, or the imitation of nature, realism and verisimil-
itude, and the presence of a sculpture occupying your space, whether
in a private room, a gallery, museum or church. Chapter 3 will be
about group sculpture, and the interaction between forms of different
sizes, as in the Madonna and Child, or man and animal, telling a story,
or carrying a message, as in the work of Giovanni Pisano or Ana Maria
Pacheco. In Chapter 4 we will consider relief sculpture, its importance
in medieval times and the way it has metamorphosed through the
ages from something narrative and architectural as in the cathedral at
Autun, into manifestations like engraved glass in the work of John
Hutton at Coventry Cathedral or the flattened silver in the *Thirty
Pieces of Silver* by Cornelia Parker. In Chapter 5 we will be looking
at the role of the bust as a three-dimensional portrait, but also as a
vehicle for the debate and comparison between painting and sculp-
ture, known as the Paragone, which started in the Renaissance and
continued in the practice of painter/sculptors like Daumier, Picasso
or Giacometti, where it became reinvigorated by the influence of
ethnographic art. The bust is still used today in a conventional context
to perform a commemorative function.

In sculpture the role of commemoration has always been important
if you think of tomb sculpture from classical and medieval times to

our own day and this will be looked at in Chapter 6. This subject used to be thought of in terms of memorials to the great and the good, but now, as a result of the work of scholars like Mary Beard, we have discovered how much we can learn from the tomb sculpture of ordinary people. The concept of the public memorial, whether it be in war cemeteries like those of the First World War in France on the Western Front, or in a village or an urban situation, has changed considerably since the eighteenth century. However, it was in the neoclassical period that the significance of the spectator was greatly increased, especially in England, through the work of sculptors like Rysbrack and Roubiliac.

In Chapter 7 we will look at sculpture and its setting, and the difference this can make whether it be inside or outside. There will also be discussion of the significance of land art and why it is a change from sculpture of the past employing many different materials, subjects and contexts. Conversely, Chapter 8 might seem to be off the point, because it is about drawing and the idea of what is called 'sculptural drawing' in particular. Drawing from plaster casts especially became the foundation of the academic training of artists, certainly from the Renaissance onwards, following the re-discovery of classical antiquity. Then it was believed that only sculpture from the ancient world had survived because so few painted images had been found, except in written descriptions of great artists, like the ancient painter Apelles for instance. The study of sculpture has remained important primarily because it teaches one so much about seeing the same thing from many points of views. We will see how sculptors and painters of different periods have used drawing for this purpose in Chapter 8.

Finally, Chapter 9 will be an epilogue about the relationship between sculpture and three-dimensional design, and how sculptural and aesthetic qualities can impinge upon and cross over into other areas. The kind of conjunction I am interested in discussing is the point at which you might start looking at the beautifully tooled parts of an engine as three-dimensional pieces in their own right or where the design and manufacture of glass can be turned into a three-dimensional work to be looked at for purely aesthetic purposes. In this section we will look at examples like the Bugatti, the Spitfire and the glass sculpture of Dale Chihuly. This is the happy conjunction between perceived beauty and function.

From this Introduction it will be clear that this book will be quite wide ranging, but, like the others, I hope it will be saved from becoming too generalised by the focus on the singular qualities

of individual objects. Their setting and historical context will also figure, but the main emphasis will be on learning to look in a three-dimensional way and understanding that the experience of sculpture can be as rich and rewarding as looking at paintings. Sculpture is often in fact a more familiar part of our lives because it is all around us in a way that painting can rarely be, except for example in a frescoed chapel or a painted room perhaps; but even then it is on one flat plane only. Yet, simply because of its familiar presence, sculpture can be ignored in the sense that many commemorative statues in London for instance have just become part of the familiar landscape of places like Trafalgar Square. This was part of the reason for the introduction of the changing sculptures on the previously empty Fourth Plinth which we will look at in more detail in Chapter 6. In his essay on this subject in the year 2000, the critic and historian Richard Cork, who was a member of the advisory panel on the Fourth Plinth, made this idea plain when he said that:

> Our advisory group unanimously concluded that the plinth should continue to be used as a springboard for specially commissioned sculpture.
>
> (Cork, *Annus Mirabilis? Art in the Year 2000*: 247)

The possibilities of sculpture have been opened out in recent years so that our visual curiosity can become properly engaged, not only about recent work, but about other fascinating aspects of our Western sculptural tradition; what Professor Alex Potts justly called 'The Sculptural Imagination' can serve to start us off on this visual journey.

The influence of the classical tradition and the development of sculptural types

INTRODUCTION

Most people would agree about the huge influence that classical sculpture has had in subsequent periods in Western art. Many of the sculptures in this chapter are very, very well known and you could ask what the point is of writing about them again. But that really is the point in the sense that they have been so influential. At the beginning of Chapter 2 of his *Europe: A History*, Norman Davies makes it clear that we have to consider particularly ancient Greece.

> There is a quality of excellence about Ancient Greece that brooks few comparisons. In the same way that the quality of Greek light enables painters to see form and colour with exceptional precision and intensity, so the conditions for human development in Greece seem to have favoured both the external environment and the inner life of mankind. Indeed high intensity sunlight may well have been one of the many ingredients which produced such spectacular results – in which case Homer, Plato and Archimedes may be seen as the product of native genius plus photochemistry. . .
>
> Much of Greek civilization was lost. Much was absorbed by the Romans, to be passed by them into the Christian and Byzantine traditions. Much had to await rediscovery during the Renaissance and after. Yet, one way or another, enough has survived for that one small east European country to be regularly acclaimed as 'the Mother of Europe, the source of the West', a vital ingredient if not the sole fountain-head of Europe.
>
> (Davies, *Europe: A History*: 95 and 139)

Most historians I think would agree with this but the other related idea is that of continuity and the attitude of different subsequent periods to the ancient world so that it provides a fascinating continuity

of tradition and reinterpretation too. So, these well-known sculptures like the *Laocoön* and the *Winged Victory of Samothrace* have become so familiar through interpretation and reinterpretation over and over again. Therefore you can learn a great deal not only about the objects themselves but about how different cultures saw them later on. Interpretation and reinterpretation will be a recurring theme throughout this book. The works I have chosen are particularly important because they represent types of sculpture in the sense of free-standing, relief or group sculptures for example, and for establishing different functions for sculpture, like, for example, what their purpose was in terms of telling a story or commemoration.

The ancient world also established and perfected two major techniques for sculpture, namely carving in all sorts of materials, particularly marble, onyx, sardonyx and ivory, and modelling and casting in bronze; its artists can be said to have perfected these techniques if you look at the Riace Bronzes or the Parthenon Frieze. The idea of perfection and classical beauty remained a very potent idea fuelled especially by the views of artists and thinkers from the Renaissance to the nineteenth century. This was in turn reinforced by the development of academic theory in which the classical sculpture tradition became the only one worth studying (even though by the middle of the nineteenth century the interest in the medieval world known as the Gothic Revival was well under way).

So, these types and techniques of sculpture can be traced all the way through until the twentieth century when the turning to alternative cultures became more fundamental and was underpinned by profound alterations to our understanding of the visible world (see *Learning to Look at Modern Art* Chapter 1). This is why the changes which happened to sculpture in the 1960s and 1970s are thought of as so important because they seem to have opened up three-dimensional art even more through the installation, the use of industrial materials and the heritage of collage. However, even now you can still find artists like Antony Gormley who are preoccupied with the human figure, which was the central concern of the sculptors of antiquity.

THE IDEAL BODY

Plates 1.1 and 1.2 The Riace Bronzes by Phidias(?), mid-fifth century BCE

The importance of mimesis and verisimilitude

The idea of the sculptural presence

Modelling and casting

One of the major considerations in the context of looking at sculpture is the relationship with the spectator, the fact that in the case of free-standing sculpture particularly, the object actually exists in your space, it shares your space with you; it is not abstracted on to a flat surface as it would be in a painting. Nowhere is this more true than with the bronze Greek figures known as the Riace Bronzes (named after where they were found beneath the sea in the Straits of Messina). Their

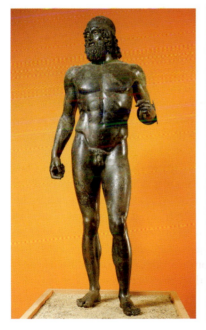
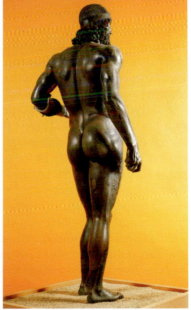

Plate 1.1 Bronze of Riace A. Reggio Calabria, Museo Nazionale della Magna Grecia. © 2013. Photo Scala, Florence. Courtesy of the Ministero Beni e Att. Culturali.

Plate 1.2 Bronze of Riace A (back). Reggio Calabria, Museo Nazionale della Magna Grecia. © 2013. Photo Scala, Florence. Courtesy of the Ministero Beni e Att. Culturali.

extraordinary quality is that when you walk into the room where they are displayed, you feel you are actually meeting them. The experience is uncanny and exciting at the same time. This is partly because of their gestures and the disposition of the weight of their bodies so that they almost seem about to move from their positions of stillness. The other characteristic which is outstanding is the modelling of the surface, the musculature and the feeling of tactile qualities of the form; you really want to touch them.

In the first place they are more than human because they are slightly over life-size at approximately 6 foot 6 inches or 2 metres high and also idealised as fine male specimens of different ages. Yet at the same time you know they are sculptures and not literally real. This is made explicit by the colour of them and the sheer artistry of the modelling; this is not just about the form of the bodies, but about the spaces in between, particularly the arms and the torsos and between the legs. Also, they appear to be moving out into your space as though about to greet you and this is added to by the effect of their slightly open mouths and the display of teeth. The experience of sculptures can have a challenging actuality so that you can see them as objects and as real at the same time. It is not certain what they were made for or what their purpose was, but the most intriguing explanation, and in a way the most convincing, is that they were part of a group of figures situated as warriors in the sanctuary at Delphi, along the sacred way; that might explain their hands held out as if in greeting to the visitor, or more likely, as most scholars think, they would have been designed to be holding shields and spears.

One's first experience of looking at these two sculptures is to take you back to the fundamentals of looking at three-dimensional art: their extraordinary presence in the room, taking up your space, and their gestures and open mouths which make them look as if they are speaking with you, welcoming you and engaging you in conversation. They are beautiful physical specimens, and you feel their flesh is firm but soft; yet they are obviously cast in bronze because of their colour and the patina on the surface. Even so, they are unnervingly real. The process of lost wax bronze casting is complex and lengthy. First of all the artist models the figure in clay or wax and then it is covered in plaster to make a mould which is then taken off and filled with grog. After this the outside of the mould is covered in a layer of wax with another plaster mould on top. Then the whole thing is heated, and the wax runs out, leaving a space, and the molten bronze is poured into the space where the wax was, between the two plaster skins.

When it is cooled the hollow cast can be revealed. It has to have lots of funnels for air to escape, so that bubbles can be avoided. Afterwards, the funnel holes have to be filled and the surface worked over, burnished and polished, to give the kind of wonderful effect we see here.

The Greeks believed in the idea of mimesis which means the convincing imitation of nature so that ambiguity between the natural and the made takes place. The famous stories of Pygmalion and the legend of the Cnidos Aphrodite are obvious examples of this. The other characteristic that makes sculptures more real is that you can walk round them and their bodies change as you do so, even if they were designed to be seen from set viewpoints as these probably were; the back view for instance can give you a whole new perspective on them, as can the view from the side. In other words, your experience of the figures changes as you look at them, making them seem more alive. Also, they are gesturing as though they have only just taken up those positions. This is why I think the idea of them being part of a group of warriors standing outside the sanctuary at Delphi (which was built to commemorate the Greeks' victory over the Persians at the battle of Marathon) is the most convincing argument about what their original purpose may have been. Nigel Spivey, in his book *Understanding Greek Sculpture* (1996, p.135), describes how the primary source for this idea is the work of Pausanias, who was a Greek writing in the second century CE, who travelled all over Greece and recorded his impressions of places like Delphi and the sculptures which were still in situ at the time. John Boardman in his *Classical Art* seems to agree that this is the most plausible explanation when he says:

> It seems likely that they are from a group, showing heroes or heroized mortals. Candidates include the dedication by Athens of a group of heroes, generals, and gods at Delphi to commemorate the victory at Marathon and made by Phidias.
>
> (Boardman, *Classical Art*: 98)

As you start to look more closely at these bronze figures you realise that the bodies are really quite abstracted and the vertical and horizontal axes of the body are carefully emphasised across the shoulders, across the chest, the pelvis and the navel, across the knees and across the feet. They are in the contrapposto position with the weight on one leg and the other more relaxed. This sets up movement and rhythm in relationship to one side and creates movement and variety

for the eye. Also, the fact that the heads are turned in relation to the shoulders, that one hand, and indeed one leg, is in front of the other, all helps to create variety and movement for the eye. Then, add to that the fact you can walk round them, they are in your space and yet the verisimilitude is not so great that you forget they are bronze sculptures. They may indeed have been modelled and cast according to the proportions of Polycleitos which are connected with symmetry and proportion and the concept of idealisation; these ideas were expressed in his canon which was about ideal proportion. By that he meant what we would call symmetry in the relationship of individual parts to the whole, although unfortunately the complete version of this theory has not come down to us.

As you continue looking at them you find that it is not just the bodies and the limbs themselves that are convincing, but the spaces in between which help to express the forms, what is known as the negative space between the arms and the torsos and between the legs. The surrounding outside edges of the forms are very telling as well, expressing the shapes of the muscles. In addition, the light helps you to see the surfaces of those forms and their underlying structures. The lighting of sculpture is very important and can reveal some areas more than others; the shadows along the insides of the arms and the legs, for instance, make shapes that also reveal the underlying muscle structure. This all helps to create variety for the eye. This is all greatly helped by the polishing and burnishing of the surface which helps to catch the light. Bronze casts are hollow but you feel these bodies are solid and able to move at any moment. In fact so naturalistic are they that some people believe that they may have been cast from real bodies rather than modelled first and then cast in bronze. It is well known that the ancient Greeks set great store by the beauty of the athletic body and the Olympic Games were conducted in the nude so that the male physique could be seen to be flawless.

In his book *Sculpture: The Art and the Practice*, Nigel Konstam, himself a practising sculptor, explains his discovery and consequent belief that the warriors must originally have been cast from the finest bodies of athletes.

> My own assessment of the Riace Bronzes remains the same as it was before my discovery: they are the best. One need only compare them with modern works cast from life to see that Phidias [if it was he] intervened decisively to achieve these superb results. He becomes more human and less of a superman as a result of this discovery.
>
> (Konstam, *Sculpture: The Art and the Practice*: 201)

Apparently, according to Konstam, artists would not have had the technology to cast heads at that time, so those would have been modelled. But the point he is making is that, even though they may have been castings originally, they still move us as works of art in their exploration of the mystery of three-dimensional image making. This idea is developed in a different way in the legend of the Aphrodite of Cnidos, where, so the story goes, when a certain young man saw this figure he was so moved that he tried literally to make love to it.

THE CULT FIGURE AND THE IMPORTANCE OF SCALE BOTH LARGE AND SMALL

The lost figure of Zeus at Olympia, *c.*430s–420s BCE

Plates 1.3 and 1.4 *The Winged Victory of Samothrace*, *c.*190 BCE

Plates 1.5 and 1.6 *The Spinario* or *Boy with Thorn*, first century BCE

The idea of the large-scale sculpture with the power to intimidate is nowhere clearer than in the lost cult figure of Zeus at Olympia, which was considered one of the wonders of the ancient world. It was carved in gold and ivory, the so-called chryselephantine material. It was 13 metres high and carved by Phidias, the creator of the marbles on the Parthenon, and probably of the Riace Bronzes, as we have seen. It was probably begun in the 430s BCE when it was supported by an armature of wooden beams, and it took up most of the space in the sanctuary. It contained so much ivory that Phylo of Byzantium claimed it was the reason nature created elephants. When pagan cults were banned by the Christian Emperor Theodosius I (347–395 CE), the statue was looted and taken to Constantinople where it perished in a fire in 475 CE. The sculpture only exists now in various reconstructions and mainly in the descriptions of those who saw it long ago. However, we need to refer to it because it can be seen as an important source for the idea of sculpture and the large cult figure. This idea had been used in ancient Egypt of course but its significance for us lies in the importance of its status in classical antiquity.

The most detailed written description we have of the Zeus comes from Pausanias's *Description of Hellas* which was written while most Greek sculpture was still standing; more importantly, this cult figure exerted great influence on the way ancient rulers chose to depict themselves. There was a magnificent throne with sceptre, Nike and eagle which were adopted by eastern rulers and Roman emperors

alike. When the Zeus went to Constantinople it inspired Christian artists to show Christ in the same pose as the powerful Pantocrator, where the Nike transforms into an angel holding a cross. The scale is the significant thing here, intended to overawe the spectator and make him/her feel humbled and overwhelmed. The same could be said of all over-life-sized figures of rulers, from the Roman emperors Augustus and Constantine down to dictators of the present day like Stalin or Saddam Hussein.

Another kind of over-life-sized figure, which comes from a later period in Greek sculpture, is the *Winged Victory of Samothrace* which incorporates movement and drapery on the body.

This sculpture is carved in marble. Even so it may have been modelled first in clay and then copied in marble afterwards. Sculptures like this were often painted, in which case it would have looked very different. With carving you need to be able to visualise inside the block so modelling first is a good idea and then drawing the dimensions of the form you want on the marble block itself. After that it has to be

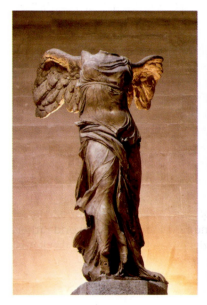

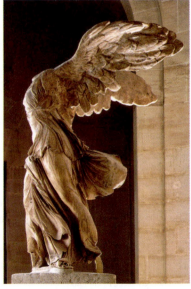

Plate 1.3 *Victoire de Samothrace* © RMN-Grand Palais (Musée du Louvre)/Gérard Blot/Hervé Lewandowski.

Plate 1.4 *Victoire de Samothrace* © RMN-Grand Palais (Musée du Louvre)/Gérard Blot/Hervé Lewandowski.

roughed out with chisels and then the cutting gets gradually finer until you are ready to sand and polish it. So, it is possible that the early processes were the same whether the sculpture was marble or bronze. The most extraordinary quality of this figure is that it communicates power and drama as it strides strongly forward.

This sense of dynamic movement is communicated by the wings which stream out behind, and the drapery expresses the tension in the body underneath, particularly where it clings to the leg on the right and around the chest and thigh; it makes you feel that the body is stretching and straining. The wings are attached to the body in such a way that they appear to be part of it and the negative spaces between and under them help to express this. The figure stands over three metres high and it is thought it was originally intended to stand up on the prow of a ship as its base. It may have been intended to commemorate a victory. In spite of the fact that it has no head, we feel that it is still there, or implied, even though we cannot see it. The edges of the sculpture are also important. The flowing direction of the top of the wings contrasts with the lower more angled parts of them underneath. Then, the shape moves inwards to the torso, making an elongated triangle below, which is emphasised by the arrangement of the drapery over the pelvic area; this makes a counterpoint between the shape of the underneath of the wings and that of the body which helps to create a rhythm between solid and void, and form and space; lower down, our eyes move into the taut and dynamic edge of the lower leg on the right and the one on the left moving forward.

This figure has been used several times as the point of comparison between the ancients and the moderns. It is referred to by Naum Gabo as we shall see later in this chapter; it was also cited by the poet Filippo Marinetti in his Futurist Manifesto when, as the leader of the Futurists, he made his statement about the motor car being more beautiful than the *Winged Victory of Samothrace*. He meant of course the need to embrace the modern and new industrialised world rather than always looking back. But the dynamism of this figure also lends itself to that kind of comparison more than many static classical sculptures do.

This greater dynamism and expression is characteristic of the Hellenistic period of Greek sculpture. This refers to classical art and culture which spread beyond Greece after the death of Alexander the Great, in 323 BCE. We shall see some other examples from this period later on in this chapter.

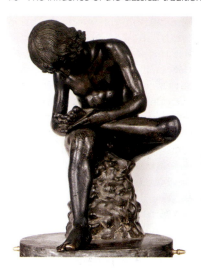

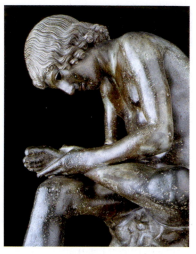

Plate 1.5 Boy with Thorn. Rome, Musei Capitolini. Bronze. © 2013. Photo Scala, Florence. Courtesy of Sovraintendenza di Roma Capitale.

Plate 1.6 Detail of Roman copy of Spinario © Araldo de Luca/Corbis.

In contrast to what we have just been looking at, the figure of the Spinario is tiny, being only 73 centimetres high without its plinth. But it is not only the size of this sculpture that is interesting, but the intimacy of the action that he is performing. There he is, looking at the sole of his foot with such concentration that nothing else matters. He holds his foot gently in his left hand and his head is bent forward as he tries to take the thorn out. When you see this sculpture in the original you cannot believe that the eyes are hollow, such is the intensity with which he is looking down, and you feel you are there with him in his search. But it does not matter whether the eyes are actually there or not (although they would have been originally made of paste and gems) because the positions of the head, torso and limbs are what convey the feeling of absorption and focus.

Nothing about this figure is straight. If you start by looking at the head you will see that it is at a slightly steeper angle from the shoulder as it looks down, then the upper and lower arm on the right as you see them are at another two angles. The upper arm is in line with the angle of the upper body and the outer edge of the back, which contrast with the slope of the thigh and lower leg as it crosses over at another angle to the other leg. Then the second leg is not quite

upright with the foot only lightly touching the ground to keep the balance as he sits on a textured rock. These angles are held in balance by a vertical which runs down the side of the neck, through the chest and the groin area so that you feel he is really sitting on the textured rock which acts as a foil to the smoothness of his skin which has the combination of softness and firmness we associate with that of a young boy. This is particularly telling in Plate 1.6 where the gap between the rock and the lower leg makes this communication of feeling particularly effective. The texture of the hair performs the same function as the curls touch the cheek.

The sense of verisimilitude combined with abstract qualities is nowhere clearer than in this figure and it creates a dynamic tension which makes you want to touch him. The space between the profile and the foot is alive in a way which is remarkable and helps you to understand as clearly as possible what sculpture is about in the interaction between form and space. The fact that this sculpture is so small makes it even easier to visually understand than a large figure like the *Winged Victory of Samothrace*. So scale both large and small can bring special qualities to our experience of sculpture.

THE RELIEF AND THE CONCEPT OF NARRATIVE

Trajan's Column, second century CE

Plate 1.7 The use of cameo in the Tazza Farnese, third century BCE

Plates 1.8 and 1.9 The Pergamon Altar, second century BCE

Plate 1.10 The Parthenon Frieze, fifth century BCE

Another sculptural type which is very important is that of the relief, in which the sculptor carves or models in a more pictorial way, on a flat surface. This is most evident and easiest to see on a small scale in cameos like the Tazza Farnese which we will look at. However, first and foremost in the ancient world, reliefs were used for commemoration in various forms, like sarcophagi or memorial columns. One of the most famous examples from the classical world is the marble column carved to commemorate the Emperor Trajan and his campaign to subdue the Dacians in the area of Central Europe we would call Romania. The process of making these reliefs was a real feat of engineering, quite apart from its sculptural qualities. The

episodes were carved on a series of marble drums mounted one on top of the other and then made to look like a scroll unfurling until they reached the top, where there was originally a gilded statue of Trajan. The construction has been described by the sculptor Peter Rockwell in a way that gives you an idea of the extraordinary skill of the Roman craftsmen involved.

> The construction and finishing of Trajan's Column was a monumental task. At Luna [near Carrara in northern Italy] workers quarried the components of the column: eight solid marble blocks for the base, twenty massive marble drums measuring three and a half metres in diameter for the column shaft and capital . . . each drum likely arrived in a roughly cylindrical shape from the quarry; prior to pulling each in place, it would have been necessary to make them into the final desired shape and then to cut the internal stairway. The reliefs were probably carved after the drums were put in place fastened with metal dowels fitted into the upper and lower faces of the drums and secured with lead.
>
> (http://www.stoa.org/trajan/introductory_essay.html)

The column was also a memorial to Trajan and his ashes were buried in the base. When the cast of the column was made for the cast gallery at the Victoria and Albert Museum (see Chapter 2) you can see that there the reliefs were mounted on a brick column and they are in fact easier to see in cast form because the column is displayed in two halves. If you look closely at these episodes you can see that different levels of relief are incorporated, from almost flat, which is called bas-relief, through medium to high relief. This enables the artist to create a sense of recession but without the use of perspective as it would have been in the early Italian Renaissance (see Ghiberti in Chapter 2). A more accessible and decorative kind of bas-relief can be experienced in the Tazza Farnese.

Another well-known context for bas-relief is the more purely decorative one of the cameo where a stone like onyx or sardonyx is used because it is stratified and the artist can carve through one kind of stone to reveal a background of a different colour. Nicholas Penny explains this very clearly:

> These were often cut out of banded agates found in Arabia and India, termed onyx when they are black and white, or sardonyx when the colours are brown or red and white. One stratum of the stone was left for the background and another used for the head

or figures presented in relief. The art of cutting cameos was first perfected at the Hellenistic courts, above all at that of the Ptolemies in Alexandria, and was enthusiastically patronized by the Roman conquerors of Egypt.

(Penny, *The Materials of Sculpture*: 16)

The Tazza Farnese is a beautiful example of this type of carving from sardonyx. It celebrates the fertility of the river Nile and shows very clearly how the pictorial qualities of this kind of carving can be enhanced by the different colours which are revealed.

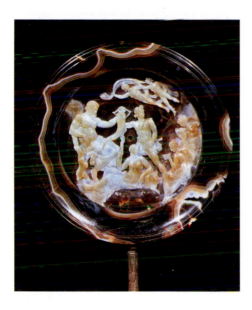

Plate 1.7 Tazza Farnese (Farnese Cup) in sardonyx amber with a large cameo depicting the adoration of the annual flooding of the Nile. Naples, National Archaeological Museum. © 2013. DeAgostini Picture Library/Scala, Florence.

Reliefs were also used on other kinds of memorial sculpture like sarcophagi; then sometimes the relief can be so high that you can barely see the background and sometimes the figures are almost free-standing as in the Pergamon Altar now in the Pergamon Museum at Berlin.

Like the *Laocoön* (see Plate 1.11), the Pergamon Altar is another superb example of Hellenistic sculpture and it is every bit as expressive except that it is part of the whole architectural construction of the altar. According to Von Zabern (1995), the Pergamon Altar was originally part of an Acropolis and stood in a square space of its own, free-standing about one-third of the way up the hill.

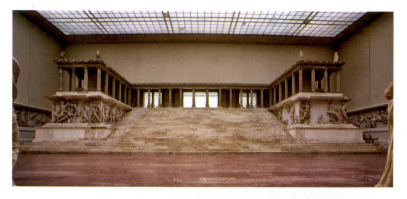

Plate 1.8 The Pergamon Altar. © bpk/Antikensammlung, SMB/Jürgen Liepe.

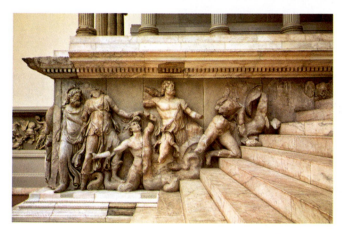

Plate 1.9 The Pergamon Altar. © bpk/Antikensammlung, SMB/Johannes Laurentius.

To call this remarkable building an altar, however, is clearly an understatement. The actual altar for burnt offerings was set in a court surrounded by a long, graceful colonnade. Together, the altar for burnt offerings and the colonnade structure were raised on a massive podium which was cut on the west side by a broad flight of twenty four stairs. The visitor mounted these steep steps to reach a frieze 2.30 metres high worked in bold relief depicting the struggle between the gods and the giants.

(Von Zabern, *The Pergamon Altar,*
Its Discovery and Reconstruction: 17)

From the point of view of the idea of relief sculpture the figures on the northern side of the stairwell are nearly free-standing and spill out on to the stairs. As you walk up to the top you almost feel they are accompanying you or at least moving with you, so dynamic are their actions and the feeling of energy they convey.

Sometimes this kind of high relief is referred to as architectural sculpture. The idea behind this is that the sculptural forms should be integrated into the fabric and design of the building. The main type of sculpture behind this concept was relief sculpture. In spite of its enthusiasm for the free-standing human figure, the classical period also used relief sculpture as we have seen in relation to Trajan's Column and the Pergamon Altar. But neither of these is a building strictly speaking, although the scale of both is large and grand. This would of course apply to the reliefs on the frieze of the Parthenon which most certainly was a building, which we will now go on to consider.

The Parthenon Sculptures are part of the frieze going round the inner structure of the building. They would have been painted and only seen by the spectator from below.

The scenes are designed to fit into the architectural form without losing the overall shape of it. This shows most clearly on the north frieze of the temple which includes the horsemen riding in the procession.

But what is really fascinating is the way the figures are placed one behind the other in varying heights of relief. So the cutting of the stone is staggered according to where a particular figure is in the arrangement. The height of the horses and the figures in the foreground is the same as in the background. But perspective is not needed to make space behind because the illusion is created by the varying depth of carving. The other interesting point about this is that the angle you would have seen it from allows you to see all the figures as separated, even though they are overlapping. In his book on *Greek Architecture and Sculpture* (2006), Ian Jenkins has demonstrated how the sculptor has created a rhythm of blocks of horses and riders which do overlap, held at either end with riders which do not, and which are the deepest cut and nearest your eye. At the angles you would have seen it from this would have created a great sense of forward motion. You can get some idea of it from an angled photograph like Plate 1.10 if you look at the underbellies of the horses nearest to us; there you can see that they are more deeply cut and therefore cast deeper shadows to create more recession. As a result they look as though they are jostling and moving forward.

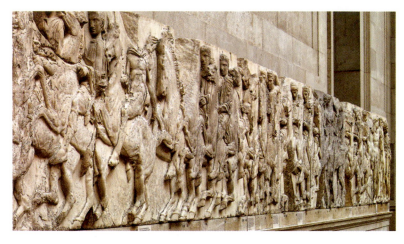

Plate 1.10 The Parthenon Sculptures: marble relief (Blocks XLII, XLIII & XLIV) from the north frieze of the Parthenon. © The Trustees of the British Museum.

There is no real certainty about the meaning of these figures in procession to a festival dedicated to the goddess Athena, but one of the most plausible is that these reliefs may have been about the idea of resurrection, but on earth rather than in an afterlife. The original building was dedicated to Athena and the idea of regeneration, because of the olive tree which started growing again on the Acropolis, in the ruins left by the invading Persians. In a recent article in the magazine of the British Museum it was suggested that:

> Like the shoot springing from the blackened olive stump, the city is rising again, and, where there once were ruins, the Parthenon is gleaming at its heart. With the horsemen of the frieze, Athens is riding to resurrection.
>
> (Stuttard and Moorhead, 'Riding to Resurrection': 51–53)

Relief sculpture has many applications and its relationship with architecture is one of the most fascinating, because it can be used to decorate a building and give it meaning. This was particularly true in the medieval period as we shall see in Chapter 4.

THE GROUP SCULPTURE AND THE INTERACTION BETWEEN FIGURES AND MAN AND ANIMAL

Plate 1.11 The *Laocoön* by the workshop of Hagesandros, Athenodorus and Polydorus of Rhodes, *c*.25 BCE

Plate 1.12 The equestrian monument to the Emperor Marcus Aurelius, CE 173

The most extraordinary quality of the group shown in Plate 1.11 is of course the emotional expression of these figures in an agony of suffering. We can see this not only in their faces but also in the angles and tension in the muscles of their bodies and the position of their limbs. And yet the group stays together as a whole. It is contained within the outside edge, so that the writhing movement stays within a limited area, making it more full of tension because it cannot break out. The spaces between are again very important because the snake which is about to bite the man's hip on the right is set in the space where your eye is focussed. The joining of the figures is greatly helped

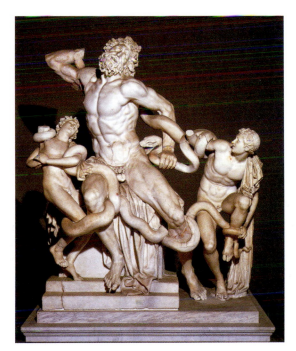

Plate 1.11 Marble sculpture of *Laocoön and his children*, Roman copy of a Hellenistic original. Vatican, Museo Pio-Clementino. © 2013. DeAgostini Picture Library/Scala, Florence.

by the positions of the writhing snakes because, if you try to follow where they are going, you see that they move around and within the group, interweaving and stopping the forms from breaking out. That tension between containment and struggle is what makes this such a fascinating and moving piece, which has captured the imagination of all who see it, from the time of its making, but particularly since its rediscovery in 1506. The powerful effect of emotion is also aided by the angles of the planes of the bodies in space and their lines of direction. If you allow your eye to focus on the angle of the head of Laocoön himself, and then to travel down the centre of the chest, you will see that it moves in a curve and appears to join up with his thigh, which then comes out towards you. Similarly, there is a line which travels across his breast and into the upper arm which moves backwards and then downwards in space.

The two young sons and their bodies look up and lean towards the main figure in the middle. The boy on the right is leaning forwards and looking up. The one on the left looks upwards at the same time. All is in motion, and yet static simultaneously, so your eye is constantly moving within a confined space at the same time. This group is more abstract than the Riace Bronzes because they are not going to move into your space, rather staying in their own mythological world. But the raw emotion in the presence of imminent death is there for all to see. It teaches us that sculpture is about form and space and this is what makes its solid presence so tangible, and yet ultimately mysterious because this group in extreme agony is frozen in time.

This sculpture is justly famous not only because it is a superb example of how to weld several figures together in the art of group sculpture, but also because of its influence and its historiography. The rediscovery of it is well known and very dramatic in itself. On 14 January 1506 a workman was digging in a vineyard in the grounds of the villa which in Roman times had belonged to the Emperor Titus; he came across a blocked-up niche in a wall and opened it to find this marble group. When Pope Julius II heard about it, he sent the architect Giuliano de Sangallo who took his friend Michelangelo with him to look at it. Sangallo recognised it as the great sculpture described by Pliny the Elder in his book *The Natural History*. Everyone was amazed, not only because of the beauty of it, but also because of the powerful expressiveness which was different from what was expected of classical sculpture at that time. It depicts the moment in Virgil's *Aeneid* when the Trojan priest Laocoön, who had

prophesied the disaster of the invasion of Troy by the Greeks in the wooden horse, and who had displeased the gods, was set upon by snakes which came out of the sea and on to the beach where he was preparing to sacrifice a bull to Neptune:

> Their foreparts and their blood red crests towered above the waves; the rest drove through the ocean behind, wreathing monstrous coils and leaving a wake that roared and foamed. And now, with blazing bloodshot eyes and tongues which flickered and licked their hissing mouths, they were on the beach. We paled at the sight and scattered; they forged on, straight at Laocoön.
>
> (Virgil, *The Aeneid, Book II*: 57)

When you read the whole of Virgil's vivid and dramatic narrative, you can understand why it was such an inspiration to the makers of this sculpture, and indeed to subsequent writers on art, particularly from the Renaissance onwards. In the eighteenth century for instance, there was considerable debate about the relationship between the depiction of pain and aesthetic appreciation. It formed the basis for one of the most famous discussions of the relative powers of poetry and the visual arts, by the German writer G.E. Lessing, who wrote an essay entitled 'Laocoön or Concerning the Limitations of Painting and Poetry' in 1766. It was written in answer to an even more famous piece of writing by J.J. Wincklemann called 'Thoughts on the Imitation of Greek Art in Painting and Sculpture', published eleven years earlier, in 1755. Wincklemann wrote about 'noble simplicity and quiet grandeur' in relation to the depiction of this tragic moment:

> The general and most distinctive characteristics of the Greek masterpieces are, finally, a noble simplicity and quiet grandeur, both in posture and expression. Just as the depths of the sea remain calm however much the surface may rage, so does the expression of the figures of the Greeks reveal a great and composed soul even in the midst of passion.
>
> (Quoted in Preziosi (ed.), *The Art of Art History: A Critical Anthology*: 35)

In answer to this view, Lessing wrote that, for him, poetry comes out the winner because it can more easily express extremes of feeling, which in the visual arts would lead to ugliness. Talking in general terms first, he then goes on to use the *Laocoön* as his more specific visual example:

Rage and despair did not degrade any of their works. I venture to say they never depicted a Fury. Wrath was reduced to seriousness. In poetry it was the wrathful Jupiter who hurled the thunderbolt: in art it was only the stern Jupiter . . .

. . . If we apply this now to the Laocoön, the principle which I am seeking becomes apparent. The master strove to attain the highest beauty possible under the given condition of physical pain. The demands of beauty could not be reconciled with the pain in all its disfiguring violence, so it had to be reduced. The scream had to be softened to a sigh, not because screaming betrays an ignoble soul, but because it distorts the features in a disgusting manner. Simply imagine Laocoön's mouth forced wide open, and then judge! Imagine him screaming, and then look! From a form which inspired pity because it possessed beauty and pain at the same time, it has now become an ugly, repulsive figure from which we gladly turn away. For the sight of pain provokes distress; however the distress should be transformed, through beauty, into the tender feeling of pity.

(Quoted in Harrison, Wood and Gaiger (eds)
Art in Theory 1648–1815: 482)

Lessing is making the point that it is easier for the subject of a tragic narrative like this to be told by the poet, where the story moves on in time for the reader, who does not have to dwell on the ugliness of the raw emotion, so the ability of the writer to move the emotions is greater because of the reader's imagination. The argument is well made in favour of poetry, but it is worth remembering that Lessing did this famous analysis from an engraving of the *Laocoön*. Michael Baxandall makes this point in his book *Patterns of Intention*:

This has not always been so to the extent it now is so: the history of art criticism in the last five hundred years has seen an accelerating shift from discourse designed to work with the object unavailable, to discourse assuming at least a reproduced presence of the object. In the sixteenth century Vasari assumes no more than a generic acquaintance with most of the pictures he deals with; in particular his celebrated and strange descriptions are often calculated to evoke the character of works not known to the reader. By the eighteenth century an almost disabling ambivalence had developed on this point. Lessing cannily worked with an object, the Laocoön group

that most of his readers would have known, as he only did himself, from engravings or replicas.

(Baxandall, *Patterns of Intention*: 9)

This is a significant aspect to remember because we live in a time when the visual image is instantly available, and it is easy to forget that much of the writing of the past was done from limited reproductions made by copy engraving. But that does not alter the fact that this sculpture, along with others in the Papal collection in the Belvedere at the Vatican, like the *Apollo Belvedere* or the *Belvedere Torso*, was revered, loved and copied by artists down the ages. We shall see examples of this in later chapters.

The human figure mounted on horseback is another type of group sculpture. Unlike the one we have just been looking at, the equestrian monument to the Emperor Marcus Aurelius is Roman and it is a monument, not to a god like Zeus, or a mythological figure like Laocoön, but rather expressing the idea of the memorial or commemoration of a real person which was and is a very important part of the history of sculpture.

The other idea shown here is that of the symbiosis between man and animal which has also become familiar in Western sculpture through the centuries. But this is one of the original sources which have come down to us. The reason that it survived as a free-standing group sculpture during the medieval period was because it was thought to be of the Emperor Constantine, who legalised Christianity as the official religion of the Roman Empire in CE 303, and whose mother Helena (according to medieval legend) was supposed to have discovered the wood of the True Cross.

This group of horse and rider stands 3.5 metres tall and so is much larger than life size (14 feet high by 12 feet wide). It is imposing when you see the gilded bronze original which is now in the Capitoline Museum in Rome. But even the replica now at its previous site in the square of the Capitoline Hill known as the Campidoglio is imposing. The original sculpture (now in the museum) was placed there on an oval plinth later designed for it by Michelangelo, when it was moved from the basilica of St John Lateran in 1538 on the instructions of Pope Paul III. This pope had asked Michelangelo to redesign the Campidoglio to update the administrative offices of the Vatican. The equestrian monument to Marcus Aurelius stands in front of the main building, the Palazzo Senatorio, which faces you as you climb the steps from the Piazza below, with a building on either

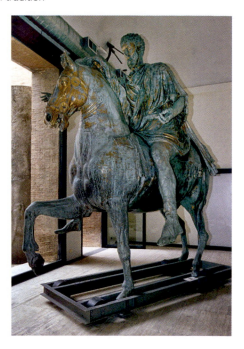

Plate 1.12 Equestrian monument to the Emperor Marcus Aurelius. © 2013. AGF/ Scala, Florence.

side, the Palazzo dei Conservatori on your left and the Palazzo del Museo Capitolino on your right. But the most remarkable characteristic of this setting is the way you approach the sculpture up the stairs known as the Cordonata. In an aerial photograph you can see that the perspective of the stairs is wider at the top than at the bottom. You feel yourself drawn up to the top where the buildings on either side continue that line, so that you come face to face with the emperor on his horse and the façade of the main palace as the backdrop behind.

At the moment the original sculpture is in the museum, and the replica is not shown in Plate 1.13, but originally the sculpture would have appeared on its plinth in the centre of a twelve point star and this would have directed the eye to the outer edges of the pavement. This is marked out by an oval which in turn echoes the shape of the plinth; the space between is decorated with trapezoid shapes which radiate outwards and then return to the centre. This would have made the sculpture appear even larger and more in tune with the proportions of the buildings. This may be difficult to see in an aerial

photograph but has been noted by Wolfgang Lotz in his classic book on Italian Renaissance architecture, where he says:

> The ornament of the pavement has another and immediately visible function. The great oval, which contains the oval base of the statue, and the lines of the ornament radiating from and sweeping back to it, make the statue look far bigger than it is. This illusory magnification is a characteristic of Michelangelo the sculptor. By 'monumentalising' the scale of the statue, i.e. by adapting it to the scale of the surrounding buildings, the statue of the Roman Emperor becomes the real theme of the architectural composition.
>
> (Lotz, *Architecture in Italy, 1500–1600*: 97)

So the point is that Michelangelo is using this architectural setting to enhance our experience of the sculpture, and more importantly still this design augments the sense of movement in the group and encourages the spectator to keep walking round and see the group from all sides.

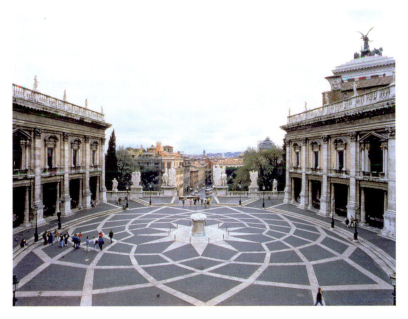

Plate 1.13 View of the Piazza del Campidoglio designed by Michelangelo Buonarroti (1475–1564) and completed in the 17th century (photo)/ Campidoglio, Rome, Italy/Alinari/The Bridgeman Art Library.

When you look at the sculpture in the round you can see that the figure of Marcus Aurelius is turning to the left and so is the head of his horse. The horse appears to be moving forward (although it is thought by some that its front foreleg may originally have been resting on the body of a defeated barbarian, as Marcus Aurelius was famous for defeating the tribes around the borders of the Roman Empire, particularly near the rivers Rhine and Danube) and when you look from below you can see that the muscles of the chest are flexed, the nostrils flared and one ear pointing forward and the other back as if cocked for orders from his master. Also the legs of Marcus Aurelius appear longer without stirrups (which were not yet invented) and come below the line of the horse's belly and they too are in tension to help him keep his balance. In his left hand, held close to his body, there would have been the reins and possibly a sceptre or an orb. His right hand is raised with the palm down and the angle of his head, slightly inclined, is thoughtful and concentrated as though he is about to speak to a waiting crowd.

Inside the museum in front of the original sculpture, your experience is more at eye level and you can see and feel the real bulk and size of the sculpture. It is immediately obvious that the bronze was gilded and that some of it is still there on the face of the emperor, and parts of his body, and the head of the horse. Marcus Aurelius's face is idealised and made to look contemplative as that was his character; he is justly famous for his *Meditations* which are a series of thoughts about the nature of life and how man should try to live:

> Each hour be minded as becomes a Roman and a man, to do what is to your hand, with precise . . . and unaffected dignity, natural love, freedom and justice; and to give yourself repose from every other imagination. And so you will, if only you do each act as though it were your last, freed from every random aim, from wilful turning away from the directing Reason, from pretence, self-love and displeasure with what is allotted to you. You see how few things a man need master in order to live a smooth and god fearing life; for the gods themselves will require nothing more of him who keeps these precepts.
>
> (Aurelius, *Meditations*. 7)

This passage comes from Book Two of the *Meditations* and was written, as much of it was, while he was on campaign fighting one of the German tribes, the Quadi in Southern Bohemia. The most striking quality of the book is its concern for the moral and spiritual

welfare of the individual through his/her own rational thinking. So when we look at the face in this sculpture it is good to remember that Marcus Aurelius's writings have come down to us and sound surprisingly modern in the sense of 'talking to oneself'.

But what makes this group into more than a grand expression of power and majesty is the way man and animal have been welded together into a whole. If you look at it in profile from the opposite side to the way he and the horse are turning you can see quite clearly how there are verticals and horizontals and negative spaces which make them appear as all of a piece. There is a horizontal line which travels from under the horse's nose, along the back and on to the curve of the tail which is flexed in tension. Then the area under the belly moves out to the top of the bent foreleg and the bottom of the buttocks at the back. There are verticals from the head behind the ears down through the edge of the chest echoed in the upright line of the rider's body and the back of the horse. This helps to emphasise the weight and anchor the whole group to the ground.

The interior, or negative, spaces are expressive of the forms too, with the spaces between the tail and the buttocks, the hind legs, under the stomach and between the forelegs all helping to enhance the feeling of dynamic tension and energy. This effect continues under the nose of the horse and in front of the torso of Aurelius and his gesticulating arm; then it moves down his back where the draperies continue the downward movement, and across the rump of the horse. These spaces also help to create a superb contour around the outside of the group which aids the communication of dignity and action which is so powerful here. These abstract qualities are very important in helping you to see the group as a dynamic whole. Altogether it is a brilliant example of two of the most important visual experiences of sculpture, the interaction between the object and its setting, and the opportunity to come up close and examine the work in some detail.

THE BUST: SCULPTURE AND THE PORTRAIT

Plate 1.14 Busts of the Emperors Vespasian and Hadrian, first century CE

Plate 1.15 The Ideal Head of Antinous, second century CE

One is often amazed by how many heads in particular seem to have survived from the ancient world. But many of these are fragments left

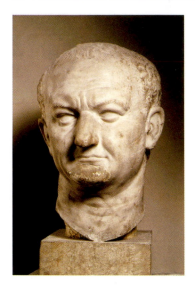

Plate 1.14 Head of Vespasian. Rome, Museo Nazionale Romano (Palazzo Massimo alle Terme). © 2013. Photo Scala, Florence. Courtesy of the Ministero Beni e Att. Culturali.

from larger full-length sculptures or equestrian monuments like the one of Marcus Aurelius which we have already looked at. But the bust is different because it is specifically designed as a head and shoulders of somebody in particular. Many of the Roman busts which have come down to us are portraits and this is the kind we need to consider as a type. One fine example is the bust of the Emperor Vespasian which was intended as a commemoration of this figure. Vespasian is presented as balding, lined and possibly about to smile. Carved in marble he gazes straight ahead and, as we look at his bust, we feel we might get to know him.

More intriguing as a subject is the Emperor Hadrian who does exist in bust form but who is better known for architectural projects like Hadrian's Wall or the Pantheon in Rome. However, Hadrian is also famous for his association with the idealised bust of the cult figure of Antinous. Antinous was a Greek boy who became Hadrian's lover and who drowned tragically and mysteriously in the river Nile. After his death Antinous became a cult figure, and busts and free-standing sculptures of him proliferated; his image was presented not so much as a likeness but more as a beautiful and sensual boy.

We may find this hard to understand but idealisation was an important part of the ancient world, as was homosexuality and the adulation of the beauty of the young male. The famous Mandragone

Head of Antinous shows smooth skin and regular features, visible in the horizontal line of the eyebrows, the aquiline nose, sensual lips, and the curled and shoulder-length hair.

Homosexual relations were acceptable in antiquity as long as the partner of an older man remained a youth; it was frowned upon and punishable between adults. This Antinous cult produced numbers of statues and busts and the catalogue of the recent exhibition *Hadrian: Empire and Conflict* was quite clear about how many still exist:

> About one hundred marble images of Antinous are currently known to archaeologists. They turn his portrait type into one of the most powerful legacies from classical antiquity, in numbers only surpassed by the images of the Emperor Augustus and Hadrian himself. Archaeologists can divide the various portraits into a number of distinct types and trace the way they were disseminated. Importantly, the pattern that thus emerges is very clearly the same as for imperial portraits, and it seems that the same workshops were involved.
>
> (Catalogue *Hadrian: Empire and Conflict*: 186)

So the bust could become a cult head, but also could be used for commemoration. It reminds us that memorials to people who have

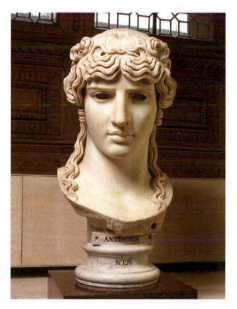

Plate 1.15 Antinous Mandragone © RMN-Grand Palais (Musée du Louvre)/Hervé Lewandowski.

lived and died in a memorable way form a large part of our sculptural heritage and we will see later on how the bust was continually revived, particularly in the eighteenth century.

CHANGE AND CONTINUITY IN MORE RECENT TIMES

Plates 1.16 and 1.17 *Back I* and *Back IV* by Henri Matisse, 1909 and 1930 respectively

Plate 1.18 *Woman with Outstretched Arms* by Pablo Picasso, 1961

Plate 1.19 *Right After* by Eva Hesse, 1969

One of the major achievements of classical sculpture we have seen so far in this chapter was the establishment of the techniques of carving, modelling and casting. We have also been looking at different types of sculpture which were established in the ancient world. This so-called classical tradition of sculpture continued until the early twentieth century, and then in the modern period there have been several inventions which have opened up different possibilities for three-dimensional art.

The first really significant development in this area was the influence of ethnographic art. In his series known as *The Backs I–IV*, Henri Matisse was still modelling in clay and plaster at the same time as he was developing his paintings of *The Dance* around 1910 (see *Learning to Look at Modern Art* pp. 43–44).

Matisse started experimenting with large reliefs 70 inches high and 44½ inches wide of the female nude viewed from behind. *Back I* starts with a figure in the contrapposto position with her left arm raised and the distribution of the weight on one side and the movement on the other which we have discussed earlier in this chapter. But gradually through the four versions, which Matisse did not complete until 1930, the figures become more and more abstract until, in *Back IV*, legs with no feet become two solid verticals moving up to the horizontal formed by the line of the shoulders, and then the hair comes down the back in a solid sausage-like shape marking where the spine would be. The proportions of a classical figure are ignored in favour of mass, bulk and solidity, showing the influence of non-naturalistic ethnographic or non-classical traditions. Both Matisse and Pablo Picasso moved between painting and sculpture throughout their lives and *Back IV* was not completed until 1930 when Matisse

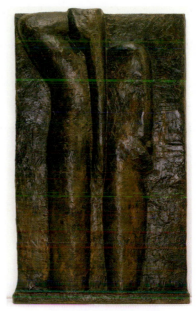

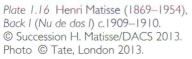

Plate 1.16 Henri Matisse (1869–1954), *Back I (Nu de dos I)* c.1909–1910. © Succession H. Matisse/DACS 2013. Photo © Tate, London 2013.

Plate 1.17 Henri Matisse (1869–1954), *Back IV (Nu de dos IV)*. © Succession H. Matisse/DACS 2013. Photo © Tate, London 2013.

was working on his murals of *The Dance* for Dr Barnes at Meryon in Pennsylvania.

A more significant and influential development in the early twentieth century was that of collage used in a three-dimensional way to construct a sculpture (see *Learning to Look at Modern Art* Chapter 5). Picasso continued to work with collage at various periods during his life and sculpture always played an important part in the development of his vision. Much later on, in the 1960s, he was still working with a type of collage where painted iron and metal sheeting were welded together in a figure like *The Woman with Outstretched Arms* of 1961; here the white sections look like a paper cut-out and the expanded metal forms a dark background against which the figure stands out in a dynamic and energetic way, almost looking as though it could move forward to embrace you. Thus it is made to appear three-dimensional because of the way the flat white sections are set against the grey background of the expanded metal. This allows the

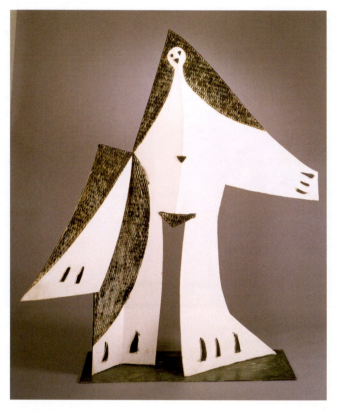

Plate 1.18 Pablo Picasso (1881–1973), *Woman with Outstretched Arms*, 1961
(painted iron and metal sheeting), Museum of Fine Arts, Houston, Texas, USA/
Gift of Mr and Mrs Theodore N. Law/The Bridgeman Art Library.
© Succession Picasso/ DACS London 2013.

configuration of the figure to appear three-dimensional from forms
which are essentially flat.

The role of collage in expanding what sculpture could be affected
the development of installation art, because it inspired the use of dif-
ferent materials and methods of construction. In the late 1960s and
1970s, Robert Morris and Joseph Beuys started using felt to create
soft sculpture with abstract fluid forms on the ground or hanging up
against the wall. More interesting still is the work of an artist like Eva
Hesse from this point of view when she started using fibreglass cord
dipped in resin to make her hanging sculptures. In *Right After* of
1969 we can see irregular suspended shapes which are open and

graceful in the way they drape and move from opaque through to translucent and transparent shapes, and reflect the light according to how they are installed.

Sculptures like this are set up in a gallery and are site specific in the sense that they will appear different according to where they are. Hesse was also a pioneer in the development of female artists at this period and would have continued to be so had it not been for her tragically early death from cancer at the age of thirty-four, in May 1970.

Hesse's sculpture is more about space than solid mass and in that sense is closer to the thinking of the Russian Contructivists who re-thought what was possible in terms of space in the early years of the twentieth century at a similar time to when Picasso was working with Georges Braque and inventing collage.

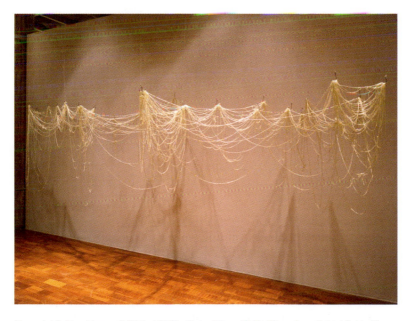

Plate 1.19 Eva Hesse (1936–1970), *Right After*, 1969. Fibreglass. 5 × 18 × 4ft (152.39 × 548.61 × 121.91 cm). Milwaukee Art Museum, Gift of Friends of Art M1970.27. Photo credit P. Richard Eells. © The Estate of Eva Hesse. Courtesy Hauser and Wirth.

Alternative ways of approaching space and form in sculpture in the twentieth century

Plate 1.20 *Linear Construction No. 2* by Naum Gabo, 1970–1971

Plate 1.21 *Venus Forge* by Carl Andre, 1980

Plate 1.22 *Laocoön* by Richard Deacon, 1996

Naum Gabo saw a difference between traditional sculpture and what he and his contemporaries were trying to do which he called constructed and kinetic. Gabo's contemporary, Alexander Rodchenko, in his *Suspended Construction*, had made a sculpture which, instead of being mounted on a plinth, was suspended from the ceiling and so moved through the air as you looked at it. Made out of thin slivers of wood it was constructed from interlocking ovals which cross and re-cross each other in a series of dynamic angles. In this case, the sculpture moves rather than the spectator, and creates its form out of space. Gabo made a very clear distinction between this kind of sculpture and a work like the *Winged Victory of Samothrace* where he says the movement is an illusion.

> For instance who has not admired in the Victory of Samothrace, the so-called dynamic rhythms, the imaginary forward movement incorporated in this sculpture? The expression of motion is the main purpose of the composition of the lines and masses of this work. But in this sculpture the feeling of motion is an illusion and exists only in our minds. The real Time does not participate in this emotion; in fact it is timeless. To bring Time as a Reality into our consciousness, to make it active and perceivable we need the real movement of substantial masses removable in space.
>
> (Quoted in Chipp (ed.), *Theories of Modern Art*: 334)

So, Gabo is making a contrast between the solid forms of the classical tradition and the translucent and kinetic forms of his own work. In *Linear Construction No. 2*, Gabo worked with plastic and nylon filament to create a sculpture just over three feet high (114cm) which is suspended over and fastened to a plinth by a screw mechanism which allows it to revolve slowly. So, as you look at it, the forms themselves change and move, describing the effect of solid volume in space as they do so. It is the kinetic qualities in the sculpture which make us see the form. The outside edges are still important, but not for containment of the form, rather to allow you to see the way the

edges change in space. There is no narrative here and no subject, but you as the spectator become involved in its changing aesthetic appearance.

You might well say that this example is not connected with the free-standing figure and of course you would be right in a way. However, one of the elements which has become very important in recent years is the role of the spectator and his or her own body in relation to the sculpture. *Linear Construction No. 2* was made late in Gabo's life in the early 1970s, by which time his legacy was being taken on board by artists of the Minimalist movement who wanted the body of the viewer to become part of the sculptural experience. Carl Andre, for instance, makes sure that the spectator is invited to enter the space occupied by his sculpture. When looking at the *Venus Forge*, you are encouraged to walk on the steel and copper plates and to follow the line which reaches into the distance; it seems to stretch much further than it actually does because of the perspectival effect of the lines appearing to converge.

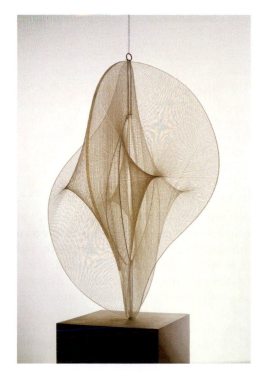

Plate 1.20 Naum Gabo (1890–1977), *Linear Construction No. 2*, 1970–1971. The Work of Naum Gabo © Nina and Graham Williams. © Tate, London 2013.

Plate 1.21 Carl Andre (b. 1935),
Venus Forge, 1980. © Tate,
London 2013/Carl Andre/DACS,
London/VAGA, New York 2013.

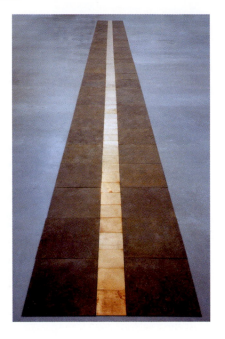

The steel plates vary in colour, and their dull surfaces contrast with the shiny copper. You are allowed to participate in this spatial experience of sculpture by walking along it. The interest in industrial processes, and the materials involved, was very much part of the Minimalist movement (see *Learning to Look at Modern Art* pp. 150–152) which was concerned, not so much with craft-based making, but more with the placing and organisation of objects, rather as an industrial designer might do. So, the relationship between mass, space and the body becomes an integral part of the experience of the sculpture, rather than something to be gazed upon.

Another example of this kind of preoccupation lies in the work of contemporary sculptor Richard Deacon, who works in laminated wood which is steamed into shape and bolted to hold it in place. His sculpture *Laocoön*, seen here in the foreground of Plate 1.22, refers to the classical work of that name, but does not describe the people or the story involved, instead concentrating on the arcs and curves and the way they move in space.

You can see through the lattice work, which makes the shapes move in several dimensions at once. It sits directly on the floor and allows the spectator to experience the sense of movement through space

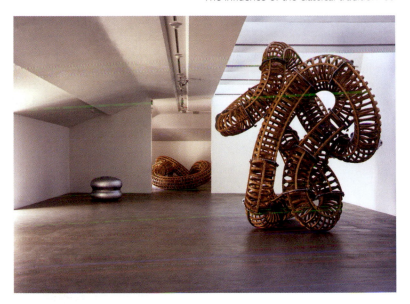

Plate 1.22 Richard Deacon (b. 1949), *Blow, After* and *Laocoön*, 1996 © Richard Deacon; Courtesy, Lisson Gallery, London.

because of its woven and translucent appearance. More interesting still is the fact that you can see into the interior of the sculpture which would not be possible if it were made of a solid material like marble or bronze, where the negative spaces would be between solid forms, rather than the multi-dimensional view you have here.

CONCLUSION

In this last section we have noticed how new developments in sculpture from the early twentieth century have shifted the emphasis away from the classical tradition. Yet, in the rest of this chapter, we have seen how in antiquity a number of different types and techniques of sculpture were established, and from that we have been able to look at lots of enduring characteristics of classical sculpture. But, in a way, one of the most important of these is the idea of commemoration, of leaving a person or persons a permanent memorial, because it spreads into so many areas connected with three-dimensional art. Of course, the ancient world tended to remember only the great and the good, but recent research has shown how much we can learn from

memorials to ordinary people in the ancient world and their inscriptions regarding who they were and what they did. This period also established the principles of memorial in terms of whether it be a bust, a column, a sarcophagus relief or an equestrian monument. We can see in later chapters how these different types have been interpreted and changed and used for different purposes. But we will also be exploring how the modern period has altered our concept of what sculpture can be, and even sometimes maintained a kind of re-interpreted continuity.

Chapter 2

The free-standing figure and its legacy

INTRODUCTION

The free-standing figure has been a potent theme underlying the background to Western sculpture. In Chapter 1 we reminded ourselves of what Gombrich famously called in *Art and Illusion* 'Pygmalion's Power', the idea that sculpture could be made to come alive. In the early Christian and medieval periods, free-standing sculpture of the human figure was feared for what was seen as its potential to encourage the worship of the graven image. Initially, as we shall see, artists used the classical language of sculpture, but later on, although the problem in relation to images generally was resolved, the free-standing statue was treated as relief or at least closely attached to walls and buildings.

In the famous statues on the north door of Chartres Cathedral, Plate 2.1, the figures look like columns and appear magnificently as part of the architecture. Of course, this need not be as exaggerated as this, if you think of the more free-standing ones at Rheims, for instance. But, in a way, the most important point about all of this would be that, if sculptural figures were to be made, they could not be naturalistic. So this is why it was not until the fifteenth century in Italy that the free-standing figure was revived, and particularly in its free-standing nude form. This is most commonly associated with Donatello's bronze David which we will look at. The technique of bronze casting had not been used for the free-standing figure since antiquity and Donatello's sculpture was very much part of the revival of interest in classical art (which had never really gone away, but whose naturalism had been suppressed or at least re-directed). Charlemagne for instance had wanted to recreate it, but in a spiritual way; the famous equestrian figure of him, which we will look at in Chapter 3, is not naturalistic.

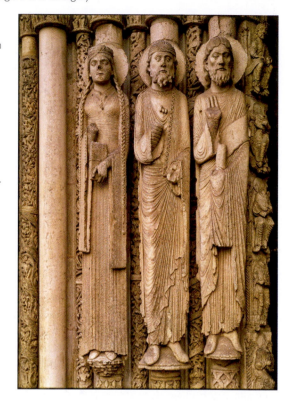

Plate 2.1
Old Testament
figures, from the north
embrasures of
the central door
of the Royal Portal of
the west façade
(stone), French
School (12th
century)/Chartres
Cathedral, France/
Peter Willi/The
Bridgeman Art Library.

The revival of bronze casting also made possible the revival of replication, because of course a bronze figure is made from an original model. Sometimes this could be made in clay, terracotta, plaster or wax. Michelangelo used wax for his tiny models of the slaves (one of which survives in the Victoria and Albert Museum) and then of course it would need to be scaled up, which, according to Vasari, was done by immersing the figure in water and gradually revealing it more and more as each section was made larger. Another form of replication, which was invented in the eighteenth century, was the pointing machine which meant you could reproduce a marble figure by carefully measuring the mounds and indentations in a plaster or clay model or an original carving, and then reproduce it. One of the most famous artists to use the pointing machine was Rodin, who, in his later years, employed as many as fifty assistants in this kind of replication work. Here is a description of this complex process from the biography of Rodin by Frederic Grunfeld:

The pointing of marble, as Malvina Hoffmann explains, is done with the assistance of a delicately adjusted three point compass known as a pointing machine which is hung on the original plaster. By means of a steel needle about seven inches long, the heights of the surface are all registered by hand and the needle is set. The compass is then transferred to the stone, and hung on three identical points to correspond with those on the plaster model. The excess stone is cut away till the needle can be pushed in to the same depth as on the original. It is not unusual to take two or three thousand points to prepare a portrait for the final surface. If the needle shifts or the needle is not accurately set, the entire effect will be ruined by errors in the pointing.

(Quoted in Grunfeld, *Rodin: A Biography*. 567)

Rodin's marble sculpture *The Kiss* was done like this, and has become one of the most beloved of sculptures. As late as 1933 the pointing machine was being recommended by Charles Sergeant Jagger (who is best known for his bronze figure of the Recumbent Figure of a Dead Soldier on the memorial at Hyde Park and his relief of No-Man's Land) in his book *Modelling and Sculpture in the Making*.

Largely as a result of this kind of replication, it was felt by sculptors such as Jacob Epstein in the early twentieth century that sculptors should get back to the real business of this tactile art by doing direct carving. The famous story of how Epstein asked Henri Gaudier-Brzeska whether he did direct carving, and Gaudier-Brzeska said he did, and then had to rush home and teach himself how to do it(!) is an example of how urgent this idea became. It meant first of all doing a drawing of the figure you want to make on the block, and then cutting into the stone or wood directly, with saws and chisels, gradually refining and refining your figure, with finer and finer chisels, until it is ready to be sanded and polished. But the whole point of this really is that it is done by the artist him- or herself, with at the most a few assistants to do the initial heavy work of getting into the wood or stone. But perhaps the most significant point about this is the ability to 'see into' the block of stone or wood the size and scale of the figure you are going to carve. You need to have what Martin Kemp has called a remarkable spatial sense to see inside the block accurately in order to gauge whether your figure can be made to emerge. When talking about Michelangelo, Kemp has this to say:

There can be little doubt that Michelangelo's sense of the conceptual foundation of art was intimately related to the powers of

visualization ideally required of any sculptor who approaches a marble block and needs to 'see' the figure within. The difference in his case is one of degree. His technique of carving, entering a block impulsively from a given angle, often diagonally, moving intuitively through the mass of marble to release the pre-envisioned forms, indicates a power of spatial visualization which has never been surpassed.

(Kemp, *Behind the Picture*: 199)

Kemp cites Michelangelo's *Unfinished Slaves* as an example of this where the figure appears to be coming out of the block. Gaudier-Brzeska's direct carving was remarkable for the tension in his figures and his idea of sculpture as a mountain. Also in this period there was the revival of stone carving, as opposed to marble, and the interest amongst British sculptors like Epstein and Henry Moore in using Hornton and Hopton stone and elm wood for instance, which were indigenous to Britain. The natural faults in the stone were regarded as an advantage and the wide grain of the wood was thought to reflect the contours of the body. As we shall see in this chapter, Epstein used Hopton stone for his figure of Lazarus and Moore used elm for his *Reclining Figure* which we will look at. As a young artist, Moore had to use whatever came his way, because the purchasing of blocks, particularly large ones, can be very expensive. At about the same time, artists like Ernst Barlach became interested in reviving the German gothic tradition of wood carving because it was so much more expressive.

At around the same time as this philosophy was developing in Germany and England, in Russia artists were moving into different areas altogether, using modern materials and forming their sculpture from steel and perspex so that space becomes the most important area of expression. In more recent years artists like Dan Flavin have been interested in new materials and new techniques and in the legacy of Russian Constructivism. The role of the spectator has become increasingly important in the sense of being invited to participate in the thinking behind the object. However, casting and carving still remain very important in the work of artists like Antony Gormley, Rachel Whiteread and Marc Quinn as we shall see.

TRANSPOSITION

Plate 2.2 *Christ the Good Shepherd*, Roman, fourth century CE, marble

This figure is not about showing the physical prowess or athletic beauty of the human body as it would have been in classical times. Instead, it represents an idea or a metaphor of Christ as the Good Shepherd, who cares for his sheep, in the way Jesus suggests He cares for His followers, in the parable as told in St Luke's Gospel. The figure is carved in marble, clothed and represented with the weight on one foot in a version of the contrapposto position. He carries a sheep over his shoulders and wears a short tunic, with a bag slung diagonally across his chest, and boots with thonged stockings. The emphasis is not on the nude body but rather on the contrast between different textures, the folds of the tunic going in various directions, and the interaction between the surface of the boy's hair and the coat of the sheep which does not appear frightened, but alert and part of the overall design of the sculpture.

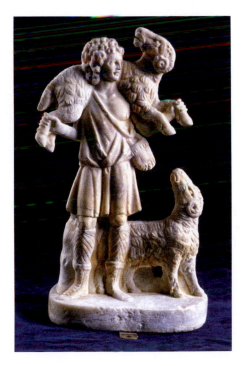

Plate 2.2 Christ the Good Shepherd, 4th century CE. Su concessione del Ministero per i Beni e le Attività Culturali, Soprintendenza Speciale per i Beni Archeologici di Roma.

Across the chest the diagonals could be seen to represent the lines of the early Christian cross, the Chi Rho symbol of Christ, with the head as the P, the diagonals in the folds, and the circle created by the arms and the head. This sculpture does not exude the desire to dominate through scale as it is only 100 centimetres, or approximately three feet, high; in fact the spectator would need to sit down in order to be on a level with it; otherwise it is they who would be dominant. The sculpture was probably designed for the catacombs outside Rome and so could not be large. Instead, the communication is about this youth carrying the burden of the lamb which seems to press down on his shoulders; the body of the animal is full of tension expressed in the angle of its head and in the boy's hands holding on to its legs and pulling its body firmly around his neck. The head and neck of the sheep turn upwards looking over the boy's head and this is augmented by the sheep below on the right looking up at him. This effect is created as much by the space between the sheep's neck and the side of the boy's head, and echoed in the shape of the hind leg and the space below it. Indeed, the hind legs look as though they are about to kick outwards in the struggle to get away. There is also the symbolism of Jesus, not only as the Good Shepherd, but also as the Lamb of God who was sacrificed for our Redemption.

The angle of the body facing forwards, the head turned at forty-five degrees, the face and the eyes engaging with the outside world, and the mouth slightly open, also suggest the feeling of a particular moment in time. The use of angles is continued in the youth's legs, one pointing forwards and the other turned sideways. The interior space between the legs becomes straight, continuing in the folds of the lower sections of the tunic, and then active again over the torso, coming to rest in the firm expression of the head. As we have seen, this figure is not designed to dominate either by its size or by its attitude, but instead is an expression of a metaphor for what the narrative and its symbolism are about. The classical language of sculpture is being transposed for a Christian and not a pagan purpose.

The fact that this sculpture is free-standing is significant too because, before long, the idea of the human body being depicted naturalistically was to be questioned fundamentally in the Iconoclast Controversy which was not finally resolved until 843 CE. The fear of idolatry in the form of visual representation was very real in the early Christian Church. The whole argument applied to images in general, but the sculptural figure, particularly the nude figure, became a subject which was not seen. Moreover, it was thought that classical sculpture,

with its emphasis on the physical, did not lend itself to the communication of spiritual ideas. However, in his book on early Christian art, John Lowden makes it clear that it was the naturalistic visual image and the whole concept of verisimilitude which was the problem. Also, that the idea of the potential transformation of sculptured flesh into real flesh, as told in the story of Pygmalion, has a part in this, as does the Old Testament story of God's instruction to Moses 'Thou shalt not make an idol'. The later medieval period abounds in stories of statues coming alive. In the catalogue of *The Age of Chivalry* exhibition, in the section on medieval sculpture, Paul Williamson discusses single figures of the Virgin and Child:

> These figures were often considered to have miraculous properties . . . and stories of statues coming to life were legion.
>
> (Catalogue *The Age of Chivalry*: 390)

Williamson cites an example from the *Lambeth Apocalypse* of 1260–1267, where a monk is seen painting a sculpture of the Virgin and Child which is in the process of gesticulating at him!

Although the Iconoclast Controversy was eventually resolved in favour of visual imagery, free-standing figures, particularly the nude figure, were largely abandoned in the medieval period in favour of relief sculpture, and sculpture which was part of something else, like a building, a tomb, a reliquary or a precious object. So this early Christian figure of the Good Shepherd is not about presenting any kind of authority, but rather concerned with conveying a much gentler and more contemplative message. More intriguingly, it presents us with the idea of transposition, using the classical language of marble sculpture to express a Christian idea. What else were artists in this period of late antiquity to do, but continue to use the classical language they knew, and transpose it to a different meaning and purpose?

THE FREE-STANDING FIGURE AND SPACE

Plate 2.3, 2.4, 2.5, 2.6 and 2.7 Three figures of David by Donatello, *c.*1433, Michelangelo, 1504 and Bernini, 1623

The relationship between the form of a sculpture and the space surrounding it is crucial to the experience of looking at it. These three famous figures of David by Donatello, Michelangelo and Bernini offer a comparison between several different approaches to this relationship. Donatello's figure is bronze and smaller than life

size at 159 centimetres; he is credited with reviving the lost wax process of bronze casting in the early Renaissance period in Italy and with making the first nude free-standing figure since classical times. Michelangelo's figure by contrast is carved in marble and 18 feet high. Then Bernini's marble *David*, which is life size, is much more active and coming out into our space. Traditionally it is said that this figure was designed to be seen from slightly off centre in front so that we can sense the moment when he is about to release from the sling the stone which will kill Goliath. The other two earlier sculptures are more thoughtful. Donatello's *David* seems to be contemplating the act he has just committed and has his foot on Goliath's head, whereas Michelangelo's *David* holds the sling and stone in readiness contemplating what he is going to do.

The first thing which strikes you about the Donatello figure is the beauty of the burnished surface of the bronze and the way it reflects the light and conveys the feeling of youthful flesh. Then, instead of the classical contrapposto you would expect, there is the slightly swayed grace of the body which gives it a more gothic rather than purely classical appearance. The stillness and inward-looking character of the figure is reflected in the way it stays within its own space. The

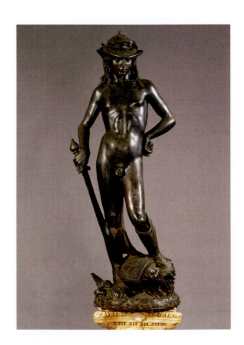

Plate 2.3 Donatello (Donato di Niccolo di Betto Bardi, c.1386–1466), *David* (before restoration), c.1433. Florence, Bargello. © 2013. Photo Scala, Florence. Courtesy of the Ministero Beni e Att. Culturali.

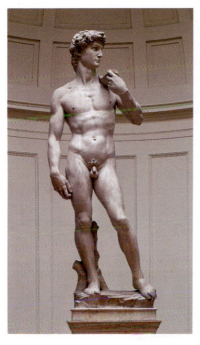

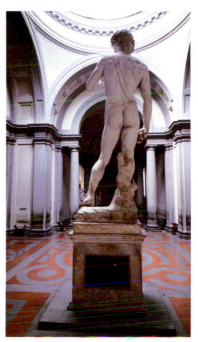

Plate 2.4 Michelangelo (Michelangelo Buonarroti, 1475–1564), *David*, 1504. Florence, Accademia. © 2013. Photo Scala, Florence. Courtesy of the Ministero Beni e Att. Culturali.

Plate 2.5 Michelangelo (Michelangelo Buonarroti, 1475–1564), *David* (from behind), 1504. Florence, Accademia. © 2013. Photo Scala, Florence. Courtesy of the Ministero Beni e Att. Culturali.

outside edge contains the form, and the beautiful negative spaces allow the eye to move round the torso in a graceful movement, creating variety and a sensual visual experience. There was a strong symbolic aspect which contributes to the idea of David as the warrior poet, holding the sword and standing on the head of Goliath and yet thinking and turned in upon himself; its size befits the story of the boy hero, so that the spectator is able to relate to it on more equal terms. The serpentine twist to the body, its smooth appearance and the facial expression contribute to an ambiguity and ambivalence which has always fascinated viewers.

Michelangelo's *David* on the other hand is so much larger than life size, heroic and idealised at 18 feet high. You feel dominated by the sheer grandeur of it, but it is still contained within its own form. The outside edge corresponds to the size of the original block and

the spaces between the forms perform a similar role to those of Donatello, except that the whole figure is more severe and more masculine. These internal spaces are more vertical and architectural and the sculpture feels less accessible than Donatello's *David*. You sense that his head might turn, that the size of the head, neck and hands are too large and exaggerated, but he too stands within an outside edge, with the contrapposto expressing movement on one side and the weight of a straight edge on the other. Both figures are adapted from the classical tradition in their posture and technique and in the subject of the nude.

In contrast, Bernini's *David* appears completely different because it is so active and so dynamic in its treatment. From recent study and as revealed in the exhibition at the Metropolitan Museum in New York, much more has been discovered about how Bernini used models in clay.

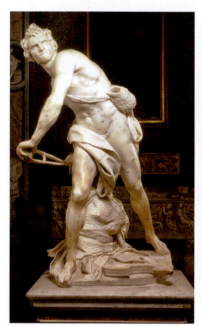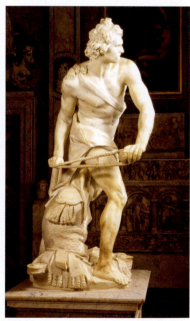

Plate 2.6 Gian Lorenzo Bernini (1598–1680), *David*, 1623. Rome, Galleria Borghese. © 2013. Photo Scala, Florence. Courtesy of the Ministero Beni e Att. Culturali.

Plate 2.7 Gian Lorenzo Bernini (1598–1680), *David* (left side), 1623. Rome, Galleria Borghese. © 2013. Photo Scala, Florence. Courtesy of the Ministero Beni e Att. Culturali.

Bernini used models to shape his ideas in three dimensions to convey his designs to patrons, and to guide his assistants.

(C.D. Dickerson, Introduction, in Catalogue *Bernini: Sculpting in Clay*. xiv)

It is often said that this figure of David was designed more pictorially, because of the angle from which it was supposed to be seen, so that you experience the full force of the diagonals. There is one arm across the body, the other in tension behind the legs which are apart, making another diagonal across the knees. One shoulder is forward and the other back and the head is also turned to create a figure like a coiled spring poised at that moment to sling the stone at Goliath. You find yourself imagining the arc which will be made in the space as the stone is thrown from the sling, the way the weight of the body will be shifted forwards and that, far from staying within the block, the figure will come rushing out into your space. This experience is intensified as you walk round the sculpture where at one point you see the head over the shoulder, the hands stretching the rope of the sling and the body taut from behind in the back muscles and the shoulders. This quality of visual change and difference applies to all free-standing sculpture, but is particularly acute here. Indeed, some of the views are not harmonious as they are in the figures by Donatello and Michelangelo. There is not the same sense of the figure having been carved from a single block.

So, with all this dynamic movement out into our space, how is Bernini's figure stabilised? Part of the answer is that the armoured cuirass at the back is joined to the drapery over David's thigh so that the figure is supported and protected from collapse. The harp, with the eagle's head, is also lying on the ground at an angle to the twisting figure itself. The differences in texture, hair, skin, rope, furry goatskin bag and pattern on the cuirass all act as a foil to the surface of the muscular active flesh of the young man. Also, the expression on his face is one of focussed concentration, so you feel he is engaging you as the spectator, as if you even temporarily represented the enemy Goliath. This David is all about dynamic action instead of different types of contemplation. There is a sense of containment and stillness in the two earlier figures, whereas with Bernini's figure it is the idea of David being caught in a moment in time.

THE FREE-STANDING FIGURE AND ITS SETTING

Plate 2.8 *Lazarus* by Jacob Epstein, 1949

Another kind of spatial dimension in relation to free-standing sculpture is where the space of its setting can give a greater meaning to the way it communicates with the spectator. In the ante-chapel at New College, Oxford, there is Epstein's extraordinary figure of Lazarus apparently rising from the dead. The figure is wrapped in a winding sheet made from strips of linen from top to toe, but excluding the face, which is thrust backwards in an awkward position. This covering makes the body into a continuous shape with no spaces in between.

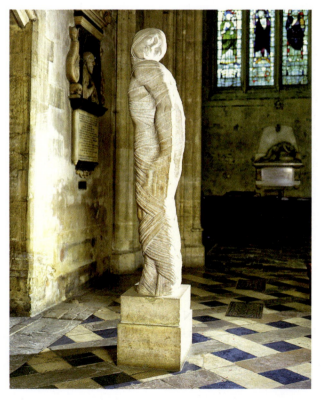

Plate 2.8 Jacob Epstein (1880–1959), *Lazarus*, 1947–1948 (Hoptonwood stone), New College Chapel, Oxford. © Courtesy of the Warden and Scholars of New College, Oxford/The Bridgeman Art Library.

Lazarus's back is curved, his arms stretched behind against the sides of his body which is supported by the tautly standing legs. So, apart from the head there is no movement. The figure looks like a block of stone which has been carved almost like a pillar, although the back, the legs and the arms indicate it is a standing figure. The head and neck are distorted as though they have lost strength and life. The figure is set in this awkward position as if in the process of coming to life again. Down below you can make out the shape of the legs standing firmly together to support the whole sculpture. It looks as though it might be slowly rising from the dead and looking back to where it has come from; and yet it is full of tension as though hovering between this life and that beyond the grave. It looks almost like an effigy on a medieval tomb which has been raised into an upright position.

However, what gives the figure far more meaning is the space in which it is standing. If you move round it you experience the upright pillar-like effect. Then, you can walk into the chapel towards the altar steps and the great stone reredos of saints rising behind and representing the idea of heaven. When you turn round and look back, you see Lazarus framed in the doorway with his twisted awkward head turned towards you and reaching out across the space between the ante-chapel and the altar, as though he is hovering between heaven and earth, between the idea of the afterlife and the prospect of returning to ordinary existence. So, the setting of this sculpture adds enormously to the complexity and subtlety of what it communicates.

Epstein believed in what he and his contemporaries called direct carving and this figure is made from Hopton stone. The issue about craftsmanship and traditional materials was very real to many artists of the early twentieth century, and a legacy of a wider concern with craftsmanship and truth to materials, originating with the Arts and Crafts movement.

THE FREE-STANDING FIGURE AND THE EXPRESSIVE SURFACE

The achievement of texture

Plates 2.9 and 2.10 *Mary Magdalene* by Donatello, *c.*1460

This figure is carved in lime wood and would originally have been gilded. It depicts Mary Magdalene as an old woman at the end of her

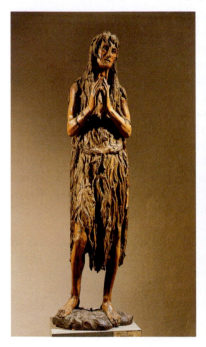

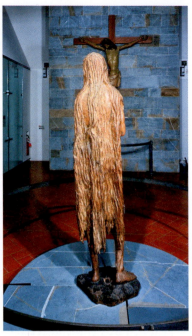

Plate 2.9 Donatello (Donato di
Niccolò di Betto Bardi, *c*.1386–1466),
Penitent Magdalene, 1453–1455,
wood carved, gilded and painted.
© akg/DeAgostini Picture Library.

Plate 2.10 Donatello (Donato di
Niccolò di Betto Bardi, *c*.1386–1466),
Penitent Magdalene, 1453–1455,
wood carved, gilded and painted. Italy;
Tuscany; Florence; Opera di Santa
Maria del Fiore Museum. © akg-
images/Mportfolio/Electa.

life, when, as legend has it, she spent many years in the desert doing
penance for her past life as a prostitute. This is no idealised youthful
figure, as we saw in the bronze David earlier. No, the whole point of
this sculpture is that it is expressive of the idea of the body in old age.
If you look closely you will see that she has lost some of her teeth and
maybe the sight of one eye through cataract. The deep eye sockets,
the hollow cheeks and the stringy neck give the figure a haggard
appearance; in particular the observation of what happens to the arms
and legs in old age is very poignant.

At 188cm or 74 inches the figure is life size, and standing in a
version of the contrapposto position. The head leans slightly to one
side, the hands are in the praying position and the feet stand on a flat

base as if about to move off the edge. The textures add considerably to the effect because of the way the animal skin of the dress runs into the hair, which is matted and unkempt; this is particularly effective at the back, where you can see the hair running right down to the hem of the dress. The internal spaces between the hair and the neck are also very effective, in the way they cast deep shadows and emphasise the form of the head and neck. Also, the contrast between the smooth surface of the arms and legs, and the rough texture of the dress and hair, only serves to add to the power of the sculpture. This is particularly true in the way the contour of the upper arm contrasts with the interior, revealing the torso in shadow and the edge of the hair.

But, above all, it is the way the wood has been carved to create variety in the surfaces which makes this sculpture so expressive and so moving. The golden colour, which would have been accentuated by the gilding originally, is an important point here. We now see it as golden lime wood, but Donatello's contemporaries would have seen it gilded like a precious object, and yet a statue of a figure ema-ciated by old age and suffering.

The tactile qualities of the surface

Plates 2.11 and 2.12 *Balzac* by Auguste Rodin, 1898

This extraordinary figure in bronze, created to commemorate the writer Honoré de Balzac, was the result of many studies, drawings and models, mainly executed in plaster. Rodin wanted to commu-nicate the spirit of the man and used expressive means to do this, through the use of the dressing gown, the figure tilted backwards and the head, which is far from being a perfect detailed likeness, as you would expect in a more conventional portrait. The result is a figure of such bulk and texture that it expresses the spirit of the man, his powerful imagination and his larger-than-life personality. But the most astonishing quality, as in all Rodin's sculpture, is the sensual tactile quality of the surface, so that you want to touch it in order to discover the monumental bulk of the figure through your hands. Rodin was very short sighted, so he had to always work very close to the model, making the surface of paramount importance to him. The poet Rainer Maria Rilkë, who worked as Rodin's secretary for a time, communicated this idea potently in his famous essay on the artist:

Rodin had now discovered the fundamental element of his art, as it were the germ of his world. It was the surface – this differently great surface, variedly accentuated, accurately measured, out of which everything must rise – which was from this moment the subject matter of his art, the thing for which he laboured, for which he suffered, and for which he was awake.

(Quoted in Elsen, *Rodin: Readings in His Life and Work*: 6)

When you first look at this sculpture, you are struck by its size of course, which is about 9 feet tall. Then you notice the long coat and the way it has been pushed into simplified shapes with the sleeves hanging loose and the arms inside, all of which emphasises the bulk of the figure. Rodin made a separate model of the dressing gown out of plaster-soaked material so it could be draped to communicate the abstracted shape of the figure. Then, your eyes move to the head, with hair like craggy thatch and the eyes deep set like holes in the

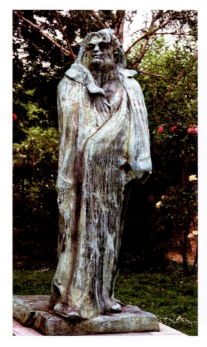 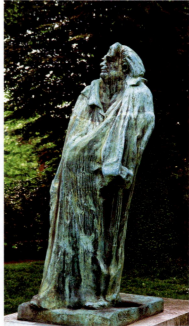

Plate 2.11 Auguste Rodin (1840–1917), *Balzac*, 1898. © Gian Berto Vanni/Corbis.

Plate 2.12 Auguste Rodin (1840–1917), *Balzac*, 1898. © Vanni Archive/Corbis.

head, and seeming to look out into the distance at an angle to the body. Rodin also made a plaster model of the head which demonstrates this very well and we will look at that in Chapter 5; both are examples of his famous saying about sculpture being primarily concerned with the hole and the bump. Balzac's weight is distributed in an extended contrapposto position, where the figure is made to lean back at an angle beyond the traditional stance, with one foot forward and the other back. One side is more or less straight and, on the other, the bulk of the material sticks out. The forms and the surface are expressive of the body of the man, but in fact greatly exaggerated and simplified. This figure is modelled so you can feel the eruptions and depressions in the surface, and it is those which communicate the character of the man, which was larger than life size in every way.

The shape and form of the outside contours express this as well. Rodin himself was very clear about the importance of the contours and explained why in his *Reflections on Art* which were put together and originally published in 1913:

> I proceed methodically by the study of the contours of the model which I copy, for it is important to rediscover in the work of art the strength and firmness of nature; translation of the human body in terms of the exactness of its contours gives shapes which are nervous, solid, abundant, and by itself [this method] makes life arise out of truth.
>
> (Quoted in Elsen, *Rodin: Readings in His Life and Work*: 154)

The point that Rodin is making here is that the outside edge of this figure and any other figure in sculpture is important because it is worked at from all sides and changes as you walk round and look at it from different points of view. It also gives the Balzac a very characteristic and powerful feeling as its edges catch the light, particularly when it is seen outside.

Expression in shape and surface

Plate 2.13 *The Avenger* by Ernst Barlach, 1914

This bronze figure is streamlined to make it look as though it is surging forward. Its head and arms are outstretched and it appears to be looking straight at the enemy, ready to strike with the curved sword. The long cloak-like costume is divided into facets which seem

to move backwards towards the left foot stretched out behind, and so to emphasise the action of running. The sword appears to be joined to the hand and arms, and then the arms become part of the shapes in the cloak. The outside edge also expresses the idea of movement and speed as the contour moves under the arms and round the shape of the weight-bearing right leg. This becomes a solid form at the base and then the edge expresses a movement like flying, behind and along the top. The sword looks as though it is going to be raised in the air to strike an enemy in front at any moment.

The figure was modelled in clay and then cast in bronze, but the curious thing about it is that it looks like facets of carved wood, as though the artist had sliced along it with a carving tool. The deep recesses around the folds of the garment are rigid geometrical shadows which make you feel this figure has become an expression of the implacable force of modern warfare, like a premonition of the horrors of the First World War, which was just beginning in 1914, when this figure was made.

There is an expressive strength and simplification in this figure which also carries the idea of the gothic tradition of German wood carving and the idea of linking with your national ethnic tradition. Artists of the early twentieth century were interested in connecting with the artistic heritage of their own country in reaction to the dominance of the classical tradition. This applied to artists of the German Expressionist movement with whom Barlach was associated; one of their leading protagonists, E. L. Kirchner, experimented with

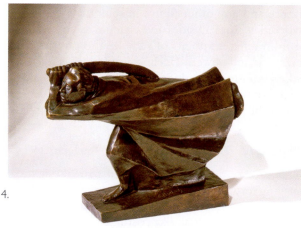

Plate 2.13
Ernst Barlach
(1870–1938),
The Avenger
(*Der Rächer*), 1914.
© Tate, London
2013.

traditional wood carving as well as painting. Barlach had adapted this sculpture from a lithograph called *Holy War* which made reference to another German tradition, namely that of graphic work with its emphasis on the importance of line, and light and shade, to create the form of this figure, whether in graphic work or in sculpture. The emphasis on the edges of the forms in *The Avenger* makes this connection particularly telling.

The structure of the material brought to the surface

Plate 2.14 *Reclining Figure* by Henry Moore, 1935–1936

The experience of the surface is not the only characteristic that can be brought to wood carving. There is also the quality of the grain of the wood which can be expressive too, particularly if it has been cut, sanded and polished as skilfully as this. Like Epstein in the previous section, Moore was a champion of direct carving and the process of making tactile contact with the material. As with carving in stone or marble you have to start with a block and gauge how you are going to be able to get the figure you want out of it. For this figure, Moore used a block about 3 feet long by 2 feet square.

Not only was elm wood available in large baulks, but Moore found it a good choice for horizontal figures because the wood has a rather wide grain which he used to emphasise the pose. The block of wood was heavy enough for him to be able to work with saws and an axe. This, he said:

> changed my attitude to woodcarving since in the smaller carvings I had sometimes felt the process of production was almost like a mouse nibbling to make a hole.
>
> (Quoted in Catalogue *Henry Moore* 1988: 182)

So, obviously Moore understood the innate characteristics and suitability of the wood he wanted to use.

But the most exciting quality of this reclining figure is the way the character of the elm wood is used to express the form of the body, so that the grain on the shoulder moves round towards the chest and neck, expressing an upward movement, curving towards the head. Further down, on the forearm, the grain expresses the musculature from the elbow to the wrist, and the hand is suggested by the flowing movement into the side of the body. Then, further down still, we find the wood has been used by Moore to express the length of the thighs

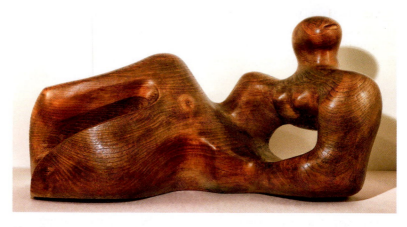

Plate 2.14 Henry Moore (1898–1986), *Reclining Figure*, 1935–1936. Buffalo (NY). © 2013. Albright Knox Art Gallery/Art Resource, New York/Scala, Florence.

and the leg area. Of course this figure does not have the same proportions as classical art and is not meant to. It is influenced instead by the ethnographic sculpture which Moore had been looking at in the British Museum, and ancient Mexican sculpture in particular. Like Rodin, he was interested in the hole and the bump and in Gaudier-Brzeska's idea of sculpture as a mountain.

So, Moore's approach is more abstract and simplified, and yet powerful nonetheless; the head seems to be turned sideways, as this woman looks over her shoulder, with her chin raised and her mouth open as though shouting into the space surrounding her. The surface of the elm wood is polished to reveal the colour and the grain of the wood. The natural qualities of the darker and lighter areas add to the expression of the surface. The face has no features except where the grain of the wood seems to suggest a half-open mouth. The edges of the form seem to travel into the opening in the middle of the figure so that there is a rhythm which travels over the whole sculpture. This lends variety to the surface even though it is above all about bulk and solidity and a kind of static monumentality which is as powerful in its way as any of the sculptures in this section.

Some people might find the distortions of this body hard to take if you imagine it as real flesh and blood. But the most interesting point about it in a way is its resemblance to an old gnarled tree trunk, weathered and ancient, as well as to the human body. Then, the

craftsmanship in the carving and polishing of the wood is there for all to see, so that it is at once a body, an ancient form and a piece of beautiful carving, all at the same time. It is not about illusion or verisimilitude but about the sculpture as object.

REALISM AND VERISIMILITUDE

Questions around realism

Plate 2.15 *Little Dancer Aged Fourteen Years* by Edgar Degas, 1881 and associated drawings

Like many of the other sculptures in this book, Degas' *Dancer* is very well known. The original figure was made in wax, which becomes an extremely malleable material with the addition of turpentine, and this is good for modelling. Degas took to sculpture, which he called art for the blind, when he started having trouble with his eyesight. He did not give up painting but continued to make experiments in which the relationship between painting and sculpture was explored, particularly in the late pastels. But the first question you have to ask yourself is why is the figure clothed? Yet it is not a trompe l'oeil figure

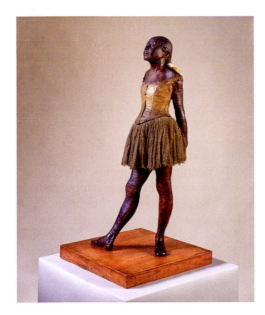

Plate 2.15 Edgar Degas (1834–1917), *Little Dancer Aged Fourteen* (*Petite danseuse de quatorze ans*), 1880–1881. © Tate, London 2013.

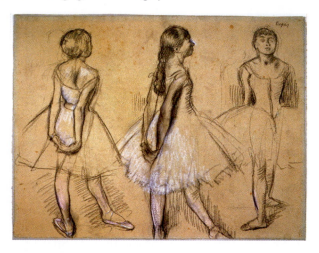

Plate 2.16 Edgar Degas (1834–1917), *Three studies of a dancer*, 1878–1881. New York, the Pierpont Morgan Library. Black chalk, 47 × 62.3 cm. © 2013. Photo Pierpont Morgan Library/Art Resource/Scala, Florence.

because you are aware all the time that the different textures of cloth and wax are related as Degas put a grey wash over the whole sculpture to make all the parts connect tonally together. It is well known that Degas was very interested in drawing, print making and photography, all of which involve a deep understanding of tonality.

The body of this girl is in tension with the legs and feet turned out in the Relaxed Fourth Position and the arms stretched behind with the hands joined together. We can see this in the sheet of three drawings of the girl in the same position but from different points of view that Degas made for his sculpture; in fact, everything about the body is in tension including head, shoulders and chest as well. Degas had been studying the young ballet dancers at the Opera during the 1870s so he knew all about the rigorous training the so-called 'rats' had to undergo.

In the study on the right you can see that the face is not idealised and looks prematurely aged, with its pinched cheeks, thin lips, small eyes and hair scraped back. The head is tilted backwards, the chin juts out and the neck is stretched at an angle to the head and shoulders. The negative spaces are superbly used to enhance the tension particularly between the back and arms in the figure in the centre and in the intervals between the torsos of the figures and those of the legs lower down. In fact, Degas has taken the classical contrapposto

position and turned it into a modern interpretation of a young person at a moment in time. Moreover, it shows the body of a young girl as it would be at that age but observing it from three angles so that you can see it in a more sculptural way. The relationship between sculpture and drawing is very important for exploring three dimensions and we will see how Degas used more drawings of this subject when we examine it in more detail in Chapter 8.

Most of the versions of the sculpture of the *Little Dancer* which we see in museums are cast in bronze. Many will know the famous story of the wax figures which were found in Degas' studio after his death, and then how plaster casts were taken of them after they had been repaired and a series of master bronzes or modèles taken from those. The bronze casts you see in museums were taken from those modèles (22 casts from each figure). The modèles themselves were only discovered and acquired by the Norton Simon Museum in 1976. In the National Gallery's exhibition catalogue, *Degas: Art in the Making* (2004–2005), there is an interesting description of how each of the processes reduced the sculptures in size:

> Although this sequence of operations is well documented, it is also possible to check technically. The modèles are about two per cent smaller than the original sculptures and the subsequent casts are about two per cent smaller than the modèles, as a result of the bronze contracting as it cooled inside the mould. There is also an appreciable loss of precision and surface detail in moving from the original wax to the modèle and then to the edition of twenty-two.
>
> (Catalogue *Degas: Art in the Making*: 41)

So, although the original version was a wax model, the casts we see are not and they vary in size and level of detail. But it is interesting to reflect on the idea that so-called realism as a shifting and changing experience was part of the thinking of this era of Impressionism. The art critic and writer Edmond Duranty, who was a close friend of Degas, made this clear in his essay 'La Nouvelle Peinture' published in 1876:

> In real life views of things and people are manifested in a thousand unexpected ways. Our vantage point is not always located in the centre of the room whose two side walls converge toward the back wall; the lines of sight and the angles of cornices do not always join with mathematical regularity and symmetry. Nor does our point of view always exclude the large expanse of ground or floor in the

immediate foreground. Sometimes our viewpoint is very high, sometimes very low; as a result we lose sight of the ceiling and every-thing crowds into our immediate field of vision, and furniture is abruptly cropped. Our peripheral vision is restricted at a certain distance from us, as if limited by a frame, and we see objects to the side only as permitted by the edge of this frame.

(Duranty, *Art in Theory*: 583)

Here Duranty is suggesting that there is no one fixed reality because we see from so many different angles and positions. He is asking us to look at it much more as a process of discovery, almost as a narrative in itself. So, although Duranty is writing primarily about painting here, nevertheless the *Little Dancer* could be seen as another kind of attempt to create a questioning of what realism is, and how we experience it, because it is elusive and ever changing. It is worth remembering that Degas had painted a portrait of his friend Duranty in which he is seen from above and at an angle.

Verisimilitude and its possibilities

Plate 2.17 *Dead Dad* by Ron Mueck, 1996

Plates 2.18 and 2.19 *St Francis Borgia* by Juan Martínez Montañés and Francesco Pacheco, *c.*1624

Unlike Degas, Mueck is interested in the very idea of verisimilitude and how you can exploit it: the borderline between the sculptural object and imitation. His figures are often weirdly and disturbingly real. One of the strangest is this one called *Dead Dad*. Smaller than life size, at 102 centimetres long, the figure lies on the floor like a corpse. Yet the surface of the figure is so real in terms of its texture that at the same time you almost feel that it is alive. Yet it is not a cast. It was modelled first as a small plaster and then scaled up into a full-blown clay model on an armature from which a silicone and fibreglass mould is taken. But then the main work is done afterwards on the surface, adding the hair, eyebrows, pubic hair and hair on the legs; too big for a doll, too small for a real man and yet it is completely lifelike in its detail. This artist is fascinated by the borderlines between art and reality, between skill and verisimilitude, life and death; because it is smaller than life size and obviously not real flesh, it manages to make the spectator think about those connections between sculpture and realism in a very interesting way.

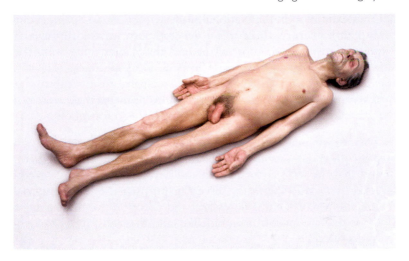

Plate 2.17 Ron Mueck (b. 1958), *Dead Dad*, 1996. Polyester resin and mixed media. © Ron Mueck. Image courtesy of the Saatchi Gallery, London.

You could compare *Dead Dad* to the waxworks in Madame Tussauds, but there the surface is more obviously made of wax. Even so, if you meet one on the stairs dressed like an attendant, as I have done, you can mistake it for real for a moment. But there the context is all important as it is placed where you might expect to see an attendant, whereas Mueck's figure is in an art gallery setting, which makes you consider it as art. Mueck learned his skills in the special effects industry in film and television, where skill and realism are often very important. When Mueck takes the silicone mould from the clay model it is absolutely crucial that it is seamless otherwise you cannot control the illusion. The spectator is encouraged to go and look really closely at the figure and explore the notion of the real in art and what it might mean.

According to Colin Wiggins writing in the catalogue of the Ron Mueck exhibition at the National Gallery (2003), Mueck comes from a line of realists who are part of a long tradition of realism in northern Europe. These artists include Dürer, Van Eyck and much Dutch seventeenth-century painting, and more recently, the German Neo-Realists of the 1920s and 1930s. All of these artists could be said to bring us face to face with these issues surrounding the visual image and our relationship with it. Another tradition which explores this area is in the idea of making the sacred real which was examined in

another exhibition in the National Gallery in 2009. In Spain, in the seventeenth century, there was a development in sculpture which required verisimilitude in order to encourage piety and bring the sufferings of Christ and the saints home to us as spectators. The aim was to make you believe, through the realism of the sculpture as mediator. St John of the Cross made it quite clear that these were not the graven idols that the early church had been so fearful of:

> The use of images has been ordained by the church for two principal ends – namely, that we may reverence the saints in them, and that the will may be moved and devotion to the saints awakened by them. When they serve this purpose they are beneficial and the use of them is necessary; and therefore we must choose those that are most true and lifelike, and that most move the will to devotion.
>
> (St John of the Cross, 'The Ascent to Mount Carmel', quoted in Catalogue *Sacred Made Real*)

So this is not about illusionism but more concerned with how to encourage piety as the Council of Trent had recommended as the spokesman for the Counter Reformation in the sixteenth century (see *Learning to Look at Paintings* p. 89). This figure of St Francis Borgia, like most of the rest of this kind of Spanish sculpture, is made from carved and painted wood using a specialised technique which was recorded by the painter Francisco Pacheco in his *Arte de la Pintura* of 1649:

> He believed it was colour which gave life to such works and the technique of painting in flesh tones was in fact known as encarnación [incarnation] literally, made flesh. . . .
>
> Once the sculpture was completely carved and assembled, its surface was prepared to receive gold and paint. Sawdust was removed. Then wood knots were pierced to expel sap and rubbed with garlic to enhance adhesion, with several coats of glue applied to the entire sculpture. It is at this stage in the making of a polychrome sculpture that Pacheco's *Arte de la Pintura* becomes an invaluable reference for preparation, gilding and painting techniques. Traditionally two types of paint were used: oil based paints for the head and exposed flesh [usually hands and feet], and egg tempera paint over gold leaf for the drapery. The physical qualities of these particular paints created different effects; oil paint can result in a smooth reflective and more nuanced surface, while

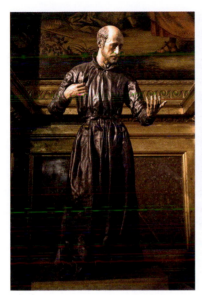 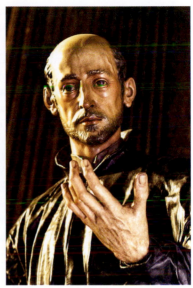

Plate 2.18 Juan Martínez Montañés
(1568–1649) and Francisco Pacheco
(1564–1644), *St Francis Borgia, c.*1624,
painted wood and cloth stiffened with
glue size, 174 × 68 × 51 cm (68½ ×
26¾ × 20⅛ in.). Photo credit Antonio
Barranco/Marta Torres Morera Martos,
University of Seville.

Plate 2.19 Juan Martínez Montañés
(1568–1649) and Francisco Pacheco
(1564–1644), *St Francis Borgia* (detail),
*c.*1624, painted wood and cloth
stiffened with glue size, 174 × 68 × 51
cm (68½ × 26¾ × 20⅛ in.). Photo
credit Antonio Barranco/Marta Torres
Morera Martos, University of Seville.

matt tempera paint contrasts with the gold below. Preparation for
the estofado used for decorating the drapery was more time-
consuming than that for the encarnaciones [flesh tones] of the face
and hands. Both processes began with brushing the bare wood
surfaces with warmed giscola [animal glue and garlic essence] after
which the materials and procedures varied.

(Catalogue *Sacred Made Real*:19 & 64)

In the case of *St Francis Borgia*, only the head and hands were
carved, as the body is a manikin so that it could have its costume
changed for different church occasions. When this figure came to the
Sacred Made Real exhibition, it was very striking how affected one
was as a spectator, regardless of whether you were a believer or not.
Here was a life-size figure of 174 centimetres where you could look

into the eyes and see the emotional expression. You could identify with what he was feeling. There were other examples, particularly of the crucified Christ which verged on the gruesome in the depiction of blood and wounds and the concentration was more on the physical suffering which He endured. However, the really interesting thing was that you always felt the sculpture was a representation separate from you as the spectator. St Francis's costume and its material really look as though there is a body underneath and his contrapposto position, his hands and the angle of his head make him look as though he is about to speak. But, above all, it is the eyes that are so expressive. In this case they are painted, but sometimes they were glass eyes which were inserted from behind the front of the face and the face then rejoined to the back of the head in the area of the beard. However, if you look at them in close-up, you can see there is even the depiction of the vitreous humour around the iris making the apparently living thickness of the eyelids even more convincing. These sculptures manage to move us through the way they occupy the same space as us but not by confusing us through illusionism. We know by their dress and demeanour that they are separate from us, as mediators, not substitutes for the divine.

CASTING AND ITS USES

The plaster cast and the concept of reproduction

Plate 2.20 The Cast Courts in the Victoria and Albert Museum

Plate 2.21 *Untitled (Room 101)* by Rachel Whiteread, 2003

Plates 2.22 and 2.23 *Learning to Think*, 1991, and *Sound II*, 1986, by Antony Gormley

The idea of realism and verisimilitude can also be linked to the concept of a plaster cast made from a sculpture already in existence, like those in the cast galleries in the Victoria and Albert Museum. These are literally moulds made of great works of art, for the most part from the classical, medieval and Renaissance periods, to show what the great masterpieces from the past were like, particularly in relation to their size. The obvious example to show would be the famous cast of Trajan's Column which was made in two halves and the casts moulded round a brick chimney-like structure. There is a famous photograph of it being made, and many of the sculptures illustrated in this book also exist as plaster casts in this remarkable gallery. They were

originally done for educational purposes, for art students to draw from; of course they had been used in art schools for years as part of the academic curriculum. More recently, History of Art students have also used them when learning about the history of sculpture. They are still useful for these purposes even though many of them were made over a hundred years ago. In fact, they can sometimes be used to tell whether an original has changed over that period.

The process of making a plaster cast is also fascinating because the mould can be used over and over again. First of all a mould has to be taken from the original sculpture itself and then that is filled with plaster, before the mould is peeled off to reveal the cast. Mr Bullen, who was employed at the museum in the 1880s, recorded his methods:

> I should first of all get my materials, plaster and lime, then commence at the base, or at any point of the figure that was desirable to make up any mould in pieces so that it would come off easily, care being taken that the mould is of sufficient thickness, not allowing any wood to be placed in it. When dried and oiled, the mould placed together in its case would last for years and be fit to take any number of casts from.
>
> (Mr Bullen, writing in 1881, quoted in
> Trusted (ed.) *The Making of Sculpture*: 161)

More recently artists like Rachel Whiteread have used casts in their work. Whiteread uses plaster to take casts from the interiors of objects, to literally make the space of them into sculptures to be contemplated and thought about, like *Room 101* at the BBC which was exhibited in the Cast Courts at the Victoria and Albert Museum in 2003. It was designed to encourage spectators to think about the continuing possibilities of plaster for sculpture making. Whiteread is most famous for *House* which was made in 1993 (see *Learning to Look at Modern Art* p. 196).

Another kind of casting has been exploited very successfully by Antony Gormley, who makes plaster casts of his own body and then covers them in lead (see *Learning to Look at Modern Art* p. 248). He explores and extends the whole traditional idea of sculpture and the human body by having them lying on the floor, or suspended from the ceiling for instance. The one called *Learning to Think* is a case in point, where all the figures are hanging, apparently without heads, and the title is evocative of meaning because of that. But many would agree that his most interesting work is where he puts a figure or figures in a particular setting, as in the one known as *Sound II* in the crypt

Plate 2.20 The original installation in the Cast Court of the reproduction of Trajan's Column around its brick core; plaster; cast by Monsieur Oudry; French (Paris); c.1864, from the original Roman, 113 CE; South Kensington Museum; 1 August 1873 © Victoria and Albert Museum, London.

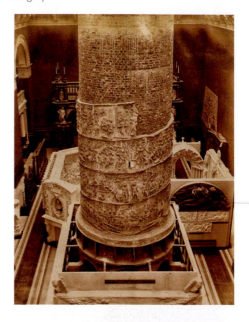

Plate 2.21 Rachel Whiteread (b. 1963), *Untitled (Room 101)*, 2003 © Rachel Whiteread.

Plate 2.22 Antony
Gormley (b. 1950),
Learning to Think, 1991.
© Antony Gormley.
Courtesy White Cube.

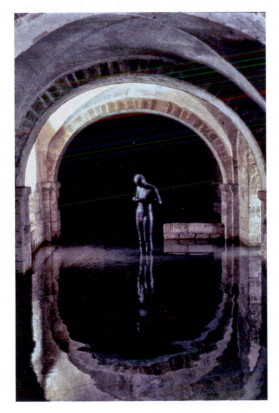

Plate 2.23 Antony
Gormley (b. 1950),
Sound II, 1986.
Winchester Cathedral
crypt. © Antony
Gormley. Courtesy
White Cube.

of Winchester Cathedral where the area regularly becomes flooded. Then, the viewer has to look on from a distance, and contemplate this lonely and isolated figure and its reflection in the watery space around it; it is an example of where the spectator feels involved with a presence that they can relate to. In an address to the Art and Spirituality Conference in 1996, Gormley made it quite clear that the idea of presence is what he is interested in:

> I am interested in reviving this idea of presence. Can we have presence without the God? . . .
>
> It has seemed for quite a long time obvious to me that the body can represent at the present time what abstraction did at the beginning of the twentieth century. That is the ground on which all the seeds of emancipated identity are to grow: the last frontier, the inner realm (space has been probed but what do we really know of the body's darkness). The body, not as an object of idealization that should be forced to carry allegorical, symbolic or dramatic readings, but the body as a place. The body not as hero or as sexual object, but the body in some way as the collective subjective – the place where we all live. The place on which the pressures of society are inscribed and out of which expression, language, feeling can come.
>
> (Quoted in Hutchinson *et al.*, *Antony Gormley*: 156)

So Gormley sees the presence of the sculpture as the most important thing and the language of the human body can be used for that, not in the sense that the classical world understood it, but much more as a kind of space in which contemplation can go on. For, unlike *St Francis Borgia* whom we looked at earlier, this is not the figure of an individual, but a representative of the human race standing in a sacred place with no pre-ordained iconography. As with much contemporary art, you are asked to think for yourself as well as to feel the presence of the work.

THE IMPERFECT BODY AND THE FRAGMENT

Plate 2.24 *Storm Man* by Germaine Richier, 1947–1948

Plates 2.25 and 2.26 *Alison Lapper Pregnant* by Marc Quinn, 2005

Rodin is famous for being interested in the idea of the fragment as a whole or complete sculpture and his figure of the *Walking Man* is an

example of this (see *Learning to Look at Modern Art* p. 50), but he also treated the female body as a fragment and collected classical sculpture as fragments as well; what interested him above all was the form of a particular section of the body regardless of whether it had limbs or a head.

Other sculptors, like Germaine Richier, for instance, who professed themselves admirers of Rodin's work, took this idea further. In Richier's sculptures *Storm Man* and *Hurricane Woman*, made in 1947–1948, the nudes look as though they have been ravaged or burned and bombed in the war. The despair recorded by Simone de Beauvoir (see *Learning to Look at Modern Art* pp. 142–143) is expressed in these figures. The model for *Storm Man* was the same fellow, now eighty years old, who had modelled for Rodin's *Balzac* which we looked at earlier. But here you do not want to touch but only to empathise, and admire at the same time, the ability of the human body to survive.

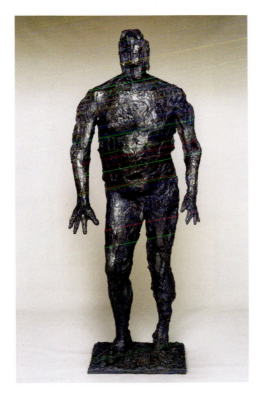

Plate 2.24 Germaine Richier (1902–1959), *Storm Man* (*L'Orage*), 1947–1948.
© Tate, London 2013/ ADAGP, Paris and DACS, London 2013.

But with Marc Quinn, the whole idea is different. For his figure *Alison Lapper Pregnant* he chose the most perfect piece of white Carrara marble weighing 12 tonnes and then carved Alison Lapper who was eight months pregnant at the time. He took a plaster cast of her and then spent ten months carving the sculpture in Italy. It is 12 feet high (3.6 metres). She is a very beautiful woman with a congenital condition which means she has no arms and much shortened legs; so you can say hers is not the perfect body. But the form of her torso is beautifully rounded, with its swollen breasts and tummy, and the expression communicated by the figure is smooth, soft, peaceful and seraphic.

In doing this Quinn challenges our idea of the so-called perfect, heroic or idealised body and encourages us to look at it and think

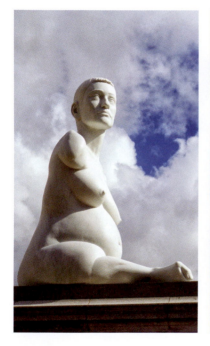

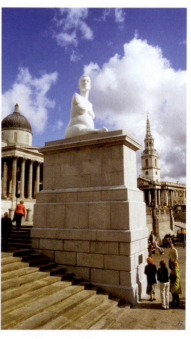

Plate 2.25 Marc Quinn (b. 1964), *Alison Lapper Pregnant*; sculpture, marble, erected 15 September 2005 (until 2007) on an empty pedestal in Trafalgar Square. © akg-images/Robert O'Dea.

Plate 2.26 Marc Quinn (b. 1964), *Alison Lapper Pregnant*; sculpture, marble, erected 15 September 2005 (until 2007) on an empty pedestal in Trafalgar Square. © akg-images/Robert O'Dea.

about it in a different way. He would say, as he did in a recent inter-view, that sculpture changes as you look at it anyway because it makes us aware of time as we walk round it. This figure of Alison Lapper was at its most impressive when it occupied the Fourth Plinth in Trafalgar Square from September 2005 to 2007, and the white marble shone out in all weathers. It raised our awareness of disability, which is important, but it also allowed us to look at what could be consid-ered imperfect in a different way. Quinn makes reference obviously to the classical tradition by using white marble and the nude body. But this figure tells us that sculpture can be about making aesthetic forms which do not have to be associated with conventional ideas of the body beautiful. Like many contemporary artists, Quinn has made us think, as well as look, in a more reflective and questioning way.

CONCLUSION

The themes in this chapter have been about many aspects connected with sculpture and the human figure. The inheritance of the classical tradition has been important of course, but so also has the way it has been transposed and transformed by artists over the centuries, espe-cially in relation to the interpretation of the free-standing human figure. In particular we have seen how important the role of the spectator has been, not just as an observer but as a participant in this experience of free-standing sculpture.

Group sculpture: the interaction between forms

INTRODUCTION

The relationship between two or more figures in three dimensions brings another ingredient into the mix and that is the interaction between several forms. We have already talked about free-standing sculpture occupying the same space as you the spectator. But the exciting point about group sculpture is that the piece can be seen as a whole yet, at the same time, the tension and interaction between those forms can add meaning and variety. If you think of the Horse and Rider, the Madonna and Child, the Pietà or the group that tells a story like Samson and the Philistine, *The Burghers of Calais* or some types of installation, you can see the point. We will now go on to consider these types of group sculpture and the effect one form has on another in the sculptor's design, starting with the equestrian monument.

THE INTERACTION BETWEEN MAN AND ANIMAL: THE EQUESTRIAN MONUMENT

Plate 3.1 *Charlemagne* by an anonymous sculptor, ninth century

Plates 3.2 and 3.3 The *Colleoni Monument* by Andrea del Verrocchio, *c.*1479–1488

Plate 3.4 *Peter the Great* by Etienne Maurice Falconet, 1766–1778, erected in St Petersburg, 1782

As we saw in Chapter 1, the combination of man and animal in the equestrian monument is an intriguing one in the sense of its scale and its setting. The same continues to be true down the centuries. If you

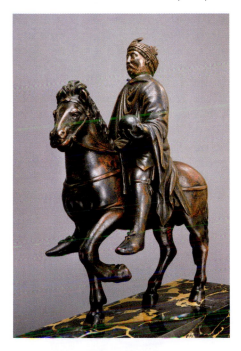

Plate 3.1 Charlemagne ou Charles le Chauve. © RMN-Grand Palais (Musée du Louvre)/Droits reserves.

take the tiny Charlemagne statuette for example, which is only 9½ inches in height, you can see immediately that it would be portable, and suitable for a table top rather than a grand figure in a square in Rome like the equestrian monument to Marcus Aurelius; it would have had to be portable because the court was often travelling. We can see that Charlemagne is wearing his crown and sitting very upright on the horse, holding the orb as a symbol of his rank as the Holy Roman Emperor, the title which was bestowed upon him by the pope who, as spiritual leader of Europe, wanted Charlemagne to be in charge of temporal power; he sits holding the orb, but without making any gestures, and the pair appear more emblematic rather than grand and idealised; they are certainly not as active as Marcus Aurelius on horseback which we looked at in Chapter 1.

The head and body of Charlemagne himself are from the Carolingian period, and were cast separately and then put together afterwards; the horse, particularly, is not in proportion to the body and was re-made during the Renaissance. By that time, with the revival of interest in antiquity, there was a greater desire to emulate the grandeur, scale and authority of a figure like that of the equestrian

monument to Marcus Aurelius. Paintings (like *Sir John Hawkwood* by Paolo Uccello for instance) were done in imitation of sculpture, but sculptural versions were made also. One of the most striking of these is that dedicated to the warrior/mercenary Bartolomeo Colleoni who had worked for the Venetian government. It was executed by Andrea Verrocchio, the teacher of Leonardo da Vinci, who himself experimented with the equestrian group in the drawings he did for the Trivulzio Monument, and the one in honour of his patron, Ludovico Sforza, neither of which was ever completed.

The most interesting characteristic of the Colleoni monument is that the figure and the horse are depicted in dynamic tension as if they are moving into battle at that moment. The horse's head is tense and

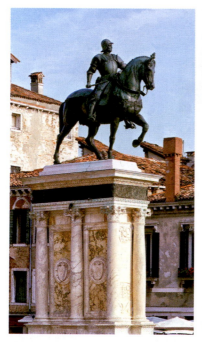

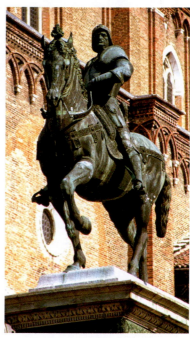

Plate 3.2 Andrea del Verrocchio (1436–1488), equestrian monument to Bartolomeo Colleoni (1400–1475) (bronze), three-quarter view from left with pedestal. Campo SS Giovanni e Paolo (Zanipolo), Venice, Italy. © 2013. Photo Scala, Florence.

Plate 3.3 Andrea del Verrocchio (1436–1488), equestrian monument to Bartolomeo Colleoni (1400–1475) (bronze). Campo SS Giovanni e Paolo, Venice, Italy. © Sarah Quill/ The Bridgeman Art Library.

listening with ears cocked and the muscles of the body and legs are clearly already in movement, as if it might walk off the plinth. The whole group is approximately 13 feet high and then mounted on a platform which makes it even more imposing. Colleoni's left arm and elbow are flexed outwards and he is holding his sword ready. Also, the head in its helmet is looking out at an angle and the eyes bulge with alert concentration. His legs are standing in the stirrups and the whole body is tense and ready for action. If you look at the spaces, between the hind legs under the belly, and between the forelegs, you can feel this tension carried into the angle of the chest and head, and along the back of the animal. Then you see Colleoni's rigid, vertical posture indicating again his readiness for action. By this time you, as the spectator, are really involved, and you can see that the whole huge weight of the bronze is balanced on the three points of the horse's feet which are on the ground. The relationship between man and animal is made entirely dynamic and exciting by the complementary tension between the two.

The idea of making the figures of horse and rider more active is carried to a greater extreme in the equestrian sculpture of Peter the Great (see Plate 3.4), which took twelve years to complete, and which was finally erected in 1782. The sculpture was commissioned by Peter the Great's successor, the Empress Catherine II; she wanted to commemorate the Tsar Peter, who had done so much for Russia, in the city of St Petersburg, which was built by him and named after him.

The Tsar sits apparently calmly on his horse, which is rearing; its mouth is open, and Peter holds the reins in one hand while gesticulating with the other towards his city, but without a sword; as in other equestrian monuments, he could be expressing the metaphor of how an able ruler, with seeming effortlessness, controls the seething power of the state. His cloak moves out behind, as does the tail of the animal. Here you realise that the whole huge sculpture is balanced on the two hind legs, and the end of the tail is attached to the writhing figure of a snake, which is anchored in turn to the enormous granite rock in several places. The scale of the sculpture stands out even more effectively because of the way the black bronze is contrasted with the white granite rock on which it is mounted.

The technical feat that this sculpture represents is discussed vividly and enthusiastically in the correspondence which Falconet had with Catherine, where he explains how he was able to make the horse balance on its two hind legs. First of all the weight of the bronze had to be

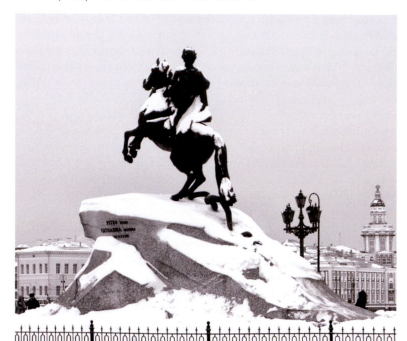

Plate 3.4 Etienne Maurice Falconet (1716–1791), equestrian monument to Peter the Great, 1766–1778, The Bronze Horseman and Decembrists (Senate) Square, St Petersburg, Russia. © Nadia Isakova/JAI/Corbis.

heavier at the back than at the front and the serpent acted as a further support. Catherine, along with others, felt that, as a symbol of envy, the serpent was too allegorical, but Falconet was clear in his defence.

> Peter the Great found envy in his path, that is certain. It is the lot of every great man.

Then in a different part of the same letter Falconet says that some people

> Have thought that the serpent should be removed; they have told me so. But these persons do not know, as I do, that, but for this fortunate episode, the statue would be most insecurely supported. They have not, as I have done, calculated the forces I require. They do not know that, if by misfortune their advice were followed, the work could not survive. It is not only a matter of supporting the horse's tail; the method I am employing and the manner in which

I am using it, answers for the legs, and it is they that answer for every-thing.

(Friedenthal (ed.), *Letters of the Great Artists*: 223)

So the serpent is vital to the success and balance of the whole sculpture which is very revealing about the technical aspects of making and casting bronze sculpture; and, what is more, the first attempt to cast it was a failure because the foundry workers were inexperienced. It took years to find the huge monolith that supports the statue, a block of granite weighing over fifteen hundred tons. A suitable one was at last discovered in the marshland surrounding the Bay of Kronstadt and conveyed to St. Petersburg by four hundred serfs using special apparatus and rafts.

(Friedenthal (ed.), *Letters of the Great Artists*: 225)

So, eventually the piece was completed, but Falconet himself had by that time left Russia and returned to France. He was a great friend of the important art critic and editor of the French Encyclopedia, Denis Diderot, and his *Reflexions on Sculpture* of 1765 were included in it as the essay on that subject. The implication of all this discussion is that the viewer should bear in mind the technical considerations as well as the content of a sculpture. In his famous essay, Falconet also writes about the importance of the site and effects of light and shade in particular.

The generality of sculptors make their models, or at least sketch them out, on the spot where the statue is to be placed. By this method they are invariably sure of their lights and shades, and of the proper effects of the composition, which otherwise might have a very good effect in the light of the workshop, but a very bad one where it is to be fixed.

(Quoted in Harrison, Wood and Gaiger, *Art in Theory 1648–1815*: 600)

The idea that Falconet is expressing here is that the making and the technique is important but so also is the viewing and that it can be appreciated as a product of the sculptor's skill as well as for its verisimilitude. In recent years the role of the viewer in the context of sculpture has also come to be considered, particularly from this period of the eighteenth century onwards. It has to do with the growth of the idea that sculpture came to be seen as a separate subject and the development of the concept of what Alex Potts called 'the sculptural imagination', in his book of that name.

SMALL-SCALE ANIMAL SCULPTURE WITH MORE THAN ONE FORM

Plate 3.5 *Tiger Devouring a Gavial, Crocodile of the Ganges* by Antoine Louis Barye, 1833

Plate 3.6 *Il Cavaliere (Horseman)* by Marino Marini, 1947

Tiger Devouring a Gavial is a small sculpture: it is only 39½ inches long and was designed to sit on a table as a decorative object. Immediately you see it you want to put your hand on the tiger's back to feel its shape and texture which contrasts so well with the skin of the crocodile. As you look at it you almost feel the difference between the softness of the fur and the hard scaly surface of the crocodile. Then there is the expression on the tiger's face as it sinks its teeth and jaws into the beast with its eyes focussed and its ears back. The tension in the haunches and the tail behind and the evident force with which its forelegs are holding the struggling crocodile creates a sense of concentrated and controlled energy. There is aesthetic tension too between the ferocity of what is happening with the wildness of nature and the desire to touch and appreciate the beauty of the textures.

The modelling here is extremely fine and Barye was able to use wax which became increasingly common in the nineteenth century in France. Nicholas Penny suggests that wax was particularly good for modelling this kind of action and dynamic tension in sculpture:

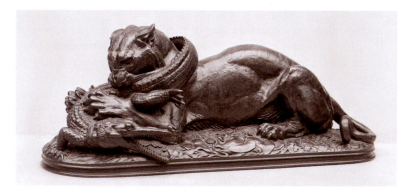

Plate 3.5 Antoine Louis Barye (1796–1875), *Tiger Devouring a Gavial* (*Tigre devorant un gavial*). Statuette. French, probably cast after 1847. New York, Metropolitan Museum of Art. Bronze. 7⅝ × 20 × 7¼ in. (19.4 × 50.8 × 18.4 cm). Rogers Fund, 1910 (10.108.2). Black and white photo. © 2013. Image copyright The Metropolitan Museum of Art/Art Resource/Scala, Florence.

The new attention to movement among nineteenth century European artists – especially evident in the sculptures of animals made in France – gave the wax model a new importance . . . the bristling fur and quivering muscles of Barye's jungle creatures . . . and the straining torsion and tortuous balance of Degas' ballerinas required for their initial study, if not final realisation the even more responsive and malleable material of wax.

(Penny, *The Materials of Sculpture*: 217–218)

This is especially interesting as Penny is saying that these sculptures were full of a kind of action which involved the spectator in an emotional way. It is for this reason that work like this is referred to as Romantic Sculpture because it expanded the possibilities of what could be done particularly in bronze. Small domestic sized works like this were popular with the new wealthy middle-class patrons, who came to the fore in France superseding the aristocracy after the Revolution and the Napoleonic period.

Il Cavaliere (see Plate 3.6) is by contrast a sculpture of an ordinary unidentified horseman, much smaller in scale than the ones by Verrocchio and Falconet, but larger than the one of Charlemagne with which we started this chapter. The man sitting on the horse is anonymous, and he has no definite features or clothes. We can see that his head is tilted slightly, and his back, arms and legs are in tension; there are no reins for him to hold on to, and he appears to be naked. The horse stands on a low plinth with its ears flattened, and its head and neck stretched forward forming a near horizontal with its back; its mouth is slightly open and its body is very tense, like that of its rider. The spectator is made to feel that horse and rider have been frightened by something, and have come to a sudden halt, as though frozen with fear.

Another difference from the other equestrian groups we have looked at is that this one is unheroic. It is very simplified, so that you see the forms stripped of any detail. The figure makes a vertical, in line with the four legs of the horse, which are stiff and not articulated, and yet the whole muscle structure of the animal is completely understood and visualised by the artist. Then, the horse's back is a horizontal, so that the whole sculpture is like a kind of organic cross. The simplification and the quiet drama of the whole piece make it very moving.

Marini is supposed to have said that his horseman sculptures are based on the people he saw fleeing during the war in Italy; he

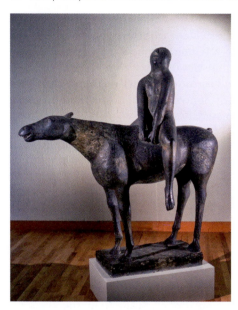

Plate 3.6 Marino Marini
(1901–1980), *Il Cavaliere*
(*Horseman*), 1947. © Tate,
London 2013/DACS 2013.

described an experience he had during the war whilst he was on a train:

> The war was nearing its end, bombs were falling, the nights were sleepless. I looked out of the window of my train carriage and saw a horse rearing. And its rider who seemed to fly into the air crashed to the ground in the next moment. It was almost like a Saul on the road to Damascus experience. The creature lay on the ground but the gesture reaching up into the sky remained: it became to me an allegory for form and life.
>
> (Catalogue *Marino Marini: Miracolo*: 89)

Some of Marini's sculptures of this subject are more agonised than this. So, far from being grandly commemorative, these put the horse and rider into an entirely different context, which is both anonymous in the sense that the individual is not named, and yet it is particular because the action appears to be taking place at a moment in time. Marini is indeed asking us to look at the sculpture in a more abstract way as a sculptural object as well as a horse and rider. It is also more democratic because of its anonymity. The equestrian monument had been used for commemoration of famous figures, at least since Roman times, and indeed they can be found in towns and cities all over the

world as a way of remembering famous people. But, although this hierarchical use for the horse and rider can still be found, artists like Marini (and others like Elizabeth Frink for instance) have found a more ordinary interpretation in which the rider becomes more like everyman, and in which we identify with the feelings of man and animal in general.

In his book *Modern Sculpture*, Herbert Read put the work of Marini in the context of what he once called 'the geometry of fear' which he saw in the art of the postwar period along with others we have considered, like Richier in Chapter 2. Read then went on to say that:

> Anxiety even as a pathological condition is seldom unmixed with hope; the mind of man alternates between a sense of despair and a sense of glory.
>
> (Read, *Modern Sculpture*: 118)

This could indeed be seen to reflect the different types of equestrian sculpture we have been looking at in this section, large and small, heroic and ordinary, as well as ancient and modern.

THE RELATIONSHIP BETWEEN TWO FIGURES LARGE AND SMALL

Plates 3.7 and 3.8 Madonna and Child: the *Madonna del Colloquio* by Giovanni Pisano, *c.*1302

Plate 3.9 *Madonna and Child* by Henry Moore, 1943

Part of the fascination of group sculpture lies in the relationship between forms, particularly if one is large and the other much smaller. One of the most enduring of these is the Madonna and Child, from the Christian tradition. Here it is not only the relative sizes of the figures but the emotional connection between the two which can be so effective. One of the most eloquent of these is the so-called *Madonna del Colloquio* by Giovanni Pisano who worked mainly in Pisa at the end of the thirteenth and beginning of the fourteenth century.

First, as this nickname implies, the figures look as though they are conversing with one another because of the concentrated way the baby gazes at his mother, and vice versa; he is sitting very upright and appears to be leaning outwards slightly, as babies are inclined to do, so his body is flexed, and she supports him, not only with her right

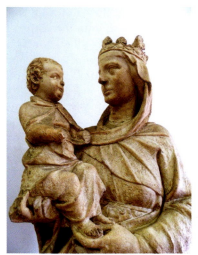 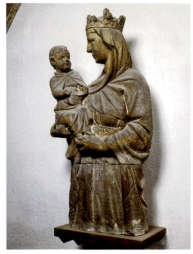

Plate 3.7 Giovanni Pisano (*c.*1248–1314), *Madonna of the Colloquy (Madonna del Colloquio)*, 13th century, originally at the gate of the cathedral, now in the Campo Santo, Pisa. Photo credit: David C. Hill.

Plate 3.8 Giovanni Pisano (*c.*1248–1314), *Madonna of the Colloquy (Madonna del Colloquio)*, Campo Santo, Pisa. © 2013. Photo Scala, Florence.

arm and the bent fingers of her right hand, but also with her other hand holding his feet and steadying his potential for action. This seems to create a kind of animated tension in the figures, and particularly in the space between the two heads. The shape created by the two profiles and their shoulders is alive with communication and under-standing. This is greatly added to by the movement in the drapery, particularly in the veil around the Virgin's head, which moves down the side of her face and neck, and across to the child, joining up with the diagonal folds across his chest. This curving line then connects up with the inside edge of the Christ child's body, moves down to the Virgin's hand holding the feet, and comes back up her arm, uniting the two by the subtle rhythm it creates and the sense of movement it gives to the two figures. Also, the intensity of their mutual gaze allows for a containment of the figures within the outside edge of the sculpture, which in turn allows the spectator to concentrate on the emotional intimacy between mother and child. The understanding of the mother is enhanced by the slight tilt of her head, and the animation of the baby's expression as he appears to smile slightly.

The fact that the Virgin is wearing a crown derives from the idea of the Virgin as the Queen of Heaven; this comes from the Byzantine tradition, which was so important in Italy because of its geographical position between eastern and western Europe. The eastern idea of the Mother of God included the concept of the Theotokos, embodying the abstract concept of the Incarnation, which you find in the more formal format of icons and Byzantine images of the Madonna Enthroned. But Pisano's Madonna is very different because of the humanity and animation of the figures. This humanity of expression is partly explained by the revival of interest in classical art, which we will look at in more detail in the chapter on reliefs, and which was expressed later by the poet Petrarch. But it was also the result of profound changes in the approach to Christianity, which had happened in the thirteenth century, through the teachings of St Francis of Assisi, and the philosophy and theology of St Thomas Aquinas. An important part of St Francis's teaching was his suggestion that the world of nature was God's creation, and therefore worthy of being observed and depicted realistically, as a reflection of the Glory of God. This idea of a more intimate relationship between man and nature was expressed in his Canticle of the Sun:

> Be praised my Lord, through all your creatures, especially through my lord brother Sun, who brings the day, and you give light through him. And he is beautiful and radiant in all his splendour! Of you most high he bears the likeness.
>
> (St Francis of Assisi, Canticle of the Sun,
> *Umbrian Text of the Assisi Codex*)

During the same century there was also the spread of ideas contained in the more theoretical writings of St Thomas Aquinas in which he suggested that scientific and rational investigation was legitimate in the eyes of God as long as it did not supplant the spiritual. In other words, Faith and Reason are different ways of thinking and should remain so. In his *Summa Contra Gentiles*, written between 1259 and 1264, Aquinas makes these ideas very clear.

> The gifts of grace are added to us in order to enhance the gifts of nature, not to take them away. The native light of reason is not obliterated by the light of faith gratuitously shed on us. Hence Christian Theology enlists the help of philosophy and the sciences. Mere reasoning can never discover the truths which faith perceives; on the other hand it cannot discover any disagreement between its own intrinsically natural truths and those divinely revealed . . .

In fact the imperfect reflects the perfect; our enterprise should be to draw out the analogies between the discoveries of reason and the demands of faith.

(Thomas Aquinas, *Summa Contra Gentiles 11*)

So, the desire for enquiry into the physical world was to be permitted. This marked a huge change in the Christian approach to science, to observation and to rational thought. This cultural and religious context is generally thought to have encouraged a greater degree of naturalism and observation in the arts. Giovanni Pisano's contemporary, Giotto, is the artist most closely associated with these ideas, and in particular the teachings of St Francis; it is therefore worth remembering that Giovanni Pisano did a full-length Madonna to accompany Giotto's fresco cycle in the Arena Chapel at Padua, where the painting is closely related to sculpture in its sense of mass and space.

The *Madonna del Colloquio*, which we have been looking at, is carved from marble but, because it has been outside, it looks pitted and weather-beaten. It was originally carved for the tympanum over the west door of Pisa Cathedral and could be dated as early as 1276, but the date more commonly accepted now is 1302. It was rediscovered in 1829, amongst scattered marble figures in the Campo Santo at Pisa, and now resides in the Cathedral Museum. It stands 132cm high but is thought to have had some length added to it, so originally it was about 97cm high and you can see the join along the Madonna's hip line.

Henry Moore was a great admirer of the work of Giovanni Pisano, and, in his introduction to the book by Michael Ayrton, which he collaborated on, he talks very interestingly about the weather-beaten look of many of Giovanni's sculptures. This is partly because so many of them were outside, but also he says it may be because they were made of fresh, so-called green marble, which is easier to carve, and it would probably have come from the local quarry of San Giuliano, which was softer anyway:

> Giovanni's marble from San Giuliano wasn't all that hard which is why his exterior sculptures are so weathered. I don't think we lose anything essential by the weathering. I even think the weathering reveals the big, simple design of his forms more clearly. It probably reduces what we see to what it had been a stage before it was finished, simplifying it back again without the detail.
>
> (Ayrton, *Giovanni Pisano, Sculptor*,
> Introduction by Henry Moore: 9)

Many of Pisano's sculptures are more weather-beaten than the *Madonna del Colloquio* but you can see that the surface does not appear polished as we expect marble to be, and it gives it the appearance of stone, which of course it naturally is. But it was not only the weather-beaten look which Moore admired, but also Giovanni's sculptural originality; in an unpublished note of the 1950s he stated:

> But besides all this sculptural originality [experiment] [expression] a greater quality still is the warm human dignity and tenderness and grandeur – something akin to Masaccio.
>
> (Unpublished note from late 1950s, H. M. F. archive quoted in Henry Moore, *Writings and Conversations*)

Masaccio's painting of *The Madonna Enthroned* in the National Gallery in London (see *Learning to Look at Paintings* Plate 53) is supposed to have been an inspiration for Moore's famous group often referred to as the *Northampton Madonna* which we will go on to look at now.

Henry Moore's *Madonna and Child* (see Plate 3.9) carving in Hornton stone was made for St Matthew's Church in Northampton as a commission from Canon Walter Hussey who is well known as a patron of modern British artists. Here, Henry Moore has made a group which has a quiet dignity and stability. The Madonna looks in the direction from which you the observer approach it, and the baby looks straight at you when you come close. She is seated on a low stool, which means her upper legs are at a steeper angle, making the child sit comfortably against His mother. But they are not communicating together in the way that Giovanni Pisano's mother and child are; here, the Christ child looks out at us as many Madonnas of the past have done, particularly icons or Madonnas enthroned like the one by Masaccio already referred to, which Moore knew well; he was a great admirer of Masaccio and used to visit the frescoes in the Brancacci Chapel every morning when he was in Italy as a young artist, in 1925. He admired the mass, gravity and monumentality of this work and has imbued his group with those characteristics.

From the sculptural point of view what is also fascinating about this group is the different angles of the forms which create movement and variety. The Virgin's head looks one way and the child's another, then the child's knees are at an angle and the mother's knees are straight. The drapery moves horizontally across, as do the lines of the knees, the elbows, and the child's and the mother's shoulders. The upright column of the Madonna's neck makes a vertical which moves down through

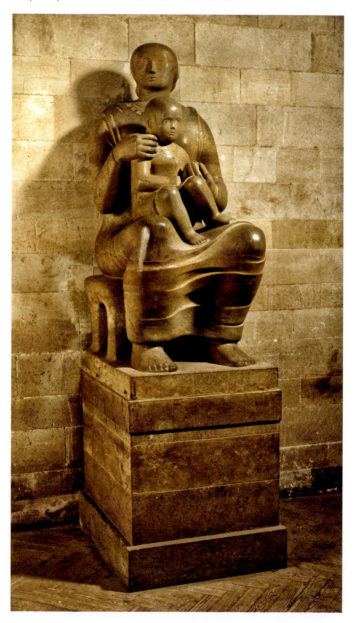

Plate 3.9 Henry Moore (1898–1986), *Madonna and Child*, 1943–1944 (LH 226).
Photo credit: John Hedgecoe. Reproduced by permission of The Henry Moore
Foundation.

Christ's head and arm and into the lower leg of His mother. The vertical and horizontal axes are further accentuated by the plinth and stool on which the group is sitting. The whole piece is simplified and yet expressive, dignified and approachable. The golden colour of the Hornton stone creates a feeling of warmth which is appealing to the spectator; at just under 5 feet high, it is slightly smaller than life size, which also helps with this. The group is mounted on a plinth which emphasises the vertical and horizontal axes of it, and allows the spectator to appreciate its simple and dignified monumentality. Moore had been interested in the subject of the mother and child since his earliest days as a sculptor in the 1920s, but he understood that the Madonna and Child must be imbued with this kind of gravity in order to communicate something of the sacred tradition to which it belongs, and this in turn connects it with both Masaccio and Giovanni Pisano.

THE RELATIONSHIP BETWEEN TWO FIGURES OF EQUIVALENT SIZE

The dissolution of forms

Plates 3.10 and 3.11 The *Rondanini Pietà* by Michelangelo, *c.*1555–1564

This is a very extraordinary piece of work, the last by Michelangelo. The whole sculpture is 6 feet 4¾ inches; it is a large life-sized group, which appears to be elongated because of the narrowness of the whole. The Virgin stands on a plinth at the back behind her Son, making her appear taller, and the body of Christ is placed slightly lower, so that she appears to be bending over Him and stopping His body from falling. His legs are carved in such a way that they appear to be slack and lifeless, slightly bent, with one foot turned on its side, demonstrating that it is without tension. Yet, you know logically that, with her arms and hands in that position, she would not be able to support a male body from that angle. So, is He hovering between life and death? But, if so, His body looks as though it is about to collapse, as there are slack muscles in the torso too. Also, there is a gentleness about the Virgin's expression which is achieved through the angles of her head and body leaning over and protecting Him.

The sculpture is carved in marble, but, apart from the legs, it is unpolished and you can see the marks of the chisel around the heads and faces. At the base you can see the remains of the block from which

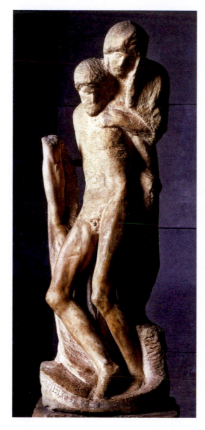

Plate 3.10 Michelangelo (1475–1564), *Rondanini Pietà*, 1555–1564, marble sculpture, 195cm height. DeAgostini Picture Library/M. Carrieri/The Bridgeman Art Library.

Plate 3.11 Michelangelo (1475–1564), *Rondanini Pietà*, detail of the heads of Christ and Mary (marble). Castello Sforzesco, Milan, Italy/Giraudon/The Bridgeman Art Library.

it was carved and, on the left-hand side, the fragment of an arm repre-senting part of a previous sculpture which Michelangelo destroyed. The group appears at one and the same time to be coming out of the block and sinking back into it. But above all it is the expressions on the faces and the angles of the heads that contribute most to the pathos of this work. The faces particularly are very sad, but also hardly there, as if they were both about to disappear into the next world. Altogether it is deeply moving and mysterious at the same time because, as we have seen, sculpture is essentially an art with a strong

physical presence and yet this one appears to be dissolving before our eyes.

There has long been a debate about the nature of Michelangelo's finished and unfinished works and the fact that our modern era seems to prefer works of art which are presented in an unfinished or fragmentary state. Whilst it is true that Michelangelo still had this piece in his house when he died and that he had probably changed his mind about it at least once, nevertheless the idea that it cannot be considered as complete is questionable. A better idea perhaps is to consider this final version as a palimpsest which is how it is described in an article published by the Commune di Milano as part of a detailed guide to the sculpture collection in the Sforza Castle where it is held.

> Consequently the Rondanini Pietà can be viewed as a palimpsest in which the superimposition of the new 'text' has partially cancelled the signs of the original text and what remains of the first version can be considered 'unfinished' solely because of the unavoidable coincidence of the suspension of work on the death of Michelangelo.
>
> (From the *Sculptural Itinerary: Museo d'Arte Antica, Sforza Castle, Milan*: 2)

This is worlds away from the monumental heroism of the David and its showy technical virtuosity which we saw in Chapter 2 (and indeed the early Pietà of 1494 which is now in St Peter's Basilica in Rome). Here the idea is to use the sculptor's skill to make the bodies powerfully expressive and yet dematerialised. At the end of his life, Michelangelo spent much time contemplating his own death, particularly in his very moving sonnets and Crucifixion drawings (see *Learning to Look at Paintings* pp. 182–4). We can admire both sculptures equally for different reasons and appreciate that Michelangelo made this Pietà at the end of his life when he was using the skill and understanding of the carver's art, combined with a lifetime's experience, to create something which almost seems to deny the materiality of sculpture.

Two figures and the use of a dynamic twist

Plates 3.12 and 3.13 *Samson Slaying the Philistine* by Giovanni Bologna, *c*.1562

This is a most exciting and dynamic example of a two-figure group sculpture which stands at 209.9 centimetres. It is so full of action that it almost seems to be more than two figures. As you look at it the group is based on a dynamic crossover of two diagonals, one from the top left side, with the hand holding the jawbone of the ass, down to the right hand of the Philistine and the other from the right profile of Samson moving down to the left foot of the Philistine. This is reinforced by the effect of a figure of eight incorporating the two heads, that of the figure of Samson and that of the Philistine, so that a serpentine movement is set up between the upper and lower sections

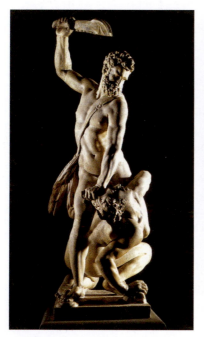 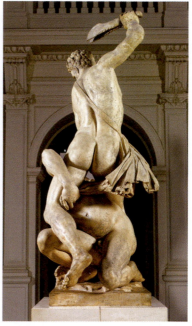

Plate 3.12 Giovanni Bologna (1529–1608), *Samson Slaying the Philistine*, *c*.1562. Florence, Italy, mid-16th century. © Victoria and Albert Museum, London.

Plate 3.13 Giovanni Bologna (1529–1608), *Samson Slaying the Philistine*, *c*.1562. Florence, Italy, mid-16th century. © Victoria and Albert Museum, London.

of the group. This is done partly by making the figure of the Philistine crouch backwards between Samson's legs so that Samson can hold his hair with great force and his hand becomes part of the curve of his victim's body.

The piece of flying drapery out at the back adds to this feeling of tense, dynamic and immediate action, particularly when you look at it from behind, where it appears almost as if it is alive. The shape of the right-hand outside edge is more jagged and the left-hand side more flowing. Geometrically it represents a corkscrew movement, and all this action in the group only rests on four points, the two feet and right hand of the Philistine, and Samson's right foot which with the knee forms a vertical going up through his body. The whole effect is one of twisting movement. If you look at the angles represented by Samson's body you will see that it comes down to the ground in a zigzag. The whole composition expresses active tension in the hard unyielding material of marble, and makes it appear muscular and malleable, such is the level of skill achieved by the artist who made it.

Of course, the story of Samson and the Philistines is one of action and excitement, and in the Old Testament Book of Judges it says that Samson slew a thousand Philistines with the jawbone of an ass; but here we see a fierce, focussed and concentrated struggle with one person which seems to represent the heart of the story. For Samson had been taken prisoner by his own people, the Israelites, for causing trouble with the Philistines as the occupying power, because he could not marry the woman he had been promised, as she had been given to another man. At the heading of Chapter 15 of the Book of Judges in the King James Bible, the story is summarised as follows.

> Verse 1 Samson is denied his wife. Verse 3 He burneth the Philistines' corn. Verse 9 He is bound by the men of Judah and delivered to the Philistines. Verse 14 He smiteth them with a jawbone . . .
>
> (From the Book of Judges in the Old Testament, Chapter 15)

This is a story of anger, injustice, betrayal and rebellion, and the element of struggle, and ultimate victory, is expressed in this powerful three-dimensional depiction of it.

MULTIPLE GROUPS OF FIGURES

The nude female figure in a group

Plates 3.14 and 3.15 *The Three Graces* by Antonio Canova (second version), 1814–1817

The case for idealisation in marble sculpture is nowhere clearer than in Canova's famous group of *The Three Graces*, who were supposed to represent the three daughters of Zeus, Thalia (Youth and Beauty), Euphrosyne (Mirth) and Aglaia (Elegance). The original version was made for the Empress Josephine, wife of the Emperor Napoleon in 1812, and is now in the Hermitage Museum in St Petersburg. The one which is better known in England is the version completed for the Duke of Bedford between 1814 and 1817, and installed at his

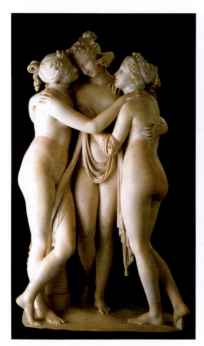
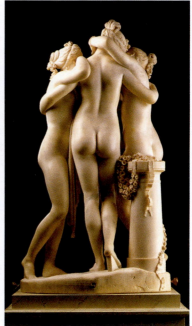

Plate 3.14 Antonio Canova (1757–1822), *The Three Graces*, Rome, Italy, 1814–1817. © Victoria and Albert Museum, London.

Plate 3.15 Antonio Canova (1757–1822), *The Three Graces*, Rome, Italy, 1814–1817. © Victoria and Albert Museum, London.

sculpture gallery at Woburn Abbey; it was bought through public subscription in 1994, and is now shared between the V&A in London and the National Gallery of Scotland in Edinburgh.

When you stand and look at it you can see that it is the most extraordinary piece of work. The marble appears crystalline yet soft at the same time and the surface looks like real skin, particularly on the neck of the left-hand figure, and around the waist of the one on the right. Yet they are idealised, as a type of beauty derived from the classical tradition, and figures like the Venus of Cnidos which we discussed in Chapter 1. There is little texture, apart from the hair and drapery, but these perform very important functions in relation to the group. The hair and hairstyles are subtly varied and draw attention to the angles of the heads, and the drapery holds the figures together gracefully. They are slightly different in height, with the right-hand one appearing shorter, and the central figure seeming a tiny bit taller than her sister on the left. The sloping shoulder of the central figure moves into the profile of the right-hand one, creating space and movement. If you look at the profile of the right-hand figure, you can see it stands out against the space, and the lower section of it carries the eye across the sloping shoulder of the central figure and into the contour of her head which slopes the other way. Similarly, the gaps between the pony tails and the necks allow the eye to travel down the edges of the backs which are ever so slightly varied, with the legs alternately bent and straight; this varies the distribution of the weight in each figure, including the contrapposto of the one in the centre. The arms crossing in front and the two hands appearing round the backs are also important for establishing an undulating rhythm which moves through the group as a whole. The feeling of controlled and subtle movement creates a sense of aesthetic and sensual enjoyment which is sublimated into an idealised form.

The Duke of Bedford himself called *The Three Graces* a work of consummate skill and noted

> the morbidezza – that look of living softness given to the surface of the marble, which appears as if it would yield to the touch.
>
> (Catalogue *Return of the Gods*: 22)

The idea of grace was also important according to Canova's friend, Quatremère de Quincy:

> The novel and ingenious entwining of three female figures which, from whatever side they are seen as one walks round them, reveal

in different configurations nuanced varieties of forms, of contours and of human affections and sympathy . . . and the group was set on what was thought to be an ancient marble plinth (in fact dating from the 18th century) which was fitted with bearings while the base of the sculpture was given brass knobs, so that it could be rotated and its multiple viewpoints enjoyed as it was turned.

(Ibid.)

Here, there is no message or story. The spectator is expected to enjoy the group purely for aesthetic reasons. It was designed to be looked at in a gallery for display.

The Duke of Bedford placed *The Three Graces* at the end of the sculpture gallery at Woburn, amongst his outstanding collection of antique sculpture, and other works by British contemporaries like Sir Francis Chantrey who we shall look at in Chapter 5.

The idea of the tragic group and the sense of drama

Plates 3.16 and 3.17 *The Burghers of Calais* by Auguste Rodin, 1888

This is an example of a sculpture which is so well known that you can come across a version of it in a number of different countries and settings across the world, from Japan and America to Victoria Tower Gardens in London, and of course, the town of Calais itself for which it was originally designed. But also, we know a lot about the process of making it, how it began and the nature of its commission. It was originally requested by the town of Calais to commemorate the famous six Burghers who saved the city from a long siege during the Hundred Years War. They offered to sacrifice their own lives and surrender the keys of Calais to the king of England, Edward III, who was only persuaded to relent when his queen, Philippa of Hainault, intervened on their behalf. The Burghers were spared, and so was the city, from the continuation of the pain and suffering of the siege which had already lasted for months.

This story is told in the *Chronicles* of Froissart which chart the story of the Hundred Years War between England and France in the fourteenth and fifteenth centuries. So this group sculpture represents a powerful and tragic narrative; when you stand in front of it and walk round it, it is the tragedy and drama which you feel first of all. This is because of the gestures and the body language of the figures, which is another aspect of this group, as we know a great many of the

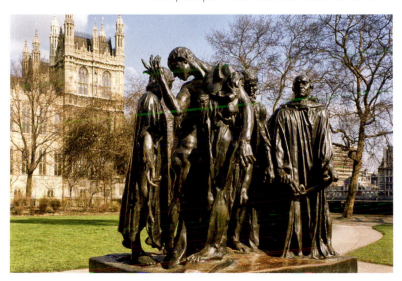

Plate 3.16 Auguste Rodin (1840–1917), *The Burghers of Calais* (bronze), Victoria Tower Gardens, London, UK/The Bridgeman Art Library.

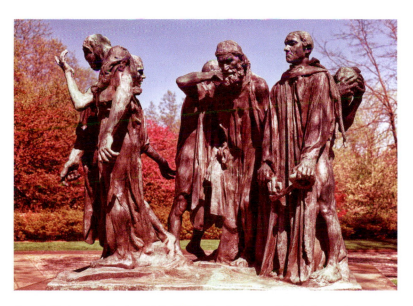

Plate 3.17 Auguste Rodin (1840–1917), *The Burghers of Calais* (bronze). Hirshhorn Museum & Sculpture Garden, Washington D.C., USA/The Bridgeman Art Library.

maquettes and models which Rodin made for it. So, there is a kind of narrative in the making of this group as well as in the story itself; you can go to a Rodin exhibition for instance, and see busts of the different figures or single standing ones, and, if you go to the Studio Museum at Meudon outside Paris, you can see many of the plaster casts which Rodin made for it. This sort of experience is not possible with many sculptures mostly because the preparatory work has disappeared, but it is important because it gives us an insight into the complexity of making sculpture.

The Burghers group are most often photographed from 'in front' where you can see the leader, Pierre de Weissant, holding the keys of the city, but when you stand in this position to look at it, what you are first conscious of is the movement of the figures. The person next to Pierre de Weissant stands still with bowed head, staunchly and humbly supportive of his leader. Then, behind and to the right, is another man with his head held in his hands in a dramatic gesture of anguish and despair. Then, behind on the other side, is a figure with his arm raised at an angle which allows the eye to move to the left to find the last two people, slightly separated from the rest, but moving round towards them. There is an undulating and active rhythm to the whole group, which moves round and seems to come to a stop with the indomitable and monumental form of their leader. The figure which is seen from behind on the left has his right arm raised which connects him with the one immediately in front of him, who has one hand behind and one in front in order to be joined to the group. But the space between these two at the back is very telling as it seems to increase the feeling of movement, tension and emotion, right through the group.

The surface of the sculpture is also important, particularly as the long tunics anchor the figures to the ground and add to the stability of the group, in spite of the movement. Also, the scale of the figures is slightly larger than life size at 217 centimetres high, but this effect is added to if they are standing on the ground rather than up on a plinth. There is something more powerful about them if they are at ground level because you feel closer to them and their tragic situation. But if they are up on a plinth, they are further away and appear more like a monument to the whole episode because they cannot appear so individualistic at a distance. Either way, the connection the spectator has with the tragic nature of the group is involving and personal.

As there are so many versions of this sculpture we can also gain insight into the importance of the setting. An outdoor setting gives

the group room to expand into the surrounding space, whereas, if it is inside, it can seem as though the figures are pushed closer together. If they have verdigris on them through being outside, they can appear more ancient and weather-beaten; if they are newly cleaned you have more chance to observe detail like the left foot of Pierre de Weissant which is turned on its side in an awkward and anxious position; and there is also great tension in his bare left leg which adds strength and fortitude to the figure. There is restless emotion in the walking figure on the left, helplessness in the one next to him, despair and fear in the ones at the back, and resignation and determination in the two at the front. What makes this group so remarkable is the way it communicates movement, and yet you are able to see it as a whole, so you feel the story even if you do not know the detail of what it is about.

The communication of an emotional idea and spectator involvement

Plate 3.18 *The Dark Night of the Soul* by Ana Maria Pacheco, 1999–2000

This group could more properly be called an installation because it has to be set up on a particular site in a gallery and it is not permanent. The spectator is encouraged to move amongst the figures; they are carved from wood and then painted and they are positioned around a kneeling nude hooded figure which has been tied to a stake and shot with arrows. The poses and expressions of the figures show varying degrees of horror, or disturbance, some have questioning expressions, or a mixture of both like the one on the left at the back. They are dramatically lit and placed on a shallow platform as if on a stage or taking part in a tableau vivant. This photograph does not show the group as a whole, but even so you can get an idea of how it feels and what it is about.

The sizes of the figures vary; the central hooded figure is 165 centimetres high, and he is surrounded by larger than life-sized figures wrapped in black garments. They look threatening because of this and more powerful than the kneeling figure which appears like a victim because of his startlingly pale body and the fact that he is tied to a stake; but this also has to do with the way the whole of the group is lit with a spotlight in a dramatically theatrical way. This means that the onlookers appear more in shadow, but they are also smaller than

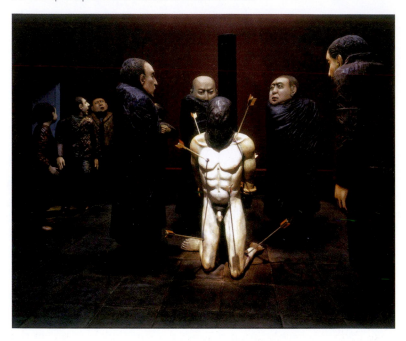

Plate 3.18 Ana Maria Pacheco (b. 1943), *Dark Night of the Soul*, 1999–2000. Reproduced by courtesy of Pratt Contemporary Art.

the big figures just described. Behind there are faces full of emotion, fear, disillusionment and anger. They all have white skins and staring eyes, but the angles of their heads, as well as their bodies, vary in relation to one another, from the point of view of creating differences in body language and facial expression. As you walk amongst them you feel fearful, anxious and uncertain and you are made to think about power, political agendas, injustice, vulnerability and the possibility or not of political protest.

When you are in the presence of this group sculpture you feel that you are part of it and it encourages you into very mixed feelings. Is this an episode of martyrdom like the story of St Sebastian? Or is it a more modern scene of torture and political cruelty exercised by the power of the state? The answer is that you cannot be sure of what it is about in terms of a specific story, because it is not a narrative, but deliberately ambivalent in its communication and presentation.

Some of the answers can be provided by the fact that Pacheco is Brazilian in origin; she comes from a town called Goianá, not far

from the new capital Brasilia which is 'on the boundary between the vast untamed swampland of Matto Grosso, the Pantanal, where even today many Indian tribes still live'. Pacheco attended university in Goianá and described how the ancient and modern exist side by side:

> When you leave the building (the University) you go out to confront this landscape and ecology that has nothing to do with what you have learned . . . everything is thin, uncertain, distorted, scared and fearful like an animal hunted.
>
> (Ian Starsmore, *Inventing the Black Powder*,
> Pratt Contemporary Art, 1989, quoted in
> Catalogue *Ana Maria Pacheco*: 8)

But Brazil also has a mixed history in another way, if you think of how it was heavily influenced by the slave trade with Africa and the power of the Roman Catholic Church. Pacheco feels all of this and it is present in her work; in particular she is fascinated by the kind of spiritual realism we looked at in Chapter 2 (in the figure of St Francis Borgia) which she can see in the Roman Catholic churches in Brazil. Like them, Pacheco's group requires dramatic lighting, but in this case the central figure is modern and hooded like a terrorist or a prisoner in Guantanamo Bay for example, and the clothes all the figures are wearing are simplified and modern.

When Pacheco made this group sculpture she had been Associate Artist in residence at the National Gallery for two years and she used paintings in the collection as her points of reference, most obviously *The Martyrdom of St Sebastian* by the Pollaiuollo Brothers. In its catalogue which was prepared for the exhibition of *The Dark Night of the Soul*, the National Gallery shows that Pacheco uses a multiplicity of sources, including photographs by Robert Mapplethorpe, as well as more documentary ones. Pacheco was trained as a painter as well as a sculptor and she makes prints too. The prints particularly are used by the artist as preparation for a group like this where the tonal values are particularly important and the painting technique on a gesso ground is similar to the one she uses for her pictures. The making of the sculptures is complex and many layered. To begin with the group was 'mapped out' with a chainsaw by assistants who deal with the logs initially when they arrive in the studio, and bring them to a state where the artist can begin to use the hammer and chisel and work them to a high finish:

they are initially blocked out with a chain saw, then details such as heads, hands and feet are carved, while much of the drapery is worked with a blow torch. The colour, mixed with diluted emulsion paint, and the same kind of gesso that is used for the paintings, is applied with cotton buds.

(Catalogue *Ana Maria Pacheco*: 47)

Once Pacheco starts working with the chisel, she says the sculpture changes as she works.

I know, of course, the structures of the composition, but how it is going to evolve I don't know. That's why I don't make models, because otherwise it would be just a design. You'd be dealing with what you know. In the visual arts you have to deal with what you don't know.

(Ibid.: 31)

So, Pacheco is interested in the idea of the work evolving and the elements of creative discovery in the process. This is partly what makes it seem so alive, and she is very sure about the importance of the whole piece occupying your space.

You can change the composition of a painting or a print. But, with sculpture, at least the way I do it, it is very restricted. Apart from anything else, you are dealing with the space you actually live in, a chair for example, or a fridge, occupies that same space. That creates an enormous difficulty for you to break through the visible world to the world one wants to deal with, that is the invisible.

(Ibid.: 32)

Thus, the presence of the sculpture, and your interaction with it, is very important to Pacheco and particularly the concept of moving into an imaginative world which can be just as real as the physical one. Here we are in the territory of the verisimilitude of the Riace Bronzes as much as in the spiritual reality of the Spanish Counter-Reformation sculpture, which we looked at in Chapters 1 and 2. This enduring concept of real presence is one of the most compelling aspects of sculpture. You are no longer on the outside looking in but, in a mysterious way, as the spectator, you become deeply involved and part of the work of art itself.

CONCLUSION

The idea of the importance of the spectator's role in sculpture has cropped up several times in this chapter, not just from the point of view of verisimilitude, but also in terms of what could be called the imaginative experience of sculpture. Clearly the spectator was important to artists like Falconet in the eighteenth century, or Pacheco in our own time, and indeed to patrons like the Duke of Bedford in relation to Canova and *The Three Graces*. This concept becomes even more significant when it comes to sculpture used for memorials and commemoration, which we will consider in Chapter 6. The relationship between and contrast with painting has also occurred several times: Pisano and Giotto as contemporaries, Henry Moore's admiration for Masaccio, and Pacheco and her practice of painting and print making. The idea of the comparison between painting and sculpture, the so-called Paragone, was important in the Renaissance, as we shall see in Chapter 5.

Chapter 4

Relief sculpture and its purposes: communication, decoration and narrative power

INTRODUCTION

There are many types of relief, but they are mainly used for narrative of different kinds, for the telling of stories, for commemoration of great episodes, for instruction or indeed for decoration; they range from low or bas-relief, schiacciato, which is almost like engraving, to medium and high relief, which can be nearly free-standing. Reliefs can be made out of stone, marble, bronze or indeed precious metals like silver and gold. One of the most fascinating aspects of relief sculpture is that it is not free-standing and, as a consequence of that, its role is more pictorial, and so it occupies a place between painting and sculpture in that sense. We have seen in a previous chapter how it was used in classical times, on columns, altars, temples and sarcophagi. After the fall of the Roman Empire in the early fifth century, sculpture of all kinds became less prevalent, certainly in the sense of its attachment to buildings. Those objects which were made tended to be more portable like Anglo-Saxon jewellery as found at Sutton Hoo, or the Byzantine cameo and Carolingian ivories which we will look at later on in this chapter.

At that time, they wanted to establish something equivalent to Imperial Rome, but in the name of the church, with Charlemagne as Holy Roman Emperor. But it is thought that the revival of architectural sculpture had much to do with the establishment of more settled communities a little later on, from the first millennium onwards. In his book, based on the Charles Norton lectures, called *Romanesque Architectural Sculpture*, Meyer Schapiro has this to say about the equestrian statue of Charlemagne which we have already looked at in Chapter 3. As we discovered, it is extremely small, being only about 9 inches high, but Schapiro points out that it was

based on the much larger statue of Marcus Aurelius which we saw in Chapter 1.

> This statuette in bronze is a tiny figure; it is not a monumental statue at all. Through these works, then, we see how the classical tradition of monumental sculpture was assimilated to the current practice of an art of the treasure object, of the shrine, of the sacred table, the altar.
>
> (Schapiro, *Romanesque Architectural Sculpture*: 15)

So these artists were imitating the classical past but in a completely different context. The same is true of monumental sculpture which, according to Schapiro, started to revive when settled communities began to thrive after the first millennium. Describing some sculpture on the tympanum of the west door at Moissac in southern France, he has this to say:

> they enunciate hierarchy, status, doctrine and moral principle in an imagery that combines elements of the visionary and the real. Here, teachings of the church are addressed to the community outside the framework of ritual and at the boundary between the religious and secular worlds.
>
> (Ibid.: 29)

By this time, monasticism under the Benedictine order was thriving, and the monk Raoul Glaber could write his now famous passage about Europe being clothed in the white robes of the church, which is one of the most important primary sources from this period and is often quoted:

> Therefore, after the above mentioned year of the millennium which is now about three years past, there occurred, throughout the world, especially in Italy and Gaul, a rebuilding of church basilicas . . . It was as if the whole earth, having cast off the old by shaking itself, were clothing itself in the white robe of the church. Then, at last, all the faithful altered completely most of the Episcopal seats for the better, and likewise the monasteries of the various saints as well as the lesser places of prayer in the towns . . .
>
> (R. Glaber, *Concerning the Construction of Churches throughout the World*: 18)

So, in these more settled times, sculpture takes on a didactic role of communication between the church and the community, and relief sculpture attached to buildings became particularly important in this function between the religious and the secular worlds.

By the time we arrive at the Renaissance in Italy, relief sculpture is still very important but it is being used in a more naturalistic way, partly through the use of single viewpoint perspective, but also because of much greater acceptance of the study of the real world through the teachings of figures like St Francis of Assisi and St Thomas Aquinas which we discussed in Chapter 3 and the ideas of Petrarch. Petrarch, for instance, recommended the study and depiction of the natural world with reference to antiquity, but for a Christian purpose. Anthony Levi makes this very clear in his book *Renaissance and Reformation: The Intellectual Genesis* where he suggests that:

> It is true that Petrarch was part of a continuing movement which found in Virgil a precursor of Christ, in Ovid's *Ars Amatoria* a work of religious edification, and which now increasingly found Christian edification in Cicero and Seneca. He taught not so much a rediscovery of ancient Latin literary texts as a different way of reading them. But the new view of human experience, which was to upgrade some forms of instinctive behaviour as well as to insist on commitment to high moral values, involved a new way of reading the antique texts for the elevation of their personal ideals. That is what the quattrocento meant when it invariably traced back to Petrarch the origins of what it was soon calling the renaissance.
>
> (Levi, *A Renaissance and Reformation: The Intellectual Genesis*. 86)

These are broad generalisations of course, but they do help us to understand the shift of emphasis which occurred between the relief sculpture of Gislebertus and that of Donatello.

Revivals and re-interpretations of the classical tradition are very interesting in relation to relief sculpture, just as they are in relation to the free-standing figure. There was a particularly fascinating revival of relief sculpture, especially in England, in the eighteenth century. This was fuelled by the English gentry's fascination with collecting classical sculpture on the Grand Tour, and the commissioning and making of replicas, or at the very least, sculptural objects, which imitated the classical world in a new way. This in turn was encouraged by the new discoveries at Pompeii and Herculaneum and of course the Elgin Marbles from the Parthenon. The idea of recreating the beauty of the newly discovered Greek sculpture was very important to sculptors like John Flaxman, whom we will look at, and the inventions of Josiah Wedgwood for whom Flaxman worked for a

time. Wedgwood wanted to revive, or indeed re-invent, the skill of the cameo and the very low relief which it represents. His Jasperware was designed to do just this; it was a fine-grain unglazed stoneware and his most famous achievement was using it for his replica of the Roman Portland Vase.

In the nineteenth century, there was a move away from this kind of classical revival, into a very different world of expression and raw emotion in the Romantic approach to art as shown by the work of Auguste Préault. More importantly, for the development of the modern period, there was the move into ethnographic art and alternative cultures in the work of Gauguin, and we shall look at some of his wood carving which was influenced by the Oceanic world of the Marquesas Islands, and later of course there were Picasso and others who became generally more interested in ethnographic art.

The understanding of very low relief will also take us into the relationship between sculpture and drawing and also between sculpture and engraving. There is a sense in which Donatello's use of schiacciato is closer to drawing and engraving than to the three-dimensional art of sculpture, and that is why the engraved glass of John Hutton at Coventry Cathedral can be looked at in relationship to this. Relief can also be well nigh universal, if you consider it in relationship to money, medals and coins. The contemporary sculptor Cornelia Parker has explored this territory in her installation called *Thirty Pieces of Silver*, of 1988–1989, in which she literally flattened all sorts of pieces of silver plate and arranged them in an installation. Like much art of today, this is not so much about skill, and more about context. But, as we shall see, the setting for reliefs is often very important, especially in the relationship between sculpture and architecture as we shall go on to see now.

THE COMMUNICATION OF A MESSAGE

Plates 4.1, 4.2, 4.3, 4.4 and 4.5 The sculpture of Gislebertus at Autun, *c.*1120–1135, Cathedral of St Lazare

Plate 4.6 *The Story of Jacob and Esau* by Lorenzo Ghiberti, second set of bronze doors, 1425–1452, the Baptistery, Florence

When you climb the steps to see the tympanum at the western entrance of the Cathedral of St Lazare at Autun in Burgundy, you are faced with an extraordinary doorway. There is a Roman arch, with

pillars and pilasters, divided by a central sculptured section called the trumeau, which is a nineteenth-century restoration. But, as soon as you look more closely, you see that the design of this arch is in many ways very different from the classical tradition. Round the outside edge of it there are the signs of the zodiac, alternating with seasons of the year, set in concave medallions which lend a regularity and symmetry to the irregular and idiosyncratic images. On the left of this picture you can make out the sign for Pisces, of two fishes facing in opposite directions. The concavity of each circle means that the carving stands out more. Then, in the next section, still on the outside, there is a beautiful interweaving design of fruit and flowers, held together by an undulating 'rope' of carved stone, which creates movement around another concave arched background. Then, even more interestingly, below this there is a plain concave section to the arch, which provides a visual space before the complexities of the Last Judgement on the tympanum itself.

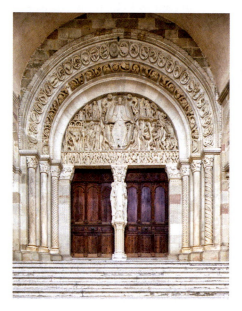

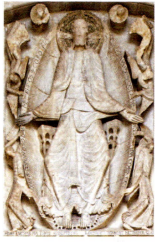

Plate 4.2 Tympanum and doorway detail, Cathedral of Saint Lazare d'Autun. Autun, Saone et Loire, Bourgogne. © 2013. White Images/Scala, Florence.

Plate 4.1 Tympanum and doorway, Cathedral of Saint Lazare d'Autun. Autun, Saone et Loire, Bourgogne. © 2013. White Images/Scala, Florence.

Here we find Christ in a mandorla, as he would be in a Byzantine mosaic, with a halo and a cross behind His head. But the design of the figure is what is outstanding; the shoulders, arms and hands are covered in wide sleeves which form two shapes looking like elongated crescents. When you look more closely you see that it is more like a cape where the border on the left has been opened out. Then the legs are bent into a semi-squatting position which makes a lozenge shape. The folds of Christ's costume augment and enliven the surface design of the figure, so that it stands out and draws your attention, particularly to the shoulders and the legs. The face stares out at us, but the expression is less than it would have been originally, because the tympanum was covered in plaster in the eighteenth century, and some of the fine detail of the features came away when it was removed in the nineteenth century. Under Christ's feet is the famous inscription that the work was made by Gislebertus. Nobody knows for certain who he was, but it is thought that he came from Vézelay and led the sculpture workshop at Autun from c.1120 to c.1135. On either side of Christ in His mandorla, this sculpture is divided into separate stones much as the panels on a painted altarpiece would be, like the much later Last Judgement by Rogier van der Weyden in nearby Beaune or his famous *Descent from the Cross* (see *Learning to Look at Paintings* pp. 136–138). On Christ's left, and our right as we look at it, we see the weighing of the souls with St Michael and the Devil, and further to our right, the descent into Hell. Above St Michael are the Gospel writer St John and his brother St James. On the other side are the rest of the Apostles looking at Christ, with St Peter turning the other way to look at the souls coming up, with Noah's Ark above, and the Virgin Mary in heavenly Jerusalem above that. Beneath all of this there is a horizontal lintel with the Blessed on the left as we look, and the Damned on the right, with an angel trying to recall some of them to forgiveness and heaven.

But the most telling part about the whole design is the way that you can see what it is about from the layout and, above all, the expressiveness of the figures. The height of the graceful, elongated form of St Michael (Plate 4.3) is accentuated by his elegant drapery lines and his wings moving upwards. The contour of his back and upper thighs is emphasised by the edge of the draped angel behind. This is contrasted with the face of the Devil and his body which echoes the position of St Michael but is more angular. In this section in particular you can see how high and deeply cut the relief is, and the separate stones behind, especially when the sun is going down in the west, and the rays catch the edges of the stone carving more emphatically.

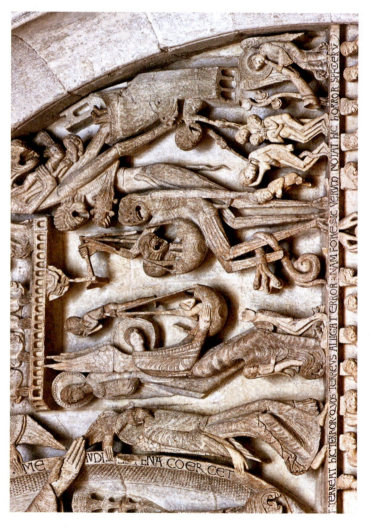

Plate 4.3 Weighing of Souls, Cathedral of Saint Lazare d'Autun, west façade, 1120–1132. Photo credit: Achim Bednorz.

This is what strikes you most in the famous relief of Eve, which was originally designed for the north door. Her body is naked and straddles the rectangular stone (now split in two, but originally one piece) in a sinuous reclining position. What you cannot see easily in reproductions is how deeply cut she is and how telling are the negative spaces in front of her profile, behind her head, under the arms, and between the thigh and the lower leg. Underneath her, you are made to see behind the undergrowth where you know her genitals would be. Then, the breasts are turned towards us, although the face is in profile. The result is that she seems sinuously alive, like the serpent who tempted her, and whose form we can see in the sections to the right and left, and behind the torso; this feeling is enhanced by the carving of the hair spreading in combed lines along her arms on both sides, and the way her hand reaches to pick the apple without turning to look. The expression in her bulging and heavy lidded eyes, and the hand cupping her chin, as though she were whispering duplicitously behind her fingers to Adam, communicates this feeling of intense and secret emotion. This in turn is enhanced by the interior space behind her right arm, and the hair coming through into the triangular area between the hand and the neck. The sheer expressive power of this figure has made it justly famous and fascinating, because of the way it conveys complex and conflicting emotions.

When the doors of the cathedral are open, the interior is revealed as an extraordinary sculptural space because you can see all the carved capitals leading towards the altar, with a narrowing of the width

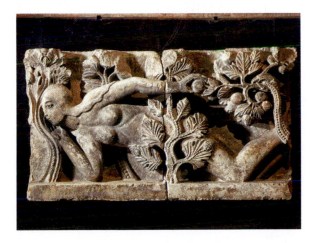

Plate 4.4 Eve. Autun, Musée de Saint-Lazare. © 2013. Photo Scala, Florence.

towards the crossing, so you are encouraged to move forwards towards the relics of St Lazarus and the mausoleum which is now in the museum. However, once you are inside the church, it is the capitals which really draw your attention, because they are placed on the eastern and western sides of the lower sections of the enormous fluted piers which support the vaulting of the nave; so, half of them are facing you as you walk in. They are fluted on all sides with plain-sided half pilasters and attached columns between. When you look at these carved capitals they are high above you. Where the acanthus leaves of a Corinthian column would be, there are episodes from the Bible, from medieval legend, from early Christian history, or indeed domestic scenes like two cocks fighting.

One of the most exciting of the capitals, from the point of view of design, concerns the story of St Vincent, a third-century Spanish deacon who was martyred and whose body was left to rot. However, the story goes that an eagle was sent by God to guard the body. Gislebertus uses two eagles, and makes them into schematic shapes which create an inverted triangle over the body, which itself echoes this shape, and which rests on foliage which reappears at the top with a cone-shaped fruit like an acorn. The birds' feet rest on the knees and the upper arm of the figure of the saint and their heads move down the side of the capital, without losing the overall shape of the stone, which is wider at the top than at the bottom. You can see the way the stone has been cut away to make room for the deep carving, particularly between the tips of the wings in the centre and under the body of St Vincent. The variation in the different textures is constantly visually interesting, as in the long incised lines for the tail feathers and the more circular shapes for the upper body, neck and head. The body of St Vincent is smooth and the oak leaves are curvaceous, restless and growing. All this visual interest is incorporated into the three-dimensional shape of the capital so you sense it as solid, and formed in the round, even though it is in relief. This in turn is enhanced by the negative spaces under the necks of the eagles which emphasise this three-dimensional experience.

The ability to communicate meaning through texture is visible everywhere here and this is particularly true of some of the capitals in the chapter house which were removed from the chancel in the nineteenth century, but which can now be viewed at eye level. If you try to count the number of different marks the artist has made you will see that there is enormous textural variety within a small space. The same would apply to the sculpture of Noah's Ark, and the one

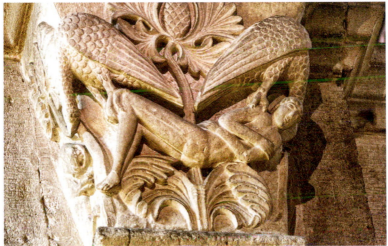

Plate 4.5 Capital, Cathedral of Saint Lazare d'Autun: St Vincent and the Eagles.
Photo © 2008 Holly Hayes/Art History Images. All rights reserved.

of the Emperor Constantine on horseback crushing a barbarian. This direct Roman reference points to something very interesting and that is that Autun was originally a Roman town founded by the Emperor Augustus. This equestrian figure echoes that of Marcus Aurelius which we looked at in Chapter 1, and which was believed to be a representation of Constantine throughout the medieval period. Moreover, Constantine is supposed to have visited Autun in 311 CE, and the entrance arch of the cathedral is based on the design of the old Roman gate into the city, known as Porte d'Arroux. This reminds us that classical remains were visible throughout France, which had been the Roman province of Gaul, and that the art of the Romanesque period was thought of in terms of a classical revival, but in a Christian context of culture and belief.

Finally, the Cathedral of St Lazare at Autun was used for the mausoleum of St Lazare, housing the relics of Lazarus, the brother of Martha and Mary Magdalene, whom Jesus raised from the dead. It was presented as a kind of tableau vivant which was removed in the eighteenth century and which has now been reconstructed in the museum nearby. Here there are three surviving free-standing figures of St Andrew and Mary and Martha (St Peter who should be next to Andrew is now in the Louvre). The whole layout of it was apparently presented as a miniature church which the pilgrims stepped down to

at the back of the altar. Originally, Jesus stood behind St Andrew and St Peter pointing at the coffin of Lazarus in the centre with Martha and Mary standing at the end. These figures are very striking in terms of their emotional expressions, like the dumbfounded recognition of spiritual power in the face of St Andrew who wears a costume resembling a Roman toga and carries a scroll with his name on it.

They remind us that relics were supposed to provide tangible evidence of an invisible God. In his book *A History of Christianity*, Diarmid McCulloch says that the importance of pilgrimages and relics originated in Jerusalem where the Emperor Constantine's mother, Helena, was supposed to have found the wood of the True Cross. But McCulloch suggests it was the certainty represented by relics which led to their eventual proliferation. Discussing Jerusalem in the fourth century CE he suggests that:

> Scepticism was generally drowned out by the eagerness of people seeking an exceptional and guaranteed experience of holiness, healing, comfort – increasingly a self-fulfilling prophecy as the crowds swelled, to the delight of the souvenir traders and night-time entertainment industry in the Holy City. There was now a proliferation of relics of the wood of the Cross.
>
> (McCulloch, *A History of Christianity*: 194)

Gradually, other relics proliferated and, by the twelfth century, the pilgrimage routes were established all over Europe, particularly in association with the Apostle St James at Santiago de Compostela; he was martyred in Judaea and his body miraculously translated to Compostela in Spain.

The Cathedral of St Lazare at Autun became a pilgrimage church on the route to Santiago. It was founded on the site of an earlier one where relics of Lazarus had been venerated since the tenth century, and as a sister church to that dedicated to the Magdalene at Vézelay. The sculptor who made these remarkable figures may have come from there, and what is clear is that they were meant to be part of a coherent iconographical programme from the moment the faithful approached this church.

The power of relief to tell a story continued into the Renaissance, and particularly in Italy. When Lorenzo Ghiberti came to make the second set of bronze doors for the Baptistery in Florence, which took him over twenty-five years, he described, in his autobiography, known as *The Commentaries*, what his intention was, saying that he strove to imitate nature with all the perspective he could:

The stories, which had numerous figures in them, were from the Old Testament. With every proportion observed in them, I strove to imitate nature as closely as I could, and with all the perspective I could produce [to have] excellent compositions rich with many figures. In some scenes I placed about a hundred figures, in some less, and in some more. I executed that work with the greatest diligence and the greatest love. There were ten stories in all [sunk] in frames because the eye from a distance measures and interprets the scenes in such a way that they appear round [plastic]. The scenes are in the lowest relief and the figures are seen in the planes; those that are near appear large, those in the distance small, as they do in reality. I executed this entire work with these principles.

(Quoted in Holt (ed.), *Documentary History of Art*: 161)

As Ghiberti says here, the scenes are from the Old Testament, and he describes each of the episodes. The one we are going to look at is the story of Jacob and Esau in the fifth frame. This passage is worth quoting as well, as he explains so clearly what he wants to illustrate:

In the fifth frame is shown how Esau and Jacob were born to Isaac; how Esau was sent to hunt; how the mother instructed Jacob, gave him the kid, and fastened the skin at his neck and told him to ask the blessing of Isaac; and how Isaac searched for his neck, found it hairy, and gave him his benediction.

(Ibid.: 162)

These reliefs are made of gilded bronze and the method of making them was extremely complex. For this Ghiberti relied not only on his own skills, but also on those of his workshop which were inherited from the medieval tradition and its guild system of training workers and encouraging apprenticeships. Ghiberti himself was trained as a painter and a goldsmith. Since the recent restoration of the panels it has been discovered that each of the doors was cast as a whole.

Not until the panels were removed did conservators realize that Ghiberti had cast each of the two doors, including the frames as a single three-ton bronze piece. 'Before him, nobody in Italy was able to create something in bronze so big in dimension, not since the end of the Roman Empire', says Annamaria Giusti, director of the Museo dell Opificio delle Pietre Dure which is overseeing the restoration. It remains a mystery how Ghiberti learned the

technique. He did not discuss it in his autobiography. 'He loved to present himself as a self-made artist,' she observes.

(Lubrow, 'The Gates of Paradise')

But the real difference between these reliefs and those on Trajan's Column, or the ones at Autun which we looked at earlier, is first that they are bronze, not marble or stone. Second, and more importantly, there is Ghiberti's use of perspective, and the depiction of space, and the way the architectural background has been used to achieve this. Diagonal lines of direction called orthogonals converge at what is called the vanishing point. In this panel you can see that the vanishing point is in the middle at the back, with the orthogonals running from the bottom corners of the frame. The tiled floor and the steps are used to enhance this effect, which is what Alberti had advised in his *Treatise on Painting*, which had been published in Florence in 1436 (see *Learning to Look at Paintings* Chapter 2). The Roman arches, with their Corinthian capitals in the foreground, recede into the background, one behind the other, and we feel we can really see what is going on, and the arrangement of the narrative follows Ghiberti's description.

The depth of the modelling of the figures of Jacob and Rebecca, underneath the arch at the back on the right, and Esau going to the fields on the far right in the background, is quite shallow. If you then

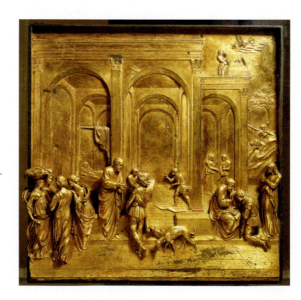

Plate 4.6
Lorenzo Ghiberti (1378–1455), Door of Paradise: Scenes from the Story of Isaac and Jacob. Florence, Museo dell'Opera del Duomo. © 2013. Photo Scala, Florence.

compare these with the high relief of the figures in the foreground, particularly those of Isaac and Jacob at the right and in the centre, you will see that there is variation in the depth. The figures are all wearing classical style draperies which nevertheless have a swaying elegance, with gothic characteristics. This is especially marked in the woman on the far right of the picture. Her shoulder comes out beyond the frame, as does the figure on the far left, allowing the eye to sense the plasticity which Ghiberti is talking about and which adds to the way the scenes are sunk back in the frame. In photographs, it certainly looks as though the floor moves into our space too. So the architectural part of the composition helps to create the feeling of recession. The gilding also adds to this effect because it is more sparing on the figures in the foreground and more solidly laid on in the background. The way the whole panel catches the light also helps to add life and movement to the scene. The chasing and all that that entailed, as well as the gilding, were done by Ghiberti's own hand, as specified in the contract.

THE IVORY, THE CAMEO, THE JEWEL AND VERY LOW RELIEF WHICH IS PRIMARILY DECORATIVE

Ivory relief sculpture

Plate 4.7 *The Lorsch Gospels, c.*810

This exquisite series of five ivory panels was originally arranged into a book cover for a copy of the Gospels so it is primarily decorative rather than narrative. It is barely the size of an A4 page, but ivory of course lends itself to small-scale work because the raw material is animal in origin, and comes in smaller quantities. The most striking quality in these three figures of the Virgin and Child, with St John the Baptist to the left and the Prophet Zacharias to the right, is the symmetry of the way they are arranged in relation to each other and to the architectural background. If you look across at the shoulders, the hands and the hems of their garments you will see that they are in line with one another. Then, individually, the shoulders line up with the capitals of the columns, and the heads have more space in relation to the area of the arches. Their eyes appear to be in line with one another, which makes their staring expression even more compelling.

The intricacy and the detail are extraordinary, in the pattern on the headdress and upper body of the Virgin, and the general movement

Plate 4.7 Front cover of the *Lorsch Gospels* by an unknown artist. Aachen, Germany, c.810. © Victoria and Albert Museum, London.

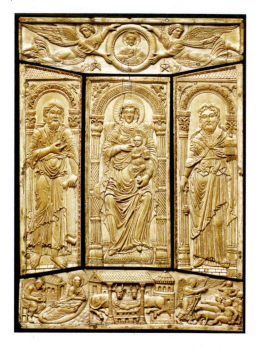

of the folds of the drapery, the fluting on the pillars and the patterning on the arches, all of which are enhanced by the different depths of the carving. The Virgin is seated and the two male figures are standing in the contrapposto position. The intricacy and delicacy are added to by the two horizontal panels above and below, which depict Christ in a medallion, with angels, at the top and the Adoration of the Shepherds at the bottom. These scenes are not realistic but are using the classical language of sculpture which has then been flattened to make it appear more hieratic and stylised; in this sense they are not narrative in the way that most relief sculpture tends to be. The language of the carving is derived from both the classical and the Byzantine traditions. This cover comes from the court of Charlemagne which, as suggested in the introduction to this chapter, was very interested in reviving Imperial Roman style and authority in the name of the church, but the objects made were on the whole small scale, and portable, like this one.

Cameo

Plate 4.8 Byzantine cameo: *The Crucifixion with the Virgin and St John, c.900*

Similarly precious and small scale is this relief in jasper of Christ's crucifixion. This is even smaller and just as emblematic as the previous example and it may have been designed to be worn, as Anglo-Saxon jewellery was too, at about the same period. The figures are simplified in terms of their arms, heads and drapery, yet the variation in the colour of the jasper allows the rich surface to come through and add an otherworldly quality through its dark and mysterious colour. Yet the composition is once again quite symmetrical, with the shape of the cross acting as the backbone of the composition and the intervals between the body of Christ and the Virgin and St John acting as eloquent negative spaces. Then you notice the body and legs of Christ are in a swayed position making an elegant serpentine curve, including the tilted head, which is echoed in the bent horizontals of the arms. Lettering plays its part in the design as do the two medallions, one on either side, which reflect the shape of the halos of the three figures. It is perfectly obvious that this was designed to be portable and possibly to be worn.

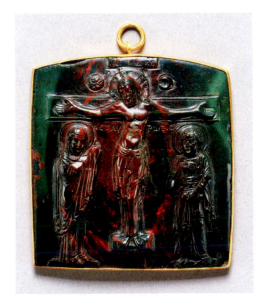

Plate 4.8 The Crucifixion with the Virgin and St John, unknown artist. Istanbul, c.900. © Victoria and Albert Museum, London.

Gold and jewelled relief work

Plate 4.9 Byzantine perfume brazier, late twelfth century

Plate 4.10 The *Pala d'Oro*, 1342 (Venetian goldsmith's work framing earlier enamels of Byzantine origin), St Mark's Basilica, Venice

Many objects from the Byzantine and medieval period are designed to be portable as well as precious and sacred. The famous Byzantine perfume brazier or incense burner shown in Plate 4.9 is a case in point where the shape of a domed and centrally planned building is made out of gold and silver work combined with decorative reliefs. The shapes of the edges of the building move in and out and are decorated with fabulous beasts, like the dragons you see here, or abstracted flowers and branches. The gold banding on the dome and walls expresses the building's essential structure aided by the contrast between the gold and the silver gilt. This feeling for the structure allows you to believe in it as a solid object even though it is hollow and semi-translucent. This is because of the perforated relief work known as filigree. These symmetrical patterns allow you to focus on the spiritual use of this decorative and functional object.

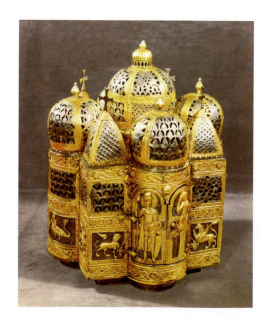

Plate 4.9 Greek orotophorus, late twelfth century. St. Mark's Basilica (Treasury), Venice. Silver gilt. H. 53 cm, diam. 30 cm. © 2013. Photo Scala, Florence.

The relationship between decoration and function is more obvious in the *Pala d'Oro*, the golden altar, also belonging to St Mark's Basilica in Venice. Here, coloured enamel work is set against a gold and jewelled background. Many of the cloisonné enamels were brought from Constantinople after its conquest by the West in 1204 and put together mainly in the fourteenth century by command of Doge Andrea Dandolo in 1343. Others may have been commissioned from Byzantine artists later, it is thought. The effect of this example of skilled workmanship is quite dazzling because of the way the light catches it and makes it into a subtle and sparkling surface which was designed to glint in the candlelight. You could argue that technically this is not a relief at all, but it and the previous item are examples of where relief sculpture meets design and the decorative arts; and it is worth remembering at this point that many artists of the Renaissance as well were trained as goldsmiths, like Lorenzo Ghiberti for instance, whom we looked at in the last section.

In his book *Diversarum Artium Schedula*, translated as *An Essay upon Various Arts*, Theophilus, a Benedictine monk of the eleventh century, spends a long time discussing the process of gilding. He describes how it needs to be beaten into the thickness you want and then mounted on parchment or panel:

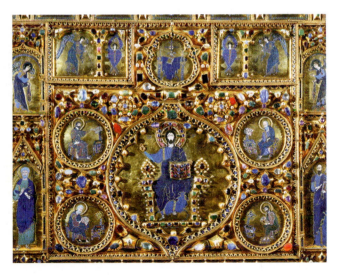

Plate 4.10 Pala d'Oro – detail (Christ the Judge and the Four Evangelists), assembled 1342. St Mark's Basilica, Venice. © 2013. Photo Scala, Florence.

> Then have a mallet cast from yellow brass, small towards the handle, and large in the flat part, with which you strike the purse upon a large and flat stone, not heavily, but moderately; and when you have frequently inspected it, you will consider whether you wish to make the gold very thin or moderately thick.
>
> (Quoted in Holt (ed.), *Documentary History of Art*: 3)

This gold leaf in the background of the *Pala d'Oro* was also tooled and inset with gems. So, the effect when you see it is of a richly encrusted solid object, the edges of which are constantly changing through directed and reflected light. As the whole interior of the Basilica was meant to be a recreation of the City of God as described in the Book of Revelation, the *Pala d'Oro* was an appropriate expression of that idea. Much of the medieval sculpture we see today would have been painted, and the colourful effect seen here gives you a vivid reminder of what that experience would have been like.

The revival of the cameo in the eighteenth century

The revival of the cameo in the eighteenth century in England was led by Josiah Wedgwood who developed Jasperware to resemble the quartz called jasper; this came in several colours, and had been used in ancient times, as we saw in the Byzantine Crucifixion we have just been looking at. Wedgwood's interpretation was a fine unglazed stoneware, which was white to start with, but which could be made to take colour. Wedgwood spent years perfecting this stoneware, and then used it for his cameo-like designs. One of the clearest examples of this technique is *The Phaeton*, designed by George Stubbs as a plaque, because it demonstrates clearly the white modelled figures against a black background, which Wedgwood called Basalt. We will look at an example of this when we discuss the *Black Basalt Vase* in Chapter 9. Stubbs knew everything there was to know about the anatomy of the horse and many of his paintings have a relief-like quality (see *Learning to Look at Paintings* pp. 100–101). Stubbs became loosely associated with a group of intellectuals, inventors and entrepreneurs known as the Lunar Men, of which Wedgwood was also a member.

Very low relief and drawing

Plate 4.11 *The Adoration of the Magi* by John Flaxman, 1797

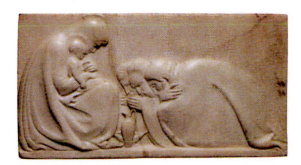

Plate 4.11
John Flaxman
(1755–1826),
*The Adoration of
the Magi*, c.1797,
marble. Private
collection.

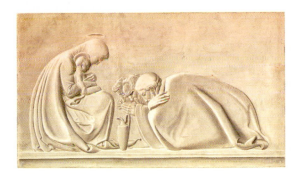

Plate 4.12
John Flaxman
(1755–1826),
*The Adoration of the
Magi*, drawing. ©
The Trustees of the
British Museum.

John Flaxman also worked for Wedgwood, as his father had done, supplying designs for his Jasperware. This involved first of all sending a drawing which, when approved by Wedgwood, Flaxman would then turn into a wax model; at that point his role ceased and his design became the property of the firm of Wedgwood. Flaxman became a sculptor in his own right, but he always retained an interest in the relationship between drawing and sculpture which is beautifully explored in these two versions of *The Adoration of the Magi*. The drawing is described in its title as being in imitation of bas-relief, which suggests it was done after the sculpture.

So, if we begin by looking at the carving in marble, we can see that it has been done very sparingly with the minimum of emphasis on texture in the draperies and the hair for instance, so that the graceful lines of the folds are emphasised to indicate the forms. This is achieved

in front, and behind the kneeling kings, by deeper cutting, and the precision and flow of the line on the right-hand side allows us to see the edge of the form further out, which indicates the bulk of the body within, and the same is true of the lines in the drapery at the back of the Virgin Mary. The edges of the forms appear to be lost and found, much as they would be in a drawing. This allows the profiles of the heads in the centre to be focussed on more easily, in differing profiles of the kings, and similarly emphatic edges of the faces of Mary and the Christ child. The pitcher in the foreground appears to connect the figures together, with the folds of the clothing running behind from left to right. The edges of the draperies are also carefully incised to allow the spaces between them, and the container, to express the idea of a gift from one to the other. If you allow your eye to move upwards, over the profile of the Virgin and to the top of her head, you can see how the line becomes shallower and shallower as it moves along, travels down the back and almost disappears before it is picked up again in the folds lower down. The expression of devotion and the feeling of concentration are both graceful and emotionally telling.

If you now turn your attention to the drawing you will see that the lines of pen and ink have an angular quality which expresses the idea of stone and carving. Then the way that Flaxman uses the brush allows you to see the surface and form of the material and the expression in the heads by means of light and shade, particularly in relation to the head of the Virgin and the king nearest us in the foreground, because they are sharply lit against respective profiles of the Virgin, her child and the two kings behind. The outside edges of the Virgin's skirt below the knee and of the jug make an alternate rhythm of light and dark to connect the two groups in the way that the carving does in the sculpture. So the use of light and dark corresponds to the use of the chisel. But even more fascinating are the subtle differences between the two, especially on the right where the back of the king in the drawing is more emphasised than in the sculpture. The expression of form in both works is so subtly done that it is not so much about imitation, but more about expression of the inherent qualities in both. Other aspects of the relationship between sculpture and drawing will be explored in more detail in Chapter 8.

Expression and bronze relief

Plate 4.13 *La Tuerie (Slaughter)* by Auguste Préault, 1834

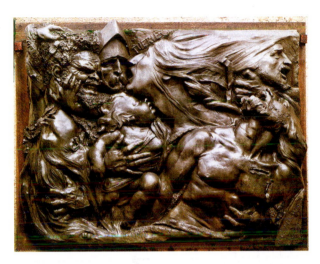

Plate 4.13 Auguste Préault (1809–1879), *La Tuerie (Slaughter)*, 1834. © RMN-Grand Palais/Agence Bulloz.

Here we seem to have entered a very different world. The first feeling that strikes you is how crowded the relief is, with very little rational idea of where the bodies are, because in the case of the figures to the left, and above, there are no bodies represented. In the foreground there is half a male torso and most of a child. But the artist wants above all to express raw emotion, and he does so by creating a sense of claustrophobia, because we cannot see where the figures are set. Such negative spaces as there are are represented by parts of limbs, like the hands in the bottom left and heads in the top right-hand corner which seem to be part of the action. Look at the way the helmeted figure's hand forms the corner of the plaque in the top left-hand corner. There is a tremendous feeling of movement and struggle too, with the open screaming mouth of the woman in the centre, echoed by that of the man in the foreground, and the others below and above, on the left and right of the picture.

This relief almost looks as though it has been cut down, but apparently it was conceived like this; it is representative of what is called Romantic sculpture, in which all noble simplicity and calm

grandeur has gone, in favour of expressing emotion and arousing it in the mind and heart of the spectator. If you compare this with the previous examples, you can see that there is an attempt to turn away from the classical tradition, to something like a medieval expression of hell. Of course there was a great interest in medieval art in the nineteenth century, most usually referred to as the Gothic Revival.

Paul Gauguin and the painted relief

Plate 4.14 *Soyez Mysterieuse* by Paul Gauguin, 1902 (lower left panel from a door frame to Gauguin's last residence in Atuona, Marquesas Islands)

Gauguin wanted to move away from the classical tradition and embraced ethnographic cultures, particularly the Oceanic. This relief is carved from sequoia wood using the ethnic types of male and female figures. It is painted in earth colours which enhance the feeling of three dimensions because the warm flesh tones come forward and the darker browns tend to recede. The carving is extremely simplified and the idea behind it seems to be to create an air of mystery and suggestion about what might be going on. This relief was part of a series Gauguin made round the door frame of his house in the Marquesas Islands where he found the native culture more intact and untouched by the missionaries than it had been in Tahiti. The whole series is entitled *Maison de Jouir*. He had been interested for a long time in the idea of mystery and symbolism in this kind of generalised and suggestive way (see *Learning to Look at Paintings* pp. 125–126). He was outraged at the lack of appreciation of Oceanic art in particular. Towards the end of his life he wrote eloquently about this in his journal:

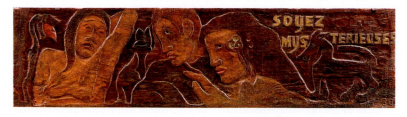

Plate 4.14 Paul Gauguin (1848–1903), Panneaux de la Maison du Jouir, 1902. © RMN-Grand Palais (Musée d'Orsay)/René-Gabriel Ojéda.

Today even if you offered their weight in gold, you would not find any more of those beautiful objects that they used to make out of bone, tortoise shell, or ironwood. The Gendarmerie has filched everything and sold these objects to collectors, and yet the administration never once thought of doing what would have been easy for it: creating a museum in Tahiti of all Oceanic art.

None of these people who claim to be so educated had any idea of the value of the Marquesan artists. There was not one official's wife who did not exclaim on seeing examples of that art: 'But it's dreadful! It's just plain barbaric!' Barbaric! That's their favourite word.

(Thomson (ed.), *Gauguin by Himself*: 280)

In turning away from the classical tradition, Gauguin was setting a trend for the future in which the aim is not naturalism or idealisation but a kind of free-ranging expression in which possibilities are endless. This relief is subtly coloured and reminds us that this branch of sculpture is the most closely related to drawing and painting, and the fact that it helped to decorate a doorway takes us back to where we began in this chapter and the close alliance of sculpture and architecture which we saw at Autun.

THE RELATIONSHIP BETWEEN RELIEF AND ENGRAVING

Plate 4.15 *The Ascension* by Donatello, *c.*1426

Plates 4.16 and 4.17 The west door of Coventry Cathedral in engraved glass by John Hutton, 1962

Donatello seems to have been fascinated by the pictorial possibilities of carved or modelled low relief, so much so that he developed an even shallower kind, a fine carving technique known as schiacciato, literally meaning squashed relief. One of the most famous of these is the marble relief of *The Ascension with Christ Giving the Keys to St Peter*, in the collection at the Victoria and Albert Museum. Some believe that it was made for the altar frontal in the Brancacci Chapel in Florence, where Masaccio painted frescoes about the life of St Peter. This episode of Christ giving the keys to St Peter is the one part of the story which is not included, so this is why some experts believe that this work may have been intended to complete the cycle.

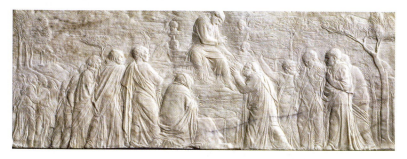

Plate 4.15 Donatello (c.1386–1466), *Ascension with Christ Giving the Keys to St Peter*, c.1426, marble; Italian (Florence). © Victoria and Albert Museum, London.

The schiacciato relief is most obvious in the background where it is used to depict clouds and a landscape with cherubs flying about. The best place to see it in a photograph is between the rock and St Peter in the foreground, where you can see the trees blowing in the wind. The trees appear to be bent by a sudden gust which has arisen at this great spiritual moment. The perspective reaches its vanishing point in the figure of Christ, and His left hand and knee form a diagonal reaching down to the figure of St Peter. The other disciples gather round, together with the Virgin Mary. The vertical and horizontal axes of the design are in the shape of the upper part of a cross with the figure of Christ at its apex. The figures all wear classical robes and look very naturalistic in their gestures and expressions. The carving of the marble is so fine, and so subtly varied, that they seem to be moving and going in and out of focus, as you really might see them. There are classical models in mind to be sure, in the technique, the naturalism and the clothes they are wearing, but this relief has been welded together with the Christian message which makes a powerful and convincing narrative point about the heart of the meaning of the story.

In some ways it can be said that this kind of schiacciato carving, which we have just been looking at, has something in common with engraving, in the sense that you are gouging out material from the surface, and of course, like relief, you cannot see it in the round. One type of work which crosses boundaries of technique and visual experience is engraved glass. One very interesting work in this field is the engraved glass west door of Coventry Cathedral, in which the figures can be seen from both outside and inside the building. Hutton worked with the cathedral's clergy to organise an iconographical programme of relevant saints and angels.

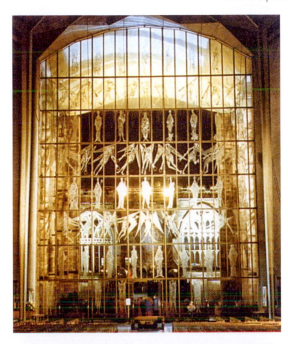

Plate 4.16
John Hutton
(1906–1978),
engraving in the west
screen of Coventry
Cathedral, 1962.
Photo © Martin
Williams.

Plate 4.17
John Hutton
(1906–1978), figure
of St Alban in
engraved glass.
Photo credit: Richard
Sadler, Anthony
Short and Douglas
Stevens.

In many ways the whole idea of this is medieval and certainly the presentation of the figures has a medieval feel to it. The Madonna and Child in the centre at the top is close to a Byzantine format in which the Madonna looks straight ahead and presents the child to us as was done in the idea of the Theotokos and Hagientra. The formalised draperies have more in common with that tradition than with those of Ghiberti or Donatello, reminding us that there was a lot of interest amongst modernist artists of the twentieth century in non-classical traditions. But the most interesting point about this is the way it is affected by the light and sometimes appears translucent and sometimes solid. When you stand in front of this door, that ambiguity between solid and void, transparent and opaque surfaces, makes for an effect which puts it directly in touch with the three-dimensional world of sculpture, especially in the way it connects with the spaces inside and outside the cathedral. It generates a relationship for the spectator between the ruins of the old and the rebuilding of the new, and gen-erates an imaginative connection between the past, the present and the future. The great medieval cathedral at Coventry was bombed in November 1940 and, after 1945, the new one, which was built next to the surviving parts of the old building, became a symbol of postwar regeneration.

RELIEF AND THE IDEA OF INSTALLATION

Plate 4.18 *Thirty Pieces of Silver* by Cornelia Parker, 1988–1989

This installation represents another imaginative idea in relation to more recent developments, where the artist's actions are as important as his or her making skills. For this piece, Parker collected a mass of silver plate, which she found in car boot sales, junk shops and markets. She brought it all together, and then hired a steam roller to run over it and flatten it. Like most types of conceptual art, it is designed above all to involve the spectator and make him or her think, not about space in relation to the body so much, as in the case of Carl Andre whom we looked at earlier, but more about the idea of the story of the thirty pieces of silver, Judas, betrayal, monetary value, property and possession.

But what surprises you about this work is the arrangement of it all into an installation which takes up a whole room. There are thirty sets of objects altogether, each arranged into circles of the same dimensions, and suspended from the ceiling on wires, so they sit just

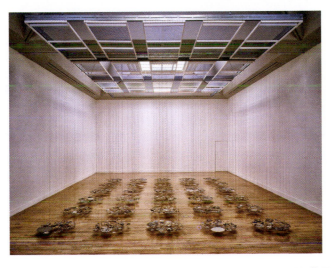

Plate 4.18 Cornelia Parker (b. 1956), *Thirty Pieces of Silver*, 1988–1989. © Tate, London 2013.

above the floor, enough to cast shadows which appear to float underneath. Here, as we have seen in other examples, the lighting is extremely important because you see the reflections of the individual shapes in terms of the reflective surfaces and their shadows. This gives them a pictorial quality, and a sense of their three dimensions, which is then completed by the fact that they are round. Some, like the cutlery or candlesticks, appear translucent and some, like the plates and bowls, are solid, and this creates variety for the eye within the arrangement. There is symmetry, as you would find in coins of the same size or value, or in the reliefs on their surface. So the whole work becomes a visual and aesthetic, as well as a thinking, experience for the spectator. The title sets your mind going in terms of the biblical references, but also in terms of money and possession and meaning. Parker says she is interested in the process of change, and the way one object can metamorphose into another. In many ways, this kind of work can be said to derive from collage because it is not crafted in the traditional sense of that word, but, like artists earlier in the twentieth century (see *Learning to Look at Modern Art* Chapter 5) for instance, she has turned this 'junk' into a form which also has multiple meanings, none of which are certain, but which rely on the spectator's experience to interpret them.

CONCLUSION

You could argue that the modern world of Hutton and Parker, in their desire to communicate, has more in common with Gislebertus than the other examples in this chapter. We should remember perhaps what Renoir told his son about Paul Cézanne being the greatest artist since the Romanesque sculptors. Yet, Cézanne himself really admired the classical tradition, studied sculpture through drawing in the Louvre and wanted to create a new kind of classical art. So, whilst we can talk of artists for and against the classical tradition, much of it has to do with the question of interpretation and context.

Chapter 5

The bust: sculpture and the portrait

INTRODUCTION

The sculpture of head and shoulders is really the equivalent of the portrait in painting, but in three dimensions instead. Like a painted portrait it records a likeness of the person and has been used in that way since classical times. But busts can also be emblematic in the sense that we do not know whether some of the busts from antiquity are actual likenesses or not. The form of the bust was revived in the Italian Renaissance especially because of the love of classical art. Also, by this later period, we can often know how accurate they were from painted portraits of the same people. Busts continued to be sculpted throughout the seventeenth century when the more expressive or expansive figures of the baroque era were developed.

In the eighteenth century neoclassical artists revived the classical bust as a way of commemorating famous men. Busts were placed in galleries, and subjects were extended to include famous philosophers, thinkers, artists and composers rather than just kings, military heroes and statesmen. This is amply demonstrated by the extraordinary collection of busts by eminent eighteenth-century sculptors, such as Michael Rysbrack, at Christ Church library in Oxford, which were described by David Piper in his book *The Treasures of Oxford* as a 'grove of busts!' The form of the bust is still used by institutions to pay homage to eminent figures, like principals or headmasters for example.

However, in this chapter we will also be exploring different aspects of the portrait bust and how it can lead us into a greater understanding of sculpture from other points of view. For instance, it gives us a chance to explore at closer quarters the whole idea of likeness, not just in terms of verisimilitude, but in terms of the essence of the

person. Also, the structure of the human head, quite apart from achieving a likeness, can be of great interest to the sculptor because of the way that you can explore the art of 'the hole and the bump' at close quarters. So much of the traditional skills of modelling and carving are about what recedes and what protrudes in three dimensions. This is what Henry Moore meant when he said that Rodin was interested in 'the art of the hole and the bump' (Wilkinson (ed.), *Henry Moore*, p. 178), as Moore himself also was, in relation to the human body, as we have seen in Chapter 2.

We will also have the opportunity to look at the relationship between painting and sculpture in more detail through the Renaissance theory of the Paragone. Of course, painted sculpture was used in medieval times to enhance the figure of a saint or the Madonna and Child, as we have seen in Chapter 3. But the whole idea of a comparison between painting and sculpture became conceptualised in the Italian Renaissance, from a more philosophical point of view, where it became the Paragone, and the idea that one might be superior to the other. In his 'Notes on Painting' Leonardo da Vinci discussed the idea that painting was superior to sculpture because it allowed the artist to remain elegantly dressed and was not dirty and dusty like sculpture. He also famously thought that the painter's powers of imagination were greater too. There was also the idea during the same Renaissance period in Italy that one might be superior to the other because of the survival of classical sculpture, and therefore the greater accessibility of the classical tradition through making sculpture. This was as much to do with the promotion of the social status of the artist in society as with the fundamental nature of painting and sculpture, because it was thought to require knowledge and education as well as manual skill.

In relation to this there is another set of ideas which is to do with the concept of sculptural expression. Picasso was famously described by his friend Julio Gonzalez (see *Learning to Look at Modern Art* pp. 236–270) as a sculptor because of his fundamental preoccupation with three-dimensional form and its powers of expression. When Picasso turned to the influence of ethnographic sculpture it was for its powers of expression and how it could affect the fetish-like aspects and that feeling of presence, not so much from the point of view of verisimilitude, but more from that of spiritual power. Gauguin had certainly felt this and his knowledge of ethnographic sculpture shows in a piece like the *Self Portrait* of 1889, where he turns the bust into the shape of a pot; moreover, it is perfectly obvious here that he was

not using classical sources, as he was fascinated with forms of the primitive and how they could provide different channels to the spiritual world. Even more interesting is the fact that he knew how to carve marble in a classical way, as the marble bust of his wife, Mette, of 1879, shows. We shall explore these issues in examples by Duchamp-Villon, Modigliani and also Giacometti. Giacometti was also interested in the idea of the essence of the person and we will look at examples of the many versions he made of the head of his brother, Diego. Giacometti was also a draughtsman and painter; many artists regard the two as interchangeable, particularly if the primary interest is in the interaction between space and form. Experiments with the bust were also done, particularly by Russian artists like Gabo and Pevsner, early in the twentieth century, using modern materials, like steel, other metals and early plastics, which we will also look at.

The bust still remains a viable form for contemporary artists such as Maggi Hambling or Emily Young, as we shall see, and they are still working with the traditional skills of modelling and carving which continue alongside the more radical developments in installation art, which we have looked at, and will continue to consider in other chapters.

THE RENAISSANCE REVIVAL OF THE CLASSICAL BUST

Plates 5.1 and 5.2 Bust of *Giovanni Chellini* by Antonio Rossellino, 1456

This is the bust of an old man. It is different from the busts we looked at in Chapter 1 because it is of an ordinary person, not a ruler, and we know who he was. He was a doctor, Giovanni di Antonio Chellini da San Miniato, who looked after Donatello. We know this because Donatello gave him a bronze relief of the Virgin and Child, which was designed in the same year in which this bust was made by Rossellino. Donatello's gift of a relief in bronze was also designed as a glass mould, so that further reliefs could be created from the back of it. Molten glass, probably from Murano, may have been in Donatello's mind, as he had recently been working in Padua, which is close to Venice, and it is thought he may have made the relief while he was still there. We also know that Doctor Chellini was eighty-four at the time this bust was made and we can see that he is an old man because of the way the bone structure of his skull and the character of the skin is revealed as it is stretched over the cheekbones and down

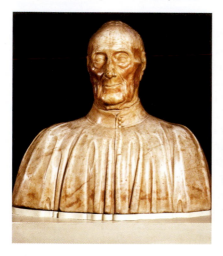

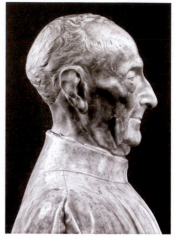

Plate 5.1 Antonio Rossellino (1427–1479), bust of *Giovanni Chellini*, marble, Italian (Florence), signed and dated 1456. © Victoria and Albert Museum, London.

Plate 5.2 Antonio Rossellino (1427–1479), bust of *Giovanni Chellini*, marble, Italian (Florence), signed and dated 1456. © Victoria and Albert Museum, London.

into the hollows beneath. The mouth and chin are similarly shown, as are the deep-set eye sockets. We can see that the mouth might smile at any moment, and the eyes appear to be focussed, even though the iris and pupil are not shown under the heavy lids.

If you start looking at the top of Chellini's balding head and move down over the forehead, you come to the sharply defined eyebrows and the shape of the eye sockets, and the way that the shadow behind the eye is created to reveal the heavy upper eyelids. The eyes themselves can be seen as balls set into the hollows of the eye sockets and the bags below add to the character of the face. This emphasises the way the skin is stretched over the cheekbones and down into the hollows beneath, with the mouth further reflecting the lower structure of the skull. Below that are the folds of skin in the neck before the rim of the collar. The shoulders are set very straight and their horizontality is emphasised further by the vertical folds of his costume. He looks as though he might smile or speak at any moment and appears to be observing you with a kindly but sharply diagnostic eye. Part of the reason for this life-like quality is that it was made from a life cast, a process of working with wax or gesso to take a mould from the head which had been used in antiquity. In his book on Italian

Renaissance sculpture John Pope Hennessy has this to say about life masks for this bust:

> We know that it was made from a life cast, because the features are rendered in great detail and the ears are shown pressed back against the head, precisely as they would have been in a wax or gesso mask . . . Rossellino seems to have had a preference for blotchy brownish marble . . . and he employs it again in the Chellini bust so subtly that the brown stains accentuate the parchment like texture of the skin.
>
> (Pope Hennessy, *Italian Renaissance Sculpture*: 56)

Antonio Rossellino, who made this bust, was part of a family of sculptors living in Florence in the middle of the fifteenth century, where the interest in sculpture centred on realism, as we have already seen in narrative relief sculpture and in the free-standing figure. The most remarkable quality of this sculpture is that, not only is it very life-like, but we also know who the sitter was, and that Chellini himself knew Rossellino and Donatello, which adds to the depth of our understanding and appreciation of him as a sympathetic, clever and characterful old man.

THE BUST AND THE IDEA OF COMMEMORATION

The Baroque bust

Plate 5.3 *Sir Christopher Wren* by Edward Pierce, 1673

Later on, in the seventeenth century, this idea of realism was carried further, by artists like Bernini, into the so-called Baroque bust, where the spontaneity was increased considerably. The bust of Sir Christopher Wren is a good example of this genre. It is altogether more flamboyant than what we have just been looking at because the head is turned at an angle and he is not looking at us but out to the right as you look at him. His hair and clothes are ornate, as was the fashion of the period, and they form a lively frame for the face and add to its animation. The outside edge of the whole composition, together with the integral plinth, makes a kind of lozenge shape out of a series of diagonals which add to the feeling of movement and life. The hair cascades on to the shoulders in waves and contrasts cleverly with the straight column of the neck which you can almost see in the

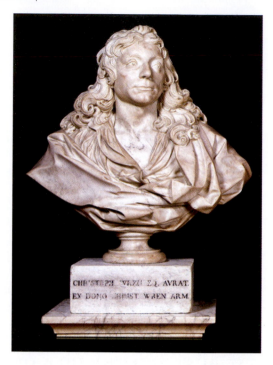

Plate 5.3 Edward
Pierce (*c.*1630–1695),
Sir Christopher Wren,
marble bust, 66.1 cm
high, 1673. © Ashmolean
Museum.

round, with the darkness of the shadow behind setting it off. The drapery, with its folds falling in different directions, adds to that feeling of animation surrounding the face, as if he was about to move in your direction and engage you in conversation. This greater flexibility and spontaneity had been initiated by Bernini in his busts like those of Pope Paul V and the Cardinal Borghese, and continued to be used by sculptors for these sorts of three-dimensional portraits of eminent figures in society.

The neoclassical bust

Plates 5.4 and 5.5 The *Marquis of Condorcet*, 1785 and *Benjamin Franklin*, 1778, by Jean Antoine Houdon

Plate 5.6 *William Wordsworth* by Sir Francis Chantrey, *c.*1820

The idea of being defined by what you had done rather than who you were continued into the eighteenth century in a very interesting way

with what came to be known as the neoclassical bust. In other words, the emphasis was on the ordinary person and what he or she had achieved. One of the most famous of these sculptors was Jean Antoine Houdon, who really became the sculptor of the French Enlightenment; he worked in terracotta and in marble.

This bust seems at once more restrained and more real. The Marquis de Condorcet is shown wearing his hair powdered, dressed and tied at the back with a bow, a cravat, a waistcoat and a jacket which he probably would have been wearing in real life. His eyes are directed away to the right and he looks as though he is listening to what someone is saying. The carving is fine and highly finished, but you feel the differences in the texture of the materials, hair, skin, linen and the cloth of his coat. Condorcet was an important member

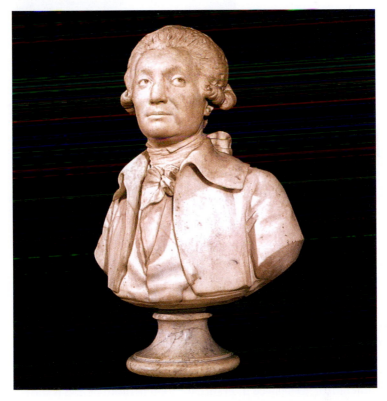

Plate 5.4 Jean-Antoine Houdon (1741–1828), *Marquis of Condorcet*, 1785. Marble, 77.5 × 50.8 cm. American Philosophical Society, Philadelphia, 58. s. 2.

Plate 5.5 Jean-Antoine Houdon (1741–1828), *Benjamin Franklin*, 1778. New York, Metropolitan Museum of Art. Marble. Gift of John Bard, 1872. © 2013. Image copyright – The Metropolitan Museum of Art/Art Resource/Scala, Florence.

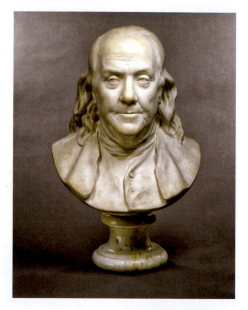

of the Enlightenment in France and was one of the editors of the *Encyclopédie*, along with Denis Diderot, whose bust was also executed by Houdon. The aim of the *Encyclopédie* was to collect all knowledge together, as part of the spirit of enquiry which characterised the Enlightenment, whose ideas spread across Europe and became the expression of liberal and tolerant, political, social and spiritual values. They wanted to revive the classical bust in the Roman manner, but at the same time, artists like Houdon give it a greater feeling of life vitality and actuality.

This is the case particularly with the busts which Houdon modelled and carved of other well-known figures of the period, like Benjamin Franklin for instance; he is shown with his hair loose and receding, his eyebrows bushy and expressive, with lines across his forehead and at the sides and between the eyes. He is looking outwards, slightly towards the left and his mouth is poised as if he is about to speak, and as though he is taking part in a lively conversation which is occurring at that moment. Franklin was one of the founders of the American Constitution, and very familiar with the ideas of the French Enlightenment, as he lived in France for long periods; he too is shown in a cravat, over which his double chin hangs, and a waistcoat and jacket, much as he might have been wearing at the time. The easy

spontaneity of these busts shows these men as if involved with the activities they were known to be connected with at the time, when these portraits were being made.

The sculpture shown in Plate 5.6, a plaster bust of William Wordsworth, we know was made in preparation for a marble one which is now owned by Indiana University; it was part of a bequest of 171 plaster busts left to the University of Oxford by Sir Francis Chantrey's widow in 1842; they are known by the collective title of The Chantrey Bequest and reside in the Ashmolean Museum. Sir Francis Chantrey always began by making a clay model of a head and then did a plaster cast from that, and some, like this one, were then subsequently carved in marble.

The most remarkable quality here is not so much the physical likeness as the expression on Wordsworth's face. You can see the marks of the modelling on the surface and that gives animation as do the pupils of the eyes which have been gouged out. His hair is dishevelled and shown to be receding, which reveals the broad and

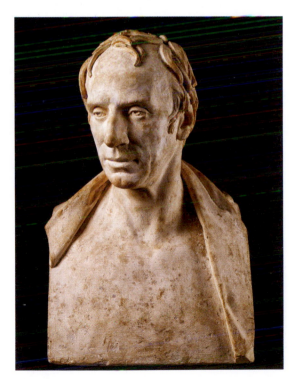

Plate 5.6
Sir Francis Chantrey,
(1781–1841),
William Wordsworth
(1770–1850),
c.1820. Plaster.
© Ashmolean
Museum.

intelligent forehead. Below the chin the neck settles into the chest area which is shown as apparently naked except for the coat thrown over the shoulders which shows more on one side than on the other. He is turned slightly to the left and slightly down so that his whole appearance takes on a faraway look as if composing a poem. At 57.5 centimetres in height it is about life size, which gives the bust added presence and life in relation to the spectator who feels on a level with it rather than dominating it, if it were smaller, or diminished, if it were larger.

OTHER POSSIBILITIES IN RELATION TO THE BUST

Plate 5.7 *Bust of a Young Couple* by Tullio Lombardo, *c*.1490–1495

This beautiful and strange double bust has many striking features about it. First, of course, the fact that it is two people rather than one; second, that it is mounted on a background, but is nevertheless carved from one block of marble. The figures are expressive, with their mouths open, looking in different directions, with the eyes more alive than in many classical busts. Also, they are carved in very high relief,

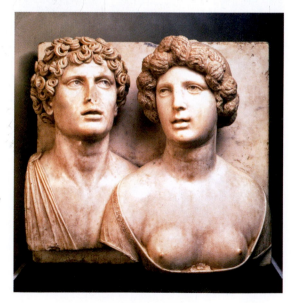

Plate 5.7 Tullio Lombardo (*c*.1455–1532), *Bust of a Young Couple*, *c*.1490–1495. Venice, Ca' d'Oro. © 2013. Cameraphoto/Scala, Florence – Photo Scala, Florence – courtesy of the Ministero Beni a Att. Culturali.

and yet are not free-standing, except for their necks, which are completely in the round if you look at them from the side. The spectator's viewpoint for each head is slightly different, as the man is cut off higher on the chest than the woman, whose breasts hang over the plinth in a very sensual way, with a flower between them, suggestive of nakedness rather than idealised nudity.

In fact, the whole sculpture has a sensual and tactile quality about it, as the marble has been carved so finely that the surface representing the skin appears to be soft and tactile, particularly under the armpits of the woman; in addition, the figures are overlapping and touching one another at the shoulders, which adds to the feeling of intimacy. The hairstyles are elaborate and carved in great detail, so you feel their different surfaces; the man's is deeply cut, with lots of tooling and undercutting, whereas the woman's has a complex surface which acts as a foil to the other, with the line of her forehead more pointed and the man's more horizontal. You wonder whether they have been surprised by someone entering the room, and whether that person is you, the spectator. Apparently, the heads would originally have been set off against a dark background, almost like a cameo, and traces of red colour have been found on the mouths of the faces themselves. This is thought to be a deliberate reference to the classical cameo, which was greatly valued in the Renaissance. The space beneath the man's chest has the name of the artist who made it and it says *Tullio Lombardo fecit*, which makes the acknowledgement part of the whole work in a compositional way.

The fascination of this piece lies above all in its air of mystery, and the questioning which it sets up in the mind and eye of the spectator, about who the people are and what they are thinking about. It is thought to be connected with a particularly Venetian attitude to antiquity which was expressed in relation to painting through the idea of the poesie (see *Learning to Look at Paintings* pp. 171–172 and the Introduction to the second edition pp. xxx–xxxi). It is now thought that this approach also applied to sculpture, where it was able to express a particular kind of dreamlike and contemplative attitude to antiquity, which relied more on classical poetry, and the idea of arcadia – the idealised and poetical interpretation of nature – as expressed in the *Georgics* of Virgil, for instance, or the *Metamorphoses* of Ovid.

Like the paintings of Bellini, Giorgione and Titian of this period, Tullio's sculpture is more about a mysterious and questioning approach, which involves the spectator in a contemplative journey,

which does not rely on any specific narrative or on the identity or portraiture of the figures. This is very like the atmosphere of the famous Venetian poem *Hypnerotomachia Poliphili* by Francesco Colonna, which is considered to be a clear expression of this approach. It was published in 1499 and is about an imaginary journey through antiquity in a dream, and a search by the hero, Polyphilo, for his lost loved one, Polia; it even contains a double bust like this one as one of its illustrations. So, Tullio Lombardo may have made this sculpture for a patron who was interested in this approach to antiquity; part of the reason for this more imaginative attitude is connected with the fact that there were virtually no classical remains in Venice, although geographically it is very near several cities which have antiquities, like Padua, Verona and Aquileia. Lombardo may have been familiar with some of these; for instance, he probably would have known the frescoes by Mantegna in the Ovetari Chapel in Padua which include a double bust like this in the background of the story of St Christopher. Mantegna's way of painting was very sculptural (see *Learning to Look at Paintings* p. 60). There is also the fact that the Lombardi family worked in the church of St Anthony of Padua and would have understood the sculptural realism of the sculpture of Donatello as well (see Chapter 4).

Sculpture and painting and the idea of the Paragone

Plate 5.8 *La Schiavona* by Titian, *c.*1511

Plate 5.9 *Aristotle with a Bust of Homer* by Rembrandt, 1653

The idea of the comparison or competition between painting and sculpture known as the Paragone became important to artists of the Renaissance around this time. Indeed Tullio himself wrote about it in a letter of 1526:

> Painting is an ephemeral and unstable thing, while sculpture is much more incomparable and not to be compared in any way with painting, because the sculpture of the ancients can be seen up to our time, while of their painting there is really nothing to be seen.
>
> (Quoted in Ames-Lewis, *The Intellectual Life of the Early Renaissance Artist*: 153)

Tullio is making the point here that there was indeed no classical painting to be seen, although paintings were described in texts like

that of Philostratus' *Imagines* which were known to the Venetians, as Paul Hills has suggested in his book *Venetian Colour*:

> On the very first page, the Greek author defined painting as 'imitation by the use of Colour'. Painting achieves more by the employment of colour alone Philostratus proposed, 'than do the plastic arts of carving, modelling and gem cutting with all their variety of materials' . . .
>
> (Hills, *Venetian Colour*: 216)

One of the prime movers in this debate was Leonardo da Vinci who wrote in his notebooks that painting is superior:

> There is no comparison between the innate talent, skill and learning within painting inasmuch as spatial definition in sculpture arises from the nature of the medium and not from the artifice of the maker.
>
> (Kemp (ed.), *Leonardo on Painting*: 38)

Leonardo's notebooks were not published until much later, but we know he visited Venice in 1500, and his ideas about how to achieve the effect of relief in painting, by means of chiaroscuro and sfumato, influenced Giovanni Bellini, and particularly Giorgione and Titian (see *Learning to Look at Paintings* pp. 63–66). However, as recent research has shown, Leonardo himself was fascinated by sculpture and he planned to write a treatise on it, and may even have intended his famous drawing of Vitruvian Man as the frontispiece, according to Martin Kemp, writing in a catalogue devoted to Leonardo's sculptural projects.

> It seems highly plausible that the Vitruvian Man was prepared as an introductory illustration or frontispiece for Leonardo's never completed De Statua.
>
> (Kemp quoted in Radke, *Leonardo and the Art of Sculpture*)

The suggestion here is that Leonardo may have been more interested in sculpture than was hitherto thought. But the Paragone remained an important issue in Renaissance theory, and spread into the debates about the superiority of drawing over colour, pursued most notably by Vasari in the preface to the third part of the *Lives of the Artists*, which we will consider in Chapter 7.

It has often been pointed out that Titian made a deliberate visual reference to the Paragone in his *Portrait of A Lady* ('*La Schiavona*'), where he is thought to have extended the size of the canvas to include

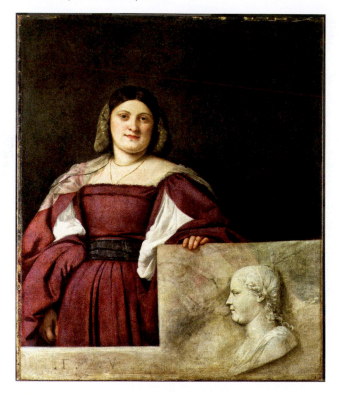

Plate 5.8 Tiziano Vecellio (Titian) (1477/89–1576), *Portrait of a Lady* (*'La Schiavona'*), c.1511. London, National Gallery. © 2013. Copyright The National Gallery, London/ Scala, Florence.

a painting of a relief of her profile, to compare with the full face of the woman herself. In the painting, the understanding of colour used to express form through colour and brushwork is evident, particularly in the treatment of the fabric of the dress (see *Learning to Look at Paintings* pp. 59–60). But the study of sculpture has always been important to painters for the understanding of its tactile qualities. Rembrandt's painting of *Aristotle with a Bust of Homer* is a case in point, where Aristotle places his hand on the head and appears to be thinking about the way it feels as well as about the poet himself. The way that Rembrandt conveys the feeling of the bust, through the hand and the arm of Aristotle, to the expression on his face, encourages the spectator to consider a whole set of ideas connected with tactile experience.

Plate 5.9 Rembrandt (1606–1669), *Aristotle with a Bust of Homer*, 1653. New York, Metropolitan Museum of Art. Oil on canvas, 56½ × 53¾ in. (143.5 × 136.5cm). © 2013. Image copyright The Metropolitan Museum of Art/Art Resource/Scala, Florence.

Daumier and the painter/sculptors: sculpture as caricature in three dimensions

Plate 5.10 *Baron Joseph de Podenas* by Honoré Daumier, 1832

Another dimension in the relationship between painting and sculpture was explored by Daumier in his busts of politicians, of which there are twenty-six altogether, made of pottery clay and painted in oils. They are only 20 centimetres high, so less than a quarter of the size of the other examples we have been looking at in this chapter. Yet the expressive vitality they exude is extraordinary. In this bust of Podenas, nicknamed Pot de Nez, this is achieved by Daumier's ability to exaggerate the features, particularly the nose, and make the eyes extremely

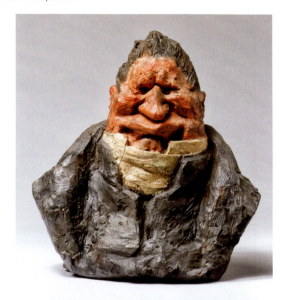

Plate 5.10 Honoré
Daumier (1808–1879),
*Baron Joseph de
Podenas*, 1830–1835.
© RMN-Grand Palais
(Musée d'Orsay)/
Hervé Lewandowski.

close together, and then turn the head into a pyramid so that the
double chin inside the cravat appears even wider and fatter. Also,
the fact that it is painted means that we see the contrast between the
cravat and the double chin more obviously than in the bust of
Benjamin Franklin in the previous section. The charcoal grey of the
jacket also helps with this, and marries the top to the bottom of
the sculpture through colour. The roughened surface also aids the
expressiveness, so that the caricatural quality is conveyed as much by
the texture as by the exaggerated features. The result is hilarious and
not entirely naturalistic; it makes the busts of Condorcet or Benjamin
Franklin seem very real by comparison, and much more like people
you might meet, as they are much closer to life size. These tiny sculp-
tures are a cross between a painting and a sculpture, and were used
by Daumier as the basis for his lithographs of these politicians (see
Learning to Look at Paintings pp. 218–220). The idea of painter/
sculptors was a phenomenon of the nineteenth century in France, and
Edgar Degas is an example of another draughtsman who worked in
sculpture as well as painting and drawing (see Chapter 2).

The bust can also be used as a separate study in relation to a full-
length figure, like Rodin's *Balzac* which we looked at in Chapter 2.
In the plaster model of the head for instance (seen in Plate 5.11 as

the ceramic version) the hair is presented as a series of lumps, as is the moustache, the nose is a blob and there are holes for eyes. Rodin famously referred to sculpture as the art of the 'hole and the bump' and this is a good example of where the expression comes from in the protuberance and recession of different parts of the head.

Another example of an artist moving between painting and sculpture is Picasso who, when he was developing Cubism, explored the human head in the bust of Fernande Olivier. The idea of dividing the face up into planes and putting them together in a new way, which was discussed in *Learning to Look at Modern Art* (see pp. 18–23), was fundamentally about new ways to express three-dimensional form and space on a flat surface. There is also another factor coming to the fore here, and that is the influence of ethnographic sculpture. Picasso's famous visit to the Trocadero Museum in Paris in 1903 is important here (see *Learning to Look at Modern Art* p. 13), but also because ethnographic sculpture offered alternative means of expression which were different and often more powerful than those of the classical tradition.

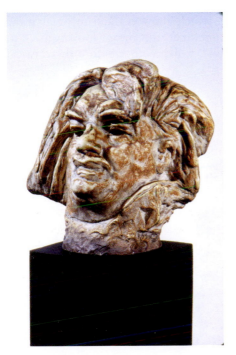

Plate 5.11 Auguste Rodin (1840–1917), *Monumental Head of Balzac,* 1897. Ceramic. 19½ × 18 × 13¾ in. (49.53 × 45.72 × 34.93cm). Milwaukee Art Museum, Gift of the McCrory Corporation M1981.74. Photo credit: P. Richard Eells.

The influence of ethnographic expression

Plate 5.12 *Maggy* by Raymond Duchamp-Villon, 1912

Plate 5.13 *Head of a Woman* by Amedeo Modigliani, 1920

In the head by Duchamp-Villon, the idea of expression which we saw in the head by Daumier is clearly important, but it is being achieved by a different kind of exaggeration of the features. The nose and eyes are enlarged and have become protuberant, emphasising the effect of the eyeball in its socket. The eyebrows are exaggerated too, moving towards an inverted triangle above the nose. The area between nose and upper lip is curved to create an effect of smiling, and the chin is tilted upwards, reflecting the angle of the line of the jaw, moving round to the back of the head. The neck is elongated and simplified like a column, adding to the effect of tension and the feeling of stretching upwards. The bottom of the neck settles beautifully into where the collar bone would be. Altogether, you gain a powerful sense of the presence of this person through these anatomical exaggerations.

The influence of ethnographic art provided artists with a whole host of possibilities for expression, which allowed them to break away from the classical tradition. Sometimes, this meant looking back to earlier periods, like the Cycladic, which comes before the classical

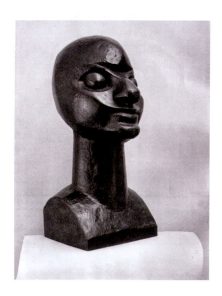

Plate 5.12 Raymond Duchamp-Villon (1876–1918), *Maggy*, 1912. Galerie Louis Carre, Paris. Photography courtesy of the author.

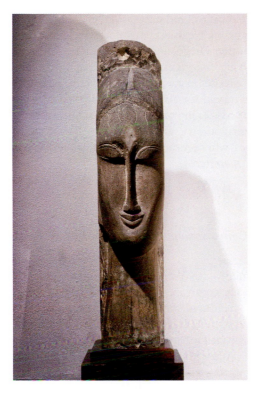

Plate 5.13 Amedeo Modigliani (1884–1920), *Head of a Woman*, 1912. Paris, Musée National d'Art Moderne – Centre Pompidou. © 2013. Photo Scala, Florence.

Greek, which became so dominant. This stone head of a woman by Modigliani is a good example of the influence of the extreme simplification found in these pre-classical sculptures. The head and neck are elongated and the carving is shallow, particularly around the eyes, so much so that they could be closed or open. The nose is long, too, and the mouth small, with upturned corners, and this gives the face a mask-like appearance. The neck is like a column again, but gets wider towards the bottom so that it supports the proportions of the head firmly; this is helped in turn by indications of the hair travelling to the top of the head, and then parted smoothly in the middle so that the line travels down towards the face. The rhythm and relationship of shapes in both these busts by Duchamp-Villon and Modigliani makes you see them as at once more abstract, and more expressive. In both cases the surfaces are much smoother than in the Daumier or the Rodin, but this allows you to see the non-classical forms more clearly.

The combination of simplification and expression, combined with roughened surfaces and exaggerated features, is explored by Giacometti in his series of busts of his brother Diego, and also of the *Venus Women I–IX* (see *Learning to Look at Modern Art* pp. 239–242). The idea behind these heads was more to get inside the essence of the being, so Diego could be used as the model for any number of busts; they do however have certain characteristics in common, like the protuberant eyes and the elongation. Giacometti, like Modigliani, was also an admirer of Cycladic sculptures, whose meaning is ultimately mysterious, as we do not know what they were for.

The bust and its setting

Plates 5.14 and 5.15 *A Conversation with Oscar Wilde* by Maggi Hambling, 1998

This is an example of commemorative sculpture, but in this case it is set outside, in Adelaide Street in central London. It is a bust set on the end of a bench, and the head and shoulders are made to cascade over it, so it becomes integral with it, as if it were a plinth. The texture of the figure is so full of wave-like forms that it is hard at first to decipher the features. You can see that the mouth is open and that the hand is holding a cigarette, so it is almost as if the figure is wreathed in swirls of cigarette smoke, which Wilde regarded as a wonderful pleasure. Hambling is more often represented by her paintings, like the one of the scientist Dorothy Hodgkin, in which the figure appears out of masses of brush strokes. So, you could say that this head of Oscar Wilde is like a painterly bust, because of the way it has been modelled, and therefore relates to other examples in this section because of this. But, of course, it is not painted like the Daumier ones we looked at earlier, and is not intended to be. The texture is achieved by the patina on the bronze, which dictates the way you have to search for the form, and indeed the likeness; the head contrasts very effectively with the smoothness of the granite of the bench, which lends it a sphinx-like quality because of the way the head is perched on the end of the granite slab. It also conveys a feeling of ambiguity and ambivalence about the figure which accords with Wilde's identity in life, as a gay man who was also a husband and father, and the way that tragedy and comedy lie side by side in his work. Wilde's plays, such as *The Importance of Being Earnest*, are hilarious, but there is real sadness in his poems, such as *De Profundis*

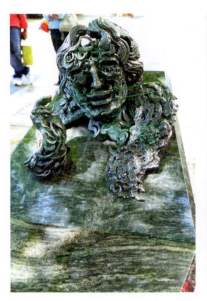

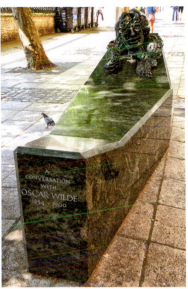

Plate 5.14 Maggi Hambling (b. 1945), *A Conversation with Oscar Wilde*, 1998. Adelaide Street, London. Photography by Finbar Good.

Plate 5.15 Maggi Hambling (b. 1945), *A Conversation with Oscar Wilde*, 1998. Adelaide Street, London. Photography by Finbar Good.

and the *Ballad of Reading Gaol*, which were written at the end of his life, after his trial and imprisonment. Also, as demonstrated here, the relationship between sculpture and painting can be ambivalent and has been the subject of experimentation and argument as we have seen in this section.

The bust as symbolic or visionary

Plates 5.16, 5.17 and 5.18 *Angel Heads* by Emily Young, 2003

These heads, of which there are five altogether, were commissioned by Standard Life Investments in 2003, for the arcaded façade of their building, known as Juxon House, in St Paul's Churchyard, outside St Paul's Cathedral in London. The heads are much larger than life size, and are set on top of round pillars of Portland stone, which are halfway between each square space in the arcading. The heads are also carved in Portland stone, but their plinths and their bases are in darker granite, which makes a tonal contrast with the stone. The

Plate 5.16 Emily Young (b. 1951), *Angel Head*, 2003. © Emily Young.
Photography by Finbar Good.

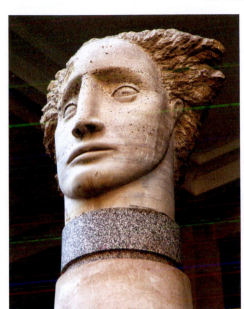

Plate 5.17 Emily Young
(b. 1951), *Angel Head*, 2003.
© Emily Young. Photography
by Finbar Good.

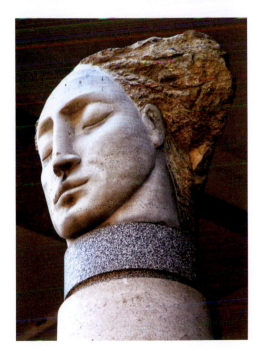

Plate 5.18 Emily Young
(b. 1951), *Angel Head*, 2003.
© Emily Young. Photography
by Finbar Good.

façade is semi-circular, facing the western entrance to St Paul's Cathedral. The heads are classical, like caryatids, but they do not provide any load-bearing support for the structure of the building. The backs of the heads are uncut so it is not clear where they are coming from, and they appear to be about to dissolve back into the stone as though going back to where they came from, into the space behind the square arches. This gives them an otherworldly and moon-like appearance. Their forms are human and differentiated, but universal. One has slanting eyes and another appears to be asleep as its eyes are closed. Yet they are not like portraits; they have broad-browed aquiline faces which appear to be looking out from another world towards the cathedral, creating a suggestion of haunting mystery which brings the commercial and spiritual worlds together in this significant and historic part of London.

CONCLUSION

Less traditional materials, such as plastic and metal, can also be used for making busts. Naum Gabo, and his brother Antoine Pevsner, experimented with this during the avant-garde phase of Russian art,

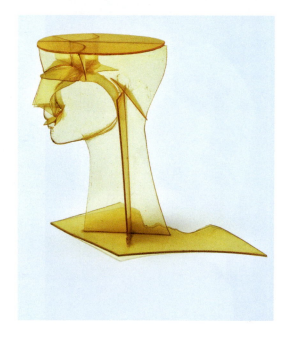

Plate 5.19 Antoine Pevsner (1884–1962), *Head*, c.1923–1924. © Tate, London 2013/ ADAGP, Paris and DACS, London 2013.

in the early 1920s. Here, the form of the head is divided into flat planes which interlock and, by the angles of their curves, express the idea of roundness by means of space. We have already explored this idea in relation to the human figure in Chapter 2.

Another idea in terms of materials would be working in fabric. The work of Louise Bourgeois is a case in point here. Her bust called *Rejection* created in 2001 is made of fabric over steel and lead.

Like all her work this is very emotional; the face looks as though it has staring eyes and the mouth is open with the suggestion of teeth below the upper lip. Bourgeois made sculpture out of all sorts of

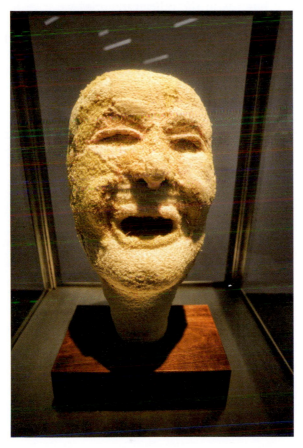

Plate 5.20 Louise Bourgeois (1911–2010), *Rejection*, 2001. © Sergio Goya/dpa/ Corbis/DACS 2013.

materials including tapestry as well as other textiles. She was brought up in a household which repaired tapestries by such illustrious names as Gobelin and Aubusson, so she was familiar with textiles and what they will do. Here she uses fabric in a highly imaginative way to arouse disturbing and unsettling emotions in the spectator. The fabric looks like towelling, giving the bust the comforting appearance of a doll, but the expression is anything but comforting and not what you expect from this material. The bust is mounted on a thin tapering neck as though it is stretched with tension and anxiety. It does not appear to have any hair and so this could be suggesting a prisoner, a cancer victim or someone who has been tortured.

So in the bust, as in the other categories we have looked at, tradition can exist side by side with more unconventional expressions. But the story of the bust and its ramifications does not end there, for the fact remains that busts continue to be made in commemoration; our institutions are full of them where they play a role similar to the full-length commemorative statue, which we will be considering in the chapter on memorials.

Chapter 6

Sculpture, memory and commemoration

INTRODUCTION

This chapter will consider the use of sculpture for different kinds of memorial and commemoration. Since the time of the ancient world memorials have been very important and you only have to think of the idea of the Necropolis or City of the Dead to realise that. The making of tomb sculpture to the great and the good as individuals has long been part of the commissioned side of the sculptor's art, and can involve all the types of sculpture we have considered so far. However, since the nineteenth century particularly, many memorials have been put up in our towns and cities, raising issues about the role of public sculpture more generally; recent debates about the Fourth Plinth in Trafalgar Square in London, or the positioning of the figure of Nelson Mandela, are cases in point. We will also consider the advent of the war memorial in the twentieth century in our towns and villages. The idea of remembering the huge losses from two world wars, which involved so many people and their families over a wide spectrum, has also been a phenomenon of the modern era.

The term commemoration is used widely and loosely to incorporate a number of different kinds of memorial, like the tomb, the effigy, the shrine or the reliquary, and we need to consider these and whether they are truly commemorative or more like the embodiment of an idea. The tomb usually contains the body of the individual to whom it is dedicated, and it may house more than one if it commemorates a family: sometimes this can be a vault or a mausoleum in which several people are buried, as in the mausoleum of the Howard family at Castle Howard in Yorkshire, or the royal one at the Escorial Palace near Madrid. The tomb can also become a building, which brings us to the relationship between architecture and sculpture in the context

of memorial work; we will consider particularly the proliferation of architectural memorials after the First World War.

An effigy on the other hand is a more symbolic representation of a person rather than a likeness and can also be something which is made and then destroyed in a ritual way, as in the case of Guy Fawkes for example. A shrine, however, is usually associated with a particular place where the person concerned was well known in life. In this sense, a shrine can commemorate a lifetime's work or some kind of martyrdom; this often applies to a saint like Thomas Becket at Canterbury or Our Lady of Walsingham. In more modern times you could say that Elvis Presley's home at Graceland in America has become a shrine. Then there is also the concept of the reliquary where some part of a holy person, a saint or a sacred idea can be commemorated, and sometimes even a whole church, like the Santo Church in Padua for instance, which is dedicated to the memory and miracles of St Anthony.

In other words memory plays and has played a very important part in all types of sculpture for a long time, since antiquity. The need for something tangible is important and could apply to the painted portrait as well as the bust, but with sculptural memorials there is also more emphatically the idea of a place to which you go to pay your respects. The Tomb of the Unknown Warrior in Westminster Abbey would be an obvious example of this.

TOMB SCULPTURE: THE RELIQUARY, THE SHRINE, THE EFFIGY, THE EMBLEMATIC MEMORIAL AND THE TOMBS OF INDIVIDUALS

Plates 6.1 and 6.2 The reliquary and shrine to Ste Foy at Conques in south-western France, tenth century with later additions

This small, precious and magnificent figure of Ste Foy (or St Faith) is only 33½ inches or 85 centimetres high. The gold leaf has been mounted over a wooden core and then encrusted with jewels. The saint herself is thought to be entirely legendary in the sense that she is a theological saint; this means that, along with Hope and Charity, Faith may be an adaptation from the idea of the virtues known in the classical world which are referred to in St Paul's letter to the Corinthians. The figure of Ste Foy is strangely powerful with her upright position and staring eyes. The fact that the figure is covered

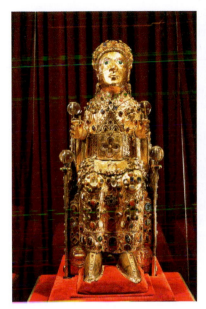

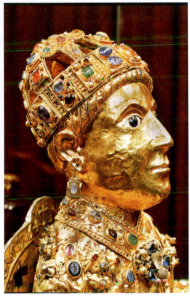

Plate 6.1 Majesty of Ste-Foy, 985 AD. Reliquary statue of the Holy Faith in gold and precious stones. Conques, Abbey of Sainte-Foy. © 2013. DeAgostini Picture Library/Scala, Florence.

Plate 6.2 Majesty of Ste-Foy, 985 AD. Reliquary statue of the Holy Faith in gold and precious stones. Conques, Abbey of Sainte-Foy. © 2013. DeAgostini Picture Library/Scala, Florence.

with gold leaf, which has been beaten out and then studded with jewels, means that the reliquary of the head of Ste Foy cannot be worshipped for itself. The central idea behind a reliquary was that it represented something sacred, associated with the body and living presence of a saint; it acted as a mediator between the human and the divine, between earth and heaven; so it assisted the belief in the promise of eternal life which lies at the heart of the Christian faith; it was also able to perform miracles, which this one apparently did.

But the representation had to be symbolic, with the jewels emitting light and sparkling in a way that was supposed to represent the virtues of the saint's life and character, although St Faith was more abstract, so this represented the embodiment of an idea rather than a commemoration. The fact that this figure is three-dimensional like a free-standing sculpture did lead to questions as to whether it might be an idol. There is a remarkable description of these types of figures

by Bernard of Angers. In 1014 he was sent to investigate this figure and others like it; although he started out as sceptical, in the end he had to admit the spiritual power of the image. In the book of the *Miracles of St Foy* he wrote:

> A venerable and antique custom exists both in the lands of Auvergne, Rodez, and Toulouse, and in the neighbouring regions. Each district erects a statue to its saint of gold, silver, or another metal depending on its means, inside which either the saint's head or some other venerable part of his body is enclosed . . .
>
> I contemplated for the first time the statue of St Geraud standing on an altar, a statue remarkable for its fine gold, its stones of great price and reproducing with such Art the features of a human face that the peasants who looked on it felt themselves pierced by a penetrating gaze and sometimes thought that they glimpsed on the rays from his eyes the indication of a favour more indulgent to their wishes . . . Finally on the third day we came nearer to St Foy [of Conques]. It happened by good fortune and by chance that when we entered the monastery the secluded place was open where the venerable image is kept. When we arrived before it, we were so cramped because of the great number of the prostrate faithful that we could not ourselves bow down. This annoyed me and I remained standing to look at the image.
>
> (Bernard of Angers, quoted in Duby and Daval,
> *Sculpture: From Antiquity to the Middle Ages*: 336)

Thus Bernard realised that the power of such statues lay in their spiritual rather than their physical presences so they could not be considered as idolatrous.

We can feel something of this sense of the sacred partly because of the way Ste Foy is housed separately in the treasury, but also because of its staring expression, its stillness and rigidity and the fact that it is not naturalistic but beautiful and exquisite as a piece of design. It is too small to be truly representational like a life-sized free-standing figure, and also not realistic enough for you to believe that it could be made of flesh and blood. The position of the body is hieratic and strangely abstract, with its feet like solid pyramidal shapes of gold. The head and neck are framed and emphasised by the crown above, and by the jewelled collar below, which comes down to a point and joins the triangular frame of the emblem on the chest. Then there is a sort of gold apron on the lap, which is slightly curved. The arrangement of the jewels on the knees expresses the shape of that part of

the body, while the lower legs are shaped by a more elongated configuration of gems.

Gradually, as you go on looking at this figure, you see that the staring eyes are in line with the setting of the stones moving down the body. One is reminded of the idea that one of the sacred qualities of the saints was that they were supposed to emit sparks of light like jewels. But, in a way, the really interesting point about this figure is that you do not really need to know that, or any of the rest of the iconography, in order to be impressed by it. Its power lies in its design as well as its associations, and its ability to visually link us with the philosophy, beliefs and mysteries of the medieval era, where spiritual communication was of the utmost importance. The way that the figure developed over the centuries and was added to makes the embodiment even more powerful. It is thought that the head may even have been started from a Roman bust and the body from a crude wooden carcase, and then gradually evolved into the effigy we see today. The transformation which can be wrought through painting, decoration and polychromy was recently demonstrated in an exhibition called *Wonder* at the Henry Moore Institute in Leeds.

Effigies and emblematic memorial sculpture

Plates 6.3, 6.4 and 6.5 The effigy of a knight (probably William de Valence who is known to have died in 1282) in Dorchester Abbey, Oxfordshire, late thirteenth century

This remarkable limestone figure is in many ways not what you would expect to find on a tomb, because it seems so alive. The knight is lying on top of his sarcophagus, but his body appears poised for action, as both his hands are grasping the handle of his sword, as if he were about to draw it. His head, which rests on a pillow, looks straight up with the mouth slightly open and the eyes alert. Then, his body is twisted half on to its side, with the legs crossed as if turning to get up. One foot rests on a lion at the foot of the stone slab on which he is lying. The vitality and dynamic tension in this recumbent figure seems to contradict the whole idea of the stillness of death. This effect is greatly added to by the variety in the carving and the use of different textures to create the feeling of changes of surface.

First, there is the contrast between the chain mail and the folds of the tunic; in the area below the waist and between the legs, the shape

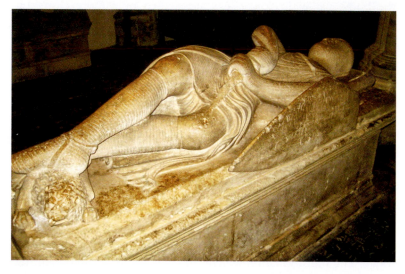

Plate 6.3 Effigy of a knight, Dorchester Abbey, late 13th century. Reprinted by kind permission of the Rector and Churchwardens at Dorchester Abbey. Photography by John Acton.

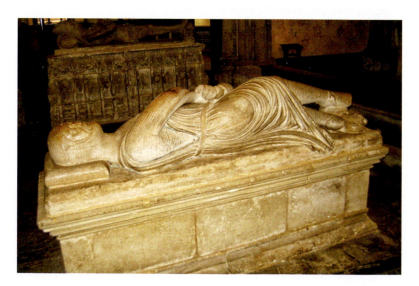

Plate 6.4 Effigy of a knight, Dorchester Abbey, late 13th century. Reprinted by kind permission of the Rector and Churchwardens at Dorchester Abbey. Photography by John Acton.

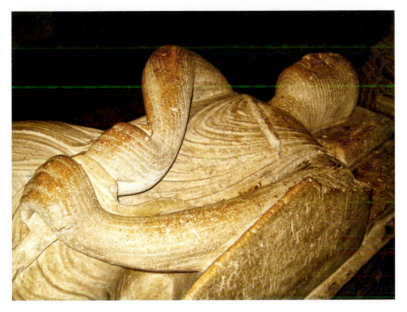

Plate 6.5 Effigy of a knight, Dorchester Abbey, late 13th century. Reprinted by kind permission of the Rector and Churchwardens at Dorchester Abbey. Photography by John Acton.

where the chain mail is revealed is triangular and contrasts with the wavy and curving movement of the drapery of the tunic; this effect is even more remarkable from behind where it drops under the armpit in a triangle, curves over the hip and cascades in semicircles and a V-shape behind. You can see the movement of his right arm which stretches back across the body to reach in front to the hilt of his sword, while the left arm is straight. Both arms are patterned with the texture of the chain mail. The folds of the tunic on the chest are curved and reflect the form of the torso underneath and mark where the shoulders join the upper body. Very effective too is the way the arms enhance the sense of the bulk of the body. So, the head moves one way, the torso another, and the legs another.

Further down, the pattern of the material expresses the whole area of the thigh and the fact that the leg on the left is more or less straight while, on the other side, the leg is bent and has more emphatic curves. In this way, the drapery is used by the sculptor to emphasise the twist and movement in this figure. This is particularly true if you look at it from behind where the curves across the back and down over the legs

are positively serpentine. The triangular shape made by the arms in front is echoed by another one coming out over the upper legs with its apex in the joined hands. This knight is in fact lying next to his shield which provides a straight line against all the curves, and then allows the eye to wander up to where the rectangular pillows are supporting the more simplified forms of the head and neck. This is also true of the area around the lower legs, which echoes this greater simplicity. Therefore all the movement is in the central section, and contained by the forms at either end, and this is particularly the case I think if you look at the sculpture from there. It is possible that the whole tomb was designed to be free-standing in the sense that you can walk right round it, and see the effect of the different angles, which create that strong sense of life and vitality which is the hallmark of this piece of funerary sculpture.

The emblematic memorial

Plate 6.6 The Jesse window in Dorchester Abbey, Oxfordshire, fourteenth century, and the Jesse figure at St Mary's Priory, Abergavenny, Monmouthshire, fifteenth century

In the same abbey church at Dorchester there is another kind of commemoration in the Jesse window on the north side of the Sanctuary. Designed probably in the fourteenth century, this commemorates the ancestry of Christ from Jesse's son King David through to Jesus Himself. The format of the sculpture shows the tree of life growing out of the navel of the reclining figure of Jesse, and travelling up into the stone tracery of the window. It is thought to be similar to what the much larger figure of Jesse, in carved oak, at St Mary's Priory Church at Abergavenny would have been like if it had not been defaced at the Reformation, except that it would have been placed against a wall rather than expressed in a window. In Dorchester Jesse is depicted in high relief around his head, but still attached to the back plate. This helps to support the stone tracery of the window, which consists of five verticals, each with five high relief figures placed near the intersections where the 'branches' come out, so that it looks as though it is growing, with each one depicted as having nodules coming out of it. The whole window seems full of life, appropriate to a literal and yet abstract interpretation of the idea of a family tree. Jesse himself is depicted as bearded, with drapery in wide folds over his legs and knees. His arm moves forward to the hand which

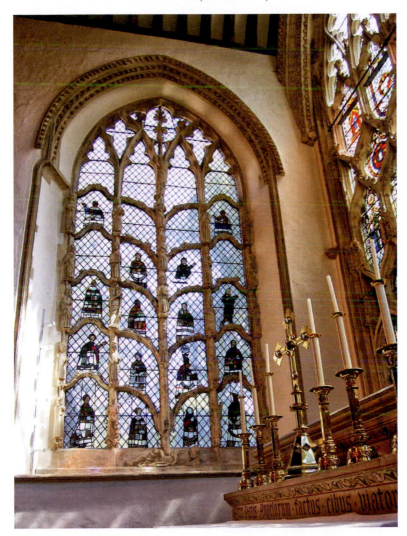

Plate 6.6 Jesse window, Dorchester Abbey. Reprinted by kind permission of the Rector and Churchwardens at Dorchester Abbey. Photography by John Acton.

holds a scroll and he rests his head on the other arm. His whole figure lies there serenely supporting the Tree of Life.

The Jesse figure at Abergavenny (Plates 6.9–6.11) would originally have been constructed using this sort of layout. As it is, the Tree of

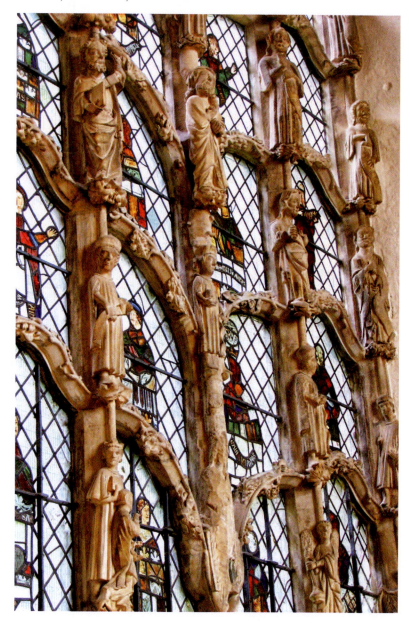

Plate 6.7 Jesse window, Dorchester Abbey. Reprinted by kind permission of the Rector and Churchwardens at Dorchester Abbey. Photography by John Acton.

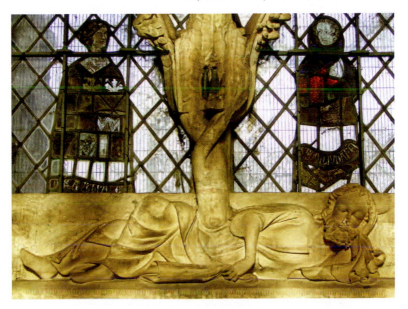

Plate 6.8 Jesse window, Dorchester Abbey. Reprinted by kind permission of the Rector and Churchwardens at Dorchester Abbey. Photography by John Acton.

Life has gone and we are left with a magnificent wooden figure as the embodiment of an abstract idea; it was carved from one piece of English oak, and has an overall appearance still reminiscent of the massive tree trunk from which it was carved.

The fifteenth-century oak has gone grey so it looks like stone and from behind you can see the chisel marks made by the carver or carvers making the figure. From behind it looks like a huge hollowed-out piece of wood and this would have been placed up against the wall with the Tree of Life rising from it. From the front it still feels enormous and solid, with the draperies expressing the bulk through the semicircular ridges over the chest and the straighter folds of the tunic underneath, and then still more drapery travelling further down the body. On top of his head Jesse wears an eastern-style headdress, and his pillow is supported by a curly-haired angel. His face is naturalistic and somewhat classical in its regular proportions, particularly in the spacing of the eyes and the straight nose. The hair flows into the beard which is divided into regular textured sections, and the line of the mouth echoes the shape where the edge of the hat meets the

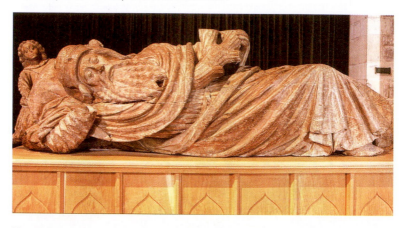

Plate 6.9 Jesse figure, St Mary Priory Church, Abergavenny, Monmouthshire, 15th century. Photography by R.J.L. Smith of RJL Smith & Associates, Much Wenlock, Shropshire.

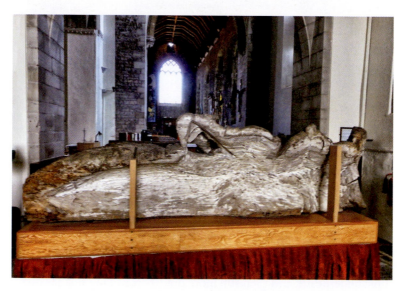

Plate 6.10 Jesse figure, St Mary's Priory, Abergavenny, Monmouthshire, 15th century. Reprinted with kind permission of St. Mary's Priory Church, Abergavenny. Photography by John Acton.

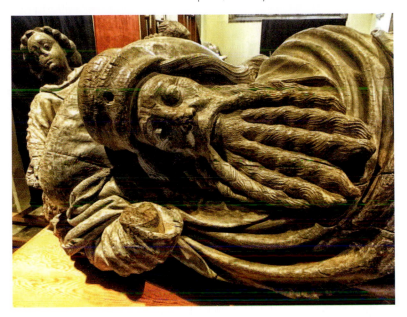

Plate 6.11 Jesse figure, St Mary's Priory, Abergavenny, Monmouthshire, 15th century. Reprinted with kind permission of St. Mary's Priory Church, Abergavenny. Photography by John Acton.

forehead. The arm on the left is a fragment, as is the place where the ancestral tree begins, and yet the overall shape is very satisfying in terms of its mass and its outside edge. Originally it would have been painted of course and, although we may like the grey and stone-like character of the wood, it would not originally have appeared like that and might well have seemed garish to our eyes and certainly very different. Even so, it tells us much about the wealth and quality of English medieval sculpture, and makes us more aware of what must have been lost at the hands of the Iconoclasts, during the period of the Protestant Reformation in England.

The tombs of individuals and their interpretation at different periods

Plates 6.12 and 6.13 The tomb of Alice, Duchess of Suffolk, St Mary's Church at Ewelme, Oxfordshire, *c.*1475

Plate 6.14 The model for the tomb of Niccolo Forteguerri by Andrea del Verrocchio, *c.*1476

Plate 6.15 The tomb of the Blessed Ludovica by Bernini, San Francesco a Ripa, Rome, 1671–1674

Plate 6.16 Memorial to the Duke of Argyll by François Roubiliac in Westminster Abbey, 1749

When you enter St. Mary's Church in Ewelme, completed around the middle of the fifteenth century with its perpendicular east window and its equally shallow arched ceiling, you feel you are standing in a simple parish church and you would have little or no idea that it contained such a grand tomb as this. This is a memorial to Alice de

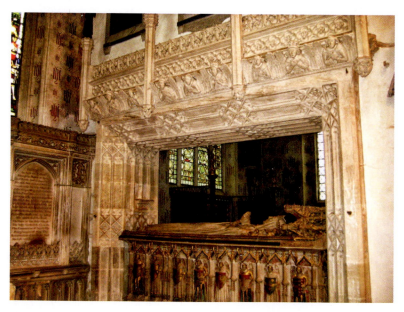

Plate 6.12 Tomb of Alice, Duchess of Suffolk, St Mary's Church at Ewelme, Oxfordshire, *c.*1475. Courtesy of the Trustees of the Ewelme Almshouse Charity. Photography by John Acton.

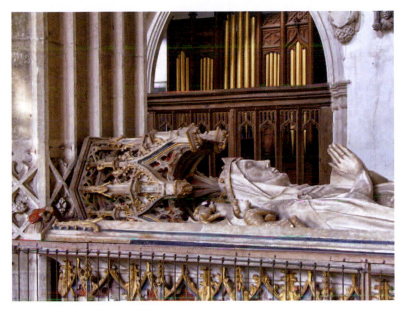

Plate 6.13 Tomb of Alice, Duchess of Suffolk, St Mary's Church at Ewelme, Oxfordshire, c.1475. Courtesy of the Trustees of the Ewelme Almshouse Charity. Photography by John Acton.

la Pole, who was the granddaughter of the poet Geoffrey Chaucer, the author of *The Canterbury Tales*. The Chaucer family had close associations with Ewelme because Alice's father, Thomas Chaucer, who became Constable of Wallingford Castle, married the owner of Ewelme Manor.

Alice's tomb itself is a superb example of carving in alabaster, a stone which is similar to marble in many ways, but softer and easier to carve; it is also more fragile and when thin, takes on a remarkable translucent quality, being used for windows before glass was commonly available.

When you look at Alice's head in detail, you can see this in the carving of the nose when it appears with the light from the window behind shining on it. She wears the Order of the Garter on her left arm, and the hands are pressed together in the praying position. She is dressed in the costume of a Vowess, a widow who has taken the vow of chastity for the rest of her life. Her husband, William de la Pole, was murdered in 1448 and she lived on until 1475; it was her son John, the second Duke of Suffolk, who commissioned this tomb.

The face itself seems more like a portrait than an emblematic or symbolic image as it is full of character, with its long nose and slightly protruberant upper lip and firm chin, accentuated by the wimple which spreads beneath and over her chest in graceful semi-circular folds; this is echoed by the circle of the coronet on her head. Then, the veil and dress contrast with this as their folds are straight and deeply carved, giving her figure a long, horizontal and peaceful quality; she looks as though she is at rest. The real body is contained within the chest immediately beneath which is richly decorated with gilded and painted figures carrying shields decorated with coats of arms, all wearing coronets and wings, some dressed as knights in armour and some wearing clerical tunics. Above them are a row of pointed arches which are joined together in a decorative and rhythmic way.

 Much of this decoration is gilded and painted giving the surface of the tomb a rich and colourful decorative appearance, especially the golden knight figures which are set off by what looks like a green cloak behind; similarly the trefoils above them are coloured. There is gilding on Alice's coronet and on the angels which support her pillow; above that there is an elaborate gilded and painted canopy. At her feet there is a ledge on the same level possibly to support candles to light the figure. Then, beneath this, there is a lower section which is much plainer, with a row of unglazed gothic windows through which you can view a stone sculpture of the skeletal and haggard body precisely as it would look in death, perhaps following illness.

The whole tomb is surrounded with a stone carved frame, but this is not a wall tomb in the normal sense as it was obviously designed to be seen from both sides, though not from either end, and so therefore it is not free-standing. This frame is beautifully carved, with upright and horizontal decoration, and above it a deep lintel decorated with stone angels in relief and hexagonal pilasters topped with more angels, carved in oak this time and standing on guard over Alice. The effect of this rectangular stone frame around the tomb is to add monumentality to the figure and it makes a setting which asks to be noticed; it is grand and yet intimate at the same time because you see it from both sides and can look closely at the figure although it is placed slightly higher than eye level. In the intimate space of this quiet interior you are invited to contemplate the idea of death and the possibility of eternal life.

The move from a recumbent effigy to a live figure on a tomb dates from the late fifteenth century, most probably in Italy. This marks a

move to naturalism which we have noticed in other sculptural types and this can be applied equally to tomb sculpture as to other categories. The revival of the classical language of sculpture can be tracked in relationship to memorial sculpture just as it can in the rest, as we have seen in other chapters, on the relief, the bust or indeed the group sculpture. In tomb sculpture the sources are not so literal, but the classical revival is there very clearly in an example like the monument to Niccolo Forteguerri by Andrea del Verrocchio in Pistoia Cathedral. More interesting perhaps is the terracotta model for this tomb which was subsequently altered. If we look at the model or bozzetto for this (see Plate 6.14) we will see that it is on a much smaller scale and is a high relief sculpture set in a frame in terracotta, 39.4 centimetres by 26.7 centimetres. The figure of Christ is set in an oval mandorla surrounded by angels, beneath which is the figure of Charity. The cardinal himself is seen below kneeling on a sarcophagus with the figure of Faith to the left and Hope to the right. It was designed to be a wall tomb so was not meant to be seen in the round. Instead, it looks like an enormous three-dimensional picture in which all the

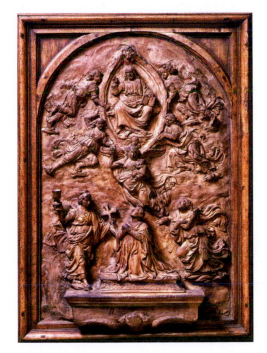

Plate 6.14 Andrea del Verrocchio (1435–1488), model for the Monument of Cardinal Niccolo Forteguerri, Florence, Italy, 1476. © Victoria and Albert Museum, London.

figures are presented as naturalistic, with the use of lyrical and flowing classical draperies to create movement throughout the composition. This is exactly contemporary with Alice de la Pole's tomb and yet the language of sculpture is quite different.

Later on, the classical language of sculpture continued to be stretched to the point where it became extreme in the Baroque era. Just as we saw with his figure of David, Bernini shows a dynamic energy in the treatment of the marble in the figure of the *Blessed Ludovica Albertoni*. Ludovica lies on her bed and is writhing in a combination of agony and ecstasy. Here the boundaries between the spiritual and the sensual are blurred so that we, as the spectators, feel we might be intruding on a private moment in this woman's life. Like the famous *Ecstasy of St Teresa* (see *Learning to Look at Paintings* pp. 78–80) this is designed to be seen from one angle in the nave of the Church of San Francesco a Ripa in Rome, and is set behind a proscenium arch, making it more like a tableau vivant than a sculpture, and the red jasper bed cover adds to the feeling of voluptuous and expressive sensuality. The marble is cut and polished so that it seems to move before your eyes, and the boundaries between painting, sculpture and architecture seem to coalesce into one combined sensual experience, for the sake of inspiring your emotions and your piety, as the Council of Trent had decreed (see *Learning to Look at Paintings* pp. 89–93).

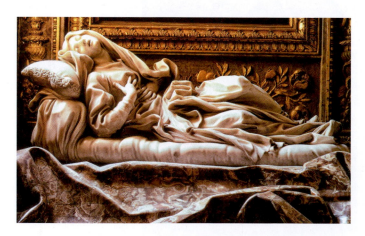

Plate 6.15 Gian Lorenzo Bernini (1598–1680), *Blessed Ludovica Albertoni*, marble. Church of San Francesco a Ripa in Rome, Lazio. © 2013. DeAgostini Picture Library/Scala, Florence.

The Duke of Argyll, who is commemorated in the sculpture shown in Plate 6.16, was famous as a politician and soldier. Between 1700 and 1714 he was a general who had fought alongside Marlborough in the War of the Spanish Succession at battles like Blenheim, and played an important part in the suppression of the Jacobite rebellion in Scotland in 1715. His tomb is presented in pyramidal form, with black marble in the centre for the plinth and sarcophagus, a large inscription on a different coloured marble above and at the back. Then, lower down there is represented in white marble a figure of Fame who appears to be helping to write on this tablet. Beneath her is a seated half-reclining figure of Argyll himself in Roman costume. Beneath this, and much nearer the viewer, are the figures of Eloquence on the left and Wisdom on the right. The most striking thing about the arrangement is the way this group is gesticulating as though taking part in a drama, particularly the figure of Eloquence who stretches a hand out to the spectator as if asking them to stop and hear the themes that they are propounding; in order to achieve fame, you need not only military prowess but also wisdom and eloquence, achieved by Rhetoric and the study of the classical past. Beneath her feet, Eloquence has two volumes, Caesar's *Commentaries* and the speeches of Demosthenes. So you could say that here is an example of spectator involvement which is secular rather than religious and that this is what the patrons of the eighteenth century wanted.

If you saw this monument in Westminster Abbey you might give it no more than a passing glance or walk straight past it to go to Poet's Corner or the tombs of the kings and queens of England. Everyone normally associates Westminster Abbey with the history of England and particularly of its monarchy. However, what was less well recognised until recently is that the abbey is also home to a considerable number of fine eighteenth-century, mainly marble, funerary monuments. In his book *The Silent Rhetoric of the Body*, Mathew Craske has written about eighteenth-century English memorial sculpture as having an iconography of its own and as being regarded by contemporaries as valuable and worth spending considerable amounts of money on:

It is notoriously difficult to gain an accurate sense of the real cost of luxury goods in the eighteenth century. However whilst a butler could be engaged at six guineas per annum, an ambitious monument with numerous figures was likely to cost two or three thousand pounds . . . Such was the expense that this was the only

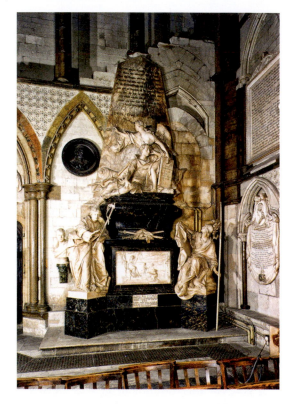

Plate 6.16 Louis François Roubiliac (1702/5–1762), John Campbell, 2nd Duke of Argyll (1680–1743). Tomb. Sculpture, 1745/49, London (England), Westminster Abbey. © akg-images/A.F. Kersting.

type of art made in London that was routinely subject to legal contract, in order to protect the investments of sculptors and patrons alike. So important were tomb commissions to London's sculptors that they became the only form of art that was routinely 'puffed' – that is, advertised in the form of planted reviews in the society columns of newspapers.

(Craske, *The Silent Rhetoric of the Body*: 31)

Also, there seems to have been an audience for this kind of work and it became the subject of publicity and critical review, particularly in Westminster Abbey where interestingly Roubiliac was able to use a modified version of the language of the kind of dramatic sculpture we have just been looking at in the previous section:

The sculptural conventions that had been invented to commu-nicate the zeal of Counter Reformation piety, or represent the

masculine military authority of the continental absolutist state, were converted to the cause of fashioning the heroes of a liberal Protestant polity. Roubiliac's spectacular, highly illusionistic, military allegories in the Abbey had the effect of transforming the nave into a theatre of militaristic spectacle.

(Ibid.: 91)

So it is being suggested here that there was a move away from the religious message in tomb sculpture in the eighteenth century to the idea of nationalism, heroism and echoes of Greece and Rome. We may well find a monument like this pompous and overblown, and the allegory itself is incomprehensible unless you know what it is about. But, once we understand the cultural context, we can see why it looks as it does. Certainly, monuments like this cost a great deal of money, and they also bestowed great fame on their creators. Whether we like it or not there is considerable skill required for the designing and making of a monument like this.

The proliferation of more secular memorials continued in the nineteenth century where they were often put up outside. If you just take London for example, it seems there is memorial sculpture everywhere you go, and everywhere you look.

Nelson's Column in Trafalgar Square is a fine example of this; designed by William Railton, with the figure carved by Edward Hodges Baily, it was erected in 1843 to commemorate Nelson's great victory at the battle of Trafalgar in 1805. The whole conception, incorporating as it does a fine piece of urban design, was always intended for use by the public.

A little further behind, in St Martin's Place outside the National Portrait Gallery, we find the monument to Edith Cavell, nurse and heroine of the early years of the First World War, which is typical of the kind of naturalistic carved or cast figures which exist all over London. They are important from the point of view of history, gratitude and remembrance. The idea of remembrance became even more important in the twentieth century, particularly after the Armistice in 1918, and this is what we will go on to look at in the next section.

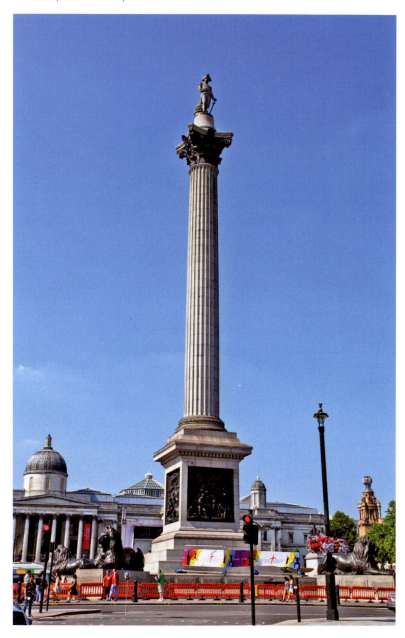

Plate 6.17 Edward Hodges Baily (1788–1867) (designed by William Railton), Nelson's Column, 1843, Trafalgar Square, London. Photography by Finbar Good.

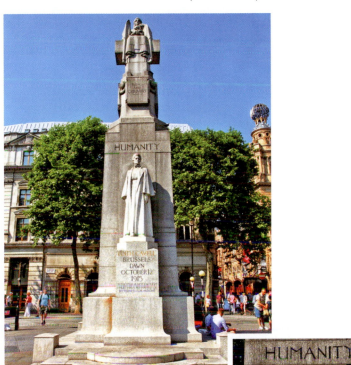

Plate 6.18 George Frampton (1860–1928), statue of Edith Cavell, 1920, St Martin's Place, London. Photography by Finbar Good.

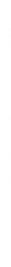

Plate 6.19 George Frampton (1860–1928), statue of Edith Cavell (detail), 1920, St Martin's Place, London. Photography by Finbar Good.

ARCHITECTURE AND THE MEMORIAL

Plates 6.20 and 6.21 The Cenotaph in Whitehall, by Edwin Lutyens, from 1919

Plates 6.22, 6.23 and 6.24 The War Stone: the British Cemetery at Bagneux, Gézaincourt near Doullens, northern France, designed by Edwin Lutyens and installed from 1918

Plates 6.26, 6.27, 6.28 and 6.29 The Royal Artillery Memorial at Hyde Park Corner by Charles Sargeant Jagger, 1925

Plates 6.30, 6.31 and 6.32 The Memorial to Bomber Command overlooking Green Park in London, by the sculptor Philip Jackson and the architect Liam O'Connor, 2012

Plate 6.33 The Vietnam Veterans Memorial, Washington D.C. by Maya Ling Lin, 1982

Plates 6.34 and 6.35 The Holocaust Memorial, Judenplatz, Vienna, by Rachel Whiteread, 1995–2000

The idea of the interaction between architecture and sculpture is nowhere clearer than in relation to war memorials which proliferated most notably after the First World War. Amongst the most famous of these is the Cenotaph in Whitehall, London, designed by Edwin Lutyens, together with his concept of the War Stone, particularly for the cemeteries in France. But the encounter is also very clear in the Royal Artillery Memorial by Charles Sargeant Jagger at Hyde Park Corner in London for which Lutyens also submitted a design. These three examples are all associated with the First World War memorials, but the same kind of architectural and sculptural qualities apply to the Vietnam Memorial in Washington by Maya Lin and most recently the Holocaust Memorial in Vienna by Rachel Whiteread, completed in the year 2000.

The Cenotaph memorial has always been regarded as extremely effective since the first temporary wooden structure was erected in 1919 and thousands of people started walking past to pay their respects on the first anniversary of the Armistice. Set in front of the Foreign Office building on one side and Richmond House on the other, it is also within sight of Big Ben and the Houses of Parliament. Whitehall itself slopes down from Trafalgar Square and widens at this point; also it turns a shallow bend so you do not see the Cenotaph immediately but it gradually comes into view in a very effective way

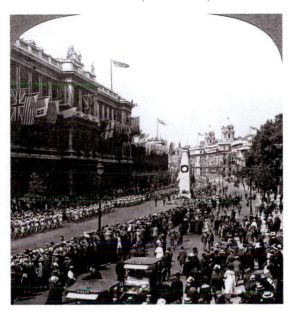

Plate 6.20 Indian troops saluting at the Cenotaph, Whitehall, London, c.1920.
The Cenotaph was designed by Edwin Lutyens (1869–1944). Stereoscopic card
detail. London, The Print Collector. © 2013. Photo: The Print Collector/Heritage-
Images/Scala, Florence.

and appears to grow to its full height in that wider section as you walk
towards it. The basis of Lutyens' design is complex:

> He used entasis with the result that the horizontal surfaces are
> arcs of a circle with a centre nine hundred feet below ground level.
> The vertical surfaces all taper so that they would meet 1000
> feet above the ground if extended. The calculations were so
> complicated that they reputedly occupied thirty three pages of a
> manuscript book.
>
> (Skelton and Glidden, *Lutyens and the Great War*: 43)

This monument is very plain with three steps at the bottom. As it
narrows to the top there is an open tomb with a circular wreath on
top like the one on the side as you approach from Trafalgar Square.
Symbolism is very important here and made still more focussed by
the wreath of poppies which is always there. In his book *The Great
War and Modern Memory*, Paul Fussell has this to say about the
significance of the poppy:

Plate 6.21 Edwin Lutyens (1869–1944), the Cenotaph in Whitehall from 1919 © Martin Jones/Corbis.

One of the neatest turns in popular symbolism is that by which the paper poppies, sold for the benefit of the British Legion on November 11, can be conceived as emblems at once of oblivion and remembrance: a traditional happy oblivion of their agony by the dead, and at the same time an unprecedented mass remembrance of their painful loss by the living. These little paper simulacra come from pastoral elegy (Milton's 'Arcadian valleys purple all the ground with vernal flowers'), pass through Victorian sentimental poetry, flesh themselves out in the actual blossoms of Flanders, and come back to be worn in buttonholes on Remembrance Day.

(Fussell, *The Great War and Modern Memory*: 248)

So the idea of the poppy and the fact that it grew in such profusion on the Western Front becomes joined up with the national memory in a way which gives it greater significance. It was the first colour to appear after great disturbance of the earth. Behind the Cenotaph itself there is also movement with the gentle slope past the entrance to Horse Guards Parade and the gradual curve round. In this sense the Cenotaph is also a very good example of urban design and presents a still sculptural focal point within the movement created by the

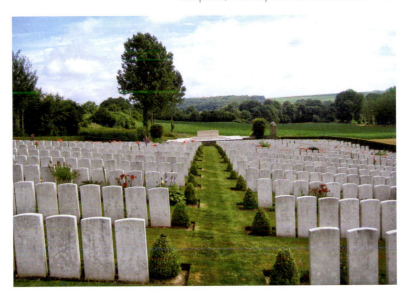

Plate 6.22 Edwin Lutyens (1869–1944), view of the War Stone and graveyard at Bagneux from 1918. Photography by John Acton.

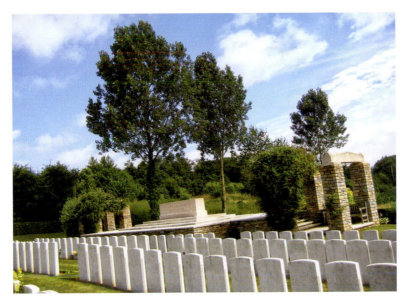

Plate 6.23 Edwin Lutyens (1869–1944), view of the War Stone at Bagneux from 1918. Photography by John Acton.

geography of the site, and of course, the constant streams of traffic both ways. Also, the Cenotaph is non-denominational, and so can provide a focus of memory and respect for everybody, right in the heart of London, where the main government offices still are. It is politicians after all who send soldiers to do their bidding.

The problem for a memorial where large numbers of people of different backgrounds, nationalities and beliefs are involved is that it needs to be more abstract so that all those concerned can relate to it. For this reason alone Lutyens' idea of using a war stone, which could be placed at each war grave site, was very imaginative. From the beginning he had a clear idea about its shape and form and what it should communicate.

> On platforms of not less than three steps the upper and the lower steps of a width twice that of the centre step to give due dignity: place one great stone of fine proportion 12 feet long set fair and finely wrot – without undue ornament and tricky and elaborate carvings and inscribe thereon one thought in clear letters so that all men for all time may read and know the reason why these stones are so placed throughout France – facing the west and facing the men who lie looking ever eastward towards the enemy.
>
> (Skelton and Glidden, *Lutyens and the Great War*: 24)

The elements of measurement and proportion, the idea of horizontality and rest, the implication of the recumbent body and that those of all faiths could relate easily as it was non-denominational, these were all important considerations. Yet, at the same time the War Stone resembles an altar at which a service could be held. The idea that nature would play its part in the cemeteries and the various settings of the war stones was very important to Lutyens. It is thought that he was helped by his friend the gardener Gertrude Jekyll; he had worked with her on a number of garden designs, particularly Hestercombe in Somerset. Lutyens himself said:

> They should be known in all places and for all times as the Great War Stones, and should stand, though in three continents, as equal monuments of devotion, suggesting the thought of memorial chapels in one vast cathedral whose vault is the sky.
>
> (Quoted in Geurst, *Cemeteries of the Great War by Sir Edwin Lutyens*: 33)

So, in his analogy of the cathedral, with the sky as a vault, Lutyens was thinking about the landscape in terms of architecture and design.

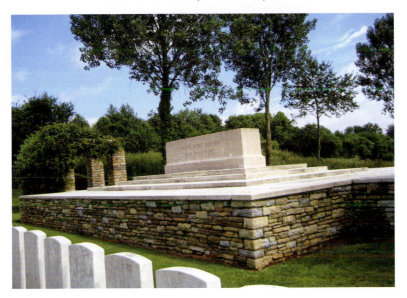

Plate 6.24 Edwin Lutyens (1869–1944), view of the raised mount and War Stone at Bagneux from 1918. Photography by John Acton.

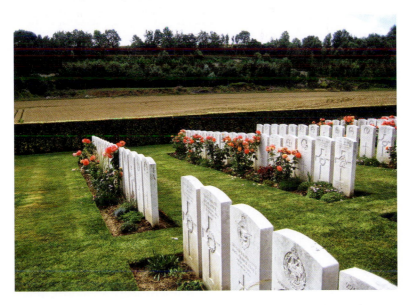

Plate 6.25 Edwin Lutyens (1869–1944), view of the cemetery and its setting at Bagneux from 1918. Photography by John Acton.

In his description of this cemetery at Bagneux, Geurst (2010, p.202) says that it is 'overwhelming due to its location. . . .'

These war stones, particularly those in the cemeteries in France, like this one at Bagneux, are very effective and affecting because of the way they are set into the landscape. Their proportions, their horizontality and their relationship with the upright gravestones allows them to sit together in the space surrounding them. Their stark geometrical whiteness contrasts brilliantly with the softer forms of nature which have grown and covered the battle-scarred landscape, their pristine appearance being the very opposite of the mud and squalor of the trenches. When you visit this part of northern France, in Picardy, the landscape is dotted with graveyards, some for thousands and some for a few hundred soldiers, some for the identified and some for the unknown. They are in the landscape and seem to be part of it, buried where they died, showing you the ubiquitous nature of the effects of this war.

This cemetery at Bagneux is on the site of a dressing station for the wounded behind the front line; as you approach it you walk along a path bounded by poplar trees on one side. The entrance is through a grey stone pergola with a clematis growing over it and attached to a boundary wall. You quickly realise that the whole graveyard is on a slope on the side of a hill and the gravestones are laid out in tune with the contour of the land. Each gravestone has an inscription, sometimes with a name and sometimes simply inscribed 'A Soldier of the Great War'. Lutyens has indeed landscaped the site to be as natural and yet as symmetrical and harmonious as possible, surrounded by trees and cornfields. The other point to make about this is that what makes these places so moving is, not only their setting and the associations with it, but also the precision in the way they are looked after by the Commonwealth War Graves Commission. The lawns and hedges are trimmed with military attention to detail and the flowers bloom round the gravestones, creating the appearance of a garden which is peaceful and aesthetic. When you stand and look at them as a whole composition, the War Stone, with its inscription 'Their Name Liveth for Evermore', and its graves make an interaction between space and form which creates a unity which is both sculptural and architectural at the same time. In this sense, the War Stone also has a cenotaph-like quality in that it is like an empty tomb.

The first point to make about the Royal Artillery Memorial, a very striking, thought-provoking and moving memorial is that it is not a glorification of war or heroism. Charles Sargeant Jagger had served

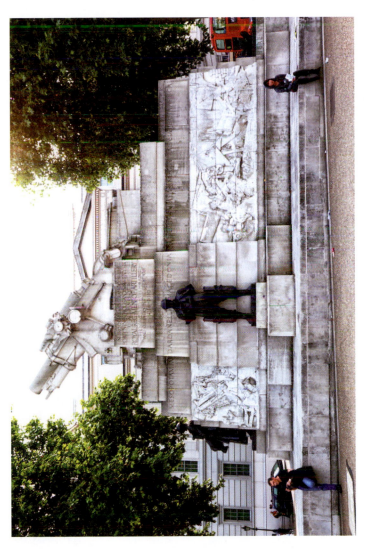

Plate 6.26 Charles Sargeant Jagger (1885–1934), Royal Artillery Memorial, 1921–1925, Hyde Park Corner, London. Photography by Finbar Good.

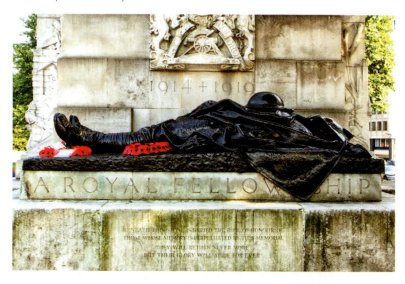

Plate 6.27 Charles Sargeant Jagger (1885–1934), Recumbent Figure of a Dead Soldier, side view, Royal Artillery Memorial, 1921–1925, Hyde Park Corner, London. Photography by Finbar Good.

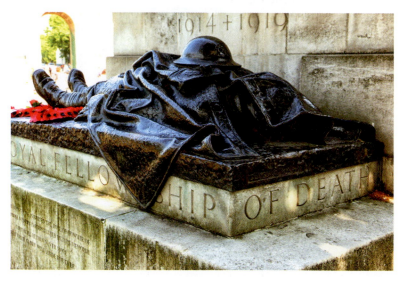

Plate 6.28 Charles Sargeant Jagger (1885–1934), Recumbent Figure of a Dead Soldier from head end on, Royal Artillery Memorial, 1921–1925, Hyde Park Corner, London. Photography by Finbar Good.

in the Artists' Rifles at Gallipoli in 1915 and then in the trenches on the Western Front, so he had experienced the horrors at first hand having been wounded and gassed several times himself. He said that these experiences 'persuaded me of the necessity for frankness and truth'. This memorial shows four different figures of artillerymen, the Officer, the Shell Carrier and the Horse Driver, who cared for and drove the horses which dragged the guns into position, and finally a dead soldier at one end, lying as if on an altar, with the list of the names of the Fallen beneath his body. Towering above them in all its power and enormity is the Howitzer artillery piece, the raison d'être of the Artillery Regiment. This central section is made of Portland stone with the gun mounted on what looks like a gigantic tomb or stepped pyramid with the free-standing figures cast in bronze so they project clearly from the pale stone background.

The Recumbent Figure of a Dead Soldier, which is particularly moving, lies on a simple stone plinth like an altar on top of three steps (see Plates 6.27 and 6.28). The man's body is covered with his great-coat as if he were a medieval tomb effigy. The inscription below the body is a reference to a passage from Shakespeare's *Henry V* which expresses the idea of a 'Fellowship of Death', and the corner of the greatcoat obscures the letters w and s in Fellowship. Like the other figures, this one is modelled and cast in bronze, but we can really only see the puttees and the hob-nailed boots with horseshoe shaped metal on the toes and heels, and the helmet placed on his chest where a wreath would normally be laid. The coat looks casually thrown to cover his face and we can just see the side, the ear, the jawline and some hair, and we, as the viewers, are encouraged to imagine who he might be, how he was killed and the suffering he and his comrades went through.

The three other figures are larger than life size with their different uniforms recorded in great detail. This is particularly true of the Horse Driver (see Plate 6.29) whose cape is coarsely textured in contrast to his helmet, his breeches and his leather leggings; his stance is pointedly sacrificial with the arms outstretched as if on a crucifix. The stone section of the monument has reliefs of episodes from various battles recorded on it and the Howitzer gun on top pointing upwards; as the land falls away towards Victoria it seems to be turned southwards in the direction of the battlefields on the Western Front.

This whole monument is not a heroic commemoration but more a dignified homage to the courage and endurance of these men and the sacrifices they made; it is quite different from the memorial nearby, to the Machine Gun Regiment, by Frederick Derwent Wood, which

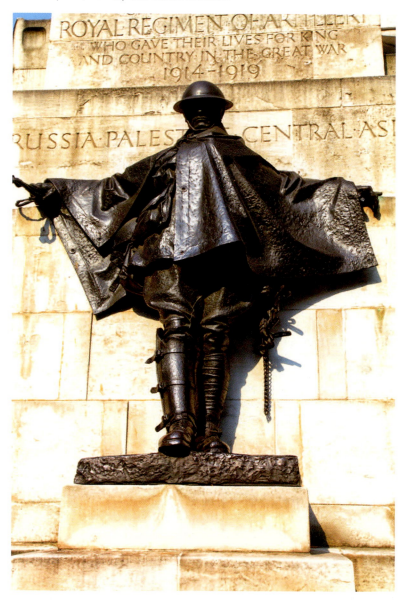

Plate 6.29 Charles Sargeant Jagger (1885–1934), Horse Driver, Royal Artillery Memorial, 1921–1925, Hyde Park Corner, London. Photography by Finbar Good.

is topped by a nude male figure of an idealised heroic type, which appears to make no reference to the reality of the experience of those brave men who manned the machine guns. At the time it was erected this monument was preferred to the Artillery Memorial which was thought to be too realistic and sombre and not appropriate to the celebration of heroism. However, nowadays we think the opposite and it is the Artillery Memorial which is more in tune with the idea of memory because it makes the spectator think about the terrible industrial nature of the 1914–1918 war and the human sacrifices which were made. The horses which were such an essential part of the artillery were only recently accorded their own monument which was erected in Park Lane a few years ago, and indeed they have been commemorated in other ways too like the novel, play and film of *War Horse*. This change in attitude has much to do with the fact that the Great War has been brought to mind in so many other ways through poetry, memoirs, documentary film and drama. Time has passed and made deeper reflection more possible, and so a more complex interpretation like the Royal Artillery Memorial means more to us now than it did at the time.

Just nearby, where Hyde Park Corner joins Piccadilly, overlooking Green Park, there is the recent memorial to RAF Bomber Command of the Second World War, unveiled in 2012. Here the issues about how traditional, heroic or modern a memorial should be have been rehearsed all over again. It took sixty-seven years for this monument to be finally erected in London. This was because of the controversy surrounding the bombing of German cities, for which 55,573 aircrew gave their lives.

This memorial is certainly traditional in its form, and the figures are reminiscent of Rodin's *Burghers of Calais*, which we looked at in Chapter 3. Cast in bronze and set on a marble and granite plinth, this group represents the seven members of the aircrew of a bomber. Each uniform has been modelled in a detailed way so that you can differentiate between them and see them not as portraits, but as generalised individuals. The sculptor, Philip Jackson, made a careful study of their uniforms from photographs and examples kept in the Hendon RAF Museum. He made small models in wax first, and then scaled them up to one and a half times life size. They have been set inside what looks like a classical temple, designed by the architect Liam O'Connor, and made of Portland stone. It has a screen of Doric columns mounted on a rusticated platform on either side marking the boundary between Piccadilly and Green Park.

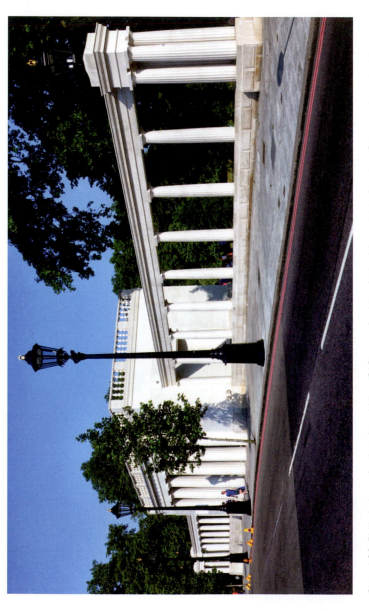

Plate 6.30 Philip Jackson (sculptor) and Liam O'Connor (architect), the Memorial to Bomber Command overlooking Green Park in London, 2012. © Liam O'Connor Architects & Planning Consultants. Photography by Finbar Good.

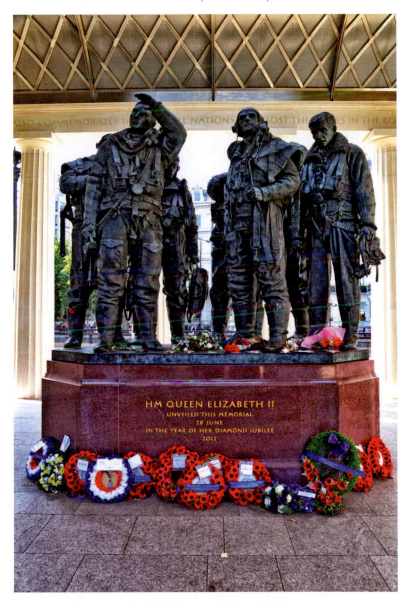

Plate 6.31 Philip Jackson (sculptor) and Liam O'Connor (architect), the Memorial to Bomber Command overlooking Green Park in London, 2012. Reprinted with kind permission by Philip Jackson © Liam O'Connor Architects & Planning Consultants. Photography by Finbar Good.

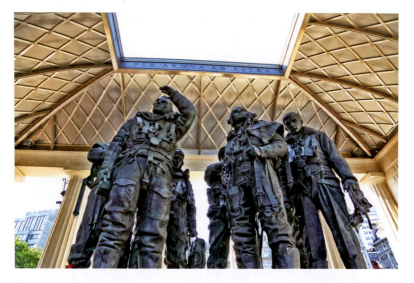

Plate 6.32 Philip Jackson (sculptor) and Liam O'Connor (architect), the Memorial to Bomber Command Overlooking Green Park in London, 2012. Reprinted with kind permission by Philip Jackson © Liam O'Connor Architects & Planning Consultants. Photography by Finbar Good.

But when you get inside the building you find that the roof is open to the stars in line with the motto of the RAF, *Ardua ad Astra*. The shallow oblong dome is made in a form based on Barnes Wallis's design for the geodesic air frame of a series of bomber aircraft, including the Wellington and the Halifax. In fact, some of the metal used here comes from a Halifax found recently in Belgium in which all the aircrew died; it was melted down and reconstituted to form the skin behind the criss-cross structure of the coved ceiling. The idea of it being open to the sky is deliberate, not only in a symbolic way, as it also means the bronze figures will weather naturally.

The money for this memorial was largely raised by the families of those who lost their loved ones. The skill of the sculptor and architect has been to make a memorial with which those relatives can identify. The argument about what has been called 'classical amnesia' is easy to make, but sometimes it may be more appropriate to remain in tune with the emotional needs of those who have commissioned the work. Certainly, for the Vietnam Memorial in Washington which we are going to look at next, the families demanded some figure sculptures to at least symbolise their relatives.

The Vietnam Veterans Memorial continues the theme of the relationship between architecture and sculpture in connection with memorials. It consists of a wall in the shape of a shallow V set in Constitution Gardens near the Mall in Washington D.C. Made out of polished black stone imported from India it reflects the people looking at it and the landscape roundabout. In front of the wall, there is a properly designated path for spectators to walk along which slopes towards the centre, allowing the wall to become higher as you move along it, eventually becoming 10.1 feet or 3 metres high; then it tapers down to a height of 8 inches or 20 centimetres at its extremities. The names are etched into the stone, listed in chronological order from 1959 to 1975, and there are 58,272 of them, either missing or killed in action. As you walk down towards the apex you are made to feel more and more involved; each wall has 72 panels and they in turn appear like shallow pilasters, each with 70 names.

You could argue that Maya Lin's design is like an installation or a piece of land art (see *Learning to Look at Modern Art* pp. 153–154) because it is not freestanding above the ground like the other memorials we have looked at so far. But it is permanent like a sculpture or a building, and the relationship with the spectator is extremely important because of the movement you have to make to look at it and walk beside it. In aerial photographs it looks like a wound in the landscape because the upper sections appear flush with the grass above. This is not a monument in the traditional sense, although there

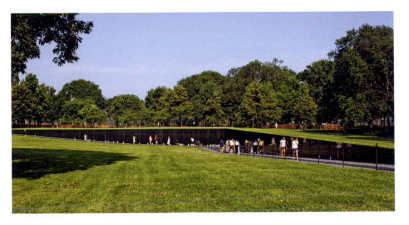

Plate 6.33 Maya Ling Lin (b. 1959), Vietnam Veterans Memorial (1982), Washington D.C., USA. © Album/Prisma/akg-images.

is a separate sculpture of three soldiers of different ethnic origins (White American, African American and Hispanic American) placed to the side so they appear to be looking at the wall. The idea behind the reflective surface of the wall is to allow the spectator to interact with it and relate the past and present together, so you feel less of an outsider than you might in relation to the Cenotaph or a War Stone. Although the Vietnam Veterans Memorial caused controversy to start with, it is now held in high regard and has taken on the role of a shrine to which people can go, and there is even a smaller half-size portable version known as the Moving Wall which travels the country so people can see it who would never be able to travel to Washington to have the experience.

Much more forbidding and eerie is Rachel Whiteread's Holocaust Memorial, an extraordinary cast sculpture made to commemorate the 65,000 Jews who were exterminated during the Nazi occupation of Austria. This is about not noble sacrifice and heroism but cruelty and injustice on an enormous scale. The reason that this monument is so chilling is that it appears to be shut away from the onlooker; it stands off centre in the square in the old Jewish quarter of Vienna. Like most of Whiteread's work, it represents the space inside something; in this case it is a library turned inside out, with the spaces left by the books turned away from you, with what would have been their spines facing inwards so you cannot identify them. The doors to the library are closed from the inside and we cannot open them because there are no handles and they are facing inwards too. You could say it hauntingly resembles a gas oven and whatever is inside cannot get out or be rescued.

This monument stands like a classical building on a low platform and the geometry of the block is carefully and clearly expressed, with an attic storey and the doors recessed beneath a plain porch or portico. The structure is relentlessly vertical and horizontal with the blocks of books carefully divided. There are two vertical divisions on either side of the door and four above and ten blocks down each side with twenty 'books' in each block and eleven 'shelves' high, so in this way it also expresses numbers and statistics like the Nazi regime. On the plinth all round are the names of the forty-one sites of the killings listed alphabetically and the dedication is written in front of the door in English, German and Hebrew.

The surface of this work is corrugated like a single-storey building and divided with monotonous regularity, and yet, by its colour and position it relates to the space around it, standing out pale and ghostly

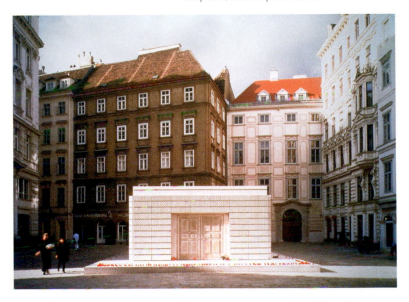

Plate 6.34 Rachel Whiteread (b. 1963), Holocaust Memorial, 1995/2000, Judenplatz, Vienna. 390 × 752 × 1058 cm. © Rachel Whiteread. Photograph by Werner Kaligofsky/Gagosian Gallery.

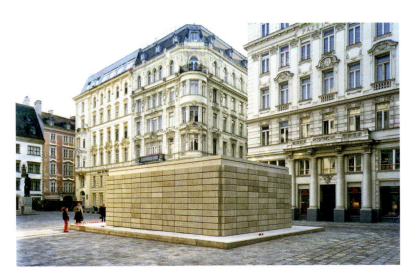

Plate 6.35 Rachel Whiteread (b. 1963), Holocaust Memorial, 1995/2000, Judenplatz, Vienna. © Rachel Whiteread. Photograph by Werner Kaligofsky/Gagosian Gallery.

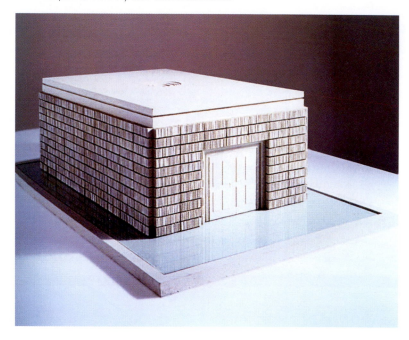

Plate 6.36 Rachel Whiteread (b. 1963), Maquette for Holocaust Memorial, 1995, mixed media. © Rachel Whiteread. Photography by Mike Bruce/d'Offay Gallery.

and yet solid and permanent. The fact that it is placed asymmetrically in the square is surprising and yet appropriate; it sits in the shadow of taller buildings near the Jewish museum and next to the site where a synagogue, belonging to Viennese Jews, was burned in 1421, and where subsequent massacres took place. When Rachel Whiteread won the competition in 1996, there was considerable controversy about where the Holocaust Memorial should be placed because of the historical context and archaeology of the site; it is right in the heart of the old city of Vienna, within walking distance of the grandeur and richness of the Imperial Palace complex.

As the spectator you feel compelled to walk round this mausoleum and it feels essentially lonely, uncompromising, immobile and immovable like the uncompromising truth. It makes reference to a culture which is text based, intellectual and non-visual, where the making of images is forbidden. The artist has obviously thought deeply about the nature of the culture and the people and made a memorial which commemorates both memory and absence; it sits there like a

lost parcel standing in the square, as though it has been delivered there with no destination, and yet it belongs here in the heart of the old Jewish quarter of Vienna. Rachel Whiteread has long been fascinated by memory and absence and her most famous works such as *Ghost* or *House* represented that very idea (see *Learning to Look at Modern Art* pp. 196–199). When asked about this work in Vienna she said:

> When I was asked to submit a plan for the holocaust memorial in the Judenplatz in Vienna, it was clear to me from the outset that my proposal had to be simple, monumental, poetic and non-literal. I am a sculptor: not a person of words but of images and forms . . .

(Townsend, *The Art of Rachel Whiteread*: 167)

This is not about the absence of someone's home and the memories it represents, but a blind, closed-up block, with all the information and learning lost and beyond recall. Its presence is about absence, a mausoleum which expresses irretrievable, shameful and incomprehensible loss.

CONCLUSION

Since the ancient world, sculpture and architecture have been used as memorials. Until relatively recently though their purpose was primarily religious or spiritual, whether it be the Egyptian Pharaohs setting out on their journey with all their belongings, or the classical idea of the underworld or the Christian concept of eternal life. But from the time of the Enlightenment in the later eighteenth century, memorial sculpture has become increasingly secular, commemorating the individual person and what they have done during their lifetime. Or it can be a place or a context, like the *Angel of the North* by Antony Gormley, situated outside Newcastle not far from the A1, which is a memorial to our industrial past. So, our towns and cities have become full of what is often referred to as public sculpture. This has come to a head in recent years over what to do with the Fourth Plinth in Trafalgar Square, which was designed in the nineteenth century by Sir Charles Barry and never filled. We have already seen in Chapter 2 how this site was used by Marc Quinn for the figure of Alison Lapper in 2005. But the issues around memorials and the Fourth Plinth had already come into the discussions more forcefully around the time of the millennium.

In his collection of essays, *Annus Mirabilis? Art in the Year 2000*, the art critic and historian Richard Cork (who is well known for his memorable book about the art of the First World War called *A Bitter Truth* (1994), in which memorials of various kinds feature prominently) wrote an interesting article about these debates; he sat on a committee called the Vacant Plinth Advisory Group, and they were surprised to find considerable strength of public feeling about what the plinth should be used for. Some people felt that it should continue to commemorate political and military heroes, as in the rest of Trafalgar Square, whilst others were concerned to be more innovative and rectify the comparative lack of modern sculpture in London's public spaces. So the proposals of this committee became just that:

> Situated at the heart of the metropolis with an enormous potential audience, it could provide a superb showcase for adventurous artists across the world. The advent of each fresh work is bound to generate debate, helping to prompt a widening awareness of contemporary developments in art. The unprecedented wealth of materials and strategies now deployed by artists should be reflected in the proposals chosen by a small, open-minded and regularly changing group of selectors. Although radical sculptors spent much of the twentieth century taking their work off the plinth, Barry's dignified slab still provides a stimulating foil for artists bold enough to take it on.
>
> (Cork, *Annus Mirabilis? Art in the Year 2000*: 248)

Since then the plinth has gone on to house a very varied group of works which have indeed provoked lively debate. We have gone from Antony Gormley's *One and Another* in which the public was invited to participate and even to perform, to the more traditional ones like the model for a memorial to the forgotten hero Keith Park (the key administrator to Lord Dowding during the Battle of Britain). The debates around the plinth's function have raised interesting issues concerning the role of memorial sculpture and will continue to do so.

Chapter 7

Sculpture and its setting

INTRODUCTION

The placing of sculpture in a setting is very important from the point of view of how it can influence the way you see it. This has been discussed in other chapters in relation to particular pieces, like the equestrian monument to Marcus Aurelius, or Epstein's *Lazarus* in New College Chapel at Oxford; and sometimes the sculpture itself can influence its surroundings, as in the case of the focal point of the Cenotaph in Whitehall; there of course you could say that the position is as much about urban design as about sculpture itself. This brings us to another aspect of this interesting subject and that is the way one area of three-dimensional art can impinge upon another. So, sculpture can interact with architectural surroundings outside or inside and also can influence the way you experience the three-dimensional aspects of an interior, as we have already seen in the cathedral at Autun for instance. Then there is the question of how sculpture can be seen in the landscape, and also how different materials can be used. We will explore sculpture made with light or sound, and the idea of land installation, or land art, where the materials of the landscape itself are used to make three-dimensional art, sometimes in an industrial context, as with Richard Serra, or in a land environment with Richard Long or David Nash.

This chapter will begin by exploring some examples of the relationship between sculpture and architecture in the late medieval and Renaissance period. First there will be discussion of a sculptural structure designed to be outside, in what was really an elaborate stone baptismal font, known as the Well of Moses, by Claus Sluter. Then a free-standing carved wooden altarpiece, the Altar of the Holy Blood by Tilman Riemenschneider, will be considered. After that we will

look at architectural decoration which becomes sculptural, as in the choir stalls at St Paul's Cathedral by Grinling Gibbons, and the concept of sculptural architecture in the work of Nicholas Hawksmoor at St Alfege in Greenwich, in the seventeenth and early eighteenth century.

In the second section we will concentrate on the interior and the use of stucco and marble in the Renaissance and later. The creation of real or illusory three-dimensional effects was done by Rosso and Primaticcio at the Palace of Fontainebleau, and Veronese and Palladio in the Villa Barbaro during the sixteenth century. Other examples of this were achieved in the stately homes of England, like Houghton in Norfolk, in the eighteenth century. Then we will consider the influence of collage on the interior through the work of artists like Kurt Schwitters or Constantin Brancusi in the early twentieth century. This was followed later on by more radical ideas in the work with light and sound by Robert Irwin and Janet Cardiff respectively. Last, but by no means least, there is the importance of sculpture and the landscape. This can vary from sculpture used in different forms of garden design, like that of Le Nôtre or William Kent in the seventeenth and eighteenth centuries, through to the more recent land art, made from the materials of industry or nature itself, as in the work of Richard Long, Richard Serra or David Nash.

THE RELATIONSHIP BETWEEN SCULPTURE AND ARCHITECTURE

Plate 7.3 The Well of Moses by Claus Sluter, 1385–1406, Chartreuse de Champmol, Dijon, Burgundy, France

Plates 7.5 and 7.6 The Altar of the Holy Blood, by Tilman Riemenschneider, 1499–1505, in the Church of St Jacob, Rothenburg, southern Germany

The Well of Moses is a piece of architectural sculpture because it was originally created as part of a whole complex at the Carthusian monastery outside Dijon. It was intended to be a magnificent architectural feature built over a pool 11 feet deep, in the centre of the cloisters, as the base for an enormous crucifixion rising 25 feet into the air.

The only part which remains in any kind of complete state is the base upon whose hexagonal form six prophets are depicted: Moses, David, Jeremiah, Zachariah, Isaiah and Daniel; the rest was destroyed at the time of the French Revolution, apart from the entrance to the

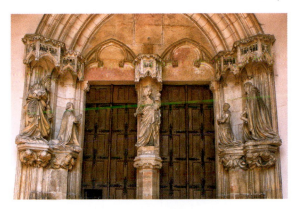

Plate 7.1 Dijon (Dép. Côte d'Or, Burgundy, France), Carthusian monastery –
Chartreuse de Champmol, former church portal – Portail de la Vierge (built as of
1388; architect: Jean de Marville; sculptures 1391–1392 by Claus Sluter). Left to
right: John the Baptist, Philip the Bold, Madonna and child, Margaret of Flanders
and Catherine of Alexandria. © Hervé Champollion/akg-images.

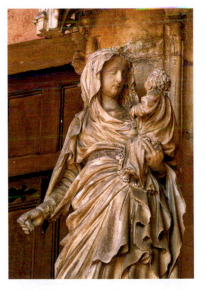

Plate 7.2 Claus Sluter
(1340/60–1404/05), Mary and Christ
child (detail). Sculpture, 1491. Stone.
Photo, undated. Dijon, Carthusian-
Chartreuse de Champmol, former
church portal – Portail de la Vierge
(built as of 1388). © Hervé
Champollion/akg-images.

chapel which has figures of the Duke and Duchess of Burgundy
at the sides and the Virgin and Child on the trumeau in the centre of
the door itself. In many ways the layout of this is similar to the west
door at Autun which we looked at in Chapter 4, but the impact is

entirely different because the figures are so much more realistic and three-dimensional in relation to the architecture.

The outstanding quality of the stone carving on both this entrance and the Well of Moses is in the treatment of the drapery, particularly in the figure of Moses (see Plate 7.3). Sluter has communicated grim disillusionment in his craggy face and the inscription on the scroll he is holding says 'The Children of Israel do not listen to me'. But the bulk and solidity of the body is communicated through the sculptural quality of the drapery, because it does not really reveal the form of the body underneath, as a classical sculpture would; instead, it shows us horizontal and vertical folds, deeply cut and swinging across the body, as though they were alive; a counterpoint is set up between the verticality of the scroll and the more upright folds on the figure of King David next door to the right. There is also enjoyment in the carving of different textures, particularly in the hair and beard. You, as the spectator, believe in the realism of the sheer bulk of Moses, and in details like his hands holding the tablets and the scroll. The architectural setting enhances the figure because it is flatter than a niche, with a horizontal architrave above the head of Moses and just a glimpse of a gothic trefoil behind. Above that, instead of an arch, are figures of angels with their inspired overlapping wings, and their faces

Plate 7.3 Claus Sluter (1340/60–1404/05), Well of Moses, c.1395/1405. Detail: Moses. Dijon, Charterhouse. © akg-images/Erich Lessing.

which are given different expressions, especially the thoughtful and sorrowful puzzlement in the face of the one on the left. Above them is a simple horizontal cornice, protruding to give the whole form greater solidity, standing out further than the base on which they are set. All the figures have individual expressions, gestures and attitudes, and those, together with the drapery, follow the architectural form and symmetry of the hexagon.

The whole complex within the monastery was intended as a mausoleum for Philip the Bold, Duke of Burgundy. When he died near Brussels in 1404, his body was carried to Dijon to be interred there on 16 June 1404, in a tomb which was also designed by Sluter and his workshop. The iconographical content was complex as has been explained: for example, by James Snyder, in his book on the Northern Renaissance, where he suggests that:

> The Well of Moses was thus a complex fusion of the idea of man's salvation through the death of Christ on the cross and the Fountain of Life whereby his sins were washed away in the waters of Baptism.
>
> (Snyder, *Northern Renaissance Art*: 67)

Craig Harbison, also writing about the same subject, thinks that Sluter enhanced his work by:

> What might be called, literally and figuratively, theatrical references. The medieval religious dramas called mystery plays commonly featured the commentary of prophets on events in Christ's life.
>
> (Harbison, *The Art of the Northern Renaissance*: 43)

The realism here may also be the result of the influence of the religious thinking of St Thomas Aquinas, which we referred to in Chapter 3, and also of the ideas of St Thomas à Kempis, the *Devotio Moderna*, and William of Ockham which Harbison also discusses:

> Whether a philosophy caused an artistic style would be difficult, if not impossible, to say absolutely. More surely, we can say that both were expressions of a new way of seeing and understanding the world.
>
> (Ibid.: 42)

These beliefs were concerned with the idea that religious devotion should be more in touch with the real world and its everyday concerns and there should be the appreciation of reality lying in what you can see. To make the Well of Moses more real the whole thing

would originally have been painted. For instance, Moses' costume would originally have been gold with a blue lining, which to our modern eyes might seem garish. In contrast, a hundred years later, in Rothenburg in southern Germany, a contract was drawn up between Tilman Riemenschneider and the Church of St Jacob where it was made clear that they wanted a carved altarpiece which was specifically not to be painted.

The Altarpiece of the Holy Blood is free-standing and integrated with the gothic architecture of its setting, so much so that the light from the windows affects the way that you see it. It is carved entirely from lime wood (although it is thought that the outer frame was made by someone else and the shrine for the relic of holy blood was also completed beforehand). Riemenschneider's part of it is concerned with the three panels of the Last Supper, in the centre, with the Entry into Jerusalem on the left and the Agony in the Garden on the right. Although the two outer panels are in relief, the figures in the central one are effectively free-standing and tell the story of the Last Supper around the section where St John tells us Jesus said that one of his disciples would betray him. The sculpture focuses on the three figures of Christ slightly to the left of centre behind, with St John in the left

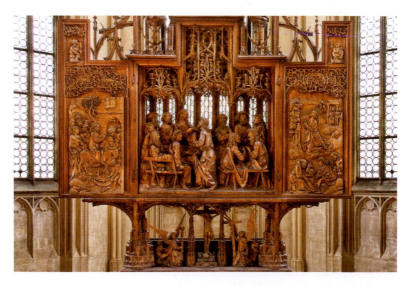

Plate 7.4 Tilman Riemenschneider (1460–1531), Altar of the Holy Blood, 1499–1505, St Jakobskirche, Rothenburg ob der Tauber, Germany. Photography by Achim Bednorz.

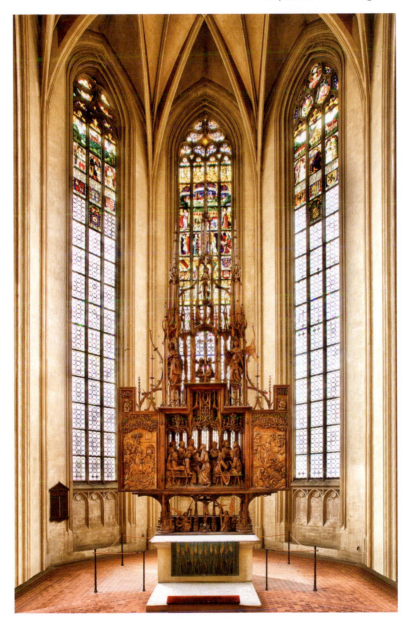

Plate 7.5 Tilman Riemenschneider (1460–1531), Altar of the Holy Blood, 1499–1505, St Jakobskirche, Rothenburg ob der Tauber, Germany. Photography by Achim Bednorz.

foreground and the figure of Judas Iscariot in the centre in front; it depicts the moment when Christ gives the sop to Judas to identify him and St John points down to the shrine of the Holy Blood where the bread and wine would be, and with his other hand, to Christ who is about to become the body and blood of the Eucharist. The three figures are expressive, and the concentration is on the communication of the story. There is fear in Judas's face and anxiety expressed in his twisted foot. Christ shows compassion and understanding and St John's face is full of foreboding, turned away from Jesus, knowing that the outcome of this will not be good. The figures are carved in plain lime wood and not painted so the concentration is on the narration of the story. As with Sluter's work, the drapery is important, but the edges are even more incisive, like the raised lines in a wood-cut (see *Learning to Look at Paintings* pp. 204–207), and southern Germany was the home of the print.

But more striking than any of this is the way the light plays over the figures, shining in a dappled way through the bottle glass of the windows, and especially towards evening when it comes particularly from behind, like back lighting in the theatre. In his book on the lime wood sculptors of Renaissance Germany, Michael Baxandall suggests that the light is designed to play an active role as much as the carving of the wood.

> During the day the altarpiece goes through a cycle of transfor-mation and Riemenschneider's mastery emerges as a manipulation of the light which is as much a medium as wood.
>
> (Baxandall, *The Limewood Sculptors of Renaissance Germany*: 189)

Baxandall is suggesting here that the way a sculpture is lit can become an active ingredient in how the spectator sees it. When it is lit from behind it becomes most effective: he then goes on to describe how it alters at the end of the day:

> In this last sustained phase the light is continually changing in detail as it passes through the rough lenses of the window.
>
> (Ibid.: 190)

This is difficult to appreciate in a photograph, but we can at least see here how the light from behind throws the figures forward into greater relief, and that their solidity and expressiveness is emphasised by the tall and ethereal light effects of the windows, which sit in a three-sided shape, allowing light from the side as well as the centre.

At the very least here, Baxandall is pointing out the significance of lighting to our three-dimensional experience of sculpture. But it is also important in another way too because, unlike the Well of Moses, this was not intended to be painted or showy. In the years before the Protestant Reformation there was considerable worry about idolatry, which was seen by many, together with the sale of indulgences, to be part of the growing corruption of the Roman Catholic Church.

The sculptural experience of architectural decoration

Plates 7.6 and 7.7 The choir stalls at St Paul's Cathedral, London, by Sir Christopher Wren and Grinling Gibbons, 1696–1698

Another example of fine wood carving in an architectural setting is the choir stalls of St Paul's Cathedral in London (see Plates 7.6 and 7.7). They were carved by Grinling Gibbons, achieving what John Summerson called 'complete plastic unity and elegance of movement'. This is plastic in the sense of sculptural, three-dimensional and enhancing of the architectural space as designed by Sir Christopher Wren. It is thought that Wren himself may have laid out the trabeated structure with its vertical and horizontal axes, and his carpenters would have made the basic carcase in oak, and then Grinling Gibbons designed the decoration which was carved in lime wood which, as we have seen, is softer and more amenable to the making of fine carving. It is thought that in the more elaborate parts Gibbons used a layering technique where separate pieces of lime wood were glued together.

The whole layout of these choir stalls is like the façade of a classical building, with the lowest pews in front arranged like tall steps, very simple, with slightly decorated square and rectangular panels on the front. Gradually, as your eye moves towards the back, the panels become more elaborate, and they are interspersed with decorated pilasters. Above that is a deeply carved frieze with heads of cherubs and swags topped by an overhanging and firmly horizontal cornice, supported by corbels, and then lifted by an attic storey carved with heads of cherubs, acanthus leaves and swags of flowers and fruit. These repetitive and rectangular lines of stalls are punctuated in the middle, and at the ends, by more elaborately carved seats for dignitaries, which provide a pause in the rhythms created by the horizontality of these forms. The combination of movement and control in this complex scheme is what gives these carvings their architectural and sculptural character.

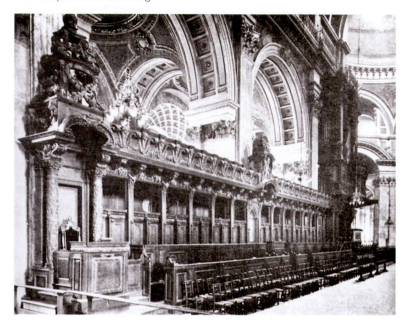

Plate 7.6 Grinling Gibbons (1648–1721), choir stalls at St Paul's Cathedral, 1696–1698, London. Reproduced with kind permission from Stobart Davies.

Plate 7.7
Grinling Gibbons (1648–1721), choir stalls at St Paul's Cathedral (canopy over the Dean's Stall), 1696–1698, London. Reproduced with kind permission from Stobart Davies.

To really look at this whole creation in detail you need to select an individual part like a section of the canopy over the Dean's Stall. Here, on the very top, is a lion sitting in a nest of acanthus leaves, held in place by a circle from which spring two downward scrolls, leading the eye to the heads and bodies of two cherubs, and between them is a concave circle decorated with more acanthus leaves and scrolls going in different directions. The feet of the cherubs rest on pieces of architrave which express the fact that the whole design has convex projection as well as concavity; it is all about controlled movement, including the sense that the plant life is moving and growing. Above the stalls rise the great arches of Wren's cathedral, allowing the light to cascade down which increases the three-dimensional effect of the choir stalls. Then the choir stalls themselves enhance the movement of the arches, and anchor them to the ground, because the wood is darker and so contrasts with the effect of light, air and space above. It is a brilliant example of how architectural and sculptural schemes can interact with one another.

The dynamic and sculptural interpretation of the wall

Plates 7.8, 7.9, 7.10 and 7.11 Church of St Alfege, Greenwich, London, by Nicholas Hawksmoor, 1712–1714

Plate 7.8 Nicholas Hawksmoor (1661–1736), Church of St Alfege, 1712–1714, Greenwich, London. Reproduced with the permission of the Vicar, Churchwardens and Parochial Church Council of St Alfege Greenwich. Photography by Finbar Good.

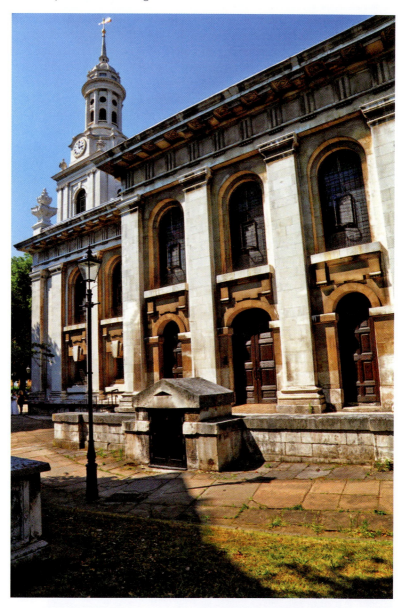

Plate 7.9 Nicholas Hawksmoor (1661–1736), Church of St Alfege, 1712–1714, Greenwich, London. Reproduced with the permission of the Vicar, Churchwardens and Parochial Church Council of St Alfege Greenwich. Photography by Finbar Good.

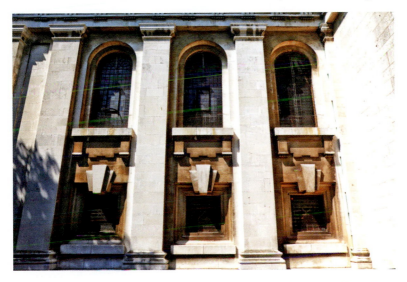

Plate 7.10 Nicholas Hawksmoor (1661–1736), Church of St Alfege, 1712–1714, Greenwich, London. Reproduced with the permission of the Vicar, Churchwardens and Parochial Church Council of St Alfege Greenwich. Photography by Finbar Good.

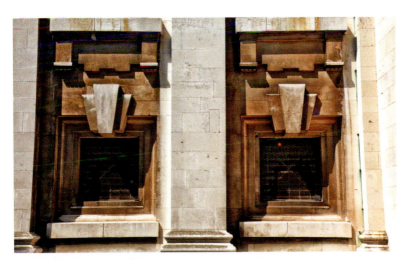

Plate 7.11 Nicholas Hawksmoor (1661–1736), Church of St Alfege, 1712–1714, Greenwich, London. Reproduced with the permission of the Vicar, Churchwardens and Parochial Church Council of St Alfege Greenwich. Photography by Finbar Good.

It can be argued, and indeed has often been said, that some artists have a sculptural vision as in Mantegna and Michelangelo (see *Learning to Look at Paintings* pp. 60–63 and 57–59 respectively). This can also be applied to architects such as Le Corbusier from the modern era (see *Learning to Look at Modern Art* pp. 180–184) or Michelangelo again from the Renaissance as we saw in Chapter 2. In the context of looking at sculpture, Nicholas Hawksmoor's Church of St Alfege at Greenwich in London is a good example of this kind of plastic expression.

The front façade in Plate 7.8 is based on the triumphal arch, but the sides of it are trabeated and the arcuation in the centre rises through the entablature and interrupts the triangular form of the pediment. The proportions of the central arch appear narrower than the sides. There is also a rhythm of solid and void across the front because the two side blocks are solid. This also creates an effect of light and shade and is articulated further by free-standing pillars and squared-off pilasters.

But it is when you move round the corner to look at the side wall that you see real sculptural articulation. The tall arched windows are divided into blocks of three, and the central section protrudes from the wall, creating a bulge, which adds to the expression and relates to the rhythms of the façade. The square windows below in Plates 7.10 and 7.11 have dropped corbels and are deeply set into the wall, creating another rhythm of light and shade and solid and void; the proportions are unexpected because these windows are smaller and squarer than the ones above. The frieze and cornice continue round from the front, creating continuity as well as variety. The whole design contributes to the concept of plastic expression. It has been said by one of Hawksmoor's biographers, Kerry Downes, that walls were an expression of his architectural and sculptural imagination:

> We may say, for example, that Hawksmoor was concerned with the wall as a plastic medium capable of exploration, development or sculptural treatment, and we may even become metaphorical and call it, for him, an organic medium with its own life, in which individual forms grow out of the wall or grow together to compose it.
>
> (Downes, *Hawksmoor*: 148)

This, it seems to me, is what has been achieved here at St Alfege where the interpretation of the wall is as dynamic and sculptural as any of the other city churches which Hawksmoor designed.

The relationship between the outside and the inside of a building and further connections between sculpture and architecture

Plate 7.12 The North Artillery Shed, the Chinati Foundation, Marfa, Texas, by Donald Judd, from 1971

More recently, and in a completely different context which is also connected with the idea of installation art, the relationship between sculpture and architecture is further explored. The artist Donald Judd, in the North Artillery Shed, has explored the relationship between the exterior and interior of an industrial building which has been changed from its original use by the American army as a storage space. Space is the operative word here, as Judd was fascinated by the architectural side, namely its enclosure, and the special connection between the three-dimensional object and the observer, which we explored in Chapter 1 in the work of Carl Andre.

When you look at the façade of this industrial building, you can see that it has been tidied up, in order to reveal the relationship between the top half and the bottom, divided by a horizontal line. There is a contrast in colour between the grey on the upper area of cleaned-up corrugated iron, and the mellow red of the brick below. You will see that the door is grey and so are the glazing bars of the windows, and this tunes in with the upper section. Then there is a yellow rectangle in the middle which belongs with the yellowish grey band of brickwork below, where the cornice and frieze would be on a classical building. Interval and proportion are important too between the windows and the horizontal line they make above, which is on the golden section (see *Learning to Look at Paintings* p. 4), as is the door as well. You could even say that this is a stripped down version of the façade of a classical building, with the portico where the windows are and the pediment expressed by the corrugated iron, with its pale yellowish grey rectangle and the square above. In the way that he has stripped it back to its basic design, Judd has revealed the harmony, symmetry and proportion of the original industrial form.

When you go inside, you find the space is full of Judd's sculpture made from polished steel boxes, which are arranged carefully in rows, to fit in with the interior structure of the building; they, and the floor, are equally highly polished, and the light from the windows creates chiaroscuro, which has the effect of hardening and softening the edges of the boxes and makes some of them reflective and some of them

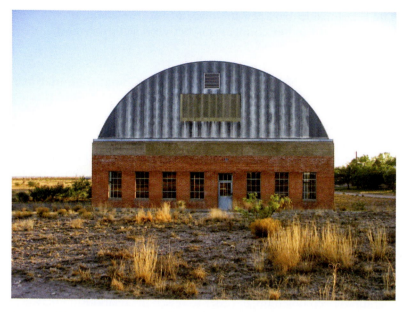

Plate 7.12 Donald Judd, façade of the Artillery Shed, Marfa, Texas, from 1971. © Judd Foundation/VAGA, New York/DACS, London 2013.

opaque. In Plate 7.13, the boxes in the foreground are dark and then, on the right, they are more blurred where it is light, and on the left more sharply defined where it is darker, so the space is articulated and varied according to the light. This effect is further enhanced by the arrangement of the vertical and horizontal beams which form cubes of space in contrast to the solid volume of the boxes. Like Carl Andre's *Venus Forge* which we looked at in Chapter 1, the boxes appear to stretch away into the distance, making the spectator feel the space more clearly. In the interior of the South Artillery Shed on the same site, you can see another phenomenon associated with Judd's work, and that is colour and reflection, so the colour of the boxes in the foreground appears to show a view of the interior as well as the exterior of the three-dimensional form.

Judd himself was fascinated by space and its architectural qualities and by new ways of looking at sculpture. He had started out as a painter, and colour almost always plays a role in his work; he felt that in the past sculpture had been seen in a limited way. In the catalogue to the Donald Judd exhibition in 2004, Nicholas Serota described Judd's approach thus:

For Judd, space as well as material and colour, were the principal constituents of the visual. He regarded the concept of 'space' in art as being poorly understood and barely explored in past practice, and he believed that this was an area to which he had made a very significant contribution. 'The smallest, simplest work [of mine] creates space around it, since there is so much space within . . . This is new in art, not in architecture of course'. In Judd's view, sculpture from the Greeks to the mid twentieth century had been totemic in character and therefore deriving from the human figure.

(Catalogue *Donald Judd Exhibition*: 103)

So, Judd embraced the concept of the installation wholeheartedly; he was interested not only in the idea of its impermanence, but also in making a whole context like this one which could last and continue to be visited, like the land art of some others who we will consider at the end of this chapter. But, as we have seen, Judd was also fascinated by the interior and its plastic possibilities, and so first we need to go on and look further at some of those sculptural aspects.

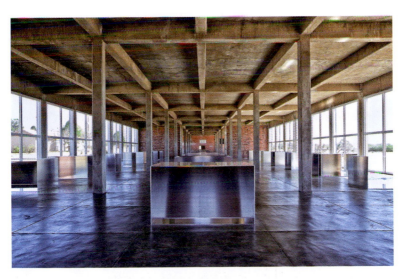

Plate 7.13 Donald Judd, 100 untitled works in mill aluminum, 1982–1986. 41 × 51 × 72 inches. Permanent collection, the Chinati Foundation, Marfa, Texas. Art © Judd Foundation/VAGA, New York, NY/DACS, London 2013.

SCULPTURE AND THE INTERIOR

The use of stucco and its possibilities

Plate 7.14 The interior decoration by Rosso and Primaticcio at the Palace of Fontainebleau, 1541–1545

Plate 7.15 The Villa Barbaro by Palladio, 1550–1558

Plates 7.16 and 7.17 The staircase and marble hall at Houghton Hall by William Kent, Colen Campbell and Michael Rysbrack, 1722–1735

Plates 7.19 and 7.20 The sculpture studio of Constantin Brancusi as left in 1957 and his sculpture *Fish*, 1926

Much sculpture made as part of interior design in the past involved the use of stucco which is essentially a kind of plaster made from lime and white marble dust which can be moulded and modelled. Sometimes it has other ingredients added to it like wax, milk and other organic substances, according to Nicholas Penny in his book *The Materials of Sculpture*; stucco lustro for instance is stucco that can

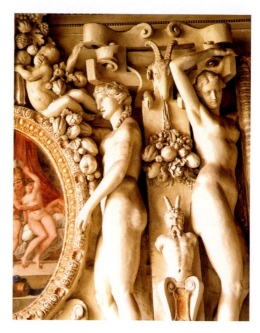

Plate 7.14
Francesco Primaticcio (1504–1570), stucco on the wall of the king's palace, 1541–1545, once room of the Duchess of Etampes. Fontainebleau, Musée du Chateau. © 2013. DeAgostini Picture Library/Scala, Florence.

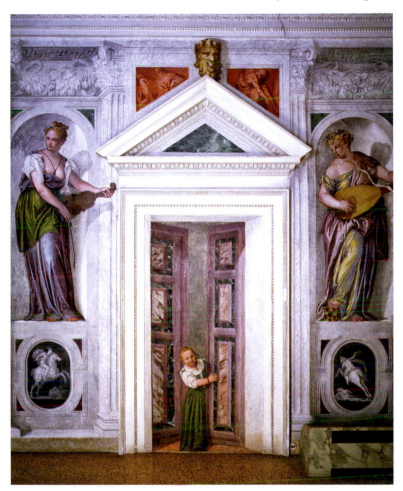

Plate 7.15 Paolo Veronese (1528–1588), Female Figure at Door, 1550–1558, from Fresco and Stucco Cycle at Villa Barbaro by Veronese and Vittoria. © Araldo de Luca/Corbis.

be polished when the ratio of marble dust is higher and sometimes gesso is added. One of the best examples of this tradition is seen at the Palace of Fontainebleau where the technique was brought from Italy by the artists Rosso and Primaticcio for the French king, Francis the First, in the sixteenth century.

Here classical nude figures in stucco surround paintings of classical subjects. Sometimes the pictures are oval and sometimes rectangular;

it is a way of making a whole wall come alive with that relationship between sculpture and painting which we discussed in Chapter 5; but here these arts are not in competition as they were in the arguments about the Paragone which we looked at in that chapter, but being used to enhance one another in a very ornate way. This kind of decoration may not be to our taste today. It was developed particularly in Europe and the most extreme form of it must be that in the Rococco interiors of the Emperor's Hall at the Residenz in Würzberg, by Balthazar Neumann, where every surface is decorated and the whole seems to be moving and bulging. Illusion could also be important in this context, as we shall see in the next section of this chapter.

The enhancement of the relationship between landscape sculpture and architecture can be seen in the work of the Venetian architect Andrea Palladio, particularly in his Villa Barbaro where he organised a sculptural semi-circle of sculptures called a Nymphaeum like a grotto to extend the space in the first-floor salon. When you are inside it looks as though the basin and fountain and sculptures are part of the room. Inside (Plate 7.15) the theme is continued with Veronese's illusionistic decoration where people appear to open doors or gaze at you from a balcony. Look at the way the figures, apparently in niches, extend beyond the confines of the painted architecture to create a three-dimensional effect like sculptures would. On the other side of the room you look out over a vista of landscape which has been carefully controlled to appear harmonious like the repoussoir effect in a painting by Claude Lorraine (see *Learning to Look at Paintings* p. 41).

In England these ideas were employed not only in gardens but also in the houses of the great and the good, like Houghton Hall, the home of Robert Walpole in Norfolk. Here William Kent designed a staircase which he decorated to look like sculpture, using an illusionistic decoration to make you see and think in a three-dimensional and sculptural way. As you begin to climb the stairs you see there is a platform in the stairwell; you soon realise that this forms a tall plinth for a reproduction in bronze of the Borghese Gladiator; in the background of Plate 7.16 you can see Kent's use of the monochromatic grisaille technique to make it look as if it is made of stone. Then you notice that the bronze figure is pointing you in the direction of the double height marble hall (Plates 7.17 and 7.18), where the walls are articulated by marble sculpture in the form of urns, niches, busts and caryatids supporting the fireplace.

You enter a world of white marble and the eighteenth-century idea of the classical world. Rysbrack's bust of our first Prime Minister,

Plate 7.16 William Kent (1685–1748), view of the Gladiator from the Stone Hall, 1722–1735 (photo). Houghton Hall, Norfolk, UK/The Bridgeman Art Library.

Robert Walpole, presents him as a virtuous Roman with the hunting scene of the sacrifice to Diana, the goddess of hunting, behind. This relief is a sculptured picture in a frame presenting the scene in a frieze-like composition, idealised and grave. But what really strikes you is the refinement and variety of the carving with such complex and subtle variation that it appears like a painting, even to the extent of being set in a marble frame. The concept of the double-height room was derived from the Queen's House at Greenwich, which had been designed by Inigo Jones; he studied Palladio's work in and around Venice and is credited with bringing the classical language of architecture to England.

The idea of bringing found objects together and composing them into a whole environment is another aspect of the huge influence

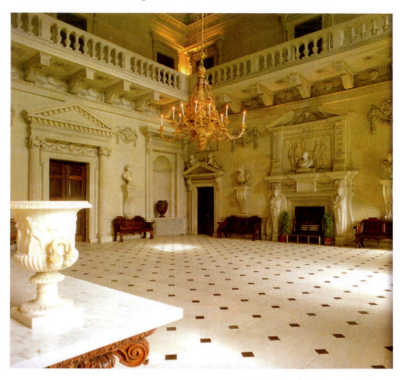

Plate 7.17 Colen Campbell (d. 1729) and William Kent (1685–1748), Marble Hall at Houghton, 1722–1735. Houghton Hall, Norfolk, UK/Photography by Nick McCann.

Plate 7.18 Michael Rysbrack (1694–1770), bust of Robert Walpole, *c.*1726–1730. Houghton Hall, Norfolk, UK/Photography by Nick McCann.

of collage which was examined in *Learning to Look at Modern Art* (Chapter 5 from p. 126). Later on in this chapter we will see the influence of Picasso's collage on the work of the land artist Richard Serra. In particular the artist Kurt Schwitters was famous for doing this in his work (see *Learning to Look at Paintings* p. 41).

Another kind of sculptural interior can also be experienced through the deliberate exploitation of the sculptor's studio and its contents. This was done by Constantin Brancusi through his own photographs, and he left his studio in Paris to the French nation; it is now displayed in the National Museum of Modern Art at the Pompidou Centre in Paris. Brancusi intended this as a carefully laid-out and premeditated sculptural experience and the photographs were designed to do the same. He made sure the spectator could pick his/her way through the apparent clutter of the studio without touching the fragile and delicate surfaces of the sculptures.

In order to understand what Brancusi meant by this we need to focus on one of his well-known works called *Fish*, of 1926 (Plates 7.19 and 7.20). This piece is made from carved wood and metal. The fish of the title is set on its side, made of highly polished bronze, and placed on a circle of mirror-like metal in which it is reflected. In Plate 7.19 you can see this is then mounted on a beautifully carved plinth, which resembles the trunk of a tree or an enlarged egg cup, with a hole through it, the edges of which are shown as chiselled. Then, the whole piece is set on a black circle, as a plinth which is only just raised off the floor. The whole sculpture is based on a kind of equilibrium where you feel that the fish might move at any moment; it appears almost to be swimming in the luminous and transparent reflective surface below, which suggests water: you can see this better in Plate 7.20 which has a different wooden plinth, one of several versions that Brancusi made of this sculpture. Yet, you know that this is impossible. The potentially slippery and fluid movement of a fish is countermanded by the defined edges of the ovoid shape and you find yourself looking at it as an oval placed on a circle with another circle in the wood below. Of course the whole sculpture can be looked at as abstract and yet it appears to have an organic form suggested by the title. You feel you would like to touch it and yet you are prevented by its almost machine-like finish. It is also important that the spectator looks down on it so that he/she can explore the reflections and the way the fish changes as you walk round it. The reflections in the surface also allow it to appear to move. If you look at it end on, it can appear to be swimming.

Plate 7.19 Constantin Brancusi
(1876–1957), *Fish (Poisson)*, 1926.
© Tate, London 2013/ADAGP,
Paris and DACS, London 2013.

Plate 7.20 Left side
view of *Fish* by
Constantin Brancusi
© Christie's Images/
Corbis/ADAGP,
Paris and DACS,
London 2013.

It may seem surprising to us that Brancusi could place this delicate and refined piece in the cluttered interior of his studio, and yet of course he did often make several versions of the same subject.

However, it was the very delicacy and fragility of the plastic experience that he wanted the spectator to see and feel. He is famous for his aphorisms about sculpture, like 'Beauty is the harmony of opposing things'. In the catalogue of the Brancusi exhibition held in 2004, Carmen Gimenez wrote about the apparent contradictions in Brancusi's work:

> Few have surpassed Brancusi in his ability to compose such complex equations with such simplicity, using all kinds of materials, from stone and wood to metal.
>
> (Catalogue *Constantin Brancusi*: 19)

After this Gimenez goes on to discuss the photographs Brancusi took of his studio and its contents:

> Nor have many better understood the spatial potentiality of sculpture, the singular manner in which each piece occupies both its own place and projects itself by means of its aura as an animated 'ghost sonata'. This appears in the thousands of photographs taken by Brancusi of his work. These should not simply be considered as exceptional documents, but also as other sculptures, since they show us new ways to see and feel the infinite malleability of space, which is lived physically and in reality, but is also present as a 'spectral double'.
>
> (Ibid.)

This commentary is about the concept of how the sculptures could enjoy another appearance in the photographs of the studio. There we can see the way they behave in space, and thus they can have more than one life. The idea behind the photographs referred to as the 'spectral double' was that they should give us an additional and alternative experience of the sculptures.

The sculptural use of light

Plate 7.21 Scrim installation (*Untitled*) by Robert Irwin, 1971

This piece is about making sculpture with light. Irwin uses it to alter the spectator's experience of the space around them. The installation has been made by stretching white translucent fabric (scrim) over a wooden frame, in front of a skylight, so that the light becomes

Plate 7.21 Robert Irwin, *Untitled*, 1971. Synthetic fabric, wood, fluorescent lights, floodlights. 96 × 564 in. approximately. Collection Walker Art Center, Minneapolis. Gift of the artist, 1971. © ARS, New York and DACS, London 2013.

diffused and spreads from end to end of the white rectangle. But what is really interesting about it is the way it appears to alter the shape of the room. The reflection on the floor seems to move beyond the surface and create depth, so that you are not quite sure whether it is there at all, as if it might not be solid after all. The angle of the installation also increases the effect of space, making it appear deeper and wider than it really is. As the spectator, you feel disorientated, and you are not sure where you are; the space seems to surround you and move because you are no longer sure where its parameters are.

If you look at the scrim from the side, the light takes on a milky and translucent appearance; you can no longer see even a suggestion of windows and you feel as if you could walk into it towards a horizon amidst the space, and the 'horizon line' fades off towards the left. Beyond that you can see what appears to be a wall, but it is not certain what angle it is at. You are not sure what is solid and what is not and where the edges begin and end. Like other Minimalist works we have looked at, and like much land art, the effect of this is horizontal rather

than vertical and not about solid volume, but about space. Artists like James Turrell and Dan Flavin (see *Learning to Look at Modern Art* pp. 223–227) also started working with light at this time; in fact Flavin particularly referred to his work as the architecture of light, and admitted to the influence of the early Russian Constructivists whom we looked at in Chapter 2.

The effect of sound

Plate 7.22 *Forty Part Motet* by Janet Cardiff, 2001

In a similar way there are also artists working today who deal with sound and space. In this installation you are invited to stand in the middle of a group of speakers emitting sound in unison which alters your sense of the space around you. The *Forty Part Motet* is based on *Spem in Alium* by Thomas Tallis. The forty speakers work like individual voices and you even hear the members of the choir chatting before the music begins. But, when you sit in the centre of the installation, as you are meant to do, the music all comes together and you feel you are inside the sound in a way that you would not be if you

Plate 7.22 Janet Cardiff (b. 1957), *Forty Part Motet*, 2001. Mixed media. Lent by Pamela and Richard Kramlich and the American Fund for the Tate Gallery, fractional and promised gift 2003. Tate Photography. © Janet Cardiff.

were sitting in the audience in a concert hall. So, like Irwin's light installation, your sense of where you are is disorientated and you gain a sense of space within the music itself.

Sculpture, light and the influence of photography

The idea about light altering spectator experience was experimented with by an earlier artist, namely Medardo Rosso, who worked with not only the idea of dissolving form in sculpture (see *Learning to Look at Modern Art* p. 49) but also how it changes with photography and light. A recent exhibition in Venice in 2007 was devoted to this side of Rosso's work and it showed very graphically how the spectator's experience of sculpture could be changed by the way it was photographed. This is another way in which the setting, the surroundings and the lighting can influence the experience of sculpture.

SCULPTURE AND LANDSCAPE

Plates 7.23 and 7.24 Sculptures in the gardens at the Palace of Versailles in France, seventeenth century, and at Rousham Park in England, eighteenth century

The idea of the relationship between sculpture and its setting, and how it alters the way you see it, especially in connection with architecture, as we saw in Chapter 1, goes back to antiquity. However, there is a more specific development, concerned with garden design, which originated in the seventeenth century and extended into the landscape garden movement in the eighteenth, particularly in England.

In Plate 7.23 you can see the idea of using sculpture in the garden very clearly. Sculptures like this are designed to designate a boundary as expressed by the hedge in the background. They are statues derived from the antique as you can see from the nearest one on the left in the foreground. They are designed to create a focal point for the eye and to contrast with the green behind. They are also set off by the pyramids of yew which you can see on the right, and which have been shaped by the art of topiary, which is a form of sculpture. Their stark dark geometrical shapes and their shadows make an effective contrast with the more naturalistic forms of the sculptures, and through the chiaroscuro of dark and light as well. These figures are in the gardens at the Palace of Versailles which were designed by André Le Nôtre who had previously created those at Vaux Le Vicomte for Louis XIV's

Plate 7.23 Versailles (France), Palace of Versailles (built from 1661 by L. Le Vau, from 1678 by J. Hardouin-Mansart). View of the park with sculptures. © akg/Bildarchiv Monheim.

first minister, Nicholas Fouquet. There, Le Nôtre had experimented with the geometrical ideas which he was subsequently to use in the gardens at Versailles.

The painter Nicholas Poussin designed architectural figures known as Termes for Nicholas Fouquet; his earliest biographer, Bellori, records that he saw him modelling them in clay before they were carved in marble; eventually, they were taken to Versailles, after the fall and disgrace of Nicholas Fouquet in 1661. Poussin's paintings often include sculpture and architecture and we saw how his work influenced Ian Hamilton Finlay in *Learning to Look at Modern Art* (pp. 80–81). In fact, so-called classical landscape painting like that of Poussin and his contemporary, Claude Lorraine (see *Learning to Look at Paintings* pp. 39–41 and pp. 185–186), was very influential on the development of English garden design in the eighteenth century.

William Kent's garden design and layout at Rousham Park in Oxfordshire was influenced by this development and is still largely as he left it; we can see immediately that it is much more informal than Versailles, for example in the way the natural landscape is allowed to impinge on the bridge, with its figures of Venus and the birds on either side (Plate 7.24). It allows it to seem wild and yet to remain what Horace Walpole called scenes that are 'perfectly classic'. The

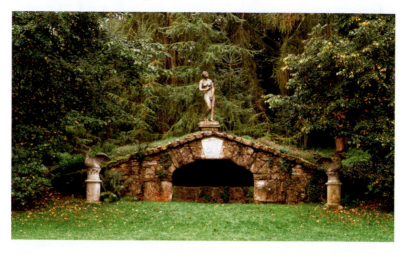

Plate 7.24 Rousham Park designed by William Kent (1685–1748), *c.*1738, Rousham, Oxfordshire, England. Partial view with bridge. Photo by Barbara Opitz. © akg/Bildarchiv Monheim.

idea of the serpentine line and the element of surprise are part of this much more informal and natural-looking design. However, it was derived from classical landscape painting and also from the idea of the re-creation of arcadia in pictures called poesie like those of Giorgione and Titian (see *Learning to Look at Paintings* pp. 169–172).

Setting sculpture in the landscape

The idea of setting sculpture in landscape was to go further than garden design. In the twentieth century it was taken on by Henry Moore who was fascinated by the idea, and he experimented with it in the extensive grounds of his house and studio at Perry Green in Hertfordshire. However, he was not above changing the landscape to suit his sculpture: in 1978 he talked about how he changed a hill:

> The small hill on the horizon is man-made. When I acquired the ground it was a pyramid of waste gravel. But you cannot put a sculpture on a pyramid if the point is too small, so I had a bull-dozer and shaped it into a small hill (sometimes mistaken for a pre-historic barrow). Now I want to put sculpture there. The sky is the perfect background for sculpture because you are contrasting solid three-dimensional form – the sculpture – with its opposite

the sky, which is space with no distractions The hill is first seen from three or four hundred yards away, therefore a sculpture needs to be of some size. The first things I tried on the hill were too small – from a distance they looked as though they could be a stray sheep that got there.

<div align="right">(Moore, Writings and Conversations: 65)</div>

The *Reclining Figure* Moore used here was enlarged from a maquette which he had made in 1938. The idea about large forms in a landscape was important, and recently the Gagosian Gallery in London showed Moore's *Late Large Forms* in an exhibition and they looked magnificent, more boulder-like and part of the natural landscape than they had out of doors.

But by 1978 when Moore was doing these experiments, the idea of what sculpture could be was changing, and we need to go on now and look at land art and what it can mean.

Landscape and the installation – the concept of land art

Plates 7.25, 7.26 and 7.27 *Highland Time*, 2002, and *Rhone Valley Stones Spiral*, 2000, by Richard Long

In the year 2000, in the pristine newly opened galleries of Tate Modern in London, in the section then called Landscape, Matter, Environment, there was a display which spoke volumes about the changes that had taken place in painting and sculpture, and, in particular, the development of installation art.

Beside a water lily painting by Monet, on the floor was a piece of three-dimensional art called *Red Slate Circle* by Richard Long; not carved or modelled, but made from carefully arranged pieces of red slate, in a circle which you could walk round. You could look at it closely, examine the different shapes, see the light and dark within them and admire the colour, but they were not carved or modelled like traditional sculpture would be. Like the piece by Carl Andre which we looked at in Chapter 1, the *Red Slate Circle* is horizontal and not vertical like most sculpture of the past. You relate to it in an entirely different way and you do not want to touch it because the pieces are craggy and uncut; instead, you look at it and it reminds you of the landscape in the natural world and makes you think and remember places you have been to. As it is on the floor you experience it as if you were walking in the landscape.

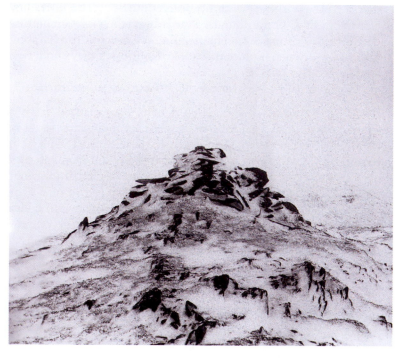

Plate 7.25 Richard Long, *Highland Time*, 2002. © Richard Long. All rights reserved, DACS 2013.

HIGHLAND TIME

A WINTER WALK OF SEVENTEEN DREAMS
CROSSING CREAG DHUBH CAIRN AT A MIDDAY
FROM A BLIZZARD TO A FULL MOON RISING
WHILE THE EARTH TRAVELS 5,740,000 MILES IN ITS ORBIT

SCOTLAND 2002

Plate 7.26 Richard Long, *Highland Time*, 2002. © Richard Long. All rights reserved, DACS 2013.

Richard Long's work is closely related to walking, as he started by walking in the landscape and recording his walks in photographs. As a student at St Martin's School of Art in London in the 1960s, Long had been part of a group which was encouraged to look at sculpture in a different way, saying in effect that it could be anything. This course ran alongside the more famous abstract sculpture course run by Anthony Caro. It was vocational and known as the Advanced or A course:

> Conceived in 1964, it pioneered radical approaches as to the nature of what sculpture or even art might be. Students were often accepted on this course on the basis of interview alone, without portfolio or other qualifications and it attracted a number of other brilliant and unconventional students including Barry Flanagan, Gilbert and George, and Hamish Fulton.
>
> (Catalogue, *Richard Long: Heaven and Earth*)

Long was allowed to experiment with walking in the landscape and leaving lines and circles of where he had been. These were then photographed to record the event. Sometimes, as with *Highland Time* in 2002, the experience is recorded in a text as well (Plate 7.26).

The idea here is that three-dimensional art can be about the experience of the space in the landscape and drawing the spectator's attention to that experience. More telling in a way are the installations in galleries or exhibition spaces, as seen in Plate 7.27, *Rhone Valley Stones Spiral*.

Here you can see how carefully the stones have been selected for their size and colour, their irregularity and the way that Long creates careful and aesthetic symmetry, from the spiral moving outwards in ever-widening curves, like ripples in the water. You as the spectator are made aware of the spiral, the constantly varying shapes of its component stones and the subtle colours moving between shades of white, buff and grey.

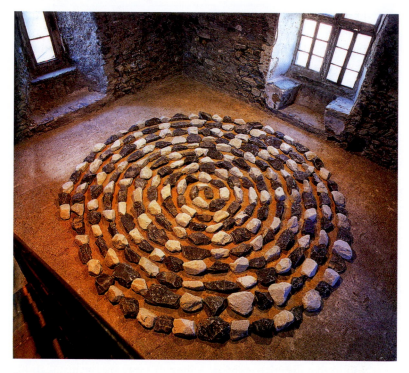

Plate 7.27 Richard Long, *Rhone Valley Stones Spiral,* 2000. © Richard Long. All rights reserved, DACS 2013.

Sculpture and the urban and industrial landscape

Plates 7.28, 7.29 and 7.30 *Fulcrum,* 1987, and *Left, Right,* 2001, by Richard Serra

Fulcrum is sited in an area of London known as Broadgate which is behind Liverpool Street Station and owned by a corporate organisation called British Land, which is typical of a type of corporate patron that takes pride in commissioning and buying sculpture for its land and buildings. In a leaflet published about this project, the director of British Land, John Ritblat, said of the project in Broadgate:

> As custodians of Broadgate's matchless array of sculpture, ceramics, paintings and mosaics, we at British Land are delighted by the way they enhance the environment for those who work in or pass through the estate. For Broadgate's art is a social amenity of a kind

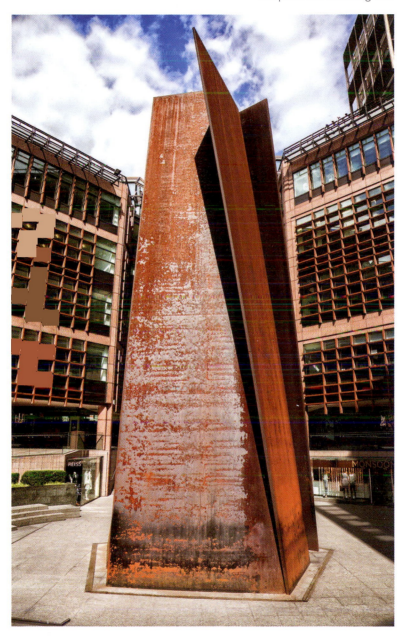

Plate 7.28 Richard Serra, *Fulcrum*, 1987. Photography by Finbar Good. © Richard Serra/ARS, New York and DACS, London 2013.

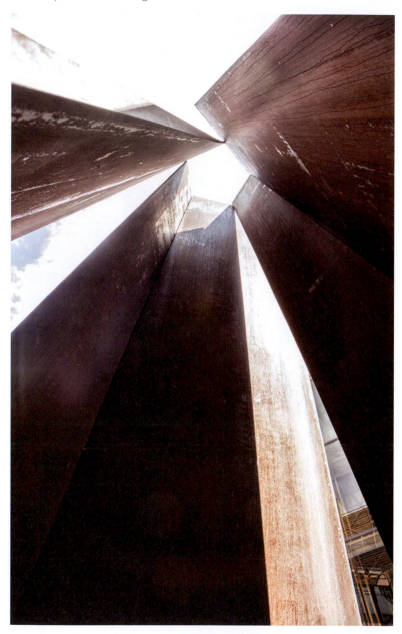

Plate 7.29 Richard Serra, *Fulcrum*, 1987. Photography by Finbar Good. © Richard Serra/ARS, New York and DACS, London 2013.

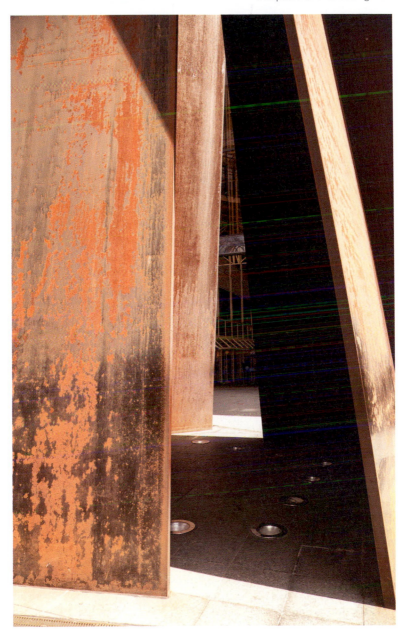

Plate 7.30 Richard Serra, *Fulcrum*, 1987. Photography by Finbar Good. © Richard Serra/ARS, New York and DACS, London 2013.

rare in London. Informally presented, broadly selective, alterna-
tively reflecting and counter-pointing the excitement of urban life,
the collection has become a focus of one of the world's great cities.
British Land, as owner and manager of Broadgate, takes pride in
this hugely successful marriage between commerce and art.

(Ritblat, *Art at Broadgate*: 2)

Thus this project is an advertisement for British Land as well
as being there to be enjoyed by the public and to appeal to their
imagination as spectators in the space. Serra's *Fulcrum* is part of a
collection of sculptures which are integrated with the architecture and
urban environment. The piece presents itself in a different way from
Long's work because it is made of sheets of industrial Corten steel
which rusts and changes colour in the weather but remains stable.
Serra has made these sheets lean into one another in an apparently
precarious way because they are not riveted and seem to stay there
through a controlled equilibrium and balance of their own. They look
like elongated triangles cut off at the top and leaning together to form
a pyramid. The sculpture is set in a shallow octagonal space and, as a
spectator, you walk down some steps to look at it, and you can
go inside, so you can feel the weight, the size, the balance and the
equilibrium of the whole creation.

In these three photographs you can see that, when you are inside,
there are spaces between the steel sheets letting shafts of light into
the interior and allowing you to experience a sense of the inside as
well as the outside space; thus you can gain a real feeling for the scale
which is much greater than life size, at 55 feet or 16.7 metres high;
so the whole sculpture is quite dominating and intimidating, but
strange and uplifting at the same time.

As a young sculptor, Serra worked in vulcanised rubber, but he is
most famous for his very large Corten steel sculptures in which you
are invited to experience walls of steel like the sides of a ship, which
are often tilted, as in *Left, Right* (2001). Then, you can move between
the sheets which seem to tilt towards you as you go down a narrow
corridor, as you might in a shipyard. You experience a feeling of
claustrophobia, helped by the changes in the light as you venture
inside into semi-darkness, and come out at the end of the curve and
into the light again. It is 12 feet 6 inches high by 40 feet long and
you feel dwarfed by it. So, once again this is about space in relation
to the spectator's body and visual experience. You feel small and you
have to move in order to experience this work; it is also in a spiral

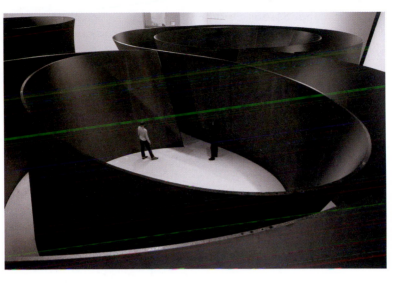

Plate 7.31 Installation view of the exhibition 'Richard Serra Sculpture: Forty Years', MoMA, NY, 3 June 2007–10 September 2007; The Abby Aldrich Rockefeller Sculpture Garden, 3 June 2007–24 September 2007. Digital image: Lorenze Kienzle. © The Museum of Modern Art, New York/Scala, Florence/ARS, New York and DACS, London 2013.

formation, but upright this time, and tilted at an angle. Serra calls the overall form a torque spiral.

Serra's father was an engineer and he himself started as a welder in a shipyard; but also this is about the idea of industrial memory which is very important to him. So also is the concept of sculpture made out of flat sheet metal which is then put together to create space, and which is not modelled or cast or carved, but folded, bent and tilted. As a young sculptor Serra published a text about all the words that could be used to describe what metal could do in his *Verb List* of 1967–1968, which starts with 'to roll, to crease, to fold, to store, to bend' and goes on until it ends with 'to continue'. The idea expressed here is part of what was preoccupying many artists at the time about how to extend the possibilities of sculpture beyond traditional boundaries. Robert Morris (see *Learning to Look at Modern Art* pp. 151–152) had started working in all sorts of materials including felt which he draped against the wall and suspended from the ceiling. The idea of soft sculpture was not new if you think of Claes Oldenburg and his *Soft Typewriter* of 1963 (see *Learning to Look*

at Paintings pp. 84–85). Another type of extension of this kind of experimentation was growing sculpture in the landscape, as we will go on to see now in the work of David Nash.

Sculpture grown in the landscape

Plates 7.32, 7.33 and 7.34 *Ash Dome* as photographed in 2004 and drawings; *Shooting Star*, 1987, all by David Nash

David Nash works mainly in Wales where he has been since 1968. In a sense nature is his studio, because with *Ash Dome* the sculpture has been grown from ash saplings over a period of years. The use of the word 'grown' is apt here, because originally the trees were planted in a circle and their trunks have been trained to grow inwards so that the foliage joins together above to form a dome. It has an architectural

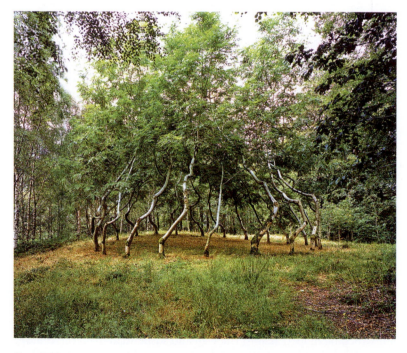

Plate 7.32 David Nash, *Ash Dome*, 2004.

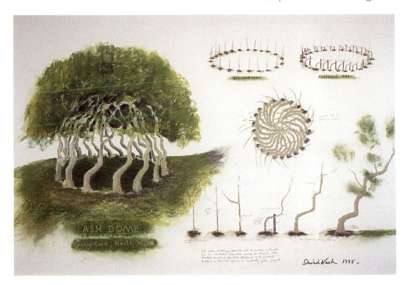

Plate 7.33 David Nash, *Ash Dome*, drawings, 1995. © David Nash. All rights reserved, DACS 2013.

feel to it and you can walk inside it and experience the green and leafy shade and the extraordinary shapes the trunks have made as though they were dancing in formation. The space surrounding them and the setting in the clearing of a coppice is also important for the experience of a kind of growing and changing space.

But Nash does not leave it there as a type of controlled planting; having planted it and trained it, he also draws it in several planes. In 1995, he drew his concept of what it would eventually look like. In this drawing, on the left we can see what it will eventually look like with the dancing trunks and the dome above. To the right at the top are two circles showing the vertical growth of the saplings and the way they are starting to be trained. In the middle of the page you see what it will look like from above as if the stems of the trees and their branches were the spokes of a wheel. Below that are drawings of the different individual saplings and the forms they might take. Nash has drawn the ash dome in a sculptural way, complete on the left, and then as seen in different planes from the side and from above and also the forms and characters of the individual trunks. Once again, as with Long's work, photographs are important for charting the progress of the sculpture and, like Serra's work, it has

architectural features because you can experience its space both inside and outside.

Nash also works with nature in other ways too. His 'quarries', where he works when he holds an exhibition, show him working with the chainsaw on a crane which he controls himself, as he did in his recent show at Kew Gardens. There he was able to place some of his sculptures in the glass houses, as if they were growing naturally amongst the plants. He works with chainsaws of different sizes, from big ones when doing the bulky work down to small ones for the finer shapes. The cuts the various saws make are important from the serrations on the surface to the idea of partially slicing through sections. But most interesting and most elemental of all is the way Nash works with fire. Some of his sculptures are wholly or partially charred like *Shooting Star*. Here, on the parts which are not charred you can see the striations where the wood has been sawn. Made of partly charred elm, the form moves out energetically towards the left as you see it in Plate 7.34. The blackened parts look deep and dense and mysterious. Then, as your eye moves out to the less charred sections you can see the striations of the saw cuts mixed with the grain of the wood. The black part could be the night sky and the woody part could be the light shooting out across it. Nash himself is very articulate in what he has to say about his relationship with wood, as an artist, craftsman and maker:

> If someone asked what material I was using when I was first making wood sculptures, I would say 'I am working with wood'. This was usually just planks and beams from demolition sites. When I no longer had access to that, the only available wood was fallen trees. Then I realised I was working not just with wood, but with where the wood came from – the tree. I was experiencing the trees by carving at first exclusively by hand (I didn't have a chainsaw for ten years). When you carve oak for example, it really bites back at you, it's got a lot of resistance. Carving lime – a soft yielding wood – on the other hand, is a very different experience. I was learning the language, the different dialects of these different woods.
>
> Once I started looking more into living trees and began to plant them, I saw how they are a weave of the four elements. The trees are seeded in the earth, which is full of minerals. That's a world of matter and solids. They need light and warmth (which is the fire element) and they need water and air. I realise that wood is a very balanced amalgam of these four elemental forces.
>
> (Lynton, *David Nash*: 116)

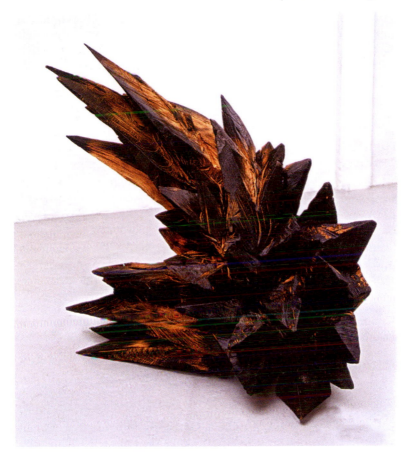

Plate 7.34 David Nash, *Shooting Star*, 1987. © David Nash. All rights reserved, DACS 2013.

So, Nash's approach is about working with nature as a living thing and understanding it in relationship to trees and how they grow. After this introduction he goes on to describe the growing habits and characteristics of all the trees and woods he works with. In *Ash Dome* and *Shooting Star* we have seen examples of this sense of the four elements in relation to wood as a growing and working material.

Both Long and Nash are working in the landscape in their different ways. Their lyrical and poetic approach to it has much in common with the English Romantic tradition in painting and poetry, with

Constable and Turner, Wordsworth and Coleridge. This could also apply to artists of the so-called Neo-Romantic tradition of the 1930s and 1940s like Paul Nash and John Piper (see *Learning to Look at Modern Art* pp. 256–257 and pp. 221–223) and of course Henry Moore.

CONCLUSION

Long, Serra and Nash are closely linked to the ideas and attitudes associated with land art. This turned out to be one of the most potent aspects of the shift in sensibility in the 1960s when there was a turning against traditional forms of painting and sculpture (see *Learning to Look at Modern Art* pp. 150–154). In the introduction to *Land, Art: A Cultural Ecology Handbook*, published by the Arts Council and the RSA in 2006, the editor, Max Andrews, discussed land art and how it became associated with ecology and environmentalism and new perceptions which went beyond the idea of the object in the landscape:

> Land Art belongs to a moment during which North American and European art practice seemed to take unprecedented forms and directions, broadcasting itself on new creative frequencies and becoming increasingly concerned with, for example, process and language.
>
> (Andrews (ed.), *Land, Art: A Cultural Ecology Handbook*: 18)

Andrews explains how it came to be seen as necessary to work with the material of the landscape itself rather than placing architectural and sculptural objects in it. One of the earliest people to express this view was the American artist Robert Smithson, who is most famous for his installation of 1970, called *Spiral Jetty*, at Salt Lake in Nevada. This has become an iconic symbol of the land art movement. He wanted art to come out of the museums and galleries into the natural world and become what he called site specific:

> The visual values of the landscape have been traditionally the domain of those concerned with the arts. Yet art, ecology and industry as they exist today are for the most part abstracted from the physical realities of specific landscapes or sites. How we view the world has been in the past conditioned by painting and writing. Today, movies, photography and television condition our perceptions and social behaviour. The ecologist tends to see the landscape

in terms of the past, while most industrialists don't see anything at all. The artist must come out of the isolation of galleries and museums and provide a concrete consciousness for the present as it really exists, and not simply present abstractions or utopias . . . We should begin to develop an art education based on relationships to specific sites. How we see things and places is not a secondary concern, but primary.

(Robert Smithson quoted in Andrews (ed.), *Land, Art: A Cultural Ecology Handbook*: 22)

Therefore the idea came about of working with the landscape and industrial sites themselves rather than painting them or making sculpture to go in them. In some cases, particularly in America, this kind of work was very extreme as with Christo and Jeanne Claude and Walter de Maria for example (see *Learning to Look at Modern Art* pp. 194–196 and 153 respectively). Max Andrews in the introduction to *Land, Art: A Cultural Ecology Handbook* suggests that there were a number of factors in the 1960s which contributed to this new perception, notably Rachel Carson's seminal book *The Silent Spring* and the first photographs of earth from space:

Various events could be said to have marked this emergence: the success of Rachel Carson's *Silent Spring* [1962], an incendiary account of the effects of industrial and agricultural chemicals, was an important landmark. The publication of the first photographs of earth from space in 1968 were surely another. Seeing the fragile beauty of humankind's only home laid bare, provided, needless to say, a profoundly new perspective. The first Earth Day in 1970 also contributed to and was a symptom of a growing impulse towards stewardship and conservation.

(Andrews (ed.), *Land, Art: A Cultural Ecology Handbook*: 18)

From the late 1960s there was a move away from the making of painting and sculpture into the installation, working with the actual material of the landscape, whether natural or industrial as we have seen in the work of Long, Nash and Serra. Land art was part of a wider movement which included Minimalism, Fluxus and Arte Povera which all began at around the same time (see *Learning to Look at Modern Art*, various chapters). But that is not to say that more traditional forms of sculpture have not continued to exist as we have seen in previous chapters.

Sculpture and drawing

INTRODUCTION

The idea that sculpture is essentially about seeing in the round makes its relationship with drawing particularly interesting. In this chapter we will look at the idea of sculptural vision in connection with drawing and wherever possible the relevant sculpture will be illustrated as well. This topic was partially explored in *Learning to Look at Paintings* (pp. 182–184) but I want to try and take it further now.

What do we mean when we talk about sculptural drawing? Certainly it is about form and the interaction between form and space. But also it must be about the communication of a feeling of three dimensions on a flat surface. This has been important since drawing really developed in the Renaissance, particularly in the context of the study of classical antiquity; it continued to be important after the founding of the academies for the training of artists in the seventeenth and eighteenth centuries. The drawing from plaster casts of classical sculpture was enshrined in the theory of where all art students should begin. So, drawing from sculpture became the foundation of artists' training, as we saw in Chapter 2 when we discussed the plaster casts in the Victoria and Albert Museum.

A very good example of this kind of plaster cast would be the famous figure nicknamed Smugglerius, cast from the body of a smuggler who was hanged at Tyburn in 1775. In her book on anatomy for artists, Sarah Simblett describes Smugglerius, whose body was pushed into the pose of the famous classical figure of *The Dying Gaul* and sculpted by Agostino Carlini in 1775–1778. Apparently, a plaster cast of this sculpture still exists at the Royal Academy Schools today.

> In 1775 eight smugglers hanged at Tyburn England were delivered to the anatomist William Hunter. He saw one was so finely built

that he arranged for his removal to the Royal Academy of Art Schools. There, the warm corpse was set into the pose of the Dying Gaul and flayed, and cast into plaster. Smugglerius remains in a lofty corridor, subject to artists' study and the curiosity of visitors.

(Simblett, *Anatomy for the Artist*: 19)

This figure is typical of the kind of cast that the art students would have been expected to draw from as part of their basic training in academies.

The idea of drawing as the basis of the artist's training goes back to Giorgio Vasari, in his book *The Lives of the Artists*. In the chapter about the life of Titian, Vasari describes how he and Michelangelo went together to visit Titian while he was in Rome working for the Pope, and Michelangelo praised Titian's work, but said that he should do more drawing; then Vasari went on to say:

To be sure, what Michelangelo said was nothing but the truth; for if an artist has not drawn a great deal and studied carefully selected ancient and modern works he cannot by himself work well from memory or enhance what he copies from life, and so give his work the grace and perfection of art which are beyond the reach of nature, some of whose aspects tend to be less than beautiful.

(Vasari, *Lives of the Artists*: 45)

Through this story about Michelangelo and Titian, Vasari is emphasising the superiority of line over colour which played a part in the Paragone or comparison between painting and sculpture which we looked at in Chapter 5 and in the discussion of Michelangelo and Titian in *Learning to Look at Paintings* (pp. 57–60). Implied within this also is the idea of idealisation of the human figure and the making of it into something more beautiful than it could be in real life. In the famous preface to the third part of his *Lives of the Artists*, Vasari took the argument further by suggesting that drawing, or what the Italians call disegno, was the most important of all. However, in Italian this word disegno meant something more fundamentally compositional and more closely allied to our concept of design. Vasari saw disegno as the father of the three arts of architecture, painting and sculpture and as a combination of the intellectual and the practical. In their book *Objects of Virtue*, Luke Syson and Dora Thornton suggest this idea goes back further, to the fifteenth-century artist Lorenzo Ghiberti, whom we discussed in Chapter 4:

In the 1440s when the goldsmith sculptor Lorenzo Ghiberti wrote his *Commentaries*, he called disegno the 'foundation and theory' of painting and sculpture. Thus he lays the ground for Vasari's statement that 'disegno was the father of our three arts, architecture, painting and sculpture, deriving from the intellect'.

(Syson and Thornton, *Objects of Virtue*: 136)

So, this famous piece of theory can be applied to all three arts and therefore belongs more properly in the theory of design. In the epilogue of this book we will consider three-dimensional design and its relationship to sculpture.

However, in the academic training of artists it was not only drawing from sculpture which was important but also drawing from the life, together with the study of anatomy, which we will go on to consider now.

DRAWING AND THE STUDY OF ANATOMY

Plates 8.1 and 8.2 Studies for the *Libyan Sibyl* on the Sistine Chapel Ceiling, *c.*1510, and Studies for the *Dying Slave* and flayed arms, *c.*1514, by Michelangelo

As well as drawing from sculpture and plaster casts, the art student is still often expected to study the anatomy of the human body, in order to understand the underlying organisation better. This really started in the Renaissance, and everybody knows that Michelangelo's contemporary, Leonardo da Vinci, was fascinated by anatomy and the internal parts of the body, as well as the external ones. So was Michelangelo, but not for scientific reasons so much as for structural and compositional ones.

One of the most complete examples of what we are talking about here would be Michelangelo's beautiful drawing in preparation for the *Libyan Sibyl* on the Sistine Chapel ceiling. This is all about the body turning in space and the drawing of the muscles of the upper back on the left. Sarah Simblett can actually enumerate them, so clear is Michelangelo's drawing of the anatomy. Describing the left shoulder she says:

The scapula is rotated forwards by serratus anterior, pulled down and rotated superiorly by trapezius. The spine of the scapula emphasized by light is at 45 degrees rising to meet the clavicle . . .

(Simblett, *Anatomy for the Artist*: 211)

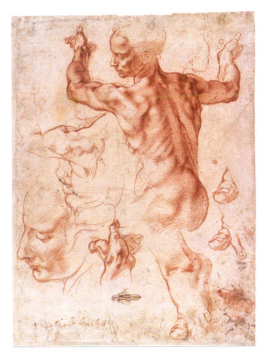

Plate 8.1 Michelangelo (Michelangelo Buonarroti, 1475–1564), Studies for the *Libyan Sibyl*. New York Metropolitan Museum of Art. © 2013. Image copyright The Metropolitan Museum of Art/Art Resource/Scala, Florence.

However, there is another aspect of this drawing which is equally interesting and that is that Michelangelo has extended the further side of the back and arm on the right so you sense it turning towards you. Here, the study of the muscles is exaggerated in the pattern of the light and shade, and the edges of the forms are emphasised to draw the eye into the centre and allow you to feel it as moving. On the rest of the page are other bits of anatomy which the artist has drawn in detail, particularly examples of the foreshortened foot and big toe. The fact that Michelangelo studied parts of the body from an anatomical point of view is taken further in these drawings of the arm in Plate 8.2 which we will go on to look at now.

On this sheet there are studies of parts of the arm in red chalk and pen and ink, made for his sculpture *The Dying Slave*, which was originally intended to be part of the tomb of Pope Julius II, which was never completed. This beautiful carving shows that quality of containment which we discussed in connection with the figure of David in Chapter 2; but here, instead of standing firmly on the ground, this dying figure appears to be sinking gradually into it. In this sheet of

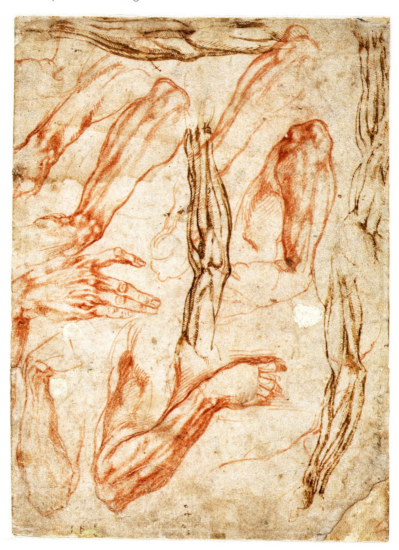

Plate 8.2 Michelangelo (1475–1564), Studies for the *Dying Slave* and of flayed arms, c.1514. Image courtesy of Teylers Museum Haarlem.

drawings, according to the British Museum catalogue, it is thought that Michelangelo turned the page round, so the sketches appear to have been made from several angles:

> In the five studies at the top of the sheet, Michelangelo began by concentrating on the articulation of the wrist and forearm with the position of the hand only outlined. He then flipped the paper the other way around to make a study of the entire arm resting on the chest in a pose close to that of the marble.
>
> (Hugo Chapman in Catalogue, *Michelangelo Drawings: Closer to the Master*: 144)

Following this suggestion, if you look at the page horizontally, you can see the pen and ink drawings of the arm more clearly, revealing the structure of the muscles, particularly in the forearm in the centre; there the artist shows how they are attached to one another by the way that he has used the darker tones, as they are thicker and darker near the elbow area. These pen and ink drawings are what are called écorché, meaning flayed, where the skin has been removed, so that the muscle structure below can be more clearly seen. But what is most remarkable about this is the way the muscles are understood by the artist so that together they make the shape of the outside edge of the forearm, and the pen strokes have been used to make it look incised or carved out of the paper. If you look just below, and just above, you can see what Michelangelo does with the forearm in red chalk, where the lower edge is again defined to allow the eye to concentrate on the internal volume of the form and its structure, as we have just seen in the drawing of the back of the *Libyan Sibyl*. Thus, on this page, there are anatomical drawings in red chalk and pen and ink taken from several angles. As we saw, Michelangelo turned the page round in order to use the spaces left after he had made the écorché drawings, and then carried on with those for his sculpture of the *Dying Slave*.

If we then turn the page back to the upright position we can see a more detailed drawing of the slave's right arm near the bottom of the page. Here the effect of carving out of the page is felt along the edge of the top of the arm, and the evidence of cross hatching in the V shape between the upper and lower sections is the indication of where the torso would be. The other extraordinary and wonderful quality is the way the drawings of pieces of arm seem to be carved out of the surface so you see the background as space bringing the whole page alive in a three-dimensional way. The more you look at it, the more

intriguing and revealing it becomes of Michelangelo's fundamentally sculptural vision. The turning of the page in particular is giving you a three-dimensional experience of seeing in a sculptural way.

SCULPTURE, DRAWING AND PAINTING

Plate 8.3 Drawing of the *Belvedere Torso* by Peter Paul Rubens, 1601–1602

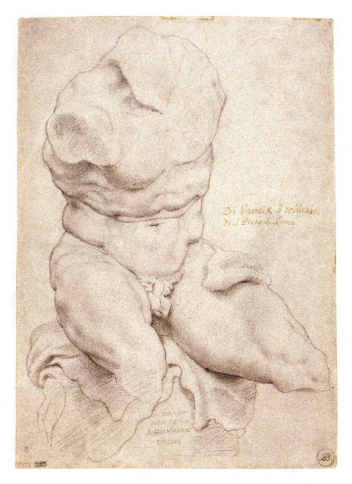

Plate 8.3 Peter Paul Rubens (1577–1640), drawing of the *Belvedere Torso*, 1600–1608. Pencil and black chalk on paper. Photography by Lowie De Peuter and Michel Wuyts. Rubenshuis, Antwerpen © Collectiebeleid.

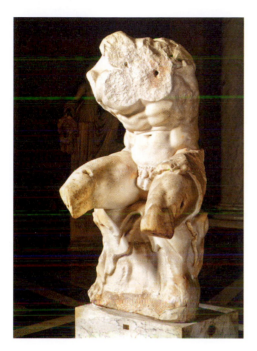

Plate 8.4 Belvedere Torso, 1st century BCE. Vatican, Museo Pio-Clementino. Marble. © 2013. Photo Scala, Florence.

The idea of painters using the study of sculpture to help them is very clearly shown in this drawing of the *Belvedere Torso* by Rubens. But painting could also be used by sculptors, as in the famous portrait of Charles I seen from three points of view, which Anthony Van Dyck did for Bernini to help him to make his bust of the king. Then, when we move on to Cézanne's study of sculpture we will see how it helped him in his experiments with the depiction of three dimensions on a flat surface in his paintings. In this drawing Rubens shows us just what is so remarkable about this fragment of classical sculpture. Here is a torso with no head, no arms and legs severed at the knee, and yet it is completely fascinating; this is because of the way that the weight is disposed, and the twisted and tilted angle in which it is bending to the left, and leaning slightly forward. You can see in the photograph of the sculpture itself, the way the stomach is flat and the rib cage is inclined over it and leaning slightly towards the left. When you move round to the back, this imbalance and tension in the body is even more evident.

Rubens has chosen to make his drawing from the front of the sculpture, and slightly to the left. He enables you to see the twist, and

the fact that the shoulder appears to be moving in front of the picture plane helps you to see the bulk of the body more clearly. He shows the character of the carved edges by varying the pressure with which he uses the black chalk. You can see this particularly down the edge on the left. If you allow your eye to travel down from the protruding shoulder you can see how the edge of the body has been defined by a darker and lighter line so that you feel the edges of the form and the tension in the musculature. It is also evident in the dark tones under the thigh on the right, and behind the knee on the left. This creates the feeling of recession and weight, and it applies to the shadow under the rib cage as well. Rubens makes you feel the dynamic tension in the pose, and yet his drawing does not feel like a stone sculpture, but more like the flesh of a real model. Rubens has drawn it as though it were alive, and as though those folds of skin were soft, and the muscular thighs were about to move. However, you know that this is impossible because of its fragmentary stone form which is made of marble and inanimate. Rubens was quite clear about this quality himself when he wrote about sculpture in his book *The Imitation of Statues*, which he wrote, in Latin, probably around 1608–1610 and which he never finished:

> And even with the best statues of antiquity the painter has to take into consideration many things and to avoid those not connected with the sculptor but with his material. To this category belongs the variety of shadows. In nature the transparence of the flesh and the skin, or the gristly parts of the body will appear softer in the shadows than in a sculpture, where they are hard and blunt, since the shadows, by the natural and insuperable density of the stone are doubled there. Those who have grasped this principle of differentiation with the necessary acuteness, cannot devote enough study to the statues of antiquity for in these misguided times how little we degenerate mortals are able to achieve.
>
> (P.P. Rubens, *De Imitatione Statuarum*,
> *c*.1608–1610 quoted in Harrison, Wood and
> Grainger, *Art in Theory 1648–1815*: 144–146)

In this drawing you can see that the shadows are indeed softer and more diffused, as Rubens says, particularly if you look at the left side of the body, and the subtlety with which he conveys the roundness and softness of the flesh. If you look at the right-hand side of the body in this photograph of the sculpture you can see the way the edges of the shadow are more sharply defined and 'more stoney'. You could

say that this is partly due to the different techniques of drawing and carving, and you would be right up to a point, but the tactile qualities feel different too; Rubens' drawing makes you feel that if you touched the body it would be soft and warm, whereas the sculpture is more concerned with the density and solidity of the form.

Rubens was fascinated by sculpture and made drawings from it all his life; he visited Rome several times and he made a collection of sculpture of his own and had it set in a gallery at his famous house in Antwerp. But what was even more interesting about this, as Christopher White points out, was that Rubens had it designed to look like the Pantheon in Rome, which was originally intended for the display of sculpture: White quotes Rubens' early biographer, Bellori:

> He had a circular room built in his house in Antwerp with only a round skylight in the ceiling, similar to the Pantheon in Rome, so as to achieve the same perfectly even light. There he installed his valuable museum.
>
> (White, *Rubens*: 67)

Further connections between drawing and sculpture can be seen in the work of Bernini. When Bernini was commissioned to make a bust of King Charles I, he was sent a fascinating painting by Anthony Van Dyck which showed the king's head from three points of view: profile, full face and three-quarters.

Later in the nineteenth century Cézanne became famous for his study of the old masters, for wanting to 're-do Poussin after nature' and for saying that artists need to learn from the past:

> The Louvre is the book in which we learn to read. We must not however be satisfied with retaining the beautiful formulas of our illustrious predecessors. Let us go forth to study beautiful nature, let us free our minds from them, let us strive to express ourselves according to our personal temperament. Time and reflection more-over, modify little our vision and at last comprehension comes to us.
>
> (Cézanne, *Letters*: 315)

In famous quotations like this, it is sometimes assumed that Cézanne meant only the old masters of painting, but he also drew from sculpture all his life, and particularly when he was working on the *Bathers* paintings of the 1890s (see *Learning to Look at Modern Art* p. 12). The reason for this was the desire to incorporate the

sculptural values of form into his pictures, especially as he could not work from live models outside. In a letter to his young artist friend Emile Bernard, he explained the problem:

> You know that I often made sketches of male and female bathers, which I would have liked to have painted, on a large scale, from life. Lack of a model forced me to be content with glimpses. There were other obstacles to overcome, such as finding somewhere to set the scene that would not be too different from the one I had imagined, of gathering together several people, of finding men and women who did not mind undressing and holding the poses I wanted. There were a thousand other difficulties, too, such as carrying around such a large canvas, the vagaries of the weather, the positioning of the canvas, the materials which would be needed to work on it. I was therefore forced to abandon my plan, which had been to revise Poussin after nature, working in the open air, with colour and light, not one of those works that are entirely conceived in the studio and that have that brown tone that indicates there was no daylight, no reflections from the sky.
>
> (Letter to Emile Bernard 1903, quoted in Cahn, *Cézanne*: 125)

So the looking at and drawing from sculpture became even more important to Cézanne from the point of view of the observation of the human figure. But what is really interesting about this is that he quite often chose sculpture from the French tradition as well as the classical. One of the most famous of these is the study Cézanne made from a work by the seventeenth-century sculptor, Pierre Puget. The figure Cézanne drew from was a plaster cast displayed in the Trocadero Museum in Paris. This place had been set up by the architect and restorer Viollet le Duc, who wanted to provide copies of architectural and sculptural monuments of French art. He is probably most famous for his reconstruction of the medieval town of Carcassonne in south-western France.

Sculpture and drawing in the round

Poussin and the Paper Museum

Plate 8.6 Degas and photosculpture

There are other aspects of copying from sculpture and what it can mean. Nicolas Poussin for instance, when he was a young artist in

Rome in the early seventeenth century, worked for a patron called Cassiano del Pozzo on what came to be called his Paper Museum; Pozzo had asked a whole group of students, including Poussin, to copy all the monuments from antiquity in Rome. So Poussin became very well versed in drawing from classical sculpture. This experience seems to have had a profound effect on Poussin's method of working. Subsequently he went on to always compose his pictures from draped wax models sometimes called lay figures. In the first place he would put them in a puppet theatre and organise the composition and lighting. Then, as Anthony Blunt describes it, he went on to the next phase:

> When the figure composition was fixed in this way, Poussin made bigger models, and again covered them with draperies. From these he executed the actual picture, never painting direct from life, but going to look at real figures when he felt the need to do so. The proportions and types of the lay figures from which he actually painted were based on his long study and intimate knowledge of ancient statues, and it was to these that he looked as the ideal for his own compositions. He felt that if he painted from life he would lose his image of this ideal.
>
> (Blunt, *Art and Architecture in France*: 169)

So, Poussin was modelling his compositions from three-dimensional figures and we saw his sculptural methods in his painting of *Et in Arcadia Ego* and the influence he had on the work of the conceptual artist Ian Hamilton Finlay in *Learning to Look at Modern Art* (pp. 78–81).

However, the idea of copying from sculpture could be taken further, into what is closer to the idea of transposition. When Degas was preparing his sculpture called the *Little Dancer Aged Fourteen*, which we discussed in Chapter 2, he probably made at least fifty-six drawings of the figure from different angles because he understood the process of needing to see in the round. As a student he would have made copies of plaster casts, like this beautiful drawing of part of the Parthenon Frieze (see Plate 8.5).

Here you can see Degas using the academic technique of softly graduated tones to reveal the form of the figure of the horseman. Then, as Richard Thomson has shown, this kind of study went through a number of phases during his life until, when his eyesight was failing, he seems to have used wax sculpture as a kind of three-dimensional drawing:

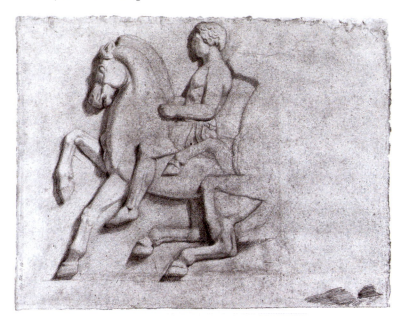

Plate 8.5 Edgar Degas (1834–1917), *Reiter zu Pferde*, drawing, Kunsthalle Bremen, Der Kunstverein in Bremen, Kupferstichkabinett. Photo: Lars Lohrisch.

> Given his willingness to destroy and restart waxes, it may be that modelling was for Degas a three-dimensional means of drawing.
>
> (Catalogue *The Private Degas:* 101)

It has long been known also that Degas was interested in photography, and it is thought by Thomson, amongst others, that he knew about the sequential photographs by Edward Muybridge which were published in the 1880s. Degas was primarily interested in the animal in movement and Muybridge's photographs revealed characteristics about the horse's gait in that it puts its feet down separately when walking, trotting, cantering or galloping.

More recently though, it has also been shown that Degas probably knew about something called photosculpture. The artist/photographer François Willème set up a studio in Paris in the 1860s for making photosculptured portraits. Twenty-four cameras were set up in a circle in a grand studio. The client was invited to stand in the centre, under a plumb-line, and a switch activated all the cameras to take pictures from slightly different angles at the same time.

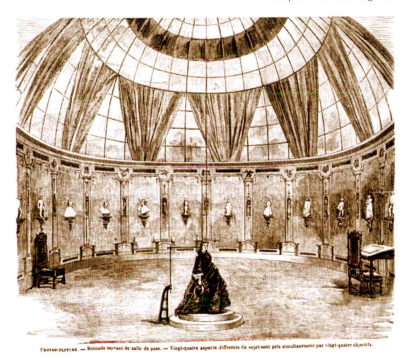

PHOTOSCULPTURE. — Rotonde servant de salle de pose. — Vingt-quatre aspects différents du sujet sont pris simultanément par vingt-quatre objectifs.

Plate 8.6 E. Morin, the Rotunda of François Willème's Studio, *Le Monde Illustré*, December 1864, p. 428. Bibliothèque nationale de France, Paris.

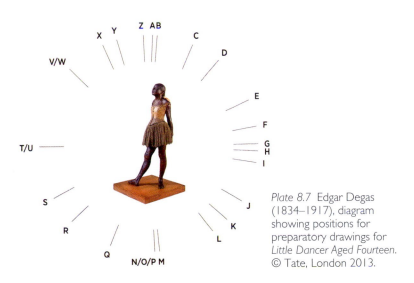

Plate 8.7 Edgar Degas (1834–1917), diagram showing positions for preparatory drawings for *Little Dancer Aged Fourteen*. © Tate, London 2013.

Then, a professional modeller was employed to transfer these images to clay or plaster and even to bronze or marble. He used a geometrical drawing instrument, probably a pantometer, to take measurements of angles, distances and elevations. Willème's ingenious methods caused a sensation in Paris in the 1860s and apparently created 'three-dimensional portraits of stunning exactitude' (Catalogue *Degas and the Ballet*, p. 86). This would certainly have fuelled that interest in realism we discussed in Chapter 2, and may have intensified the idea of making all those drawings of the *Little Dancer* in preparation for the sculpture.

SCULPTURE AND DRAWING FROM LIFE

Plate 8.8 *Woman with Arched Back* by Auguste Rodin, c.1900–1910

Plate 8.9 *Concourse (2)* by Barbara Hepworth, 1948

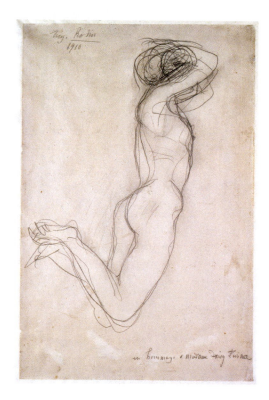

Plate 8.8 Auguste Rodin (1840–1917), *Woman with Arched Back*, c.1900–1910. Pencil on paper, 20 × 13 cm © Ashmolean Museum.

The concept of sculptural drawing and the qualities we have looked at so far can also be seen clearly, not only in drawings from sculpture, but also in examples of life drawing done by sculptors themselves. This is what we are going to look at now in drawings by artists of the last hundred years, beginning with Rodin.

Apparently Rodin's small drawing of 20 × 13 centimetres started out as a reclining figure and then was turned by the artist into an upright position. Rodin preferred his models to be on the move and liked them walking around the studio rather than being in a fixed pose. The first point to make about this figure is the way it displaces the space surrounding it. When you look at it with the paper horizontally it seems to be quite comfortable reclining in that horizontal position, but as soon as you turn it upright it becomes dynamic and full of movement.

This expresses as graphically as possible the idea of the figure moving in space. Rodin suggests this by the use of several lines to indicate the edges of the forms. The idea of the figure turning in space is indicative of how Rodin saw the model in constant movement and always occupying the space in a dynamic way. The reclining aspect shows the figure lying on her stomach with her legs flexed at the knee and her arm round her head. She looks relaxed, but as though she could move at any moment. The buttocks and the hip bone are suggested with more defined single lines and the feet appear to move as the different lines change. The darker area around the head is suggested with more fluid lines. When you turn the page upright, the figure suddenly becomes more dynamic as though jumping or flying through the air. It is the idea of a figure being seen as changing and moving in space which is so dramatic and so daring. The scale is small in terms of the size and yet you feel there is unlimited space surrounding the figure. The position on the page is important as the feet are nearer the edge than the rest of the body and this gives you a greater sense of it moving into the void. This drawing was given to the Ashmolean Museum by the family of Daisy Turner who had met Rodin in 1907 when he came to Oxford to receive an honorary degree. According to the catalogue, this drawing was not made for a specific sculpture but it is a very clear example of the sculptural understanding of space and form because of the way the page was turned to express more clearly the figure moving in space.

The composition in Barbara Hepworth's *Concourse (2)* (Plate 8.9) looks like a group sculpture because the drawing is so extraordinarily three-dimensional; the reason for this is because the relationships

Plate 8.9 Barbara Hepworth (1903–1975), *Concourse (2)*, 1948. Oil and pencil on pine panel, 66.6 × 108 cm. Collection: The Royal College of Surgeons of England. © Bowness, Hepworth Estate.

between form and space are made so clear, as if they had been carved rather than drawn. It is well known that Hepworth was primarily a carver, and this is essentially a sculptural drawing even though, or perhaps because, it is so abstracted and simplified. First of all, it is large, being 66.6 × 108 centimetres, and this helps to give it scale and monumentality. But it is the tonal relationships and the judicious use of line to emphasise the edges of the forms which helps to make this so aesthetic and so powerful. You can see this effect working if you look at the pale figure with his back towards us in the foreground and the way the edge of his torso on the right is dark next to the pale gloved hand of the surgeon on the far right, who is emphasised otherwise by the darker tones in which he is drawn. Then you see the way his dark hat is used next to the nurse in the background, and how the darks and lights alternate between the other figures behind. Gradually, your eye comes round to the figure in the centre, with the definition of his shoulder on the left, upper and lower arm, and hand. Now we can see that the right-hand lower edge of this figure is soft-ened against an oblong shadow in the foreground which separates him from his colleague next to him on the right. The pattern of hard and soft edges is very important in this drawing.

This brings us to the point that the sculptural forms are expressed as much by the spaces between the forms as by the forms themselves. The figures near the centre have their hats picked out, but it is the lozenge-shaped space between them which shows us their three-dimensionality, and the angles which allow us to see them as moving. Hepworth is also helped by the fact that their caps and gowns make simplified shapes which assist the visibility of the abstract qual-ities which are so evident here. She often used oil paint and colour as she has done here to enhance the three-dimensional definition. Sometimes she based her drawings on a gesso ground for which she used a commercially available enamel paint called Ripolin mixed with white lead and chalk.

> She equated the creation of these drawings with her carving techniques and described the feeling of a pencil incising a line through gesso as having a particular kind of 'bite' rather like on slate. Indeed, she referred to her abstract drawings as sculptures born in the disguise of two dimensions. She said 'I used the colour, not in a realistic way, but in order to stress the meaning of form and light as I had seen it.'
>
> (Catalogue *Barbara Hepworth: Hospital Drawings*. 21)

She herself was eloquent in the way she described the experience of making these drawings. In late 1947 and early 1948, the time of the foundation of the National Health Service, Hepworth was invited into Exeter Hospital by the surgeon Norman Capener, who had operated on her daughter Sarah. Hepworth vividly described the experience in her autobiography:

> I became completely absorbed by two things: first the extraordinary beauty of purpose between human beings all dedicated to the saving of life; and secondly by the way this special grace [grace of mind and body] induced a spontaneous space composition, an articulated and animated kind of abstract sculpture very close to what I had been seeking in my own work . . .
>
> (Barbara Hepworth, 1948 quoted in
> *A Pictorial Autobiography*: 50–51)

Hepworth means that, seeing beneath the surface detail of appearances, you can grasp the abstract shapes, which in turn releases one's visual understanding of the world around us. Hers is essentially a sculptural vision, encouraging us to see those connections between form and space, which express the rhythm and dedication around the operating table, without resorting to narrative or illustrative detail.

DRAWING IN SPACE

Plates 8.10 and 8.11 *Untitled (Three Cubi Studies)*, **1962–1963, and *Cubi XXVII*, 1965, by David Smith**

Plates 8.12 and 8.13 *Two Types*, **2008, and *Untitled*, 2007, both pencil on paper, and *Points of View*, 2007, by Tony Cragg**

In the past hundred years or so there have developed a number of interesting ideas about drawing in space, where the process is not so much drawing with pen, pencil, charcoal or graphite, but more about expressing three dimensions in the space itself. Moholy Nagy and his use of the Photogram is a case in point because it is like drawing with light, and the plexiglass sculpture that goes with it reflects that.

The concept of drawing in space was also developed by the American sculptor David Smith and he used industrial processes too. Like Moholy Nagy he was fascinated by the relationship between art and industry and this shows in these drawings for the famous series of stainless steel sculptures which he called *The Cubis*. In this

drawing Smith has made the forms stand out by leaving them white and sharply edged against the dark background. He made them by covering the areas of white and using an industrial spray gun and enamel paint. But, like most of the drawings we have looked at in this chapter, they have surprises in store when you start looking at them in detail. The first point is that they are very three-dimensional; if you look down in the bottom left-hand corner you can see that the legs underneath the lowest rectangle are clear behind and in front of one another; it is clear higher up too where another rectangle is tilted in space. Also very revealing is the way the spray gun has been used to create medium tones on the abstract shapes almost as you would in an etching or a screenprint (see *Learning to Look at Paintings* Chapter 8). Then, the dark areas in the background have been modulated to create a feeling of recession so the white forms look as though they are standing in space. Smith believed that drawing was the most important part of making sculpture and always encouraged his students to do it too.

Plate 8.10 David Smith, *Untitled* (*Three Cubi Studies*), 1962–1963. Spray enamel on paper, 11½ × 16⅜ in. (29.2 × 41.6 cm). Photo credit: Robert McKeever, Courtesy Gagosian Gallery, New York. © The Estate of David Smith/DACS, London/VAGA, New York 2013.

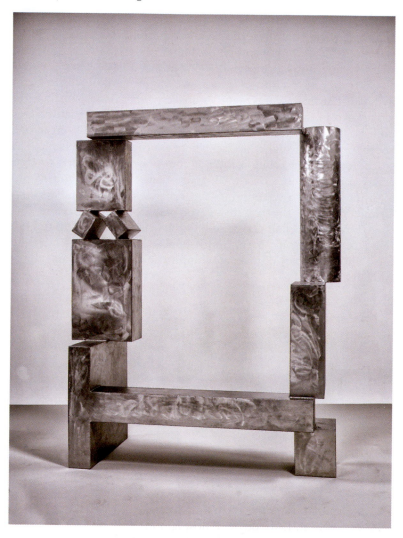

Plate 8.11 David Smith, *Cubi XXVII*, March 1965. Stainless steel. 111¼ × 87¼ × 34⅛ in. (282.6 × 221.6 × 86.7 cm). Solomon R. Guggenheim Museum, New York. Photograph by David Heald. © The Solomon R. Guggenheim Foundation, New York/The Estate of David Smith/DACS, London/VAGA, New York 2013.

I would first teach drawing; teach the student to become so fluent that drawing becomes the language to replace words . . . For the feeling of form develops with technical skill.

(Catalogue *David Smith*: 403–404)

You can see this in the sculpture of *Cubi XXVII*. Smith has used stainless steel columns, squares and rectangles to draw in space. You, as the spectator, feel that you could walk through as though it was a gateway or an architectural entrance. Quite quickly you notice that this is not only about the form and space but also about the surface, which has been tooled, refined and polished so that it catches the light and reflections.

This sculpture is not really about solid volume in the sense of density but about opening out the forms so that you can see round, between and beyond them. The scale is very large, 111¼ × 87¼ × 34⅛ inches so it stands over 9 feet tall and over 7 feet wide. It is as though the forms were drawn in space and the edges are deliberately and geometrically irregular. Smith always said that he was inspired by Picasso's understanding of sculpture where the form was opened out and became like drawing in space. In the Introduction to the catalogue of the David Smith exhibition at Tate Modern, Carmen Giménez, who was a friend of Picasso's colleague the sculptor Julio Gonzalez, says that this concept was very important to Smith.

He realized how decisive an influence Cubist Collage was on sculpture, just as he later acknowledged that sculptural 'transparency' derived from 'drawing in space' as well as from the use of industrial welding.

(Catalogue *David Smith*: 4)

As a young man Smith had worked in the Studebaker automobile factory with welding and oxyacetylene equipment, and, in the early 1930s, he started using this technique to make metal sculpture particularly from iron. Later on, and most famously, he started working with stainless steel, which he found a most versatile material. In 1938 he said:

Steel can be stainless, painted, lacquered, waxed, processed and electroplated with molybdenum. It can be cast. Steel has mural possibilities which have never been used. It has high tensile strength, pinions can support masses, soft steel can bend cold, both with and across its grain, yet have a tensile strength of thirty thousand pounds to one square inch. It can be drawn, spun, capped,

and forged. It can be cut and patterned by acetylene gas and oxygen, and welded both electrically and by the acetylene oxygen process. It can be chiselled, ground, filled and polished. It can be welded, the seams ground down leaving no evidence. The welds can possess greater strength than the parent metal. It can be formed with various metals by welding, brazing and soldering.

(Ibid.: 396)

Thus Smith brought industrial techniques into the making of sculpture and indeed into the making of drawings with a spray gun as we saw at the beginning of this section. He also liked to site his sculpture outside, which he did on his own land at Bolton Landing in northern New York State. He liked the way the stainless steel sculptures particularly reflected the light.

I like outdoor sculpture and the most practical thing for outdoor sculpture is stainless steel, and I made them, and I polished them in such a way that, on a dull day, they take on the dull blue, or the color of the sky in the late afternoon sun, the glow golden like the rays, the colors of nature.

(Ibid.: 415)

It is clear that Smith had a great feeling for the possibilities of stainless steel as a material for sculpture; he was a significant trailblazer for artists like Richard Serra and Donald Judd whom we looked at in Chapter 7. His idea of opening out the form and drawing in space was essential to the techniques he developed in drawing and sculpture. But, as we saw at the beginning of this section, Smith believed that the most important discovery for a sculptor is that of how to express form and that it is through drawing that you do that. The contemporary British sculptor Tony Cragg would agree with that. His drawing is more traditional as we shall see, as he uses pencil on paper, although it can appear like a doodle before it is turned into three dimensions.

Untitled by Tony Cragg (2007) indeed looks as though it is derived from a series of doodles which have morphed into the profiles of a series of human heads, which are not all the same, but all seen from the side (see Plate 8.12); however, you quickly start to see that they are many-layered. They are brilliantly described in terms of lighter and darker tones and lines which are wider apart and then closer together. Then, as you look at them, they seem to become one shape but full of a waving and flowing movement, which breaks up, divides

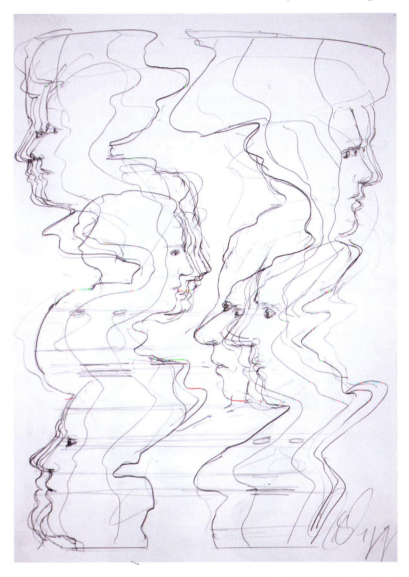

Plate 8.12 Tony Cragg, *Untitled*, 2007, pencil on paper, 52.5 × 51 cm. © DACS
2013.

and then comes together again. This 2007 drawing became a sculpture during the same period. The profiles are facing in different directions, but it is as though they have been spread upwards, some more incised than others, some darker than others, almost like strata of rock; they seem to move and flow like lava although they do end quite firmly at the edges of the page, as though they are seen as single objects, with a flowing movement between their edges. They are abstract but again derived from the study of the human head. The lines at the edges are free-flowing and moving.

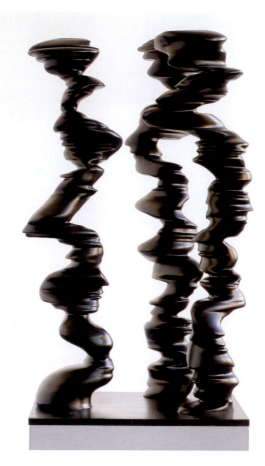

Plate 8.13 Tony Cragg, *Points of View*, 2007. Bronze, 107 × 65 × 65 cm. Photo: Charles Duprat. © DACS 2013.

In the sculpture called *Points of View*, a lava-like quality is carried into the bronze as though it had been extruded like plastic. The profiles metamorphose into one another in one continuous edge, and the whole piece looks as though it is moving. This is also because of the apparently liquid and flowing forms. You can see easily how this piece is derived from the drawing, and the way the formation of the head and profile has been used to make the basis for the shapes. Just as in the drawing, the edges are important, as are the spaces between, which enable us to see those recognisable forms. You can see lips and noses and sometimes chins and eye sockets and even a neck and the beginnings of a torso down on the left of this picture; this is helped by the fact that they are three-dimensional, like standing but moving columns. This architectural aspect is also significant because, unlike much sculpture today, these are upright and not horizontal. In many ways, Cragg's working process is very traditional:

> One factor which characterizes Cragg's work is that it is handmade. Artist friends who have visited his studio have been astonished to find that the work is still made in plaster, is carefully filed and polished by hand, and is often cut up, reworked and reconfigured in an approach that is basically the same as that used by Auguste Rodin. Cragg has a number of assistants (as of course did Rodin), but they carry out his specific instructions which are transmitted through drawings as much as through speech.
>
> (P. Elliott, 'Thinking with Material' in Catalogue *Tony Cragg: Sculptures and Drawings*. 113)

The materials from which Cragg makes his sculpture are always interesting. The one we are looking at is made from bronze which has been highly polished and then painted to get that high finish so that it ceases to look like bronze and seems to become more liquid, like Bernini's treatment of marble which we have seen. Sometimes Cragg's sculptures are coloured like the one called *Outspan* which has been painted with a saturated yellow. The idea of painted sculpture goes back to the Greeks, but here it has been used to unify a kind of collage sculpture originally inspired by the crinkled surface of an oil can and the neck of a plastic bottle. Cragg is fascinated by materials of all kinds and he started out by making a series of what he called *Potato Heads* in the 1970s and then moving into collage sculptures created out of pieces of coloured plastic. Later on, he became fascinated with working with bronze, which he treats in such a way that it can be highly polished and painted. He moves freely between

drawing, watercolour painting (like the series he did on chromosomes in 2005) and sculpture. His involvement with materials is very important as is its three-dimensional solidity. In this sense Cragg's work is more traditional than that of installation or land artists. In his preface to the catalogue of his recent exhibition in Edinburgh he called himself 'a radical materialist', and in an article he wrote in 1996 called 'The Articulated Column', Cragg said this about sculpture:

> Sculptures are often and at their best not just the result of an artist taking a material, for example a piece of stone or a lump of clay, out of its normal environment and forcing it into a form which expresses a pre-formulated notion, but rather the result of a dialogue between the material and the artist. The material finds itself in a new form and the sculptor finds himself with new content and new meaning.
>
> (Quoted in Catalogue *In and Out of Material*, p. 185)

Therefore Cragg believes that the idea of a dialogue is important in the search for meaning, which is not necessarily certain or narrative or iconographical in any traditional sense, and which might change as you look at it. In these drawings and their related sculpture that is just how it seems, as though the amorphic structures will constantly be moving and altering as you look at them. The drawings may be flat on the page, but they appear to be fluid and fundamentally three-dimensional. Cragg says that all his work starts with drawing, and this applies whether you are a painter, a sculptor or, indeed, an architect or designer.

CONCLUSION

All the artists we have looked at in this chapter have considered drawing as an essential part of the process of making works of art. But it is also equally clear that they all considered it essential for making sculpture in particular. The process of making sculpture requires you to see, think and feel in three dimensions. Drawing can help you to do that because it allows you to explore and understand three-dimensional form in a number of different ways, through anatomy, the study of sculpture itself, the articulation of form and space and life drawing. Life drawing is especially important from all these points of view, and this is why it has been, and continues to be, a part of the curriculum for the majority of art students, whatever material or area of visual art and design they eventually decide to work in.

Chapter 9

Epilogue: the idea of seeing three-dimensional design as sculpture

INTRODUCTION

In this Epilogue we will explore the idea that the aesthetic appearance of some kinds of three-dimensional industrial design can be as satisfying to look at as any sculpture; in other words they can have sculptural qualities which are important to the visual experience of the designer and spectator. The kind of conjunction here which will be discussed is the point at which you might start looking at the parts of an engine for instance as three-dimensional pieces in their own right, or the point at which the manufacture of glass can be turned into a three-dimensional work to be looked at for purely aesthetic purposes, apart from its function.

Industrial design has the advantage that it is often far more visible in the public domain, particularly if it is flying, or being driven on the road. William Morris, the great nineteenth-century designer and maker, saw no distinction between use and beauty; but he was not theoretically interested in what we would call industrial design because it is not made by hand; but, when you consider that an industrial designer like Bugatti made his own tools to create the engine and components of his famous T35 car, then this distinction becomes blurred. We have already looked at artists like Donald Judd who become very interesting because of their concepts of interior design and furniture and the idea that the work does not have to be crafted by the artist in order to be acceptable in an art gallery. Other artists, like Louise Bourgeois for example, make sculpture out of fabric, tapestry and knitting as we saw in Chapter 5. Also, there are areas like fashion cutting and design which start flat and then can take on sculptural qualities when the figure is moving inside the fabric.

During the Renaissance the goldsmith's art was regarded as the highest of skills. The great sculptor Benvenuto Cellini saw design and sculpture as one. Many artists of that time would have been trained as goldsmiths first and foremost. Lorenzo Ghiberti, whom we looked at in Chapter 4, was a case in point, as was his contemporary, the architect Filippo Brunelleschi; goldsmithing was the foundation of much of the art of the Renaissance and earlier on, as we saw in the jewelled altar in St Mark's in Venice. In his famous letter to his friend Benedetto Varchi, Benvenuto Cellini describes graphically how he believes that sculpture is the foundation of all the visual arts.

> There are many and infinite things to say about this great art of sculpture, but for so great an expert as you, it is enough for me to have indicated a small part – as much as my small talent allows. I am convinced, and I repeat, that sculpture is the mother of all the arts that are based on design [the fine arts] and he who would be an able sculptor with a good style will more easily be good in perspective, a good architect, and a better painter than those who do not possess a good knowledge of sculpture.
>
> (Cellini, Letter to Benedetto Varchi quoted in Holt (ed.), *Documentary History of Art* volume II: 36)

So, the implication here is that sculpture and design are one and the same thing; it is not until later in the seventeenth century that the so-called fine arts of architecture, painting and sculpture were separated from those of design, in the development of the ideas of the academies and the hierarchy of subjects (see *Learning to Look at Paintings* p. 144). Then, much later, William Morris brought design and fine art together again in his re-establishment in the nineteenth century of the tenets of good design in reaction to the industrial revolution; his ideas about the unification of use and beauty, of the functional and aesthetic, resulted in the coming of the Arts and Crafts movement which led eventually to the establishment in the twentieth century by Walter Gropius of the Bauhaus School of design (see *Learning to Look at Modern Art* p. 167). Another example of this kind of development would be the Victoria and Albert Museum which was founded at the time of the Great Exhibition of 1851 to house sculpture and design. A little time before that, the Royal College of Art was founded to train fine artists and designers together.

DRAWING, GOLDSMITHING AND CERAMICS

Plate 9.1 *Design for a Ewer* by Francesco Salviati, *c.*1545–1550

Plate 9.2 *Black Basalt Vase* by Josiah Wedgwood, *c.*1780

Plate 9.3 *We've Found the Body of Your Child* by Grayson Perry, 2000

The asymmetry of Salviati's vase is almost off-putting because it seems so unlikely. In fact it may not have been intended to ever have been made, but instead to have been used as a presentation drawing, which is sufficiently detailed and highly finished that it could be regarded as

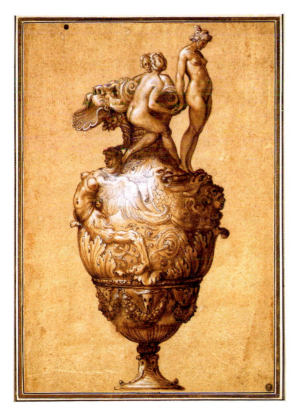

Plate 9.1 Francesco Salviati (1510–1563), *Design for a Ewer*, c.1545–1550. Pen and brown ink with grey wash, heightened with bodycolour, over black chalk on buff paper. Sheet: 411 × 276 mm. © Ashmolean Museum.

a fully completed work of art in its own right. It is made in black chalk with pen and ink and wash over it, with white highlighting. The whole drawing is made in different shades of buff; but the extraordinary thing about it is that it appears so solid and this is entirely based on tonal gradation from the lightest in the upper section on the left and the edges of the forms defined by the fine lines of the pen. The gradations of tone are extremely subtle if you allow your eye to move outwards from this highlight, and, if you turn to the left, you will see that the outside edge is in the form of a chimera with an animal's hind leg, and a human torso, with breasts and head forming the shoulders of the vase. The figures on either side seem to be resting on a series of acanthus leaves with swags and masks below where the shading becomes darker and more opaque. This in turn is echoed by darker tones above and two elegant female forms at the top, one standing and one half sitting. The whole design is deliberately assymetrical and yet extraordinarily solid so that you find yourself wondering what it might be like on the other side. It was designed with the goldsmith's art in mind but was never made. But, even if it had been made into a three-dimensional object, it would have been just as likely to be melted down at a later date, like the bronzes of the ancient world.

Goldsmith's work was closely associated with alchemy and it is an interesting fact that the person who discovered the secret of making porcelain in Dresden in 1708, Johann Friedrich Böttger, was originally employed by King Augustus of Saxony to discover the secret of how to make gold. The transfer from gold to ceramics is significant because Böttger became the originator of the manufacture of Meissen porcelain in the early eighteenth century.

In England the kind of ceaseless experimentation required for this work was done by Josiah Wedgwood. His design of the famous black basalt vase depicting a satyr, a goat and some bunches of grapes is a superb example of design.

In some ways you could say that it was descended from pieces like the Salviati drawing and the *Cellini Salt Cellar*, but it has much greater simplicity and harmony in its execution. It was made in Wedgwood's special Jasperware called Basalt which we discussed in Chapter 4. Here, though, the sculpture is fully in the round and the relief is the same colour as its background. It is also much more symmetrical than the Salviati design. If you look at it from the side you can see that its function is completely clear with the handle and the spout clearly displayed. But then, inside the handle, is the upper body and arms of

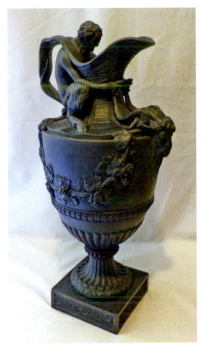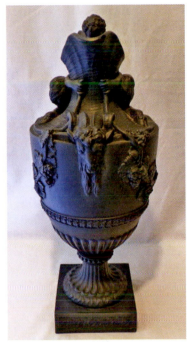

Plate 9.2 Josiah Wedgwood (1730–1795), *Black Basalt Vase*, c.1780. Private collection. Images courtesy of the author.

a man who is a satyr because his thighs are furry and he has cloven hooves and his hands are holding the horns of a goat.

The head protruding above the top level of the vase is apparently assymetrical, but beautifully balanced by the counterpoint of the handle, which joins into the curve of the top, which in turn becomes the spout. When you look from the front you see the two textured legs, the two smooth hands in unison, with the two horns of the goat and its eyes, nostrils and beard divided into two strands. This is then echoed by the bunches of grapes which curve down into swags on either side of the body of the vase, which then moves on down to a round pedestal on a square base. Your eye can then travel back up to the top where the head of the bacchic figure is viewed through the shape of the spout. These vases were replicated like bronzes, each one being numbered to locate it within a strictly limited edition. Ultimately this form is derived from the classical and Etruscan ceramics which were such an inspiration to Wedgwood, but the tactile and

visual experience of it, from the point of view of the spectator, is more like that of sculpture.

More recently these ideas about the experience of fine art and craft have been explored by Grayson Perry whose pots are based on the same kind of classical prototypes that Wedgwood might have used, like this one called *We've Found the Body of Your Child*.

When you first enter a room full of Perry's pots you are struck by the beauty of the three-dimensional shapes and their sheer aesthetic qualities. You can feel the tactile experience of the curves from bottom to top and, in the case of this one, you can also admire the reflective surface of the lustreware effect on the rim.

However, the title creates a complete contrast with the initial aesthetic experience because it shows people looking for and finding a dead baby in a snow-covered landscape. The bare trees create a series of verticals and these allow the eye to travel into and beyond the surface. You go down the slope on which the figures are standing into

Plate 9.3 Grayson Perry (b. 1960), *We've Found the Body of Your Child*, 2000. Earthenware, 49 × 30 × 30 cm. © Grayson Perry. Image courtesy of the Saatchi Gallery, London.

the valley below where you can see what looks like a frozen river. The figures are drawn in a simplified way, almost like folk art, without much detail, but expressing the inability to face up to the horror by turning their backs on the person carrying the baby. The figures and trees are placed in an expanse of space through to what look like white clouds or snow-covered hills. So the figures are not presented as relief decoration but have been drawn into the clay when it is still damp and then glazed in a variety of different shades of brown and buff, through to black at one extreme, and white at the other. The whole piece makes you marvel at the skill of the making and wince at the subject matter at the same time. Perry says that he chose ceramics and the familiarity of the shape because it would take you straight through to the painful message. At the same time he is very interested in the whole process of making, and his recent exhibition at the British Museum, called The Tomb of the Unknown Craftsman, was designed to celebrate the anonymous people who had made some of the magnificent objects in the British Museum's collection.

> Craftsmanship is about learning a particular skill that can be handed down: it's something that can be taught, apprenticed. That's what separates craft from talent and creativity. I suppose what I wanted to acknowledge, slightly mischievously perhaps, is that great things come out of craftsmanship as well as creativity.
>
> (Grayson Perry, quoted in *British Museum Magazine*, Autumn 2011: 26)

In this passage Perry is saying that what counts in art is not so much what is art, but more the skill with which it is made and the message it communicates about the culture from which it comes, and the people who made the object. Also in the exhibition, Perry had selected a prehistoric tool which was two hundred and fifty thousand years old, to remind us of the ancient origins of craftsmanship and making.

BEAUTY AND USE IN GLASS DESIGN AND MAKING

Plates 9.4, 9.5 and 9.6 *Persians* by Dale Chihuly, 2008

Plate 9.7 Glass flagon from Syria, fourth century CE

Plate 9.8 Burgundy wine glass designed by Claus Joseph Riedel in 1973 and manufactured by Riedel wine company, 2011

Dale Chihuly's forms in coloured glass, called *Persians*, create an effect of translucence and solidity at the same time. They are arranged so that you can stand amongst them and be surrounded by them. They are lit in such a way that you can experience them in terms of their texture, their solidity and their fragility. Also, their colours are rich and vivid. Their forms are more symmetrical in some places than in others and they have firm and blurred edges. In Plate 9.6 you can see the spectators surrounded by them.

However, this is nevertheless an installation which can be changed and dismantled and then reconstructed in a different configuration. The light plays a very important part in allowing the forms to move from solid to void, from translucent to opaque; edges disappear and reappear and so augment the effect of transforming the environment. They have a flower-like and jewel-like appearance and the references to Persia form a theme which encourages the spectator to think about that culture. Chihuly himself is quite clear about these kinds of generalised associations when he says:

> 'I don't know why I call these pieces Persians. I didn't do any research on the arts of ancient Persia. But the forms make me think of mystical enchanted gardens and minarets . . .' Then he later recalled 'I just liked the name Persians. It conjured up "Near Eastern", "Byzantine", "Far East" and "Venice". All the trades, smells and scents. It was an exotic name to me and so I just called them Persians.'

> (Catalogue *The Art of Dale Chihuly*: 32)

So there is a cultural connection here with the ideas of installation and conceptual art and of course these objects are closer to sculpture in the sense that they do not have any function. But the possibilities of extending the role of glass into a purely aesthetic realm makes Chihuly's work into something to be explored for its own sake, where the setting, the lighting and general installation are just as important for the spectator's experience.

Plate 9.4 Dale Chihuly (b. 1941), *Persian Wall*, 2008, 472 × 1,532 × 130 cm, de Young Museum, San Francisco, California. Photographed by Terry Rishel and David Emery © Chihuly Studio.

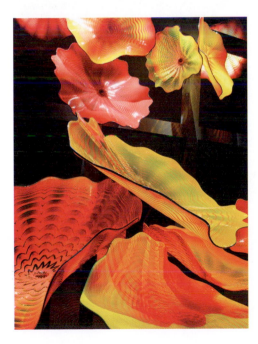

Plate 9.5 Dale Chihuly (b. 1941), *Persian Wall*, 2008. 472 × 1,532 × 130 cm, de Young Museum, San Francisco, California. Photographed by Terry Rishel and David Emery © Chihuly Studio.

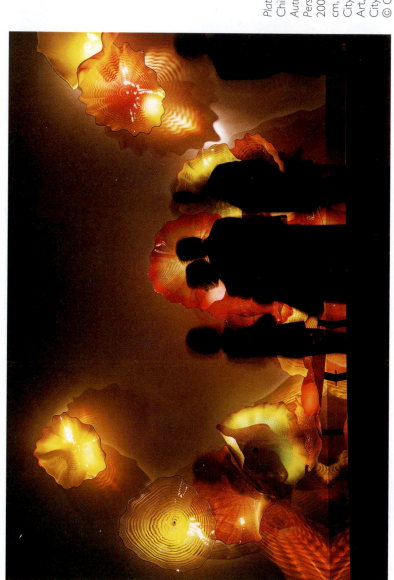

Plate 9.6 Dale Chihuly (b. 1941), *Autumn Gold Persian Wall*, 2002. 287 × 975 cm, Oklahoma City Museum of Art, Oklahoma City, Oklahoma. © Chihuly Studio.

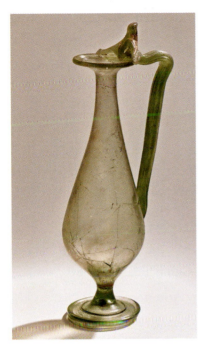

Plate 9.7 Greenish blown-glass jug with an outsplayed lip, Syria, 4th century CE. © The Trustees of the British Museum.

Plate 9.8 Wine glass, designed by Joseph Riedel in 1973, made by Riedel Glass 2011. © The Trustees of the British Museum.

The ideas that Chihuly communicates belong to the fundamental nature of glass which is that it is usually transparent until it is filled with a dark liquid or solid material. This kind of continuity can exist between a glass flagon, like the one from Syria shown in Plate 9.7, made in the fourth century CE, and a glass designed by Riedl for drinking Burgundy. In the flagon, the top, the handle and the base appear more opaque than the body, making the latter appear more transparent and yet still solid at the same time. The glass, on the other hand, will become solid when filled with the red Burgundy and stay transparent when filled with white wine or water. Even so, in this photograph the way the glass catches the light allows us to see it as solid at the base, so that it is anchored effectively to the ground on which it stands.

The ancient skill of glass blowing is very well explained here by Chihuly:

One can only wonder what kind of genius thought of blowing human breath down a metal tube, forming a bubble inside a molten blob of glass. And to think that this molten blob of glass is made only of silica or sand, the most common material in the world that can be transformed from a solid to a liquid to a solid just from fire. For me it is the most mysterious and magical of all the inventions or materials that mankind has invented or discovered . . .

(Ibid.: 14)

So, just as with the ceramics or indeed the goldsmithing we discussed earlier, Chihuly's approach is first of all about the skill of glass blowing and the way its possibilities can be extended.

FURNITURE AND ITS SCULPTURAL POSSIBILITIES

Plate 9.9 Hall Chair by Thomas Chippendale, *c.*1780

Plate 9.10 Stacking Side Chair by Arne Jacobsen, 1951

The reason that the chair in Plate 9.9, designed by Thomas Chippendale for Nostell Priory, can be experienced as sculptural is connected with its setting, so that the spaces in between express the forms as much as the forms themselves. There is a symmetry about it too which is very three-dimensional and satisfying to the eye. The oval at the back has spokes framed by a ribbon-like decoration echoed in the plainer shape of the seat and the curved arms which seem to embrace the person who might sit on it. Underneath, the four legs marry with the verticals of the arms and of the waisted section of the back, which in turn has a smaller oval within it.

This chair seems to fit beautifully with the plaster work in the recessed panel above. Originally it was painted lead white to create a subtle counterpoint with the interior of the room which was designed by Robert Adam in varying shades of white. However, the chair was grained and stained and turned darker later on, in 1819. But even so it is allowed to stand out against the different shades of white and this helps us to see its three-dimensional qualities more clearly. It stands so lightly on the floor yet looks an inviting shape to sit in. Maybe you could not describe it as sculpture exactly, but its plastic qualities of form and space are undeniable.

In contrast, the chair by Arne Jacobsen is a superb example of modern design which was created to be manufactured in large numbers

Plate 9.9 Thomas Chippendale
(1718–1789), Hall Chair, c.1780,
grained by Thomas Ward, 1819. Partial
view of Top Hall at Nostell Priory,
West Yorkshire. © National Trust
Images/Andreas von Einsiedel.

Plate 9.10 Arne Jacobsen (1902–1971), Stacking Side Chair, 1951 (manufacturer:
Richards Morgenthau Co.). New York, Museum of Modern Art (MoMA).
Moulded plywood, chrome-plated tubular steel, and rubber. 30 × 20½ × 21 in.
(76.2 × 52.1 × 53.3 cm). © 2013. Digital image, The Museum of Modern Art,
New York/Scala, Florence.

as a stacking chair for institutions and public places; when we say modern in this sense we mean that its shape is paired right down, that, unlike the Chippendale design, it has no exterior decoration and that the aesthetic appeal of it is entirely in its shape. It is made of moulded plywood, not carved mahogany, and mounted on three chrome-plated tubular steel legs with rubber feet. The whole chair has an immediate aesthetic appeal, but then you begin to see that this is achieved not only by paring down any superfluous decoration, but by meticulous attention to detail; for instance, the way the grain of the plywood travels down the back in stripes with a V in the centre which tracks into the seat and splays outwards expressing the increasing width. You can see that the circular edge of the seat is slightly raised in order to support the thighs of the seated person, encouraging them to sit back comfortably. The central leg catches the direction of the downward grain of the plywood and continues it in a vertical to the ground. At the side you can see that the legs are installed at a slight angle to give stability to the design and show that it is meant to take the weight of its seated occupant. Also, when you sit in it, you find the height of the back is just right for supporting your sitting position.

Like the Chippendale chair, part of the fascination is the way the Jacobsen one occupies the space surrounding it. The edges of the waisted back create a rhythm whose movement is continued in the shape of the seat, and then the way the shapes between the legs appear more geometrical, almost as though it was mounted on a solid volume, triangular in shape. The character of this chair makes it seem almost alive and so it has been nicknamed 'the Ant' because of its insect-like associations. This living quality will occupy us in the section on industrial design too.

SCULPTURE AND INDUSTRIAL DESIGN

Plates 9.12 and 9.13 The Model T35 car by Ettore Bugatti, 1926

Plate 9.14 The Spitfire, by R.J. Mitchell, 1939–1945

Plates 9.15, 9.16, 9.17 and 9.18 The *Paternoster Vents* by Thomas Heatherwick Studio, 2000

You would not normally think of a car in the context of sculpture perhaps, but there is a sense in which the best of them can be considered as works of art. For instance, if you go to Modena in Italy, there is a museum devoted to the automobiles of Enzo Ferrari, where

Plate 9.11 Ettore Bugatti (1881–1947), Bugatti T51, year of manufacture 1931–1934. © Bugatti Trust.

Plate 9.12 Ettore Bugatti (1881–1947), Bugatti Type 35 drawing, year of manufacture 1924–1931. © Bugatti Trust.

each car is set on a pedestal like a piece of sculpture, and of course cars are included in the design section of the Museum of Modern Art in New York. But an even more interesting example of this is the work of Ettore Bugatti. He came from a family of artists because his father was a designer and maker of furniture, and his brother was a sculptor particularly of animals.

Bugatti saw his cars as integral to three-dimensional aesthetic experience and this is particularly clearly demonstrated in the case of the model known as the T35 and what became the T51. He referred to his cars as thoroughbreds 'Le Pur Sang D'Automobiles' and they have a vitality about them which is like that of the horse. Bugatti kept and rode horses all his life and the characteristic curved radiator was based on the shape of a horse collar. The way the wheels are set in front of the radiator and at the four corners of the chassis like the legs of a horse make for a very satisfying basic shape. There is a beautiful drawing for the T35 which demonstrates very clearly how Bugatti was able to reduce his design to a simple and aesthetically pleasing shape. When you look at this drawing it seems to have the simple outlines of a fish with the back being the pointed head and the front end resembling the tail. The fish, as we know, is designed for speed and flexibility and is hydro-dynamically superb.

If you then look at the diagrams and photographs of the car itself you can see these simple lines carried into three dimensions. From the side you can see the wheels in front of the radiator, the lift of the bonnet in front of the driver, the steering wheel with the space for the seats and then the gently sloping tail. It was said by his contemporaries that Bugatti had a natural sense of how to visualise a two-dimensional form in three dimensions which we would call the sculptural vision. This meant that he could often see faults in designs in an intuitive way. He developed his own ideas on engine and trans-mission components which were an essential part of the whole design. However, in spite of this creative brilliance, he was not trained as an engineer and so always surrounded himself with people who were.

> He believed he could get his designs right first time, unlike other great automobile designers like Royce, who believed that no matter how hard you tried on the drawing board there would be some-thing to change or improve when you had run an engine or indeed several of them – the process of 'development' a word which curiously enough has no exact translation in French . . .
>
> History will judge him perhaps as the last of the artist/engineers who could build a business around himself. Engineering is full of

artists – men of vision and natural creative talent – but the march of industrial events and technical progress call now for sound theoretical bases for engineering productions . . .

(Conway, *Le Pur Sang des Automobiles*: 357)

When you look at the Type 35 in three dimensions you can see how the drawing has been translated into solid form and that the shapes and spaces are satisfying from every point of view. As far as the engine is concerned, Bugatti wanted to make the exterior of the engine aesthetically pleasing, so he covered up the complexities of the valve gear with a visually appealing cover from which emerges the exhaust manifold shaped like a bunch of bananas, which is on the opposite side of the engine to the carburettors. H.G. Conway in his book on the Bugatti racing car has this to say:

All factory fresh cars had a fine finish to the engine, alloy parts polished with fine emery, and then the larger items hand scraped for appearance and the cylinder blocks machined all over. The factory finish however was much less highly polished and mottled than most of the restored cars of today. To open the bonnet or hood on a properly maintained Grand Prix car is to delight the eye.

(Ibid.: 151)

Plate 9.13 Ettore Bugatti (1881–1947), Bugatti Type 35 engine, year of manufacture 1924–1931. © Bugatti Trust.

It is worth remembering here that Bugatti's drawings of the engine and engine parts are as beautiful as the design of the car itself. He often had to design and make his own tools in order to achieve the innovations he wanted to arrive at.

At the beginning of his book on the Spitfire, Jonathan Glancey asks the question as to whether this much-loved aeroplane could be considered as a work of art. Certainly the designer, R.J. Mitchell, came from an artistic as well as an engineering background, and although he denied it, he was always good at art at school. Glancey compares Mitchell to the great designer of locomotives, Tom Coleman:

> I mention Coleman because he came from the same social and engineering culture as Mitchell. These were men who knew, as if by instinct, how to draw a beautiful line, but would have denied that their machines were works of art in any sense, not even accidentally. And yet both achieved feats of engineering that were to stir hearts and imaginations. They are too, part of the same breed who went on to design such exquisitely beautiful machines as Concorde . . . (although they were aided by early computers

Plate 9.14 R.J. Mitchell (1895–1937), Supermarine Spitfire Mk I. Photo credit: Rui Candeias.

which could verify aerodynamic concepts in addition to the design idea).

<div align="right">(Glancey, Spitfire: The Biography: 18)</div>

From the sculptural point of view the contour of the outside edge of the Spitfire is as important as the mass and the spaces in between, because it is that which guides the eye to the three-dimensional qualities.

The body itself is extremely slim and elegant with the curve of the nose narrowing to the tail, rather like Brancusi's sculpture *Fish* which we looked at in Chapter 7. Curves are also very important in the shape of the wing and particularly the elliptical way it narrows towards the outside edge. When you look at the design as a whole it looks as though each part belongs to every other in a completely integrated way, especially the curve with which the wing joins the body and the one which connects the upright section of the tail plane. The proportions of the whole design really seem to work to express its aerodynamic purpose. Everything about it is perfectly integrated and looks as though it belongs to the whole. Most importantly of all, when you see a Spitfire flying it looks like a single entity rather as you would design the movement of a bird, particularly a bird of prey, and it is surely more than a coincidence that the Rolls Royce engines for this aircraft were named after the Merlin. The animal or birdlike qualities were described by the spitfire pilot Geoffrey Wellum in his book *First Light*, when he writes about how he saw the Spitfire when he was about to fly it for the first time and walked towards it on the runway:

> Spitfire K. for king stands waiting. The narrow legs of its undercarriage give it an almost delicate appearance. It has the air of a thoroughbred horse watching the approach of a new and unknown rider and wondering just how far to try it on and generally be bloody minded . . . There it stands getting nearer the whole time. Only 170 hours, or just less, and here I am confronted by this lithe creature . . .

<div align="right">(Wellum, First Light: 101–102)</div>

The idea of the association between a design and a living creature is fascinating and is a quality which belongs to other examples we have looked at in this chapter, like Arne Jacobsen's chair and the Bugatti for instance; it means that the design has a quality of life about it which can apply equally to a sculpture or indeed any good work of art.

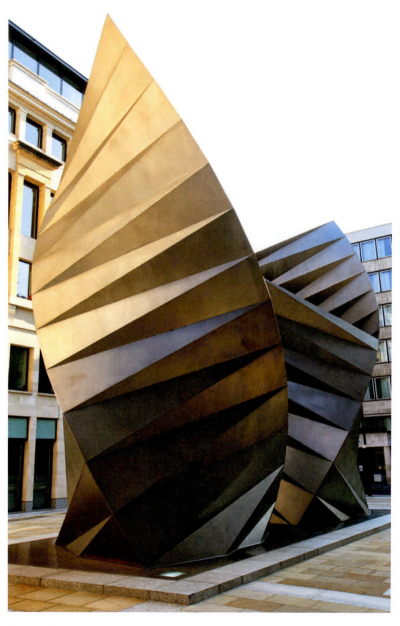

Plate 9.15 Thomas Heatherwick (b. 1970), *Paternoster Vents*, Paternoster Square, London. © Heatherwick Studio. Photography by Finbar Good.

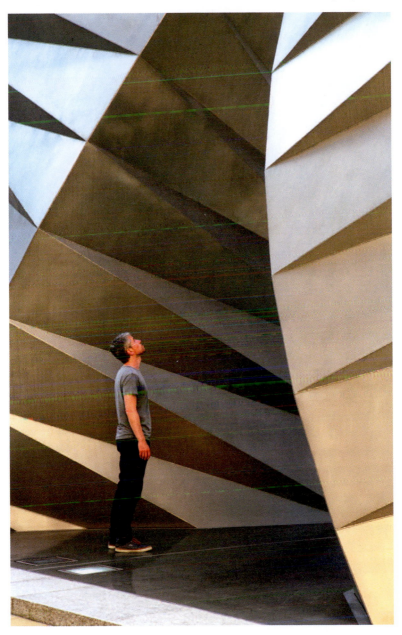

Plate 9.16 Thomas Heatherwick (b. 1970), *Paternoster Vents*, Paternoster Square, London. © Heatherwick Studio. Photography by Finbar Good.

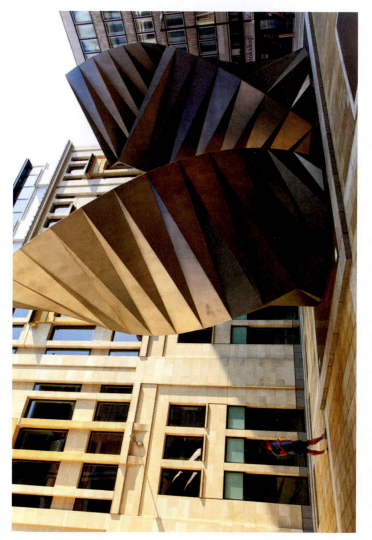

Plate 9.17 Thomas Heatherwick (b. 1970), *Paternoster Vents*, Paternoster Square, London. © Heatherwick Studio. Photography by Finbar Good.

The *Paternoster Vents*, designed by Thomas Heatherwick and his Studio, are named after the area in which they are situated, off Paternoster Square near St Paul's Cathedral in London. When you first see them they take you by surprise in a small space at the end of a narrow pedestrian alleyway. They look like the folded wings of a great bird raised off the ground and pointing into the air as if about to fly or perhaps to settle down and perch. The pleated effect of the surface creates light and shade on the folds of the dully reflective stainless steel from which they are made. You can walk between them, so their full three-dimensional effect can be felt as well as the scale, which is huge. They are 11 metres high and made from stainless steel which is 8 millimetres thick and they reach to the second-floor level of the surrounding buildings which were already there; these are designed in a post-modern neoclassical style with severe undecorated pillars and windows with the odd apparently random pediment here and there (see *Learning to Look at Modern Art* pp. 191–211). The vents themselves curve outwards and away from you, rising to a point on either side. They really do look like pieces of sculpture, and the elongated triangles of the pleats act as a counterpoint to the severe horizontals and verticals of the building façades.

The Vents' assymetrical forms are gradually revealed as you walk towards them down the narrow pedestrian walkway from Paternoster Square. From there you can see that the other side of the site opens out into Ave Maria Lane, Amen Corner and Warwick Lane which run at an angle, creating a slightly slanting end to the space. If you cross these streets and stand at Amen Corner and look back, you see the Vents head on and then the light catches them from the left, making longer shadows appear on them. Then, as you walk back and round them, the light changes and makes the surface of them seem to move and create visual variety. Optically the Vents appear from here to be in the middle of the square, but in fact they stand on a shallow rectangular plinth slightly to the side. They seem to have been set out like the facing pages of a book, in what designers call 'book-matched' design; as Heatherwick himself says, like mirror images of one another. As you move back across the street they appear closer together, and as you walk round they separate and create movement in the small square. Here you can see that they are actually standing on flat ventilators let into the plinth, which are repeated at various points along the sides of the square, wider on the left and narrower on the right, where they are closer to the buildings. Then you see that the zigzag metal shape of the Vents is

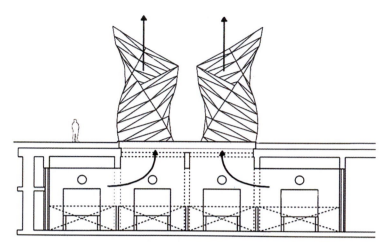

Plate 9.18 Thomas Heatherwick (b. 1970), *Paternoster Vents*, diagram of the ventilation shaft. © Heatherwick Studio.

set into the metal grid and it becomes obvious that they are ventilation shafts.

The *Paternoster Vents* were designed to provide ventilation for an electricity sub-station below ground and this diagram shows how the hot air is released from the ventilator shafts and cool air is sucked in through the grids on the ground. The design problem that needed to be solved was how to make the vents appear as small as possible so that they did not take up all the space in the square and yet function in the way they were required to.

> The commissioner had been exploring options that involved cre-
> ating a single structure that housed both inlet vents and outlet
> vents. It made a large bulky object that dominated the public
> square around it, reducing it to little more than a corridor. As this
> was a sensitive location near St. Paul's, we decided to make it our
> priority to shrink the visible mass of the vent structure to a
> minimum.
>
> (Heatherwick, *Making:* 184)

Heatherwick and his design team started out by folding a piece of A4 paper, turning the flat surface into a zigzag like pleating fabric and making it much fuller of variety and movement. The answer they came up with is imaginative and exciting and expresses something

fundamental about the relationship between the three-dimensional and the flat. It is like a piece of flat fabric which becomes three-dimensional through making it into something which can be worn by the solid form of the body. Indeed Heatherwick had 'explored the possibilities of making structures with textiles'. He talks very graphically about how he and his design team have broken boundaries, which is one of their stated aims and which he says he learned while studying at the Royal College of Art.

> Studying at the Royal College of Art gave me the space to think about the way in which I might practise as a designer when I left the education system. Instead of rigidly dividing artistic thinking into separate crafts and professions such as sculpture, architecture, fashion, embroidery, metalwork and landscape, product and furniture design, I wanted to consider all design in three-dimensions, not as multi-disciplinary design, but as a single discipline: three-dimensional design. Also, because each separate creative discipline seemed to be associated with a particular scale, there was an opportunity to take the aesthetic sensibilities of smaller scales of making, such as jewellery or bread making, and introduce these into the large-scale world of building design.
>
> (Ibid.: 11)

So you could see the *Paternoster Vents* as scaled-up pieces of folded paper made from a sheet of ordinary A4 and turned into a pair of stainless steel bird's wings.

CONCLUSION

In this chapter, and indeed in this whole book, we have tried to explore three-dimensional art, sculpture and design, from as many points of view as possible. It is a complex subject, not only in terms of many of its techniques, but also in the way it can impinge on and invade other areas of artistic interest, as when it is associated with painting, architecture or design. The most important factor, it seems to me, is that the three-dimensional experience is all around us and that we can learn to recognise that in the way we see sculpture. Indeed, the spectator could become increasingly important. In her book *The Modernity of Ancient Sculpture*, Elizabeth Prettejohn describes how the spectator and the hundred points of view could be taken more into account, particularly in the study of sculpture:

Always bearing in mind the limitations of our reproduction technologies, sculpture can help us to a more sophisticated understanding of how our own presence conditions even the most basic visual characteristics of the object; an altered point of view will change the visual relationships within the object, its relationship to its surroundings and our own orientation to it . . . every time we think we are getting the measure of the object of study, we should move round it to see what another view will reveal.

(Prettejohn, *The Modernity of Ancient Sculpture*: 251)

In other words, the role of the spectator is crucial to the three-dimensional experience, and the idea of the actual rather than the virtual presence. Sculpture always makes its presence felt in the sense that it occupies our space and is real in a non-illusory way. Yet many people remain less aware of it than of painting. This sculptural quality of realism can enhance our critical understanding of the visual arts, and indeed the three-dimensional world as a whole.

Appendix 1

Questions to ask yourself when looking at sculpture

1. Where is the sculpture situated in relation to where you are standing?
2. Can you walk round the sculpture and see it from several sides and how does it look different from different angles? Does it have a presence in your space?
3. Where is the form of the sculpture in relation to the space surrounding it? Is the sculpture contained within itself, or does it come out into your space?
4. What size is the sculpture? For example, is it life size or smaller or larger than life size?
5. What type of sculpture is it? For example, is it a relief, a bust, a free-standing figure, nude or clothed, a group or an installation?
6. What is the sculpture made of? For example, bronze, marble, stone, wood, metal, or a mixture or other materials?
7. What about the surface of the sculpture? Is it smooth and highly finished and/or polished? Is it rough? Is it reflective? Touch it if it is possible to do so. If not, try to imagine what it would be like to touch.
8. Is the sculpture outside or inside? What difference does this make to the way you see it?
9. How is the sculpture lit? What difference does the lighting make to the way you see it?
10. Does or did the sculpture have a function? For example, was it or is it part of a building? Is it still in its original setting? Is the sculpture complete or incomplete, finished or unfinished?

Glossary of some sculpture terms

This glossary cannot be like a dictionary of language as applied to sculpture. Apart from some technical terms it aims to include words whose normal meaning is extended when applied to sculpture and three-dimensional work.

Abstract In sculpture, like painting, this term is used for a work without a subject. This does not necessarily mean it is without a title designed to direct the eye and mind of the spectator. It is a term which can also be used to describe and analyse visual qualities within a sculpture like **negative space** which has been considered at various points in this book.

Alabaster A type of stone used for carving sculptures which is softer than marble and usually white. When cut thin it has a translucent quality as in alabaster windows. Also there can be a delicacy and refinement about the way the material responds to fine carving, as in the tomb of the Duchess of Suffolk in Chapter 6.

Antiquity A rather general term used to describe the classical world, and in the history of art it is applied most often to classical art as in the work of the Greeks and the Romans. The term 'antique' or 'the antique' usually refers to ancient or classical sculpture which has been continually renewed and reinterpreted by subsequent generations.

Architectural An adjective which when applied to sculpture implies a structural quality similar to that of a building. This could refer to sculpture which is integral to the architecture and used to enhance it, or it could suggest that there is a crossover between architecture and sculpture as in Hawksmoor's Church of St Alfege in Chapter 7 or Lutyens' War Stones in Chapter 6.

Armature A structure or framework used to support a sculpture from the inside; it can be made of wire, wood or steel rod; it is

primarily used for a sculpture modelled in **clay**, **wax** or **plaster** in order to hold the shape and form of the sculpture together. It can also be used to support **stucco** or plaster decoration on a wall or ceiling. Degas' *Little Dancer* in wax or the stucco decoration at Fontainebleau Palace or Rodin's plaster models would have needed an armature. Carved sculpture supports itself but might need an exterior support as in the use of the cuirass in Bernini's figure of David in Chapter 2.

Axes A term used to refer to the angles which control the design of a sculpture, like the diagonals in *Samson Slaying the Philistine* by Giovanni Bologna (known as Giambologna) in Chapter 3 or the Corten steel structure called *Fulcrum* by Richard Serra in Chapter 7.

Bozzetto Italian word for a preparatory model. See **maquette**.

Bronze Usually refers to sculpture made by the lost wax process of bronze casting so that it is hollow rather than solid. First the sculpture is modelled usually in **clay**, **plaster** or **wax** over an **armature**. Then to get it ready for casting, a plaster, or more recently a silicone rubber, mould is made which takes the character and surface of the model. This peeled or cut off and filled with **grog** to make a stable core. Then this model is covered with wax which in turn is covered with plaster on the outside done with liquid pottery clay which gets thicker and thicker with sprues and holes in it for drainage. When the whole thing is heated, the wax runs out, hence the term lost wax process. After that the molten bronze is poured into this space, allowed to cool and then the outer shell is removed to reveal the bronze cast beneath. Then, after the sprues and holes have been tidied up and filled in, **patination** can begin.

Burnishing One of the many processes of polishing and finishing metal sculpture.

Bust Sculpture of head and shoulders, usually a portrait, as discussed in Chapter 5.

Cameo The use of types of agate like onyx and sardonyx to carve through layers of banding to reach colours beneath to make a relief effect. It can also be used to make relief on brooches and rings, particularly in shell cameos, as well as on larger items; see Chapter 1. In the eighteenth century Josiah Wedgwood developed his Jasperware out of pottery clay to create the effect of cameo relief work. Cameo relief effects can be made from glass as in the Roman Portland Vase which inspired Wedgwood to invent his Jasperware.

Carving The process of taking away from a block of stone, marble, wood or other hard material using various types of chisel, hammer,

and mallet. In his book on *The Materials of Sculpture* (p.84), Nicholas Penny has this to say about the use of the chisel: 'Whereas much ancient Greek and Roman marble was carved without the use of the claw chisel, in most European sculpture since the sixteenth century this tool has been a crucial intermediary between the point chisel used for the rough shaping of the block, and the flat chisel used for the final cutting.' The claw chisel is particularly useful in a reductive process because it can be used to shave more gradually and there is more safety when removing unwanted material.

Cast or **casting** These terms are usually used to describe a plaster cast of a particular sculpture like those in the cast galleries of the Victoria and Albert Museum (see Chapter 2); they have long been used for the study of well-known pieces by students in art schools and by those studying the history of art. More recently the cast has been used by artists like Rachel Whiteread and Antony Gormley (see Chapters 2 and 6). Also of course it can refer to a **bronze** cast.

Ceramics Usually refers to pots and tiles etc. which are for use or decoration. For these, pottery clay is used and then fired in a kiln at very high temperatures to make it really hard and durable (see sections on Josiah Wedgwood and Grayson Perry in Chapter 9).

Chasing Refers usually to the finishing of the surface of a bronze sculpture, but also of course can be applied to work in silver and gold. Chasing can impart a decorative effect rather like hatching in a drawing or print.

Chisel See **carving**.

Chryselephantine A combination of gold and ivory used in ancient Greece (see Chapter 1).

Clay This can apply to a wide range of materials including terracotta and pottery clay. Both materials can be used for modelling sculpture over an armature; it is worked with the hands by means of modelling, but can also be cut with a knife or a cheese wire and scraped with a scraper, or a modelling tool, when it can resemble carving. See also **plaster**.

Collage The use of found objects which can be made into sculptures which are not modelled or carved in the traditional way but are glued, rivetted or constructed from several pieces of material. A collage is not made in the traditional craft-based way, and this is what relates it to **installation** work; it is also connected with the idea of the Ready-Made invented by Marcel Duchamp, although these are normally industrially made and not reclaimed in the same way as a 'found object' (see *Learning to Look at Modern Art* Chapter 3).

Commemoration This is usually used to describe memorials dedicated to people or events of significance, but sometimes, particularly in medieval sculpture, they become more like an embodiment of an idea, as in the figure of Ste Foy at Conques or the one of Jesse at Abergavenny (see Chapter 6).

Construction When applied to sculpture this term means built up by different techniques like welding, rivetting or glueing rather than being modelled or carved or cast in the traditional sense. This would apply to the welded steel sculptures by David Smith (see Chapter 8).

Containment A term used to describe the contour or outside edge of a sculpture so that the eye is encouraged to concentrate on the parts inside. This would apply to sculpture like Michelangelo's *David* or Rodin's *Burghers of Calais*. It can even apply to a piece like *Samson Slaying the Philistine* where all the **dynamic** energy is contained within the group (see Chapters 2 and 3).

Contrapposto A term used since classical times to refer to the pose of a usually nude human figure where the weight is on one leg, creating a vertical on one side of the figure and allowing the slack side to curve in order to create variety for the eyes of the spectator. The sculptor can express the contrast between static and dynamic, movement and stillness, and vertical and rhythmic elements in the sculpture (see Chapter 1).

Decoration This is where a sculpture can be embellished with colour and/or accessories; sometimes it can be distracting but often it can be so beautifully integrated that it can enhance the overall effect, as in the use of texture or combinations of materials as in Barye's animal sculpture (see Chapter 3) or the jewels and gold in the medieval Venetian altar (see Chapter 4).

Drapery A term used in sculpture and painting to refer to clothing and textiles, not just because they are being worn by the subject, but because they can be used to enhance the form of the sculpture as in Rodin's figure of Balzac (see Chapter 2).

Drill A tool which moves by being turned on a point into stone or wood. Drilling can be used to create the effects of hair as in the double bust by Tullio Lombardo (see Chapter 5) or deep shadows in **drapery** as in Bernini's monument to the Blessed Ludovica Albertoni (see Chapter 6).

Dynamic A word used in sculpture to imply tension stretching or pulling in several directions at once as in Giambologna's *Samson Slaying the Philistine* (see Chapter 3). It is particularly remarkable when it is achieved in a hard material like marble or bronze.

Effigy A symbolic representation of a person which is not necessarily about likeness but more about a symbolic representation; it is most often used to represent the idea of a saint or when we don't know what the person looked like, as in the knight on the tomb in Dorchester Abbey (see Chapter 6).

Embodiment This is a word which can be used when a sculpture is done to express an idea of something which, again, is not to do with likeness but more the representation in three dimensions of an idea, like the Tree of Life (see Chapter 6).

Engraving In sculpture this is more likely to refer to very low relief which is almost like the gouged lines of a metal engraving. So it could refer to a technique like **schiacciato** or engraved **glass** (see Chapter 4).

Ethnography The study of alternative cultures, usually meaning those that are different from the classical.

Ethnographic sculpture This became particularly influential in the early twentieth century as part of a general turning away from the classical tradition (see Chapter 5).

Fire gilding A technique where gold is mixed with mercury and applied to a metal like copper, silver or bronze which is then fired at a very high temperature so that the mercury evaporates and leaves the gold adhering to the surface. The gold can then be finished off by **burnishing** and **polishing** (see Chapter 4 on the Story of Isaac and Jacob by Ghiberti).

Free-standing A term used to describe sculpture in the round so that the spectator can walk round and see it from all sides (see Chapter 2).

Gilding Where gold is applied to various surfaces by **burnishing** or firing. It is often done through the use of gold leaf over a red adhesive surface called a mordant like red bole which enhances its glow. Or the metal can be beaten over the wooden carcase of a figure, as in the case of Ste Foy (see Chapter 6), or used as the background for enamel and jewels, as in the Jewelled Altar at St Mark's in Venice (see Chapter 4). It can also be used to make figure pieces.

Glass Made from a mixture of silica, lime and soda which is then heated until it becomes molten. Then it can be blown through a metal tube into all sorts of three-dimensional shapes; it can be with or without colour or made to appear transparent or solid. Glass dates from as far back as the third millennium BCE (see Chapter 9 on Chihuly's glass sculpture)

Gold A precious metal which is extremely malleable and which can be beaten into very thin sheets called gold leaf and which never tarnishes. It is often alloyed with copper to make it more durable.

Goldsmithing The skill of working in gold, which was at one time the most valued training for an artist because it involves intricate and detailed work requiring great manual dexterity and co-ordination in dealing with this most precious material.

Grain Refers to the grain of the wood reflecting the way it has grown. Carvers work with the grain as well as across it. Woods vary in degrees of hardness like oak and softness like lime, and some have more noticeable wider grains like elm. Some, like fruit wood, are less expensive than tropical hard woods such as the best mahogany.

Grog An inert material, most usually crushed fired clay, which will tolerate high temperatures; it is most commonly used for the inside of the **plaster** mould which forms the basis of lost wax bronze casting. See **bronze** and Chapter 1.

Group sculpture Sculpture with more than one free-standing figure (see Chapter 3).

Hammer. See **mallet**.

Historiography The study of what past writers thought of famous works of art like the *Laocoön* and also how they saw and studied different periods in the history of art. They can be writers who were contemporary with the artists, or ones living much later and voicing an opinion; they can add a great deal to our understanding of how famous pieces were seen (see Chapter 1).

Idealisation This term has a long philosophical history which goes back to the writings of Plato. But in terms of the history of sculpture it is used to describe something, usually the human figure, which is made to look more beautiful or more heroic than in real life.

Idolatry The worship of idols which was feared in the early Christian and medieval periods, particularly in relation to the free-standing human figure (see Chapter 4).

Industrial The use of mechanised processes, such as welding, in the making of sculpture. But it can also imply the use of industrial materials like Corten steel as in the work of Richard Serra or David Smith (see Chapters 7 and 8).

Installation Three-dimensional work which is site specific and made from ready-made materials which are changed through the artist's choice and treatment of them. An installation can also be made from natural materials as in the work of Richard Long or David Nash (see Chapter 7). These sculptures are installed in a specific place and then often dismantled for installation somewhere else. See also **collage** in *Learning to Look at Paintings* and **readymade** in *Learning to Look at Modern Art*.

Ivory A natural material derived from animal tusks like those of the elephant or the teeth of large mammals. Usually used for intricate carving on a small scale (see Chapter 4).

Kinetic Sculpture that moves in space, thus expressing form through space. Developed particularly in Russia in the early part of the twentieth century by artists like Gabo and Rodchenko; it incorporates the idea that sculpture does not have to be made from solid or static form (see Chapter 1).

Lamination The fixing of thin layers of wood or other materials which can then be cut or carved into shape.

Likeness Literally like a portrait of somebody or something implying close imitation of the natural world to the point of deceptive illusion. See **mimesis** and **verisimilitude** in Chapters 1 and 2.

Lost wax A method of casting usually in bronze. See **bronze**.

Low relief Sometimes called bas-relief. Sculpture which is carved or modelled against a background like a three-dimensional picture (see Chapter 4).

Mallet Used as a hammer. Usually made of wood and used as a hammer against the chisel in process of cutting or **carving**.

Maquette A model for a larger piece of sculpture, usually in wax, clay or terracotta; they can be used for pieces that are to be carved in wood or stone as much as for casting in bronze. See Degas and his wax models in Chapter 2, or Verrocchio's bozzetto for a tomb in Chapter 6.

Marble A limestone rock which can come in different colours; it can be shaped and sanded to a fine finish and then polished.

Memorial Memorials to the dead as well as famous figures in history form a large part of the sculptor's work from ancient times to the present day; (see particularly Chapter 6).

Metaphor This is a term which can be used to describe meaning in sculpture as in the other arts. An example of this could be the idea that an equestrian monument is about the power and control exerted by such figures as Marcus Aurelius or Peter the Great (see Chapters 1 and 3).

Mimesis See **likeness** and **verisimilitude** as discussed in Chapters 1 and 2.

Modelling Working with soft materials like clay, terracotta, wax and plaster. See **clay**.

Negative space A term used by artists to describe the shape of spaces between forms which in turn enhance the expression of three dimensions.

Nike The Greek word for victory as in the *Winged Victory of Samothrace* (see Chapter 1).

Onyx See **cameo.**

Ornament See **decoration**.

Paragone Italian term for the comparison between painting and sculpture initiated during the Italian Renaissance (see Chapter 5).

Patination The polishing and treating of sculpture to achieve an attractive exterior. Usually the word is used in connection with bronze where heat and chemicals can be applied with a brush or a blow lamp to change and enrich the surface which can then be polished. Sometimes patination can refer to the effects of weathering when sculpture has been outside.

Perspex A type of transparent plastic which can be used in **constructed** sculpture.

Photogram A technique for making images of three-dimensional objects appear to float in space.

Plaster A material made from limestone or gypsum which is heated to a very high temperature and then ground to a powder. Water can be added to form a useful substance for modelling as it sets hard; it can also then be carved as if it were a stone.

Plasticity A term used to describe the three-dimensional or plastic qualities of sculpture. It can imply potential movement.

Plexiglass A type of transparent plastic which, like **perspex**, can be used for making sculpture.

Plinth A base or platform upon which a sculpture can be mounted.

Pointing machine Used for making replicas of sculptures usually taken from clay or plaster models to stone or bronze and sometimes from bronze to marble as in Rodin's case. According to the sculptor Peter Rockwell: 'You set the pointing machine to transfer measurements from clay or wax models to stone by first establishing a series of three measuring points on each. Any other point can then be transferred from the model to the marble being carved' (Rockwell, *The Compleat Marble Sleuth*: 214). So the pointing machine will establish the height and the width all round and the depth of the receding and the protruding points for transference. For a more detailed description see Chapter 2.

Polish Put on the surface of sculptures to make the surface more reflective or more highly finished.

Polychromy A term used to describe painted sculpture. Putting paint on sculpture can change its appearance considerably (see Chapters 2 and 3).

Portrait A likeness of an individual as in the bust (see Chapter 5).

Pottery and **pottery clay** A type of clay which can be baked at very high temperatures; it is usually used for making **ceramics** of all kinds.

Proportion A type of measurement that relates the parts to the whole, hence the expression 'in proportion' or 'out of proportion' (see Chapter 1).

Relic In the most literal sense this means the remains of something which has at one time been complete. But in medieval times, particularly in the Christian world, relics came to be associated with the sacred. Usually they were connected with the body parts of saints or Jesus Christ, and with legends surrounding them; one of the most famous of these was the story told in the Golden Legend of how Helena, the mother of the Emperor Constantine, discovered the wood of the True Cross. Churches with good relics attracted pilgrims, like the Cathedral of St Lazare at Autun (see Chapter 4).

Relief A type of sculpture which is not free-standing but attached to a background and therefore more like a three-dimensional picture. The term can include cameo, ivory and ceramic work as well as jewellery and some kinds of installation. There is also **low** or bas-**relief**, or high relief as well as **schiacciato** (see Chapter 4).

Reliquary A beautiful casket or container for a sacred relic as in the Altar of the Holy Blood by Tilman Riemenschneider (see Chapter 7).

Replication Usually used to describe exact copies of sculpture made with the pointing machine or, more commonly, limited editions of bronzes and sculptures, or plaster casts taken from famous sculptures mainly for educational purposes (see Chapter 2).

Scale The size of a sculpture can be very important both in relation to its setting and how the spectator responds to it.

Schiacciato A form of very low relief which means literally squashed; it was most famously used by Donatello (see Chapter 4).

Scrim A type of open weave hessian used to wrap an armature before wet plaster is applied to it. More recently it has been used in installation work (see Chapter 7).

Sensual Usually used to describe an erotic experience, but it can be applied to the sensation of touching and feeling the surface of a sculpture.

Silicone A kind of plastic used to make materials like rubber more pliable and therefore more easily separated from the sculptor's model.

Silver See **gold**.

Steaming Wood can be steamed in order to make it bend (see Richard Deacon's *Laocoön* in Chapter 1).

Steel and **stainless steel** A type of iron to which elements, for example chromium, have been added to make it more tensile and which can prevent damaging corrosion or fundamental changes in colour.

Stereometry A geometric method used by Naum Gabo particularly for making sculpture with space rather than solid form; he made constructed sculpture out of transparent and translucent materials.

Stucco A type of plaster which is made from lime and white marble dust, to which wax, milk, gesso and other organic substances can be added. If the ratio of marble dust is higher it can also be polished (see Chapter 7).

Surface A very important part of sculpture because of its **sensual** and **tactile** qualities and the different ways in which it can be treated to enhance the visual effect.

Symmetry Connected with the idea of harmony, proportion and grace in sculpture; much admired particularly in antiquity, in the Renaissance and in the neoclassical period of the eighteenth century.

Tactile This quality refers to the idea of experiencing sculpture through touch as much as through the eyes. This is particularly the case with modelling in clay, terracotta or wax where the hand has been directly in touch with the material. But it can also apply to the carved surfaces of wood or stone. Perhaps most importantly, many types of sculpture can make you want to touch them.

Tension This can be created through the pose of the figure, the spaces between forms and the use of other materials like stretched wire (see Chapter 1).

Texture An important part of the surface of sculpture; it can be experienced through touch but also visually in terms of delight; also for expression as in the busts by Daumier in Chapter 5.

Tomb The burial place of a particular person even if that person is not identified, as in the Tomb of the Unknown Warrior in Westminster Abbey, or some tombs from the ancient world. Tomb sculpture has always been important in the Western tradition.

Tools See **carving** and **clay**.

Translation A word which could be used when a sculpture is transferred from one technique to another, as from bronze to marble or vice versa, or the translation of material from one function to another like the silver in Cornelia Parker's **installation** called *Thirty Pieces of Silver* in Chapter 4.

Transposition In this book this has been used in the sense of the movement from one style to another, as in the use of classical language for a Christian purpose in Chapter 2.

Trumeau The central pillar embellished with sculpture in the entrance to a medieval church like the one at the Chartreuse de Champmolle in Chapter 7.

Tympanum The semi-circular space above the entrance door to a medieval church as at the Cathedral of St Lazare at Autun.

Undercutting A term referring to the use of the drill to create deep shadows. See **drill**.

Verisimilitude The idea of realism as discussed in Chapter 2.

Wax A material which can be softened by the use of turpentine so that it can be modelled (see the section on Degas' *Little Dancer* in Chapter 2).

Welding An industrial technique usually used in mechanical engineering to join two pieces of metal together by means of heat. In recent times this technique has been used by sculptors like David Smith (see Chapter 8).

Wood Many different kinds of wood can be used for sculpture: lime, which is even in the **grain** and reasonably soft, fruit woods, like pear or cherry, which can be harder. Other common woods can be used like beech, birch, elm, chestnut, box, holly, laurel, laburnum, plane, sycamore, walnut and oak. Of these, some are more suitable for small items and others larger depending on the form which is being worked on. See also **grain**.

References and further reading

PRIMARY AND CRITICAL SOURCES

These are interesting and can be important because they are contemporary with an artist or a work of art, or because they tell us about views and opinions recorded in a different era.

Aquinas, T. *Summa Contra Gentiles*, taken from *Selected Theological Texts*, ed. T. Gilbey (Oxford University Press, 1955).

Aurelius, M. *Meditations*, trans. A.S.L. Farquerson (Everyman, 1961).

Cellini, B. *Treatise on Goldsmithing and Sculpture*, trans. C.R. Ashbee (London, 1898).

Cellini, B. *Autobiography*. Quoted in *Documentary History of Art*, ed. E.G. Holt, volume 2 (Doubleday Anchor, 1958).

Cézanne, P. *Letters*, selected and edited by J. Rewald (Bruno Cassirer, 1976).

Chipp, H.P. (ed.) *Theories of Modern Art* (University of California Press, 1968).

Cork, R. *Annus Mirabilis? Art in the Year 2000; Everything Seemed Possible: Art in the 1970s; New Spirit, New Sculpture, New Money: Art in the 1980s; Breaking Down the Barriers: Art in the 1990s*. A series of collected articles in four volumes (Yale University Press, 2003).

Duranty, E. 'La Nouvelle Peinture'. See Harrison *et al.*, *Art in Theory: 1815–1900* (Blackwells Publishing, 1998).

Friedenthal, R. (ed.) *Letters of the Great Artists* (Thames and Hudson, 1963).

Glaber, R. *Concerning the Construction of Churches throughout the World*, in *Documentary History of Art*, vol. 1 ed. E.G. Holt (Doubleday Anchor, 1958).

Harrison, C., Wood, P. and Gaiger, J. (eds) *Art in Theory*. Various volumes of extracts from artists' writings and criticism *1648–1815, 1815–1900, 1900–2000* (Blackwell's Publishing, 1992, 1998, 2000).

Hepworth, B. *A Pictorial Autobiography* (Tate Publishing, 2004).

Kemp, M. (ed.) *Leonardo on Painting: An anthology of writings by Leonardo da Vinci*, selected and translated by Martin Kemp and Margaret Walker (Yale University Press, 1989).

Moore, H. *Writings and Conversations*, ed. A. Wilkinson (Lund Humphris, 2002).

Potts, A. *Modern Sculpture Reader*. Compilation of artists' and critics' writings (Henry Moore Institute, 2007).

Preziosi, Donald (ed.) *The Art of Art History: A Critical Anthology* (Oxford University Press, 1998).

St Francis of Assisi, *Umbrian Text of the Assisi Codex*, trans. B. Barrett (London, 1998).

Thomson, B. (ed.) *Gauguin by Himself*. Part of a series including other nineteenth-century French artists e.g. Manet, Degas, Cezanne (Little, Brown and Co., 2000).

Vasari, G. *The Lives of the Artists*, volumes 1 & 2. Selected and translated by George Bull (Penguin Classics, 1987).

Virgil, *The Aeneid*, ed. and trans. by W.F. Jackson Knight (Penguin Classics, 1972).

Wellum, G. *First Light* (Viking Books and Penguin, 2009).

Wincklemann, J.J. *History of the Art of Antiquity*. Introduction by Alex Potts, trans. by Harry Francis Mallgrave (Getty Research Institute, Los Angeles, 2006. Originally 1764).

TECHNIQUES AND MATERIALS OF SCULPTURE

Knowledge of these can often be very informative about what is technically possible and not possible in sculpture.

Andrews, O. *A Sculptor's Handbook* (California University Press, 1983).

Hepworth, B. *The Plasters*, ed. Sophie Bowness, the Hepworth Gift to Wakefield (Lund Humphris, 2011).

Konstam, N. *Sculpture: The Art and the Practice* (Verrocchio Arts, 2002).

Penny, N. *The Materials of Sculpture* (Yale University Press, 1993).

Plowman, J. *The Manual of Sculpture Techniques*. A very well-illustrated guide to all sorts of techniques in addition to carving and modelling, including construction, collage and assemblage (A. & C. Black, 2003).

Rockwell, P. *The Complete Marble Sleuth*. A guide by a practising sculptor to carving in marble (Rockwell Publishers, 2004).

Trusted, M. (ed.) *The Making of Sculpture: The Materials and Techniques of European Sculpture* (V&A Publications, 2007).

Wittkower, R. *Sculpture: Processes and Principles* (Allen Lane, 1977 and Penguin 1991).

CATALOGUES OF EXHIBITIONS AND COLLECTIONS AND VARIOUS GUIDES

These often gather together very useful source material, illustrations and informative articles. They can also include recent views and critical thinking about a particular subject. They are usually written by

multiple authors so they are listed under the words Catalogue or Guide with the titles in alphabetical order.

Catalogue *The Age of Chivalry* (Royal Academy of Arts, London, 1997).

Catalogue *Albers and Moholy Nagy: From the Bauhaus to the New World* (Tate Modern, London, 2006).

Catalogue *Alberto Giacometti* (Royal Academy of Arts, London, 1997).

Catalogue *Ana Maria Pacheco: The Dark Night of the Soul* (National Gallery, London, 2000).

Catalogue *Andy Goldsworthy* (Yorkshire Sculpture Park, 2007–2008).

Catalogue *Anish Kapoor* (Royal Academy of Arts, London, 2009).

Catalogue *Antony Gormley: Blind Light* (Hayward Gallery, South Bank Centre, London, 2007).

Catalogue *The Art of Dale Chihuly* (De Young Museum, San Francisco, 2008).

Catalogue *Art for England: Gothic* (V&A Museum, London, 2003).

Catalogue *Ashmolean: Britain's First Museum* (University of Oxford, 2010).

Catalogue *Barbara Hepworth: Hospital Drawings* (Hepworth Museum, Wakefield and Pallant House, Chichester, 2012–2013).

Catalogue *Bernini: Sculpting in Clay* (Metropolitan Museum of Art, New York, 2012).

Catalogue *Bronze* (Royal Academy of Arts, London, 2012).

Catalogue *Byzantium* (Royal Academy of Arts, London, 2009).

Catalogue *Cast in Bronze: French Sculpture from Renaissance to Revolution* (Louvre Museum, Paris, 2009).

Catalogue *Citizens and Kings: Portraits in the Age of Revolution, 1760–1830* (Royal Academy of Arts, London, 2007).

Catalogue *Constantin Brancusi: The Essence of Things* (Tate Modern, London, 2004).

Eustace, K. *Continuity and Change: Twentieth Century Sculpture in the Ashmolean Museum* (Ashmolean Museum, 2001).

Guide *Coventry Cathedral* (Pitkin Guides, 1991).

Catalogue *David Nash at Kew Gardens* (Kew Gardens Publishing, 2012–2013).

Catalogue *David Smith* (Tate Modern, London, 2006–2007).

Catalogue *Degas: Art in the Making* (National Gallery, London, 2004–2005).

Catalogue *Degas and the Ballet: Picturing Movement* (Royal Academy of Arts, 2011).

Catalogue *Degas and the Little Dancer* (Joslyn Art Museum, Yale University Press, 1998–1999).

Catalogue *Donald Judd* (Tate Modern, London, 2004).

Guide (ed. K. Tiller) *Dorchester Abbey: Church and People* (Stonesfield Press, 2005).

Guide (Cook, B.F.) *The Elgin Marbles* (British Museum Press, 1984/1997).

Catalogue *English Romanesque Art* (Arts Council, 1964).

Catalogue *Hadrian: Empire and Conflict* (British Museum, 2008).

Catalogue *Henry Moore* (Royal Academy of Arts, London, 1988).

Catalogue *Henry Moore* (Tate Britain, London, 2010).

Guide *Hoglands: The Home of Henry and Irina Moore at Perry Green* (Lund Humphris, 2010).

Guide *Houghton Hall, Norfolk: Home of Sir Robert Walpole, England's First Prime Minister* (Heritage House Group, 2007).

Catalogue *The Image of Christ: Catalogue of the Exhibition 'Seeing Salvation'* (National Gallery, London, 2000).

Catalogue *Immaterial: Brancusi, Gabo, Moholy Nagy* (Kettle's Yard, Cambridge, 2004).

Catalogue *In and Out of Material* (Akademi der Kunst Berlin, 2006).

Catalogue *John Flaxman* (Royal Academy of Arts, London, 1979).

Catalogue *Kurt Schwitters* (Tate Gallery, London, 1985).

Catalogue *Louise Bourgeois* (Tate Modern, London, 2007).

Catalogue *Marino Marini: Miracolo* (Staatliche Museum, Berlin, 2006).

Catalogue *Medardo Rosso: The Transient Form* (Peggy Guggenheim Collection, Venice, 2007–2008).

Catalogue *Michelangelo Drawings: Closer to the Master* (British Museum, London, 2005–2006).

Guide *Museum at Reggio da Calabria*. Includes discussion of the rediscovery and restoration of the Riace Bronzes (Reggio da Calabria, Italy, 2005).

Catalogue *The National Archaeological Museum, Naples*. Contains the Farnese Collection of Classical Sculpture (Naples, Italy, 2001/2007).

Guide *Nostell Priory, Yorkshire* (National Trust Guide, 2007).

Catalogue *Objects of Design: The Collection at the Museum of Modern Art, New York* (MOMA Publications, New York, 2006).

Catalogue *The Perfect Place to Grow: 175 Years of the Royal College of Art* (Royal College of Art, London, 2012).

Guide *Pergamon Altar: Its Rediscovery and Reconstruction* (Staatliche Museum, Berlin, 1995).

Guide *Pergamon Museum, Berlin* (Staatliche Museum, Berlin, 1995).

Catalogue *Picasso: Sculptor/Painter* (Tate Gallery, London, 1994).

Catalogue *The Private Degas* (Fitzwilliam Museum, Cambridge, 1987).

Catalogue *Return of the Gods: Neoclassical Sculpture in Britain* (Tate Britain, London, 2008).

Catalogue *Richard Long: Heaven and Earth* (Tate Britain, London, 2009).

Catalogue *Richard Serra Sculpture: Forty Years* (Museum of Modern Art, New York, 2007).

Catalogue *Rodchenko and Popova: Defining Constructivism* (Hayward Gallery South Bank Centre, London, 2009).

Catalogue *Rodin* (Royal Academy of Arts, London, 2007).

Catalogue *Ron Arad: No Discipline* (Museum of Modern Art, New York, 2009).

Catalogue *Ron Mueck* (National Gallery, London, 2003).

Catalogue *Sacred Made Real: Spanish Painting and Sculpture 1600–1700* (National Gallery, London, 2009).

Guide *St Mary's Priory Ewelme* (Ewelme, UK, n.d.).

Guide *Sculptural Itinerary: Museo d'Arte Antica, Sforza Castle, Milan* (Sforza Castle, Milan, n.d.).

Catalogue *Sculpture in the Open Air at Perry Green*. And other aspects of

Henry Moore, all published by the Henry Moore Foundation (Henry Moore Foundation, 2000).
Catalogue *Sculpture in Painting* (Henry Moore Institute, 2009).
Guide *Sculpture Parks in Europe: A Guide to Art and Nature* (Birkhauser, 2006).
Catalogue *Sir Anthony Van Dyck* (Royal Academy of Arts, London, 1999).
Catalogue *Tony Cragg: Sculptures and Drawings* (Scottish Gallery of Modern Art, Edinburgh, 2011).
Catalogue *Treasures of the Fitzwilliam Museum* (Cambridge University, 2005).
Catalogue *Treasures of Heaven: Saints, Relics and Devotion in Medieval Europe* (British Museum, London, 2011).
Catalogue *Tullio Lombardo and Venetian High Renaissance Sculpture* (National Gallery of Art, Washington, 2009).
Guide *The West Window at Coventry Cathedral*. An interview with the maker, John Hutton (Counties Periodicals, various dates from 1962).
Catalogue *Wild Thing: Epstein, Gaudier-Brzeska, Gill* (Royal Academy of Arts, London, 2009–2010).

GENERAL AND CULTURAL HISTORY

This is obviously important for helping us to grasp the background of ideas from which sculpture has come and helps us to understand why it looks as it does.

Ames-Lewis, F. *The Intellectual Life of the Early Renaissance Artist* (Yale University Press, 2000).
Andrews, M. (ed.) *Land, Art: A Cultural Ecology Handbook* (RSA & Arts Council, 2006).
Aston, M. (ed.) *Panorama of the Renaissance* (Thames and Hudson, 1996).
Baker, M. *Figured in Marble: The Making and Viewing of Eighteenth Century Sculpture* (V&A Publications, 2000).
Bartlett, R. (ed.) *Medieval Panorama* (Thames and Hudson, 2001).
Baxandall, M. *Patterns of Intention: On the Historical Explanation of Pictures* (Yale University Press, 1985).
Baxandall, M. *The Limewood Sculptors of Renaissance Germany* (Yale University Press, 2004).
Blunt, A. *Art and Architecture in France, 1500–1700* (Pelican History of Art, 1953; reprinted by Yale University Press, 1999).
Boardman, J. (ed.) *Classical Art* (Oxford University Press, 1993).
Bullus, C. and Asprey, R. *Statues of London* (Merrell, 2009).
Campbell, S. and Cole, M.W. *A New History of Italian Renaissance Art* (Thames and Hudson, 2012).
Causey, A. *Sculpture since 1945*. Oxford History of Art Series (Oxford University Press, 1998).
Cork, R. *A Bitter Truth: Avant Garde Art and the Great War* (Yale University Press, 1994).

Craske, M. *The Silent Rhetoric of the Body: A History of Monumental Sculpture and Commemorative Art in England, 1720–1770* (Yale University Press, 2007).

Curtis, P. *Sculpture 1900–1945*. Oxford History of Art Series (Oxford University Press, 1999).

Davies, G. and Kennedy, K. *Medieval and Renaissance Art: People and Possessions* (V&A Publishing, 2009).

Davies, N. *Europe: A History* (Pimlico, 1997).

Duby, G. and Daval, G.B. *Sculpture*. Volume 1. *From Antiquity to the Middle Ages*. Volume 2. *From the Renaissance to the Present Day* (Taschen, 2006).

Fussell, P. *The Great War and Modern Memory* (Oxford University Press, 1975).

Geurst, J. *Cemeteries of the Great War by Sir Edwin Lutyens* (OLO Publishers, 2010).

Gleeson, J. *The Arcanum: The Extraordinary True Story of the Invention of European Porcelain* (Bantam Press, 1998).

Gombrich, E.H. *Art and Illusion* (Phaidon, 1968).

Graham-Dixon, A. *A History of British Art* (BBC, 1996).

Hall, J. *The World as Sculpture: The Changing Status of Sculpture from the Renaissance to the Present Day* (Chatto and Windus, 1999).

Harbison, C. *The Art of the Northern Renaissance* (Everyman, 1995).

Hills, P. *Venetian Colour* (Yale University Press, 1999).

Holt, E.G. (ed.) *Documentary History of Art*, 3 vols (Doubleday Anchor, 1957).

Jenkins, I. *Greek Architecture and Sculpture* (British Museum Press, 2006).

Jenkins, I. and Turner, V. *The Greek Body* (British Museum Press, 2009).

Kastner, J. (ed.) *Land and Environmental Art* (Phaidon, 1998).

Kemp, M. *Behind the Picture: Art and Evidence in the Italian Renaissance* (Yale University Press, 1997).

Krauss, R. *Passages in Modern Sculpture* (MIT Press, 1977).

Lagerlof, M.R. *The Sculptures of the Parthenon* (Yale University Press, 2000).

Levey, M. *Painting and Sculpture in France, 1700–1800* (Yale University Press, 1993).

Levi, A. *Renaissance and Reformation: The Intellectual Genesis* (Yale University Press, 2002).

Lotz, W. *Architecture in Italy, 1500–1600* (Yale University Press, 1995).

Lowden, J. *Early Christian Art and Byzantine Art* (Phaidon Press, 1997).

Lubrow, A. 'The Gates of Paradise'. An interesting article about the restoration of Ghiberti's second set of bronze doors for the Florence Baptistery (*Smithsonian Magazine*, November 2007).

McCulloch, D. *A History of Christianity* (Alan Lane, 2009).

Naginski, E. *Sculpture and Enlightenment* (Getty Research Institute, 2009).

Olson, R. *Italian Renaissance Sculpture* (Thames and Hudson, 1992).

Osborne, R. *Archaic and Classical Greek Art*. Oxford History of Art Series (Oxford University Press, 1998).

Penny, N. and Schmidt, E.D. (eds) *Collecting Sculpture in Early Modern Europe* (National Gallery of Art, Washington and Yale University Press, 2008).

Perry, G. 'The Tomb of the Unknown Craftsman'. Article on Grayson Perry's exhibition of craft at the British Museum (*British Museum Magazine*, Autumn 2011).

Piper, D. *Treasures of Oxford* (Paddington Press, 1977).

Pope Hennessy, J. *Italian Gothic Sculpture* (Phaidon, 1955).

Pope Hennessy, J. *Italian Renaissance Sculpture* (Phaidon, 1958).

Potts, A. *The Sculptural Imagination* (Yale University Press, 2009).

Prettejohn, E. *The Modernity of Ancient Sculpture* (I.B. Tauris, 2012).

Radke, G. *Leonardo and the Art of Sculpture* (Yale University Press, 2010).

Read, H. *Modern Sculpture: A Concise History* (Thames and Hudson, 1964).

Ritblat, J. *Art at Broadgate* (British Land Company PLC, 1999).

Schapiro, M. *Romanesque Architectural Sculpture*. The Charles Norton Lectures delivered in 1967. Edited with an Introduction by Linda Siedel (Chicago University Press, 2006).

Seidel, L. *Legends in Limestone: Lazarus, Gislebertus, and the Cathedral of Autun* (Chicago University Press, 1999).

Sheeler, J. *Little Sparta: The Garden of Ian Hamilton Finlay* (Francis Lincoln, 2003).

Simblett, S. *Anatomy for the Artist* (Dorling Kindersley, 2001).

Skelton, T. and Glidden, G. *Lutyens and the Great War* (Francis Lincoln, 2008).

Snyder, J. *Medieval Art* (Harold Abrams, 1989).

Snyder, J. *Northern Renaissance Art* (Harold Abrams, 1985).

Spivey, N. *Understanding Greek Sculpture: Ancient Meanings, Modern Readings* (Thames and Hudson, 1996).

Spivey, N. and Squire, M. *Panorama of the Classical World* (Thames and Hudson, 2004).

Stuttard, D. and Moorhouse, P. 'Riding to Resurrection'. An interesting article about a possible interpretation of the Parthenon sculptures (*British Museum Magazine*, Autumn 2008).

Syson, L. and Thornton, D. *Objects of Virtue: Art in Renaissance Italy* (British Museum Press, 2007).

Tait, H. (ed.) *5000 Years of Glass* (British Museum Press, 2012).

Toman, R. *Romanesque Architecture, Sculpture, Painting* (Könemann, 1997).

Tucker, W. *The Language of Sculpture* (Thames and Hudson, 1974).

Von Zabern, P. *The Pergamon Altar, Its Discovery and Reconstruction*, trans. Biri Fay (Staatliche Museum, Berlin, 1995)

Williamson, P. (ed.) *European Sculpture at the Victoria & Albert Museum* (V&A Museum, 1996).

ARTISTS' BIOGRAPHIES

These can be very variable but are often full of information which it may be hard to find anywhere else.

Ayrton, M. *Giovanni Pisano, Sculptor*. With an Introduction by Henry Moore (Thames and Hudson, 1969).

Berthoud, R. *The Life of Henry Moore* (Faber and Faber, 2003).

Cahn, I. *Paul Cézanne: A Life in Art* (Cassell, 1995).

Conway, H.G. *Grand Prix Bugatti* (The Bugatti Trust, 2004).

Conway, H.G. *Le Pur Sang des Automobiles* (Haynes Publishers and the Bugatti Trust, 1987).

Danchev, A. *Cézanne: A Life* (Profile Books, 2012).

Dolan, B. *Josiah Wedgwood* (Harper Perennial, 2005).

Downes, K. *Hawksmoor* (Thames and Hudson, 1996).

Ede, H.S. *Savage Messiah: A Biography of the Sculptor Henri Gaudier-Brzeska* (Pallas Athene, 2009).

Elsen, A. *Rodin: Readings on His Life and Work* (Prentice Hall, 1965).

Foster, H. and Hughes, G. *Richard Serra* (October MIT, 2000).

Givot, D. and Zarnecki, G. *Gislebertus, Sculptor of Autun* (Orion Press, 1961).

Glancey, J. *Spitfire: The Biography* (Atlantic Books, 2006).

Grunfeld, F. *Rodin: A Biography* (Oxford University Press, 1989).

Heatherwick, T. *Making* (Thames and Hudson, 2012).

Hedgecoe, J. *Henry Moore: A Monumental Vision* (Collins and Brown, 1998).

Hutchinson, J., Gombrich, E.H., Njatin, L.B. and Mitchell, W.J.T. *Antony Gormley* (Phaidon, 2000).

Long, R., Moorhouse P. and Hooker, D. *Richard Long: Walking the Line* (Thames and Hudson, 2002).

Lynton, N. *David Nash*. Introduction by N. Lynton (Thames and Hudson. 2007).

Oughton, F. *Grinling Gibbons and the English Woodcarving Tradition* (Stobart Davies, 1998).

Sussman, E. and Wasserman, F. *Eva Hesse* (Yale University Press, 2006).

Thompson, J., Tazzi, P.L., Scheldahl, P. and Curtis, P. *Richard Deacon* (Phaidon, 2000).

Townsend, C. (ed.) *The Art of Rachel Whiteread* (Thames and Hudson, 2004).

White, C. *Rubens* (Yale University Press, 1987).

Index

326 Index